REAL MEN

REAL MEN

Frank Rose

Photographs by
George Bennett

A Dolphin Book

DOUBLEDAY & COMPANY, INC., GARDEN CITY, NEW YORK 1980

ACKNOWLEDGMENTS

For their cooperation and assistance, we would like to thank Colonel F. L. Barksdale and Major Jim Adams of the Virginia Military Institute; Janet Halligan of the New York Rangers; Ron Towns and Ray Harris of the Youngstown Sheet & Tube Co.; Robert Thompson of Bob Banner Associates in Los Angeles; Timothy Seldes of Russell & Volkening; and Carol Goldman and Gerard Helferich of Doubleday & Company. We would also like to thank Michael Denneny, Ted Gershuny, Annie Macdonald, Linda O'Brien, Jay and Deborah Paris, Ruth and Edmund Rose, and Brynn Thayer. And we would like to extend special thanks to the seven men in this book and to their wives, lovers, friends, and co-workers, without whom this project could not have been realized.

Portions of this book have appeared in *Esquire* with the permission of Doubleday & Company, Inc.

Portions of the text originally appeared in a slightly different form in *The Village Voice* under the title, "Danny Fields is a Number-One Fan." Reprinted by permission of *The Village Voice*. Copyright © The Village Voice, Inc., 1977.

"Commando" written by Dee Dee Ramone, Joey Ramone, Johnny Ramone and Tommy Ramone. Copyright © Bleu Disque Music Co., Inc., and Taco Tunes. All Rights Reserved. International copyright secured. Used by permission.

"Float On" by A. Ingram, M. Willis and J. Mitchell. Copyright © 1977 by Woodsong Music, Inc. and ABC-Dunhill Music, Inc. Used by permission of Fee Productions-Woodsong Music.

Designed by LAURENCE ALEXANDER

Library of Congress Cataloging in Publication Data

Rose, Frank.
 Real men.

 (A Dolphin book)
 1. Men—United States—Biography. 2. Masculinity.
3. Sex role. I. Bennett, George, 1945–
II. Title.
HQ1090.R67 301.41'1
Doubleday & Company, Inc.
Library of Congress Catalog Card Number 78–20096
ISBN: 0-385-14421-0

Contents

For Beth Rashbaum and Lindy Hess

The female child's earliest experience is one of closeness to her own nature. . . . The little girl learns "I am." The little boy, however, learns that he must begin to differentiate himself from this person closest to him; that unless he does so, he will never be at all. . . . The little boy learns that he must act like a boy, do things, prove that he is a boy, and prove it over and over again.

<div align="right">

—MARGARET MEAD,
Male and Female

</div>

Introduction

This is a book about styles of masculinity. It is about power and discipline, sex and violence, and the roles they play in the lives of American men today. It can be thought of as a personal and idiosyncratic survey, using a very small and intentionally atypical sample, that was designed to produce not statistical data but individual answers to the question of what it means to be a man. This question has become so open in recent years that the "real man" of the past—that upright personification of everything male—has dwindled to the status of an endangered species. It is not our desire to preserve him. It occurred to us, however, that by looking at people who might once have been considered "real men"—athletes, steelworkers, soldiers—or whose identities might once have been wrapped up in the notion of "real men"—rock stars, actors, homosexuals, self-made businessmen—we might get some sense of the distance between past illusion and current reality.

The illusion we all know from countless John Wayne movies: "real men" are rugged, self-reliant, rational, controlled, potent, aggressive, unyielding, invulnerable. (It is almost as if men have abstracted the qualities of the phallus and made them into ideals of their own behavior.) The phrase itself implies that any man who lacks these attributes—who doesn't keep proving his manhood, who tries to get through life on anatomy alone—is a pretend man, not really a man at all. "Having balls" (testicles, from the Latin *testiculus,* diminutive form meaning "witness") is not, after all, something that can be taken for granted. Men must bear witness to their manhood all their lives, and if the demise of the masculine ideal allows for greater flexibility in doing so, it also allows for greater uncertainty. That uncertainty is the pervasive fact in any discussion of the subject today.

Uncertainty, of course, can lead to anxiety, and anxiety is one of the wellsprings of panic. It's interesting that the past few years have seen a nostalgia for pre-1960s normalcy, a resurgence of the political right, and a simultaneous new concern with men and manhood. A nostalgia for normalcy can be sensed in such diverse phenomena as the rise of the empty-headed television starlet, the current fashion in men's haircuts, and the demise of the New Left. The rise of a New Right has had its impact on issues ranging from the death penalty to government spending to the Panama Canal, but it began with and was probably sparked by conflicts over sexuality: abortion, homosexual rights, the ERA. The interest in masculinity follows a lengthy preoccupation with women—women's rights, women's roles, women's needs—and a cultural flirtation with androgyny that dates from the sixties, a time when the idea of being "normal" was disavowed by many as conformist, confining, and sick. Recent attention to men and manliness reflects the retreat to normalcy in the same way as does the reawakening of the right—that being the sector that has always sought authority, the manly virtue people inevitably look to when things have gone awry.

"Masculinity is the alfalfa peddled in Marlboro Country," observed

Harold Rosenberg (that most genuinely masculine of art critics) in 1967. Since then the currency has been debased considerably. The confusion of maleness with ersatz machismo has led to the development of a mass-consumption manliness that's even campier than the stylized version of college life now being played out by kids who hadn't been born when the last goldfish was swallowed in the fifties.

Consider the Village People, a double-platinum novelty act composed of ultrabutch stereotypes put together by a French disco producer for the gay market: John Wayne reduced to musical cartoon. It wasn't until their "Macho Man" single became a nationwide hit that their record company realized it was the average Joe who was actually buying their product. "Straight guys in America want to get the macho look," the producer concluded in an interview in *Rolling Stone*. Meanwhile, *The Deer Hunter* (which won five Academy Awards even if it didn't outgross the Village People) was replaying John Wayne for the generation that had rejected him a decade earlier in *The Green Berets*. With its contempt for chattering Orientals, its patronizing sympathy for squealing women and weaker men, and its worshipful treatment of De Niro's he-man performance in the title role, this movie tried to do for American manhood what the recent spate of youth-gang films is doing for inner-city adolescence: that is, provide an idealized reminder of what it was all about.

One thing about the men in this book: each one has his own definition of what it means to be a man. Most of them hadn't spent much time thinking about it, wouldn't have been able to articulate it, and probably still couldn't: questions like this are best not answered in words. Most of them, too, would differ with each other on crucial particulars. Still, common themes emerge: the lure of competition; the value of discipline, which at its best means simply authority over oneself; the importance of some sort of shared code; the link between sexual and aggressive instincts. Another thing about these men: each one has successfully adjusted to changing expectations about the male role—whether by accommodation, willful disregard, or some combination of both. They defy the notion that uncertainty is necessarily cause for panic.

Of course, none of these men are intended to be representative, either of men in general or of men who share their station in life. Nor are they intended to be heroes, although there isn't one we didn't come to respect and in many ways admire. We didn't go looking for heroes, because this book isn't about "real men," the mythical ideal; it's about real men. Here are seven of them.

REAL MEN

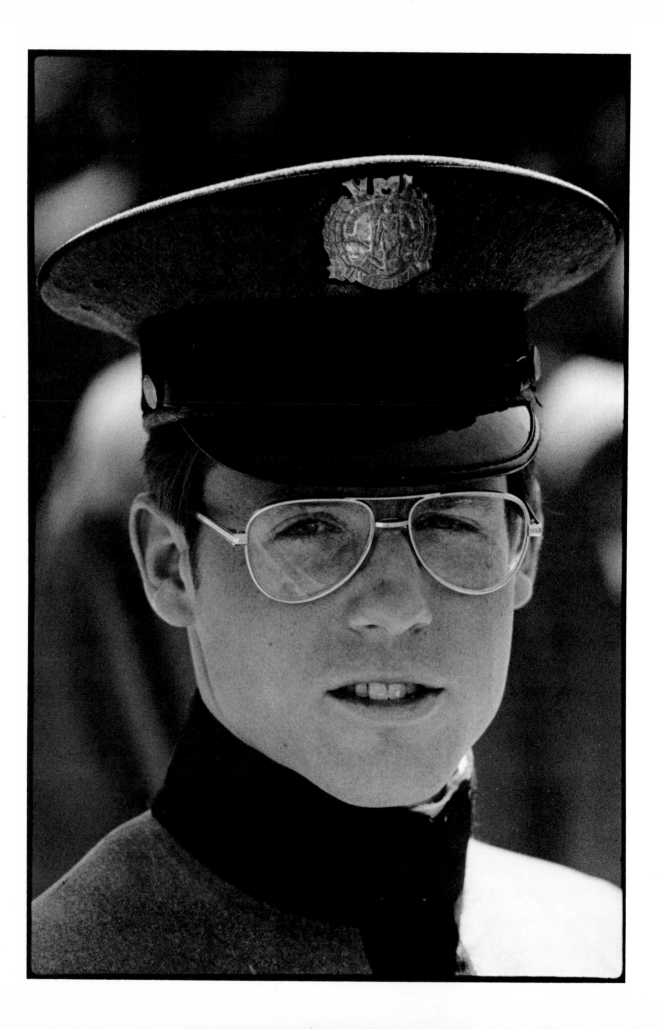

Rick Wetherill

Virginia Military Institute
Lexington, Virginia

By some quirk, or perhaps ironic design, the world's military academies have generally been situated in the most idyllic of locales. So it is with the Virginia Military Institute. For 140 years now, the institute has stood high on a bluff by a narrow stream in the lower reaches of the Valley of Virginia. There, shielded by a bevy of peaceful shade trees, it guards the northern flank of the quiet town of Lexington. Its parade ground opens to the south, to the town and the broad valley beyond. When the cadets march out on parade, as they do every Friday at 4:15 P.M., they enter a landscape of tranquil green punctuated only by the yellow stone walls of the institute itself. Even the bluish Appalachian ranges that circumscribe the valley lie hidden beyond the trees—except for one massif, still distant but closer than the rest, whose solid presence seems to imply nature's acquiescence in the proceedings. It's known as House Mountain. The cadets who pass before it wear dress uniforms of gray and white and carry brown rifles. Some of them wear wine-red sashes and carry swords that sparkle in the sun. They march three abreast through the main archway of their barracks, turn smartly right at the statue of General Thomas J. "Stonewall" Jackson that blocks their way, and proceed up a slight incline to the parade ground. There, accompanied by a marching band that seems unusually rich in drummers, they line up in long, thin columns that stretch the length of the field. After a series of barklike reports from the cadets who carry swords, a single cannon is fired. Its smoke drifts lazily across the parade, inflaming every nostril with the incendiary whiff of gunpowder. Then the flags are briskly lowered, the national anthem is played, more barks are executed, and the cadets march back inside. The tiny throng that has gathered to watch them disperses, and before long the sun sets, over toward House Mountain.

Just beyond the gates of VMI lies a small, private men's college, Washington and Lee University; just beyond that lies the central part of Lexington. There are not many people in Lexington—7,500 at last count, including students—but there is a great deal of history. The town was settled in 1778 by dour Scotch-Irish of strict Calvinist faith. Over the next seventy-five years it grew from a rude collection of log huts to a prototype of the Jeffersonian agrarian village, with two colleges, a commodious and substantial Presbyterian Church, and a debating society that addressed such issues as the hog law and the plight of the heathen who had never heard the name of Jesus. During the Civil War era, the town became linked with two of the South's greatest heroes —Stonewall Jackson, who taught physics and gunnery at VMI before the war, and Robert E. Lee, who headed Washington College (as Washington and Lee was then known) after it. As a result, Lexington has become permeated by tradition the way other towns are permeated by unemployment or religion or the sea.

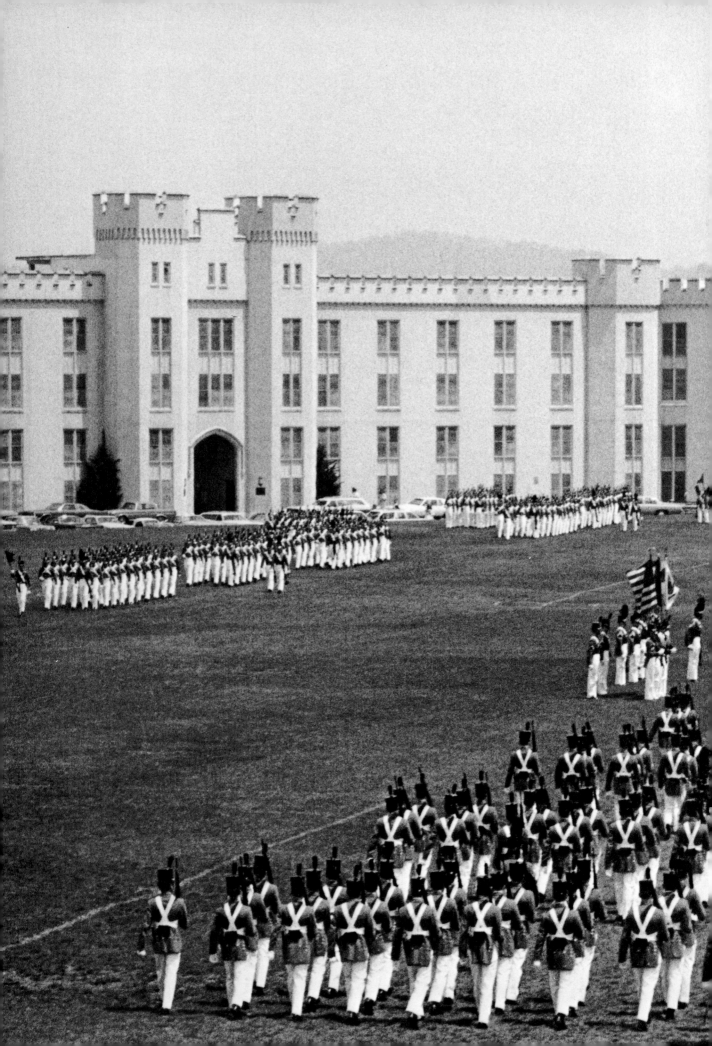

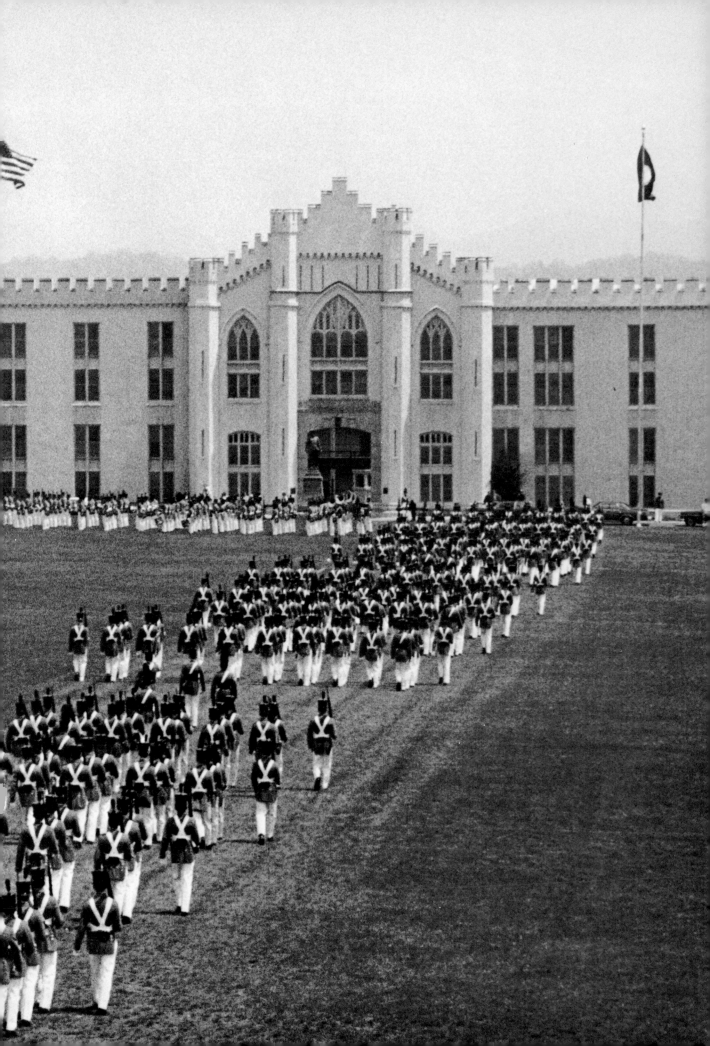

Lexington gives the impression of not having changed much, but actually it's changed quite remarkably. For one thing, it was not always permeated by tradition. In the years when the tradition was being made, it was suffused with religion. And for another thing, it did not always have a giant Kroger's supermarket on Route 11 just north of town. The Kroger's just went up a couple of years ago (replacing an earlier, smaller Kroger's that now sits abandoned out by the by-pass), but its wide aisles, overstocked shelves, and generous hours quickly made it a consumer center for the entire district. On Sunday afternoons, when everything in historical Lexington, even the Early American gas station across from the Presbyterian Church, is closed up tight, the new Kroger's and its companion Super X drugstore sit out in the pastureland with full parking lots and busy checkout counters.

What does remain, along with the tangible artifacts of the past, is a smallness of scale and a lingering air of remoteness. The nearest commercial airport is fifty miles away; the nearest metropolis is Washington, 175 miles in the opposite direction. But Lexington has a way of making other places seem inconsequential and not quite real. It is the seat of and largest town in a district of valley farmland and mountain forest known as Rockbridge County (after the Natural Bridge that is its original tourist draw), and like the land that surrounds it, its buildings recall a preindustrial age. They're constructed of hand-made brick laid in rows that aren't quite even, and they're painted a deep red that contrasts dramatically with the solid white columns that grace the fronts of so many. Lexington's love affair with white columns dates from the 1820s, when the main buildings at W&L were erected in the Greek-temple style. It peaked in the 1930s, when a turn-of-the-century structure that marked the campus' symmetry was destroyed by fire and, in an atmosphere of great rejoicing, replaced by a building that fit. Today, Washington and Lee's campus presents a flawless vision of antebellum graciousness.

VMI plays Sparta to W&L's Athens. Its tradition is sterner, harsher, yet cut from the same nineteenth-century ideal. It is geared to the production of the "citizen-soldier." In modern terms, a citizen-soldier is a man who takes one of the institute's mandatory ROTC programs and receives a Reserve commission upon graduation. But modern terms aren't used much at VMI. In traditional terms, a citizen-soldier is a man who can beat his sword into a plowshare, or vice versa, at the sound of a single bugle call. He is a warrior who can be summoned from the land, like Washington, like Cincinnatus. It is the traditional concept of the citizen-soldier one recalls on a balmy spring evening on Diamond Hill, in the ramshackle black ghetto on the other side of Main Street, as the sound of taps floats across the way, breaking the lonely Arcadian silence with nothing for response but the baying of a solitary hound dog.

Of the 1,300 cadets at VMI, only 15 per cent actually make the military their career. One who plans to is Cadet Rick Wetherill, twenty-two years old, son of a retired colonel who used to be director of Army counterintelligence. Wetherill intends to enter the Navy and specialize in antisubmarine warfare. His fiancée is a Naval ensign attached to the Atlantic submarine fleet in Norfolk. "She can drive 'em, I'll blow 'em out of the water," he said one day with a laugh.

Wetherill has strong roots in the military. One of his grandfathers was Navy, the other Army. Both his aunts married military men, and two of his

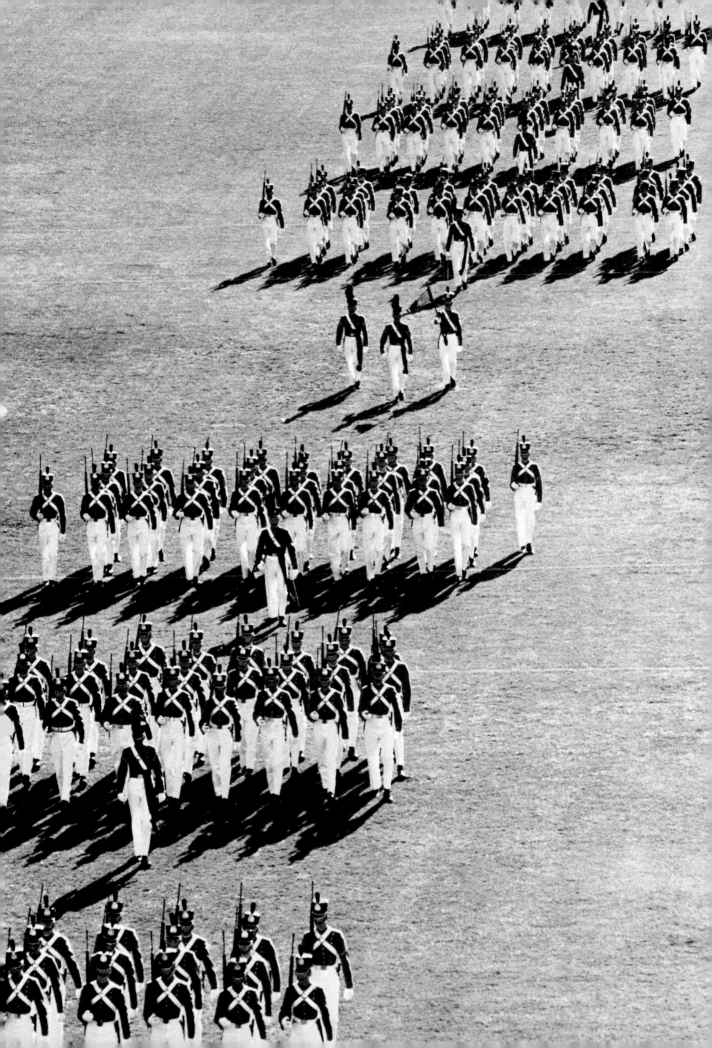

uncles went to West Point. Another uncle died at seventeen after being accidentally shot in the heart with a .22 pistol. Rick himself grew up in and around military bases in Baltimore, Norfolk, Atlanta, and Germany. He graduated from the American High School in Heidelberg, having earned good grades and served as captain of the football team. While in high school he skied at Berchtesgaden and played football in the stadium at Nuremberg. He liked the Germans, finding them organized and efficient.

Rick had an agreeable if peripatetic childhood. He didn't get into a lot of trouble. He was quite close to his father. He recalls lying with his father on the floor, his younger brother cradled in one arm, himself in the other, the family dog nestled by their heads. He remembers what it felt like to bury his face in his father's pillow when his father was fighting in Vietnam. He never minded his father's stern manner because his father was always fair and the punishment he gave well-deserved. His mother was the kind of person he could run to afterward. He could get away from her when she got angry, but there was no getting away from his father.

Rick's father was never big on war stories. He saw no combat in World War II, was unconscious for three days after a grenade blast in Korea. He remembers bullets whizzing past so fast they sounded like fingers snapping, but when Rick asked if he'd ever seen anybody he'd killed, he said no. For eleven months in 1967 and '68 he commanded a division in Vietnam. Then he came home. "He doesn't discuss those things," said Rick. "It's not a family situation. I don't think he likes killing people, but he does realize that somebody has to do it. He can do it as efficiently as possible."

Rick was "your basic guy," as he put it, when he arrived at VMI: blond hair to his shoulders, wearing blue jeans, "in the group." He didn't smoke pot but he didn't let it bother him; he just stuck to beer. Actually, he never drank a lot of beer either; because he doesn't like to lose control of his faculties. When he was younger, he wanted to play bass in a rock band. In seventh grade he actually did play bass in a rock band composed of seventh-graders. They did a lot of Beatles songs—especially selections from *Sgt Pepper's Lonely Hearts Club Band,* which had just come out—and Rick got a real thrill out of showing off. The appeal of the military has to do with much more than a mere desire to show off, however. It has to do with a sense of responsibility—a feeling that one is capable of making important decisions. (Rick admires decisiveness.) It also involves a sense that one is contributing to society. Then there is the economic security that comes with being a military man. "People say you don't need security," Rick said. "I say bullshit to that." And then, too, there is the undeniable appeal of the military uniform. "People used to say, 'Look at those fascist pigs' and stuff, back when there was a little dissension. But I think everybody gets impressed when they see a parade. And I have to admit, I don't mind being part of the gang when they're looking good."

One reason Rick likes the Navy is because you don't get dirty there; it's not like the Army, where you have to crawl around in the mud. Originally he wanted to be a Navy dentist, but his application for schooling was turned down, despite a personal plea to the chief of Naval Personnel, because the Navy's shortage of doctors has resulted in a cutback of dental-training funds. Because he's on a Navy scholarship, he has no choice but to enter the Navy anyway; but he's not too happy about it. His fiancée wanted him to consider

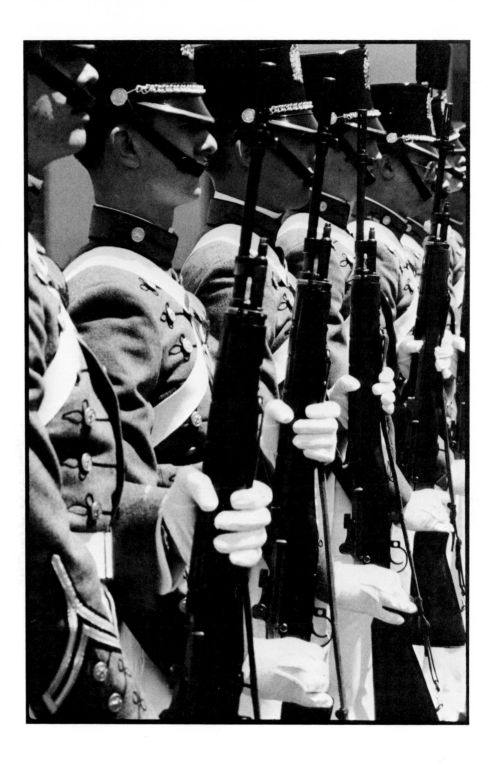

the submarine community instead of aviation (the branch that includes an-
tisubmarine warfare), because submariners have a reputation for hard work
while aviators—airedales, as they're known in the Navy—have a reputation
for swinging. Also, Rick's less-than-perfect vision will probably keep him from
being a pilot, and pilots are number one in aviation. Rick, however, is not
turned on by the prospect of spending six months of the year under water. "I
like the ground," he said. "I like to run, work out, catch some rays, get a beer,
watch TV. I guess I'm basically lazy."

The job Rick wants in the Navy is that of mission co-ordinator on a P-3
Orion. The P-3 is a four-engine turboprop with a magnetic anomaly detector

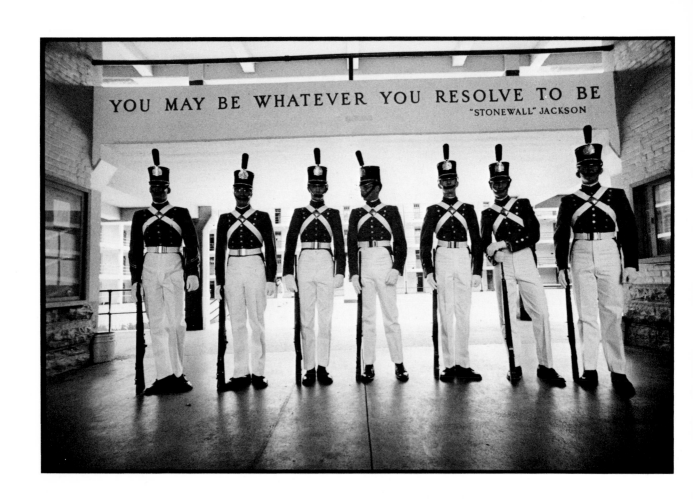

YOU MAY BE WHATEVER YOU RESOLVE TO BE
"STONEWALL" JACKSON

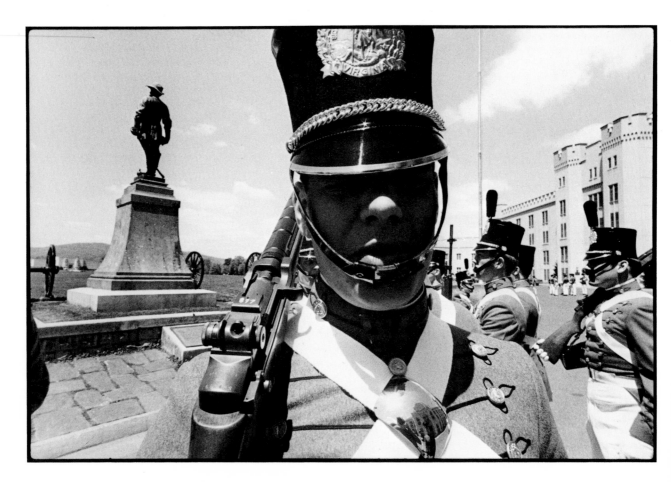

(MAD) extending from its tail. Its interior is lined with computers and has four portholes for the visual observers. It can fly automatic grid patterns with the MAD picking up disturbances in the earth's magnetic flux line. When a submarine is detected, it is identified and, if Soviet, tracked. The job Rick wants is the one flight job in the Navy that's more important than a pilot's. It's also challenging, since tracking enemy submarines is just about the most impossible task the Navy has. From Rick's viewpoint, it has other things to recommend it too: "It's ordered. It's very logical. It's mechanical, and I like to manipulate mechanical things. It's cool and calm. It's all very clean, and it takes a lot of intellect to interpret it. And the lights are mesmerizing. It's a visual rush. It makes me feel like I'm in "Star Trek."

"If you know nothing's out there it could get boring," he continued, "but if you do get a contact there's that twinge of excitement, of nervousness, forthcoming action. I can just see it. It's sort of like a hunt. There's the thrill of finding it, chasing it, and if necessary blowing it up. And the point about blowing it up is that you don't see anything. You'll just see the pieces float up, maybe bodies or something else, or else it'll completely explode or implode and you won't see anything except a little gas. It's easier to do something if you can't see it."

VMI has not always existed in its present state of pastoral bliss. On the evening of June 12, 1864, it was shelled and burned by 17,500 federal troops under the command of Virginia-born General David Hunter. The cadets, meanwhile, were retreating through the Blue Ridge Mountains toward Richmond. A month earlier they had heroically engaged the nucleus of Hunter's army near the tiny village of New Market, eighty miles up the valley from Lexington. A year before that they had buried Stonewall Jackson's one-armed corpse in the town's Presbyterian cemetery. They were living VMI's glory days.

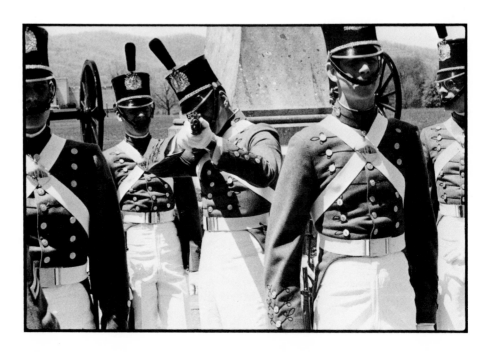

The institute had been in existence only twenty-two years when Virginia seceded. Jackson had arrived in 1851, when he was twenty-seven. He was an object of curiosity at first: a West Point graduate, cited for bravery in the Mexican War, he approached his duties with a sternness and exactitude that seemed excessive even to the strict Presbyterians of Lexington. But the fame he earned in the War Between the States quickly turned peculiarity into legend. A VMI pamphlet relates the tale of a meeting with the superintendent: Jackson arrived at the appointed hour, took a seat while the superintendent ran an errand, failed to leave even after it became obvious he'd been forgotten, and was still waiting when the superintendent returned the next morning. Jackson's characteristic inflexibility did not make him popular with students; when asked to repeat a question, for instance, he would do so verbatim. Once someone asked him if he found teaching difficult, since it wasn't what he'd been trained to do. "You may be whatever you resolve to be," he said by way of reply. His words have since been inscribed in stone for succeeding generations to ponder.

Jackson's life was rigidly structured, with set hours for reading and memorization (he taught without a textbook, having absorbed everything he needed to know) that no intrusion could disturb. He was deeply religious, even establishing a Sunday school for slaves. He did not smoke or drink or take tea or coffee, and he remained determinedly aloof from temptation. "One break in my rule would not hurt me," he said, "but it would become a precedent for another, and the whole conduct of my life would be weakened." He earned his nickname at First Manassas, but clearly he'd been prepping for it all his life.

Jackson was wounded at Chancellorsville while riding toward camp on his favorite horse, the gelding he called "Little Sorrel." He died eight days later after having his left arm sawed off while under the influence of

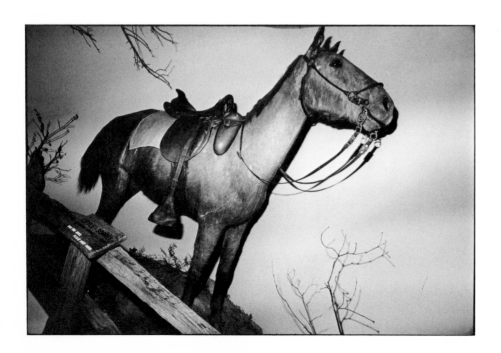

chloroform—an uncharacteristic drug experience he called "the most delight-
ful physical sensation I ever enjoyed." Little Sorrel was put out to pasture at
the institute, where he became a target for souvenir hunters who liked to pull
hairs out of his tail. His hide, or what's left of it, has since been mounted and
is now on display at the VMI museum. Horse and general must have comple-
mented each other nicely: Little Sorrel makes up for Jackson's fierce de-
meanor with a gentle, almost childlike air that speaks of sorrow sweetly borne.
His current threadbare state only enhances the impression.

VMI's bravest hour—the Battle of New Market—came a year to the day
after Jackson's burial. The conflict itself was admittedly of secondary impor-
tance: the main fight was taking place sixty miles to the east, where Grant was
advancing on Richmond. But that is not the point. The 247 cadets were part
of an army of 4,500 men attempting to halt a Union Army of 6,000 advanc-
ing on Lee's left flank. The cadets arrived in New Market after a three-day
march through the rain, and at one o'clock on the morning of the battle they
were up and on the march again. Late that afternoon, in a violent thunder-
storm, led by a tactical officer whose pants had been shot away, carrying rain-
swollen rifles that could barely be fired, they charged through a wheatfield
whistling with gunshot and muddy enough to suck their shoes off and cap-
tured a Union artillery battery. Ten cadets were killed, forty-seven wounded.
Their average age was eighteen. When Hunter burned the institute a month
later, it was in retaliation for the way they'd turned the tide at New Market.

Feeling about the war still runs high at VMI, especially among the
southern boys. When Rick arrived from Germany, one of the first questions he
was asked was which side he was on. "What?" he said, not sure what they meant.
"Are you for the North or the South?" they asked. "I'm from Germany," he
replied. They decided he must be for the North.

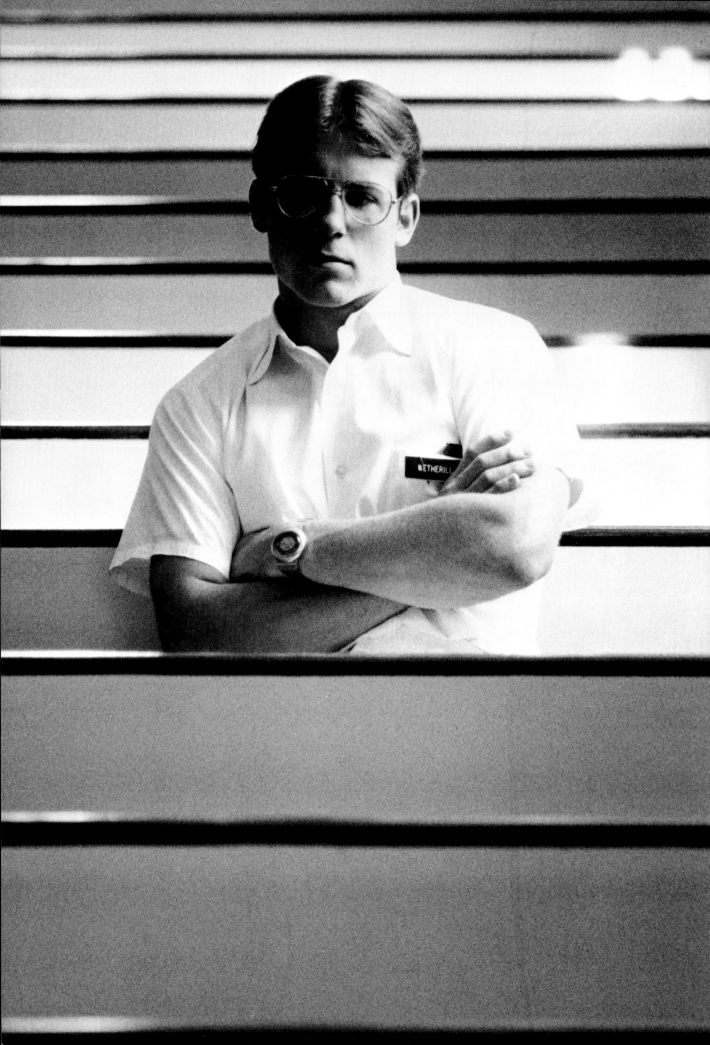

New Market Day is celebrated every year on May 15. There is a big parade and the names of the ten fallen cadets are called and until very recently the band always played "Dixie." Johnny Garnett marched in the New Market Day parade his freshman year. Garnett is one of the institute's forty-one black cadets. He's co-captain of the football team and he lives with two other black cadets, one a football star and one a basketball star, in the room next to Rick's. He marched in the New Market Day parade only once.

Garnett is the son of a master sergeant, and his family comes from Texas because his great-grandparents were sold there before the war. All his black friends thought he was crazy to come to VMI—not because of its heritage, but because of its discipline. He came anyway. "I pictured it as a fantasy world," he said. "This place was like a big castle. Everybody was marching around in formation. Everything was so regimented. It seemed like a vast dream to me— like a kind of Utopia."

Things have changed in the four years since Garnett arrived. White girls talk to black cadets now. It used to be that a black cadet had really accomplished something if he could get a white college girl to say hello. They don't play "Dixie" on New Market Day anymore either. Most of the white cadets don't understand why, but the black cadets insisted.

"I wanted to know how it felt," Garnett said, explaining why he marched that time. "I didn't want anybody to tell me, 'You should feel like this.' I had to know for myself. It was an elaborate ceremony, and it was really beautiful the way the men who died were honored. I would march for them at any time at any place. However, I would not march under 'Dixie.' That hurt me in a way I can't describe. The little catcalls that were coming from the people in the crowd, the finger-pointing, that didn't bother me half as much as that song bothered me. When that song first started, it was like somebody threw a warm cloth over my face. I couldn't hear no noise, I couldn't hear people's feet hitting the ground, I couldn't hear anything. All I could hear was that song. I thought of riding my bike when I was seven years old and hearing somebody honk the horn behind me and turning around and getting a carton of sour milk in my face. I could feel the same feeling I felt at that time. And then to hear the catcalls amplified it. To see the finger-pointing amplified it. I think I was ready to explode in the middle of that parade.

"I respect the men who died, even though they were fighting to maintain slavery, because they died for what they believed in. I will honor any man who dies for what he believes in. That's how strongly I feel about 'Dixie.' I would never do that again. I would rather be shot."

VMI really is something of a fantasy world. It has no wars to fight, no trenches to wallow in; all it has to do is turn out crisp young men in its citizen-soldier tradition, cleansed and hardened for life in a rough, often sordid world. "VMI is not the Army," the saying goes, with the implication both that VMI is not real and that reality is somehow lacking.

Cadets live by a code that recalls in rigidity the one Stonewall Jackson set for himself in the 1850s—and despite their inevitable protestations, most of them seem to like it. Some don't, having been kicked out of other, more lenient schools and told by stern or desperate fathers to shape up or make do with a high school diploma. But most come because they want to; and once having

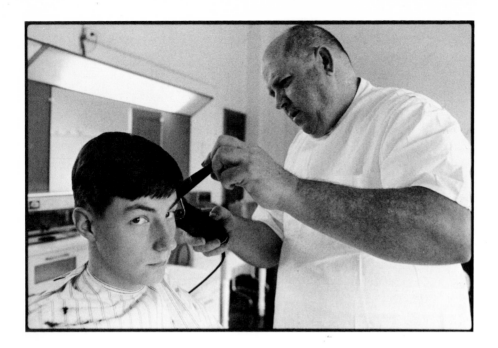

come, they are loathe to leave no matter how much the regimen disagrees with them. Leaving VMI isn't considered transferring or dropping out; it's considered quitting.

If the ordinary Lexington resident has any complaint against the cadets, it is not that they are rowdy (which they sometimes are with a vengeance) or untrustworthy, but that they are so aloof. "Cadets often feel they're a little bit better than everybody else," one cadet admitted, "because they think, *I'm doing this and I don't have to.*" They spend most of their time on the Post (as VMI calls its campus), and when they do go downtown their gray and white uniforms and ramrod bearing set them off like high-tension pigeons. But if they are isolated from Lexington, they are even more isolated from the world. Thus it was particularly curious to encounter VMI's Imperial Iranian cadets, who were dark and alien-looking and in receipt of a stipend rumored at $1,000 per month. The Iranians were not known for tact or industry or command of English. At one point they wanted the other cadets to salute them on the grounds that they were actually commissioned officers in the Shah's Navy. Their tendency to limp at crucial moments gave rise to the term "Iranian foot," referring to an attempt to get out of just about anything. Still, the Iranians did succeed in broadening VMI's horizons somewhat. One cadet even turned Moslem after they came. Unfortunately, he went berserk one night and tried to choke his roommate for throwing a piece of ham on his Koran. Rick got his hand spit on while trying to hold him back. His first impulse was to ram his fist through the fellow's face, but he thought better of it after realizing what a squirrelly little guy he was. This was a cadet who quit.

All cadets live in an immense Gothic barracks which dates from 1851 and consists of two interlocking courtyards which look like ancient cellblocks inside. They are entered by three archways, the largest of which is named for Stonewall Jackson. Entirely different standards of conduct are maintained inside and outside the arch. Outside the arch, cadets are not permitted to eat or drink (except in restaurants) or smoke or chew gum. It would look bad for a cadet in uniform to sip a Coke at a football game, for instance. Inside the arch

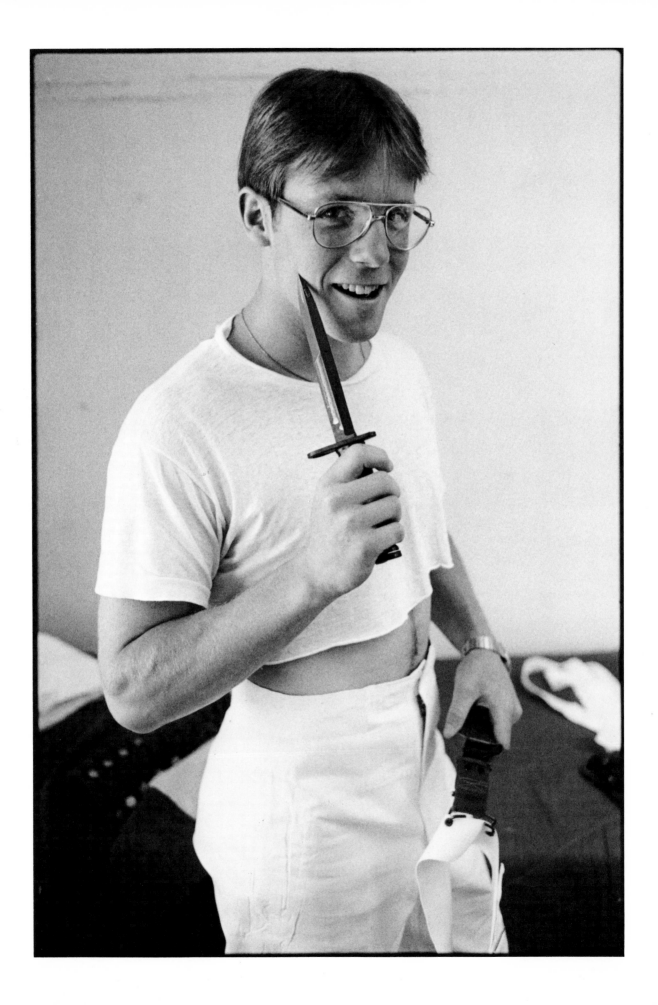

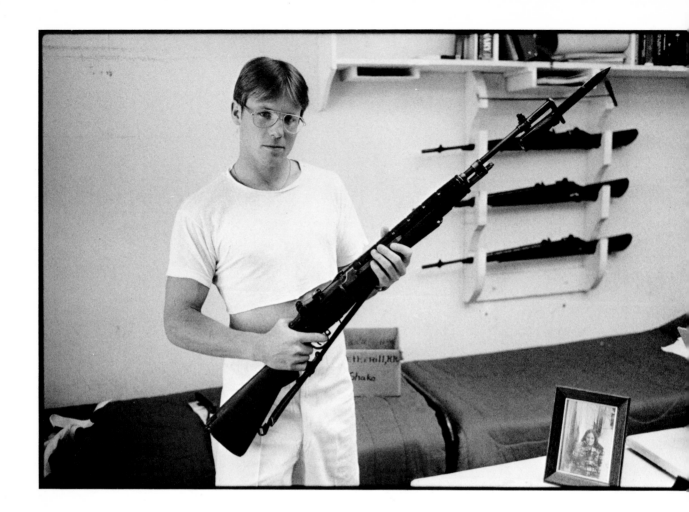

they are permitted to relax a bit. Upperclassmen, for example, can walk to the bathroom wearing only their robes. Barracks rooms are small and mean and connected by exterior passageways known as stoops. Fourth classmen—that is, freshmen—are assigned rooms on the topmost stoop; third classmen live on the third stoop, and so on. All cadets live three or four to a room and sleep on cots which must be folded away in the morning so there'll be enough space to walk around. The doors to the rooms have glass panels at eye level and no shades. There are no doors on the toilet stalls. The administration does not believe in privacy.

Uniforms are provided for every occasion: black wool duty jackets and crisp white shirts for class; form-fitting wool blouses for semiformal occasions (lunch, dinner, entertaining guests); black blazers and red and yellow ties (red, white, and yellow being the school colors) for dates; gray wool coatees with tails and gold braid and shiny black shakos with plumes on top for formal occasions (parades, interviews with the superintendent, things like that). Gray wool pants are worn in winter, white cotton ducks in spring. "Virgin ducks" are picked up at the laundry twice a week. They usually come board-stiff with starch, so it's customary to "rape" each pair with a thrust of the arm before putting them on.

In addition to his uniforms, each cadet is issued an M-14 rifle and a seven-inch bayonet. The rifles come without firing pins. The bayonets are sharp all along the bottom edge and the outer third of the top edge and have an indentation along the side which allows blood to flow out. It is against regulations to pull these bayonets out of their scabbards, but cadets do so anyway.

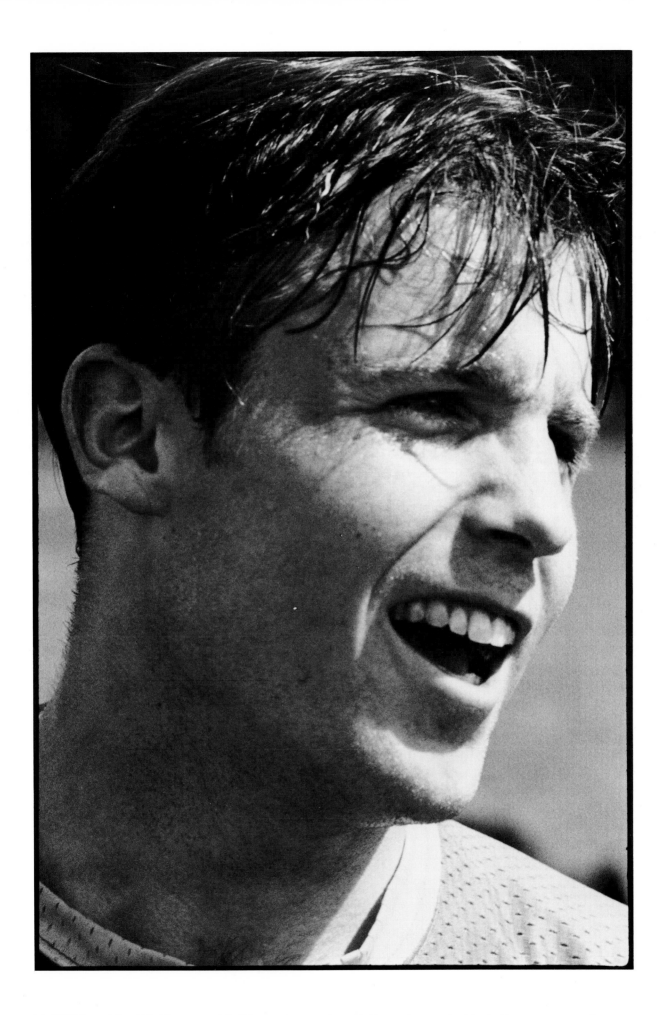

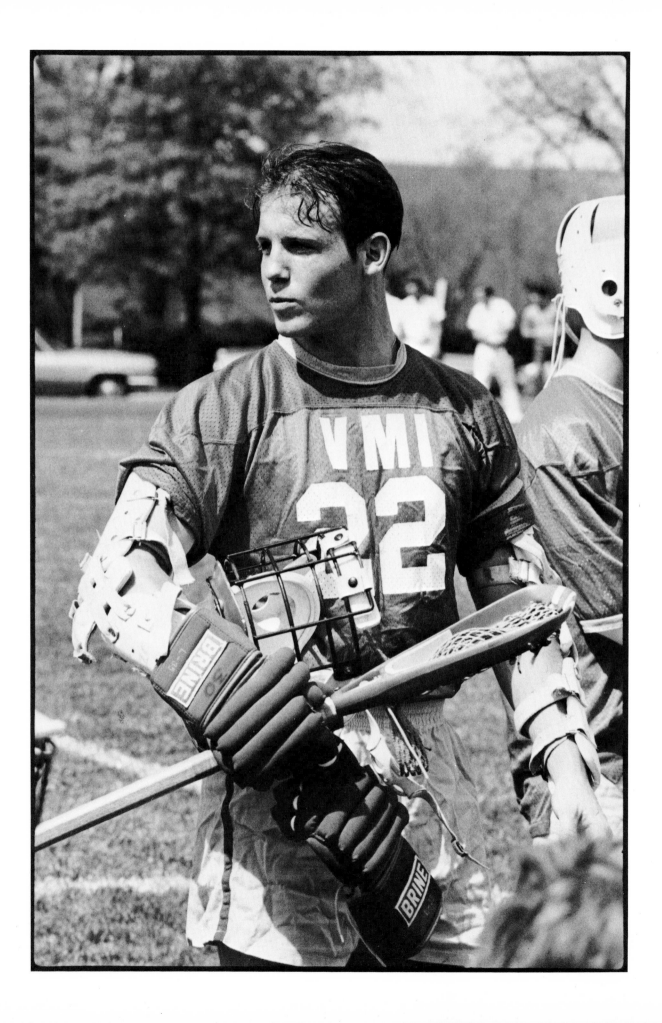

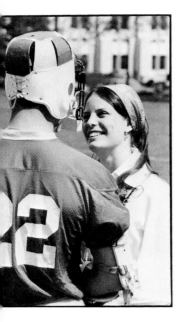

Usually they take them out to slice a cake or pick a Vienna sausage out of a can. Sometimes they play chicken: standing face to face with their legs spread, two cadets will take turns hurling a bayonet at each other's feet, moving them closer together with each turn. They also hurl their bayonets into doors to relieve the tension that builds up. Cadets talk about tension a lot.

Since bayonets must remain sheathed and rifles unfired, their use must be learned from books. Wetherill has read that the most efficient place to bayonet someone is in the abdomen, since the abdomen has no bones to catch the blade. You just stick it in the navel and rip. The guy you're fighting won't die immediately, but he'll be too busy holding his intestines in his hands to give you any more trouble.

Cadets are supposed to further their fighting technique through field training exercises. These are war games in which one group of cadets tries to move from Point A to Point B while another group tries to stop them. Rick was disappointed in FTX, however, because so little attempt was made to provide that all-important aura of realism. He unloaded an entire clip of blanks at one guy who refused to fall down dead. Another guy started yelling *"Bang-bang-bang!"* when he ran out of ammo. Rick got captured early. He was supposed to escape but decided to catch some rays instead.

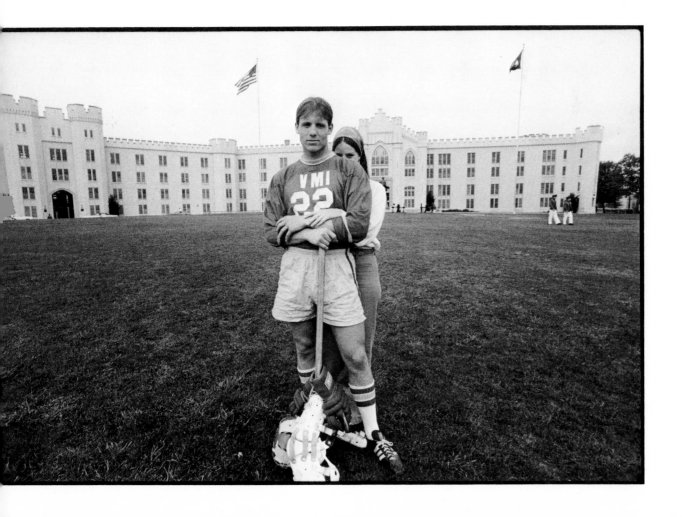

Sports have caught Rick's enthusiasm a lot more effectively than VMI's military program. He was a middle linebacker on his high school football team and liked it because he got to hit people on the field. At five-nine, 160 pounds, he's a little small for the VMI team, which depends on its ability to recruit black athletes like Johnny Garnett for much of its muscle, but he spent two years on the varsity wrestling and soccer teams and is co-captain of the lacrosse club. He's also taught boxing and is an expert skier. He likes sports because he likes to compete (winning is not all-important) and because they build his body. "I like to be pleasantly appealing to others," he said, "as well as to myself."

VMI fosters this attitude among all its cadets. Aerobics are part of everyone's daily regimen. Uniforms are designed for the well-proportioned: if a cadet is even slightly overweight, the roll around his waist will be painfully obvious under his blouse. But this emphasis on physical development contrasts with a marked lack of interest in diet. Cadets are marched to mess three times a day and served in a hall that has been acoustically designed to maximize noise. Meals are so unappetizing that large jars of peanut butter and jelly are provided to seal them in after they've been eaten. Food fights erupt in which leftovers are sent sailing through the air in waves. The only alternative to mess

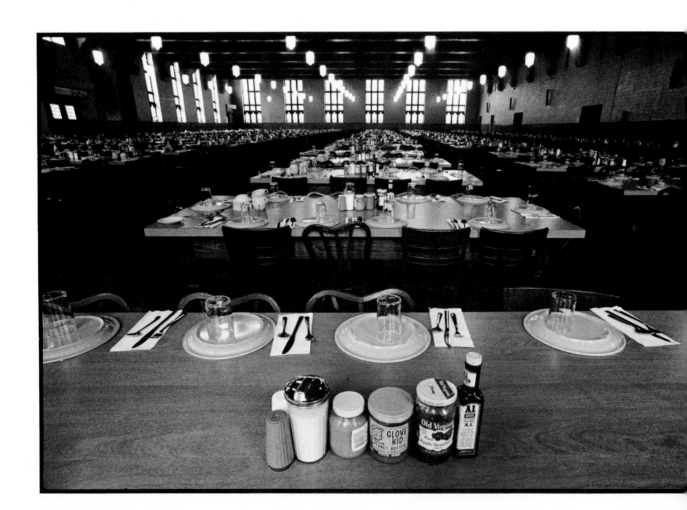

is the canteen, which specializes in fried foods and Hostess Twinkies. For some cadets, the acne problem is worse than it might be.

There is a third point of emphasis at VMI, along with athletics and the military, and that is academics. The emphasis is on science and engineering rather than the humanities, but course requirements are stiff, grade inflation is low, and good study habits are forcibly encouraged. Faculty members have been given military titles (instructor equals captain or lieutenant, assistant professor equals major, associate professor equals lieutenant colonel, full professor gets to be called colonel), although few are actual soldiers and many of those are retired. The current superintendent is a retired major general whose last command was Fort Knox, Kentucky. Like everyone else at VMI, he belongs to the Virginia Militia, an outfit described by a spokesman for the institute as "sort of a joke concept." The joke that's told about it is that if Maryland attacked, the Virginia Militia would be on the front lines. The joke that underlies that one is that when Maryland did attack, along with Pennsylvania and New York and nineteen other states, it really was on the front lines. These jokes combine to form a tacit admission that those days are over.

The corps of cadets is organized as an infantry regiment, with a regimental band and two battalions of three rifle companies each, all led by cadet officers who are known variously as "rankers," "assholes," and "dicks," depending on their relative popularity and distance from the speaker. Since promotions are granted on the basis of grades and perceived leadership characteristics, attempts to curry favor with adult authority figures are inevitable. The first-class privates who make up the bulk of the corps tend to dislike rankers who are overenthusiastic in this regard, since they themselves are likely to be the victims of it. "Shit rolls downhill," said one disaffected ranker, "and these guys get it." Curiously, however, it is the first-class privates who tend to blossom in the service, lending additional credence to the maxim that VMI is not the Army. Wetherill was a ranker briefly, but then he got busted for missing supper formation.

At the very bottom of the VMI pyramid are those cadets known as rats. Rats are incoming freshmen. The first thing they're told is that they're the lowest form of life imaginable. Then they're given a week-long experience which bears this out. This week—VMI's version of freshman orientation—is known as cadre. Cadre begins the evening after matriculation, after mom and dad have left for home. The rats have all had their heads sheared and been given baggy fatigues and shirts and baseball caps to wear. They look stupid and feel stupider. The only upperclassmen present are the officers and noncoms who run cadre. They are immaculately uniformed, polished to a glistening shine, and in total command. The rats quickly learn to fear them.

"You get a bunch of guys out of high school," explained one first classman, "they're all going every which way. You get 'em all in here together, you get 'em all looking alike, and they may feel miserable but it serves a purpose. It gets everybody moving in the same direction—doing the same thing at the same time. And you can't be nice and do it, because some of them are going to tell you where you can get off. So you have to be hard. You've got to put the fear of God into 'em."

From cadre until some time after Christmas, ratline prevails. During ratline, rats are not permitted to drink, to walk to the bathroom or the

showers except in full uniform, or to utter aloud the name of their class—the class of '81, for instance. They are given a Rat Bible with assorted facts to memorize, such as the names of the cadets who were killed at New Market, and they are forced to strain in barracks—to hold chest and face perfectly rigid, with chin tucked into throat. Hazing is no longer permitted; sweat parties are the rule now—late-night workouts which turn the fourth-class stoop slippery with sweat. Only regulation Army exercises are allowed, but that's of little consolation to the rat who has just been ordered to do 250 pushups.

Early in the fall, each first classman picks one rat who will be his dyke. The word "dyke" is spoken with a nervous titter whenever outsiders are present, since it does have other connotations and you wouldn't want to get the wrong idea. At VMI it refers to a first classman and a rat who have a special relationship with each other. The rat does chores for the first classman—getting his laundry, rolling up his hay (mattress) in the morning, helping him "dyke out" for parade. The first classman answers questions, gives the rat a feel for the place, lets him know the score. Sometimes the relationship is a formal, one-sided one in which the rat must say "sir." Other times, as with Rick and his dyke, Tom Albro of Manassas, Virginia, it is more in the nature of a partnership. "Rick's a pretty good guy," said Tom. "He's helped me out in a lot of situations. He says, 'Whatever you do, don't go in the Navy. Don't go on scholarship.' I can see his problem. I hope it doesn't happen to me." In either case, this relationship is what promotes the phenomenon known as class distinction. Class distinction operates in three-year cycles: because of the dyke system, the class of '81 will resemble the class of '78, which happens to be a lot more easygoing than the class of '79. Class distinction is good because it helps build class unity—unless it goes too far and threatens to split the corps.

Some time after Christmas, the first classmen take a vote on whether the rats have come together as a class. When they decide yes, a week called resurrection ensues. Resurrection is like the rest of ratline only worse: rats have to run to class, the sweat parties become constant, the pressure grows increasingly intense. Then comes breakout. Only first classmen know when breakout will occur. On the chosen night, a sweat party will be scheduled as usual, but instead the rats will be ordered to the gym for a workout. Afterward, they'll be put to bed as on any other night. Several hours later their doors will be kicked in and they'll be ordered to form up in the courtyard. Then the upperclassmen will take their positions—at the tops of the stairs, with garbage cans filled with water, plastic bags filled with water and toilet paper and garbage, tin cans filled with urine and feces. The rats will give a cheer for their class, then break out of ratline and bolt for the stairways. The old corps will hold them off for a while at each stoop, then let them surge on to the next one. Sometimes things get out of hand; sometimes there are lead pipes and broken limbs. Not recently, however.

Life returns to normal after breakout. There are parades and classes and athletics and studying and Mickey Mouse rules and always the pressure—the pressure to perform, to conform, to make the grade, to be a cadet. There are pranks to relieve the pressure. Stink bombs and "nigger chasers" are set off in the courtyard. Panty raids are plotted and executed against neighboring women's colleges, often in retaliation for jock raids they pull against VMI. In one such incident, almost a quarter of the corps formed a convoy that stretched two miles along the interstate and left a Mary Baldwin College dorm

a wasteland of shaving cream and water and broken glass. This drew headlines across the state. But pranks, even pranks as spectacular as this, offer brief surcease at best from the daily grind.

The VMI day begins at 6:40 each morning with ten minutes of bugle calls and ends at 11:30 each evening with taps. In between there's morning assembly and the march to breakfast and then bugle calls every hour to announce each class change. Cadets can leave the Post from 12:05 to 4:15 on Mondays, Tuesdays, Thursdays, and Fridays if they have no afternoon classes, but at 4:05 there are ten minutes of bugle calls with names like Big Toot and Little Toot and Shake-a-leg to herald inspection, drill, athletics, or parade. On Wednesdays, cadets are free to leave from four o'clock until supper formation at 6:30. At 7:25 every weekday evening they have to report to an authorized place for a status check and stay there until 11:15, at which time they get fifteen minutes to visit friends in barracks before the lights go out. On Saturdays, when taps comes a half hour later than usual, they can go off Post from one in the afternoon until midnight, and on Sundays from eight in the morning until 11:30 P.M. (except that lowerclassmen have to report for supper formation). It is permissible to stay late in the library to study. Many cadets "study" with their dates.

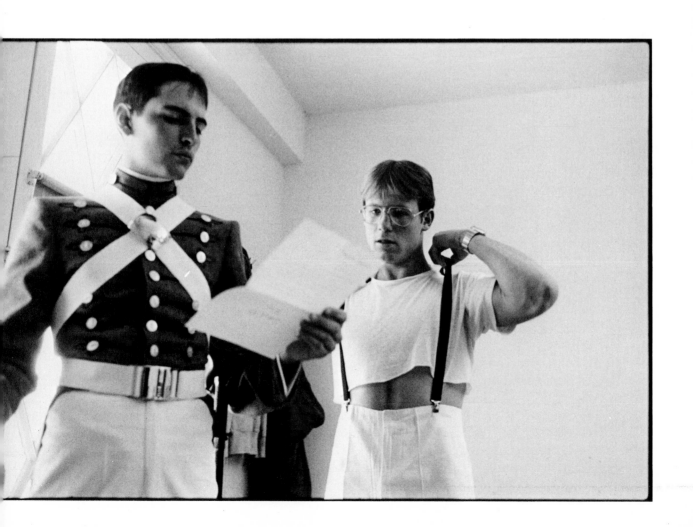

One of the most common phrases in the cadet vocabulary is "I don't have enough time." Another is "I didn't get enough sleep." A cadet who does not get enough sleep is likely to make up for it with an afternoon nap. Unfortunately, this is apt to leave him without enough time. A cadet who falls into this sort of trap is said to be stepping on his own crank—stumbling over his masculine appendage, hence, getting in his own way. It can happen to anybody. While talking to a cadet in the most relaxed of circumstances, one is apt to detect a wild look of panic flashing through his eyes. That's a signal the cadet is getting into a shitty—massive shitty, if it's really serious. In other words, he's late. Being late is bad because it means the cadet will get boned by an officer (ranker, asshole, dick). Getting boned is a euphemism for being placed on report and usually involves some combination of penalty tours, confinement to Post, and demerits. Unauthorized late study, a relatively minor offense, draws a five-one-and-five—five demerits, one week's confinement, and five hours of penalty tour in the cadet study hall. Dismissal from the institute is known as a ten-six-and-Trailways.

Discipline is maintained by a commandant of cadets (dean of students) and a squad of about fifteen tactical officers—faculty members, usually from the military science department, who help police the barracks. The commandant is invariably a VMI graduate. The commandant when Rick arrived was a Vietnam veteran who had a metal plate in his skull from a helicopter accident and was somewhat mercurial as a result. "When it got muggy and humid," Rick explained, "that plate would swell up and he'd go crazy." Many of the tac officers are VMI grads too. This puts the cadets at a disadvantage because it gives the tac officer a knowledge of the system that is too intimate for comfort. "A cadet will be a cadet," as Rick pointed out, and one of the things a cadet will do is break the rules as often and as creatively as possible. This is not considered bucking the system; it's considered playing the game. According to the public information officer, himself a recent graduate, VMI doesn't really teach discipline as much as it teaches how to break the rules and get away with it. Successful circumvention of the rules, within limits, is considered a measure of a cadet's astuteness and ability to function in later life. So don't get caught; and if you do, take your punishment without complaint.

One of the most popular ways a cadet can test himself is by "running the block"—escaping from barracks, usually to party at an illegal apartment in town or at a Washington and Lee frat house. W&L fraternities are housed in white-columned mansions that look as if they were lifted from the set of *Gone With the Wind*. Frequently they stage parties whose purpose seems to be to trash these houses as thoroughly as possible. Sawdust is spread on the floors; kegs of beer are set up on the veranda; black bartenders dispense grain alcohol; soul bands sing classics like "My Ding-a-ling" and "I'll Always Love My Mama"; and clean-cut frat boys in chinos and Top-siders smash windows and emit Rebel yells and urinate in the boxwood. Sometimes they leave their dates in the powder room and put their arms around each other and scream things like "Faggot! Faggot! Where's the faggot?" into the darkness.

To the average cadet, pent up in his tiny barracks room with nothing to do but sleep or study, this is worth risking several weeks' confinement for. Still there are cadets who don't try to run the block. Rick is one of them. He was even studying the night of the Mary Baldwin raid. "It's wrong for me to

do something behind their backs," he said. "And the thrill of getting away with it does not appeal to me. Maybe I'm too strict, but grades are more important to me. I can go out and do this crap when I have some free time."

Rick's impulse is not to break the rules but to liberalize them. He thinks the VMI environment should be a little more humane. One of the issues he has been arguing for is the matter of beer on Post. A good argument he sees for beer on Post—that is, on tap at the canteen in the PX (student union)—is the auto accident the previous spring in which four rats died: they were coming back from a keg party up the river at Goshen when the first classman's car they were riding in plowed into a tree. But the VMI Board of Visitors, far from liberalizing the drinking rules, responded by debating whether to abolish the rule that permits first classmen to keep cars.

One rule no one tampers with is the honor code. The honor code states that a cadet may not lie, cheat, or steal, or tolerate anyone who does. It is cherished among cadets the way virginity used to be cherished among southern maidens. The idea is simple: every cadet must be a gentleman. He might on occasion get slimy drunk and spout obscenities—that's understandable, even expected; but his honor is separate from that, and must at every moment be preserved.

The honor system, one hears from every quarter, is the foundation on which VMI is built. It is admittedly a nineteenth-century concept, which is perhaps why it works better at VMI than at West Point. (That it does work better is something no one at VMI is loathe to point out.) It governs all academic work, all official statements, all theft no matter how petty. It's administered by a cadet honor court, elected by the corps, which conducts all its proceedings—investigations, pretrial hearings, and trials—in absolute secrecy. The accused has the right to civilian counsel. If nine of the court's eleven voting members find him guilty, he is immediately dismissed. Once he has gone —in the very early hours of the morning, as it usually happens—his departure is announced by a low drum roll which grows steadily in intensity until it is broken by a boom on the bass drum. As the drum rolls and the intermittent booms continue, the members of the honor court march through the arch and up to the topmost stoop. From there they work their way around and down, their president pronouncing as they go the name of the disgraced cadet, the charge on which he was convicted, and the admonition never to utter his name again. By this time he is far from Lexington, on his way alone toward whatever home he might have.

Everyone loves to complain about the discipline at VMI, the petty rules and the tight hours and the never-ceasing pressure. No one complains about the honor system. Some might try to bend it; Wetherill said he'd give somebody he caught a second chance, although he'd definitely turn him in after that. But few people break it directly, and virtually everyone speaks of it in reverent tones. "It builds up a trust," said Rick, "and trust in people is fantastic."

Indeed, the entire VMI experience is designed to build up a trust, a lifelong trust that comes not only from a mutual sense of honor but also from close contact, common purpose, and shared sacrifice. There is a phrase, "brother rat," that refers to a cadet of one's own class and was used as the title of a 1938 Ronald Reagan movie about VMI life. Rick hates that phrase, and

it's true, as his best friend pointed out, that when somebody says "Hey, brother rat," the next line is usually "How about giving me five bucks?" But the sense of brotherhood that phrase alludes to is no joke. It's something that lasts for life, and it applies to graduates you never knew as well as to chums you broke out of ratline with.

This is one of the things that makes VMI (as the saying goes) such a great place to be *from*. It seems that nobody appreciates the place until they leave it. Of course, by then they have such an enormous stake in appreciating it that to fail to do so would be an act of intolerable self-abnegation. But there's more to it than that: being a VMI grad is a little like being a veteran —a veteran of a war against one's own worst instincts, against drunkenness and idleness and sloth, against lying and cheating and stealing, against any form of self-indulgence at all. Each graduate has conquered the temptation to be anything other than firm and upright; each graduate represents one more tiny victory for VMI's ideal of manly perfection.

The class of 1978—Rick Wetherill's class—was the last to have entered college with the Vietnam War still in progress. Yet for a cadet in the class of '78 whose dad was in 'Nam during the Tet Offensive, Wetherill is curiously am-

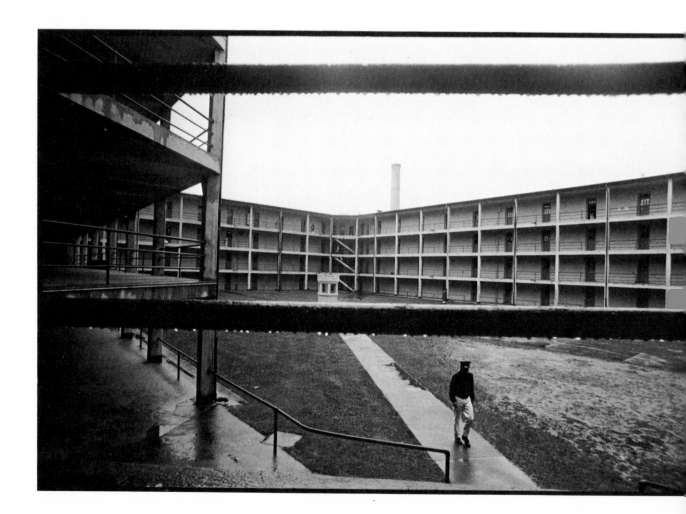

bivalent about what happened there. He prefers action novels to serious read-ing about Vietnam or any other subject, and he's been too busy with his own affairs to spend much time thinking about what went on over there anyway. "Who can say if it was a mistake?" he said. "There are too many questions, and I don't even have the knowledge to ask them.

"My father never really said if he thought it was right or wrong. He was doing his duty. The most I can say is that the Americans fought over there with my dad and there was a purpose behind their fighting, whether it was to halt communism or whether it was just to help out the South Vietnamese be-cause they didn't want the North Vietnamese coming down. I've even heard it was just American industry that wanted the fight. Who can say? But the United States does not go out looking for trouble. That's a pretty basic fact. We put off and we put off and we put off. It's like the lonely cowboy who doesn't say much until you push him over the edge. Then he comes out and beats you to a pulp."

The trial of Lieutenant William Calley was the one Vietnam issue that had a direct impact on Rick. He discussed it with his father at the time. It was important because of the way it brought military and moral obligation—two factors that ideally work in tandem—into such direct opposition. A soldier has to follow orders; no one should kill innocent people. It was a quandary, but Rick, with the help of his father, arrived at a solution. "It's very simple," he said. "You say, 'Put this in the records: I think it's wrong, and I will do it, knowing that I think it's wrong.' What more can you do in a system that is structured so that things are supposed to run smoothly? If you just sit there and say, 'No, I'm not going to do anything,' you might jeopardize the whole show. And then, what if you're wrong? So you just put it down. That pretty much absolves you of responsibility.

"Well, no. You're still responsible. That's a sticky question. I'd feel bad doing it, whatever it is. I'd feel bad after it. And who knows, if it's really wrong, no matter how bad I feel I might still get fried. But everybody would know. I guess that's it. I'd make sure people were cognizant of the fact that I was about to do something against my will and that within the system I was forced to do it. But then I'd do it, knowing that that's the way it's got to be."

Rick finds it easier to reconcile his moral revulsion at killing people with the normal conduct of war. He is aided in this regard by his view of war as a natural state of affairs. "I realize I'm not going to like hurting people," he ad-mitted, "but no matter what I say, humans will be humans and they're going to fight. Fighting is so basic—so very, very basic. Everything down to the smallest organism will fight if it's physically threatened. That's a very basic an-imal instinct. It's human to try to overcome that instinct, but that's very tough to do.

"I can't say I object. I do—I don't like to go out and kill people. It's such a waste. But I realize it's gonna happen and I'm gonna have to do it. People say you don't have to have war, but war makes the economy. I don't agree with it, but that's the way it is. Maybe I can change it; maybe not. But so many things come out of the military, so many advances. They may not have humanistic goals—to preserve humanity—but more often than not they end up being that way. Medicine. I can't give you any specific examples, but—well, maybe that's the wrong thing to pick.

"Let's look at advances in technology. The B-1 bomber—there you go. Let's not say *preserve,* but—well, that program was turned down by President Carter. But from it, a lot of new technology was developed, not only for the services but also for the airlines. And if you devise all sorts of techniques to win a war, aren't you going to have to think of ways to put things back together for yourself? The neutron bomb—it just kills people. But it doesn't destroy the economy, does it? So that's pretty good. So what comes after the neutron bomb? Maybe something to persuade people—*look, you don't want to fight.* That's pretty idealistic, but . . ."

Rick is in some ways an idealistic person. Often, however, his idealism takes surprising forms. "I want to be able to help other people," he said. "How's it gonna help other people if I'm gonna go around and kill people? Well, I like the Americans. They're a good bunch of people. I'm not out to kill people, but if I have to do it for somebody, let's have it for America."

He thought for a moment.

"I never thought I'd say that," he said at last. "But when I think about it . . ."

One item VMI is notably deficient in is females. There are some women secretaries in the administration building (a mini-Pentagon known as "Puzzle Palace" because so many people get lost in it), and there are some women behind the cash registers in the canteen, but that's about it. There are no female cadets. A couple of high school girls have sent in inquiries, but the institute informed them that women are not accepted and none of them have pursued it further. This makes VMI the sole remaining all-male baccalaureate military college in the nation. Its public information officer reported with a curious mixture of embarrassment and aw-shucks pride that it was called one of the last bastions of male chauvinism on the "Today" show. Of course, if the Equal Rights Amendment were ratified, there'd be no legal recourse—secession being no longer an option.

Glenda Rollins, Rick's fiancée, was the only female in ROTC at Duke. Like Rick, she comes from a military background: her grandfather was a pioneer submariner, her father was in Vietnam when she decided on a military career. No one seems to mind that she's the first of her sex to carry on the family tradition: her grandparents were excited; her father thought it was fine as long as she wasn't an enlisted woman; and her mother thought it would be great to travel and wear the uniform and serve the country and be a young woman on her own. Glenda likes the responsibility. As assistant submarine force training officer for the U. S. Atlantic Fleet in Norfolk, she helps administer a $3 million program and was once so busy she had to sleep in her office on twenty-eight consecutive nights. "I would go berserk if I had to stay home all day long," she said. Still, she is frustrated. She cannot serve on a submarine because the Navy already tried putting women on submarines and stopped when evidence of hanky-panky emerged. ("Men will be men," observed Rick, "and women will be women.") This makes her ineligible for the extra $100 per month her male counterparts on the sub force enjoy and for the little dolphins they wear on their chests to signal their submariner status. Her response has been to wear dolphin earrings.

As she was talking about her work, sitting in the VMI canteen on a week-

end visit with Rick, a cadet at the next table interrupted to say he associates women in the services with a lowering of standards. He added that his dad raises hell about it all the time. When Glenda, speaking firmly but evenly, said Navy women actually work harder than men because they don't want the men to think the Navy is going to hell because of them, he admitted that women do present a challenge. "You get that feeling of *competition* sometimes," he said, a little uneasily.

"A lot of jobs are as challenging as they are because men make them challenging," Glenda responded. "The first couple of months I was in my office they were all waiting to see if I was going to cry. I'm the first to admit that if I was in Vietnam and my buddy was shot next to me and he weighed two hundred fifty pounds and I needed to drag him away, I'd be at a disadvantage. But I don't think there would be that big a problem with women going to sea—if you could overcome the problems with facilities and previous attitudes."

"I have to agree with you," said the cadet, suddenly forgetting his dad. "I think the idea of women in the services is great, but—"

"But for what reason? Because we dress up the office?"

"No. Women are people, just like men are. But—I dunno. It's just been my experience that many times a woman will use her sex to her advantage."

"But there are two ends to that. It's not just the woman who's saying, 'I'm a girl and I don't have to do that kind of stuff.' If the man turned around and said, 'Yes you do, because you're in the Navy just like this guy next to you,' then things would be different. Right now the Navy is trying to get men to understand that women want to be treated as naval personnel and not as women. When everybody gets used to that, you'll never be able to make that statement."

The average VMI cadet, it is safe to say, does not yet comprehend the idea of women as military personnel. To the average cadet, women are alien sex/love objects who come to town every weekend for dates. If a cadet is lucky his date might take a room in one of the new motels outside of town and go to bed with him. If not it's back to barracks, where the only girls are the silent ones who stare out from the pages of *Penthouse*. Many cadets are more familiar with these *Penthouse* girls than with real ones. A lot of times cadets will get together in their rooms just to gaze at the flesh and read the letters. This leaves them excited but without any source of release: homosexual contact is for most unthinkable, the lack of privacy severely limits the potential for masturbation, and the naked girls, enticing and pink-lipped, remain excruciatingly two-dimensional. Two roads to relief are commonly taken. One is to wait for a nocturnal emission, which cadets often announce loudly and with satisfaction to their roommates in the morning. The other is known as "two o'clock sock": the cadet casually tosses a sock onto his radiator before retiring, then retrieves it in the middle of the night (taking care not to disturb his roommates) to satisfy his priapic obsession. The sheathing sock provides comforting warmth. "Guys will be guys," Rick noted with a grin.

Less sophisticated cadets sometimes complain that VMI never gives them the chance to polish their lines or develop any of the social graces. Rick has no such problems. He's smart enough not to rely on lines and good-looking enough not to feel the need for them. His dazzling smile and clear blue eyes

could capture any college girl's attention. Sometimes his good looks get him in trouble with his buddies, because whenever girls are around they just seem to fall his way. "Once or twice I've thought, *Why am I like this?*" he said earnestly. "*Why do I have the face I do? Why do I have a personality that enables me to attract people?* I don't know. But I hope I don't abuse it, because I've seen other people who have."

Rick met Glenda two years ago at a midshipmen's cookout in Charleston, South Carolina. She liked the way he looked and liked it that he didn't come across with some line the way every other guy she met at the cookout did. She considers him good-looking, hard-working, intellectually her equal, and easygoing in social situations. She also thinks he sometimes gets tired of hearing about the plight of women. "I really don't talk about it that much, but I guess he feels if it's been said once, saying it again isn't going to change anything. But he's so good about trying to understand, and I think he's proud of me. I will certainly have to be proud of him.

"Rick and I are different in our attitude toward the military. When I graduated, I was real enthused about being in the Navy. Rick is not enthused about being in the Navy, and he will say things that disturb me and disturb his family, because he's not graduating from VMI loving it. It's hard for me to listen to him complain about VMI. But he doesn't come across as traditional as I do, and that's just something I'll have to get used to."

On other matters, Rick and Glenda agree. They're both too science-oriented for religion; they both like to socialize; neither one is jealous. Rick wants in Glenda a partner to provide the encouragement that gives him strength. Glenda wants a marriage in which both of them would contribute equally. "It's really important that he acknowledge me as a professional," she said, "because the majority of time I don't spend sleeping I'll spend working, and the same with him. And I think it's important that Rick have some time on his own before we're married. Last year I was very caught up in wanting to be married. I would have had no qualms about putting in a transfer to follow him. Now that I've had a year to myself, I'm not that anxious to put in for a transfer. Everybody in my family expects me to go to Pensacola with Rick. I'm not interested in that at all. I don't know how we're going to work around that."

"We'll just have to be flexible," Rick said. "Everybody expects her to follow me, but it might turn out with me putting in for a transfer to go where she is."

Rick is braver than a lot of men: he likes competition so much he's marrying it. "I think women should be allowed to do anything men do," he said. "But it's the old standard male-dominant role being infringed upon, and I think a lot of men are getting scared because they're going to lose their jobs or be shown up. You may lose some things—the man coming home and having his wife bring him his paper and slippers—but that wouldn't bother me. I might come home early and bring her her slippers."

On other issues, Rick does not stray so readily from traditional values. He is a firm believer in the nuclear family as the basis of society. He thinks that when the nuclear family is disrupted, a degeneration of society results. He thinks social degeneration might be under way in the United States right now—not as a result of women's liberation, but perhaps as a result of homosexuality. He's

never had contact with anyone he knew was homosexual (except twice, with men who tried to pick him up, and they both left bad impressions), and he admits they could be right when they say they're not hurting anyone—but if there were too many of them, how would you propagate the species?

"It's like a dam," he said. "You get a crack—say, homosexuality—and somewhere else you get alcoholism—and then you get people going from alcohol into drugs—and then the crack begins to widen into mental illness. Finally, it all breaks down. I think homosexuality is just one flaw in society. But as homosexuals gain rights, they're also gaining momentum. Now if homosexuality is a flaw and it's gaining momentum, what does that indicate? No, I don't want to go out and throw them in jail. No, I don't want to go out and disrupt their movement. That's their right. But it's also society's duty to check itself in a policing action—such as you have here at VMI."

Rick has no beef with heterosexual intercourse, regular or oral/genital, but other combinations he considers kinky. He opposes extramarital sex as incompatible with the ideal of marriage. He thinks promiscuity is okay for unmarried people if they're careful, but it no longer appeals to him as it did before Glenda. "You can abuse sex," he warned. "You can lose sight of its purpose. It becomes something that loses all its beauty and then you're just getting that good old basic feeling. But that's that animalistic urge, and you want to be human. It's control of that animalistic urge that leads to the nuclear family. So if you can check it, that's being more civilized."

Checking that animalistic urge is a goal Rick has set for himself—not just with women, but also when he's alone. He hasn't indulged in two o'clock sock for a couple of years now. "It's self-denial," he said, "but on a higher level, it's controlling one aspect of your life. Just being able to control it, you've won a battle—and whenever you can do that, I think you're a better man."

Self-control is a principle Rick puts a great deal of faith in. He considers it of utmost importance, not just in sexual matters but also in emotional and social situations. It's why he won't get drunk or smoke marijuana. Like so many of his ideas, it came from his father.

One idea that did not come from his father is his notion of consistency through flexibility. If you can remain flexible in life, he feels, you can also remain consistent—since it's impossible to maintain an absolute, straight-line consistency, and since the minor variations occasioned by a judicious flexibility will in sum resemble a straight line anyway. The idea is to keep your goal in mind but be flexible enough to get there.

Rick got his ideas about flexibility in school, when, after a whole childhood spent meeting new people, he learned the value of being neutral. But at VMI, people don't seem to understand what he's saying. You can see why. VMI is devoted to the phallic virtues. It teaches the rigidity of character required in combat—the firm, unbending quality that would have a man risk death without weakening. In a context like that, it's easy to confuse flexibility with softness. Rick was not sure *I* would understand what he was saying either, so he repeated it, to make sure I got the point.

One of the most curious aspects of VMI is the intensity with which the average cadet detests the school's alumni. This attitude is particularly virulent among graduating first classmen in late spring, when alumni weekend, final

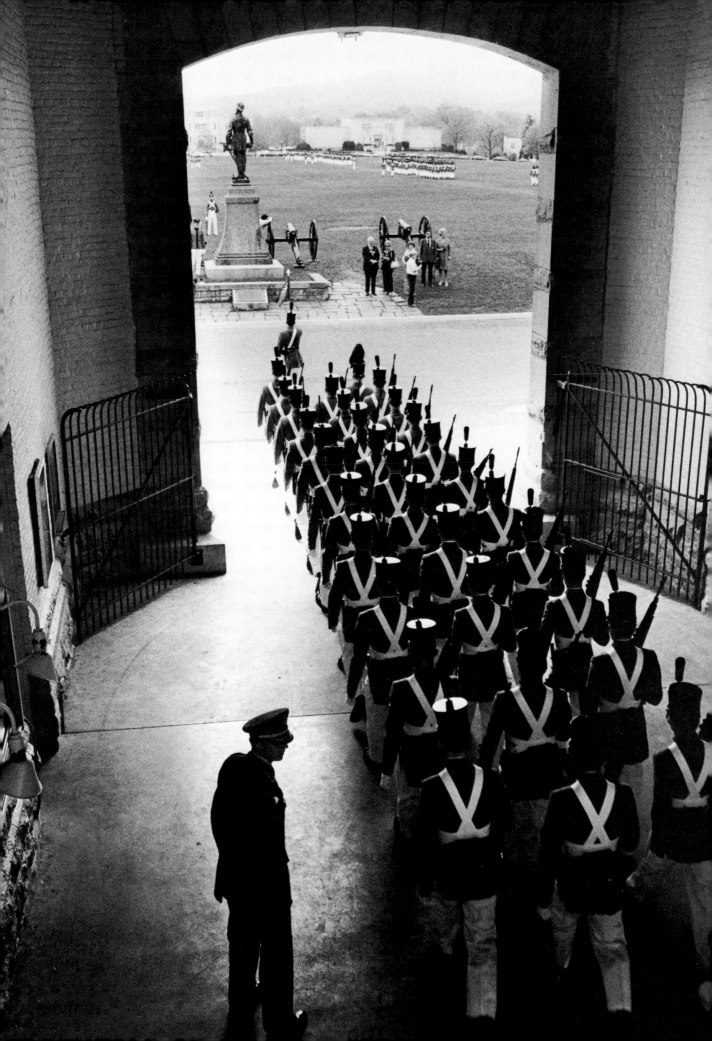

exams, New Market Day, and graduation exercises all fall together into three weeks of tension and pressure and conflicting emotions. It's almost as if they experience a brief spasm of revulsion at what they are to become. Then the tremor passes and they take their place on the parade ground, as always.

"The big thing that irritates me," said Rick's best friend, "is when they say, 'That's the way it was when I was a cadet and that's the way it's got to be now.' If we lived that way, rats would still be emptying bedpans in the Maury River. Now the alumni are gonna be coming in here and they're gonna start drinking and they're gonna get ripped. And we have to go parade for these jerks. They're gonna be yelling and screaming at us and making jackasses out of themselves. But these same people, if they saw a cadet coming up from town and he was drunk and a little rowdy, they'd bone him. That's a cheap shot, if you ask me. We're here as cadets—we need to be drunk a lot more than they do."

But no cadets were drunk on the Saturday morning of alumni weekend as the hour for parade approached. None of them were even visibly hung over. There'd been little opportunity for amusement the night before, unless you wanted to see *Psycho* at the PX or *Gone With the Wind* at the W&L student union. So it was with clear heads that the cadets dyked out inside their sturdy yellow castle as alumni and their wives lined up at the edge of the parade ground. The institute suggested a nineteenth-century wilderness outpost whose men were about to march out and scare invisible Indians for the benefit of an enthusiastic crew of shutterbuggers. The air was crystalline with expectancy.

The alumni—initiates in a special cult of manhood who have filtered out among the populace as doctors, lawyers, husbands, fathers, engineers—were not really drunk either, except with excitement at this opportunity to wander the stoops and fondle the guns of their youth. They did not, as one cadet suggested, throw beer bottles at the parade from the flag-bedecked pavilions of Moody Hall, the institute's luxurious new alumni house. Moody Hall was too far away, and everyone was served with plastic cups. But they did sit and drink, those who did not line up by the field, and they did flush with pride as the gray and white formations moved up and down the field—formations of upright young men who had confronted their animalistic instincts for sex and violence and assigned a value to each. The sharing of those values is what was being celebrated that day.

At a table on one of the pavilions sat a couple from Alexandria, Virginia. The man was stout and ruddy and wearing a yellow shirt with a red tie and a red and yellow plaid sport coat. His name tag said "'40" in one corner. His wife, who appeared soft and demure, was wearing a name tag that said "'40, '72, '76" all across the bottom. The man introduced himself as a lawyer and said they have three sons. The first hadn't qualified for life at the institute, but the second ('72) is a B-52 pilot for the Air Force and the third ('76) is a second lieutenant. The man's father, who'd also been an attorney in Alexandria, had graduated from VMI in '01, and his grandfather in '53. Stonewall Jackson had been one of the grandfather's professors. The man had brought his wife here on their honeymoon, just as his father had done, and of course she'd fallen in love with the place. "It's my type of living." She smiled. The man was feeling expansive. "I think the standards are fully as tough as when I was here," he stated with obvious satisfaction. "The rules have relaxed, quite sensi-

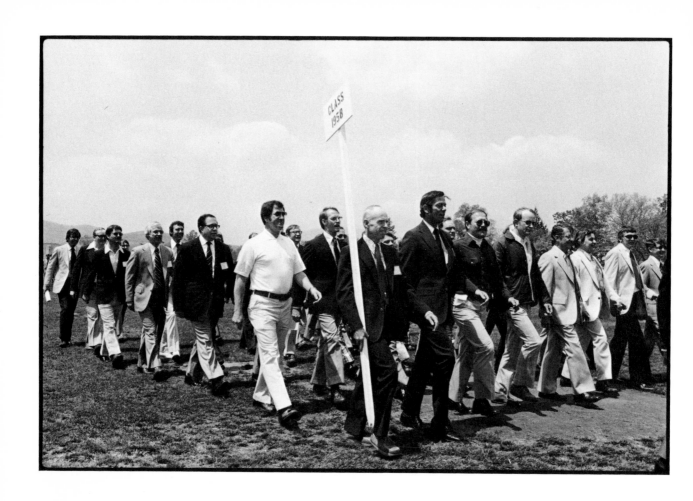

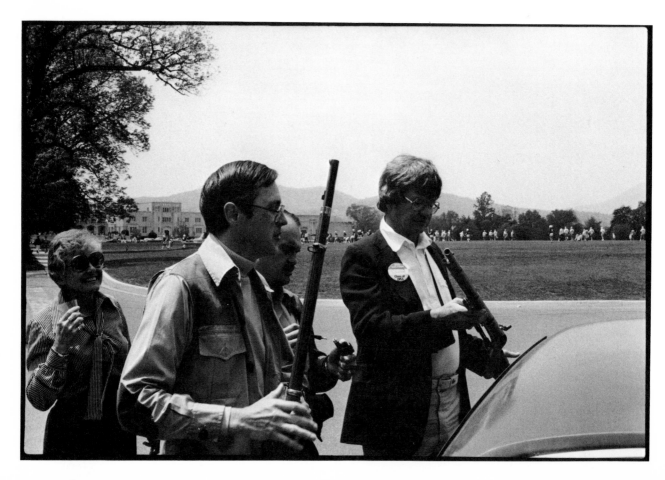

bly. Drinking in my day was instant dismissal, and the only way you could be saved was for the entire class to go on a pledge of honor not to drink in Lexington for the rest of the year. I think they've been very wise about relaxing them with a nice balance between this day and age and the general purpose of VMI.

"Of course, cadets are just like anybody else: if you give them an inch, they'll take a mile, or try to. If you give them beer in the PX, then they'll want scanty cocktail waitresses. But if you've been a cadet, you know that when someone unwinds, you should be very tolerant. You've undoubtedly heard about the bombs they used to throw in barracks? Well, when I was a cadet, it was an honor court regulation that you could not throw a bomb that had more than three pounds of powder in it or a fuse less than three minutes long. You were also required to yell 'Bomb in courtyard!' when you threw it out— and they were so heavy you didn't throw them, you rolled them out. They'd go off with a terrible blast.

"It's fun to walk in barracks. My son Bill, his first-class year, roomed in room one-thirteen, which is where *Brother Rat* was filmed. I was three doors away in room one-o-five my first-class year, and my father was in the same barracks in 1901." The crowd around us clapped and cheered as new moves were executed, new positions attained. "You know, my friends snicker a little bit," said the alumnus, "but I say this is God's country."

"Amen," said his wife, smiling.

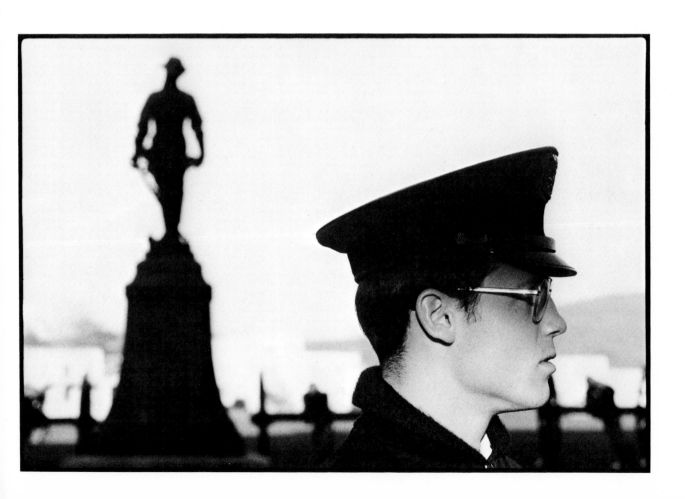

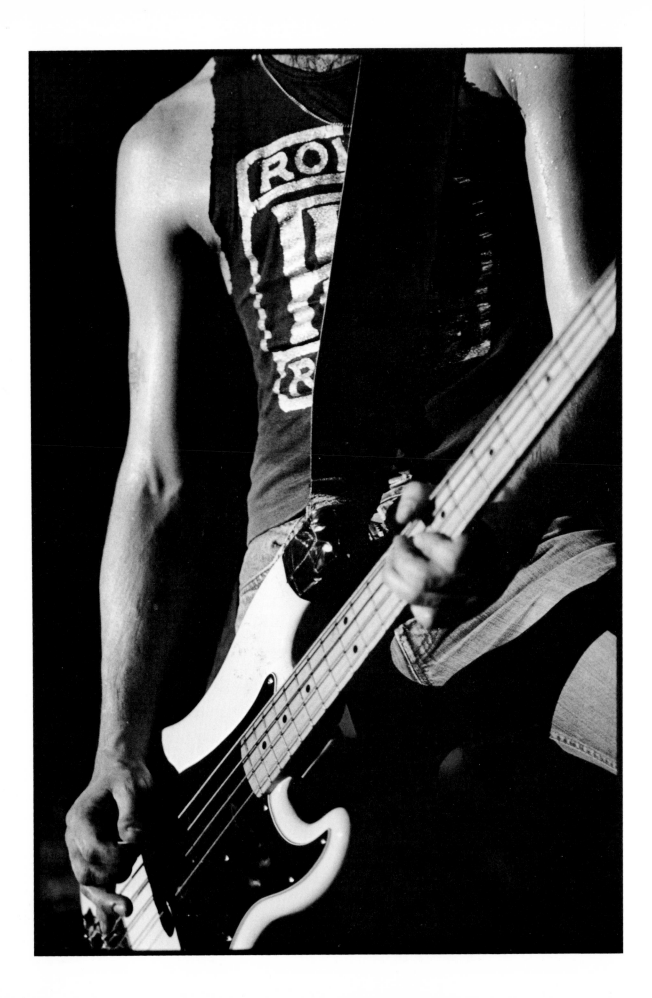

Dee Dee Ramone

The Ramones
New York, New York

In the fall of 1977, I found myself sitting in the lower Manhattan loft of Danny Fields, confidant of Lou Reed and Andy Warhol, former editor of *16 Magazine,* and co-manager of the Ramones, who are America's premier punk-rock band. Danny's loft was raw. It had twelve-foot ceilings, magnificent views of the Hudson through unwashed windows, a nude portrait of Iggy Pop on the wall, and a pair of handcuffs dangling from the pull cord on the kitchen light. We were discussing violence, which Danny finds intriguing as an idea.

"But I can't take violence seriously as an issue in punk rock," Danny said in his flat, nasal singsong. "I've never seen it in my life, except for Wayne County hitting Dick Manitoba over the head with his mike stand that night at CBGB—but that was such an isolated instance. And then you hear all this thing about that girl from England who lost an eye at a punk concert." Danny's features assumed a look of acute exasperation. "I mean, *big deal,* you know—one girl, one eye, one concert. That's the worst thing that's ever happened in the U.K.? Sports fans are *much* more violent than that. They do *terrible* things. They destroy the grass and all those things like that. They should go after sports if they're really worried about violence."

Even as we spoke, a frantic effort was under way to find Dee Dee Ramone, the bassist of the group, who had last been seen two days before. That evening Danny even resorted to phoning Dee Dee's mother in Queens, which of course only made things worse. That night, when Dee Dee finally did turn up, he told Danny he was walking down the street when these guys jumped him and beat him up, and then the cops took him away and wouldn't let him make a phone call. He didn't know his assailants. "I think they were folkies or something," Danny said later, deadpan.

Some time after that, Dee Dee told me what had really happened: he'd been taken to jail for assaulting his girl friend. He'd come home that evening, he said—home was the Village Plaza Hotel, a flophouse in Greenwich Village —and found her drunk and belligerent. She'd called him a faggot and a queer and said all he ever wanted to do was see his mother. She'd said it was her money that paid for the apartment and the furniture and everything else. He'd said "Fuck you!" and ripped her sofa with his knife and turned to her and said if she didn't shut up or leave, she was going to get the same treatment. She didn't, so he let her have it. The neighbors called the cops when they heard her screams.

Dee Dee and Connie had met about three years before at CBGB, the little dive on the Bowery where the Ramones had just started playing. For their first date they went to Rockaway Beach, a desultory stretch of sand and concrete at the end of the subway line in Queens. Connie liked that because when they got back that night she fell into her first natural sleep in years. Pretty soon

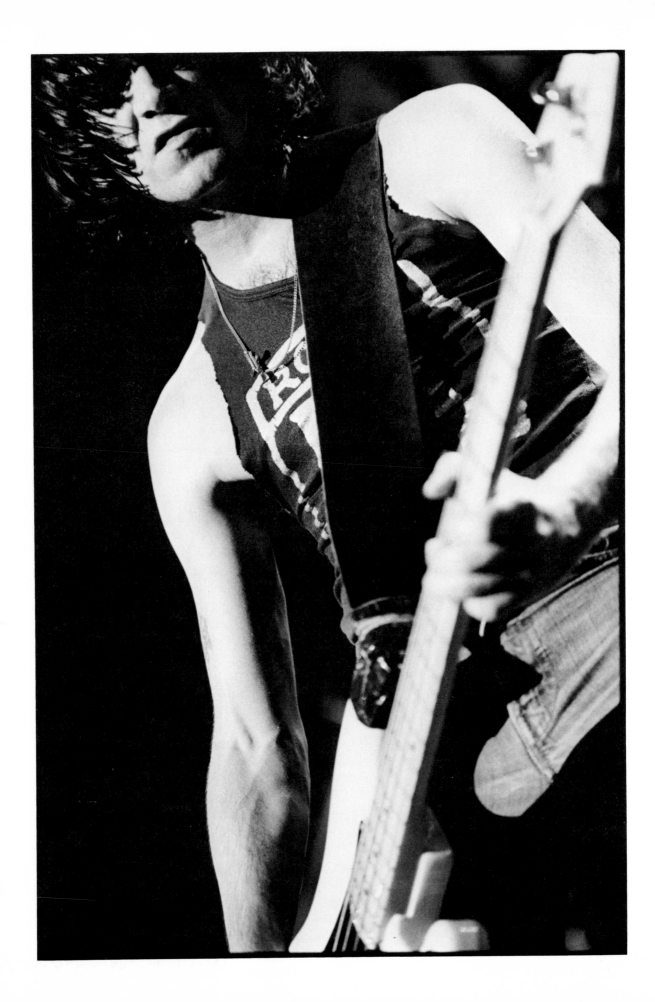

Dee Dee moved in with her. The band wasn't making any money, but it was taking up too much time for anybody to hold a job, and he needed somebody to take care of him. Connie looked like a good prospect. She was working as a go-go dancer on Forty-second Street and she had a lot of money. It wasn't long before Dee Dee started liking her a lot.

Unfortunately, Connie was the self-destructive type. Dee Dee had a $100-a-day heroin habit. It was a case of having too much in common. They spent their time staring at the walls, and all the songs he wrote came out bitter. Before long he began to feel manipulated by her, caught in her web. The night they took him to jail, he resolved to get free. He started kicking dope while he was locked up. When he got out, he said good-bye to Connie too.

"She never believed I could pull myself together," he said. "She probably thought, *Oh well, all I have to do is say, 'Dee Dee, let's get high!'* She thought I would run back like a dog. She didn't know that I had had enough of—that I had had *enough!* I think everybody's goal in life should be to become a man. And when you get to be my age and you can't consider yourself a man, you know, when you can't respect yourself, that's pretty pathetic."

Dee Dee was a Cold War baby. He was born Douglas Colvin at Fort Lee, Virginia, in September 1952. A few months later he was taken to Tokyo. His father was an Army noncom who worked for the CID and was mostly stationed in Germany until the mid-sixties. His mother is Prussian, from a wealthy industrialist family that was ruined by the Nazis. They met in Berlin after the war; she was a dancer then, at the Scala. Her family lives in territory the Russians occupied.

There were brief stays in Munich and the Rhineland, but Berlin was Dee Dee's home. He grew up in Zehlendorf, a pleasant, well-kept neighborhood that was sort of a showplace for American military personnel. Tanks rolled down the street on maneuvers every afternoon at five o'clock; the Wall was a short bike ride away. He liked to play in the bombed-out bunkers, but whenever he came home with Nazi relics his parents always got livid and ordered him to throw them away. He never quite understood why. "To this day," he said, "I wonder if any of the Nazis were really—I guess Germany was in a lot of trouble before they came into power, but I think maybe they were like socially conscious—they felt bad for Germany or something. But they were just infested with gangsters. It started out with the bullyboys and all that, and they just got carried away, those guys, *Whoa!*"

Dee Dee had fun when he was growing up in Germany. His father used to drive him through Bavaria and show him castles and things; he got to be a special fan of Ludwig II's. (Much later, when the Ramones went to England and saw their first castle together, they were disgusted because it was nothing more than a house with a wall around it—not at all like the one in Disneyland.) He got to go to East Germany to visit all his relatives. Once, during the Cuban missile crisis, his father even took him on a sudden holiday to Fort McPherson, Georgia. But his parents never seemed able to get along. They fought all the time, and when he was fourteen they split up—none too soon, in his opinion. He moved to the States with his mother and younger sister the same year. They lived briefly in New Jersey, then settled in Forest Hills, Queens. His father moved to Atlanta, remarried, and changed his religion. He

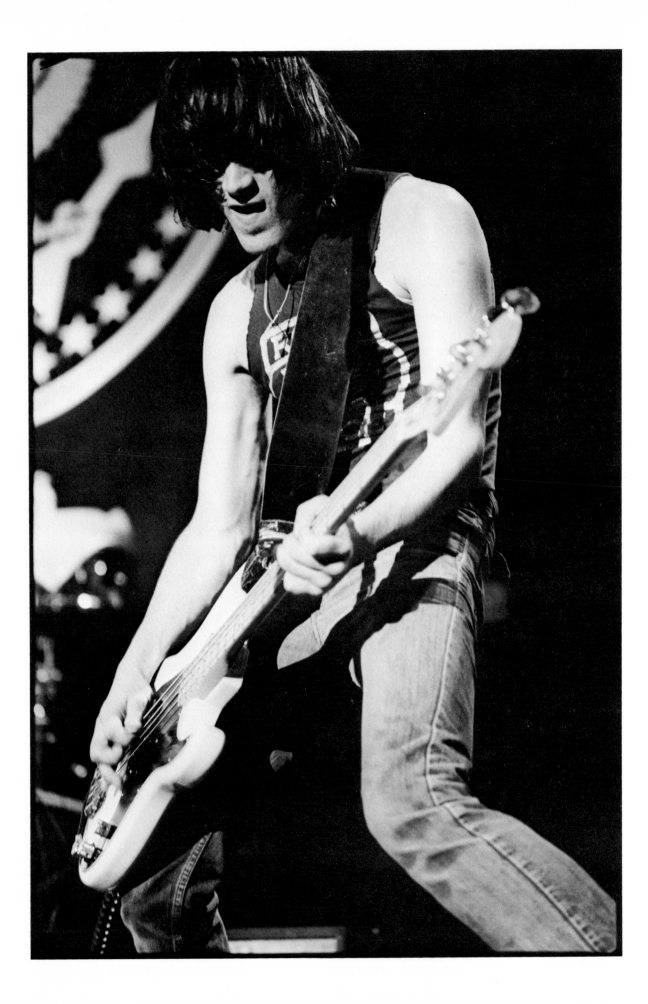

didn't write to Dee Dee much after that, and when he did, Dee Dee never bothered to answer.

Dee Dee had trouble adjusting to America—in particular, to the American educational system. In Germany he'd gone to military school; the discipline was tough, but at least he'd learned something. Here it was crazy. He walked in his first day of school in Forest Hills and he couldn't even understand what registration was. They seemed to be asking him to plan his entire future in ten minutes. He didn't have time to think. He asked for shop but they told him he had to get an academic diploma. He said he only wanted the easiest courses. He spent most of the day waiting in line. After school started, it was even worse. The teachers were stupid. They spent more time trying to control their kids than teaching them. They put kids in study hall and watched to make sure they didn't move. After a while Dee Dee just started sneaking out. He'd spend fifteen minutes in home room so he wouldn't get an absence card, then go back to the house. His mother would be at work by that time— she's a cosmetologist at Elizabeth Arden—so he'd crawl back into bed for a couple of hours' sleep. Then he'd go hang out with eight or nine other kids who were doing the same thing. Sometimes they'd go to Thornycroft Park, just off Queens Boulevard, and drink beer; other times they'd go to somebody's house and sniff glue.

When he turned sixteen, Dee Dee got his mother to sign him out of school. She didn't want to, but it looked like he wasn't going to go anyway and she figured maybe he'd be better off working. In fact, he had nothing against work. He didn't want to grow up to be a bum; he just didn't want to go to school. He didn't like it there.

One of his first jobs was working in a supermarket when he was still fifteen. He was stamping prices with a bunch of guys in the basement one day when they asked him if he wanted to snort some smack. He didn't know what smack was, but everybody was laughing at him so hard he figured he'd better do it. It just made him nauseous. But those guys made such a big deal about it he thought it had to be special, so he tried it again. Within a month he was shooting it. When he found out it was heroin, he felt really cool.

Dee Dee tried a whole series of jobs after he quit school, but none of them seemed to work out. He got a job as a butcher's apprentice, but a steer fell off its hook and nearly killed him. He got a job in an electronics store selling stereos he didn't know how to work. He worked as a mail clerk in an ad agency in Manhattan. Once he even borrowed somebody's portfolio and conned himself into a job doing paste-ups at an art studio. He got a lot of breaks, but it seemed like he screwed them all up. And he never felt there was anyone around to give him any real direction. Even after he'd busted his tail and earned his equivalency diploma and needed to know how to get into college, his father couldn't be bothered to explain.

It was okay. Adults had their own problems, and Dee Dee was in no hurry to grow up. He and his friends were outcasts. They weren't like the other kids, all so predictable. Those kids would play wild for a little while, then give it up the first chance they got to take their place on the assembly line. Dee Dee was willing to take a chance on a longer childhood.

Didn't he think about his future?

"I *worried* about it," he said. "I knew I never wanted to go into crime to make money. I just always hoped I'd be a rock star, I guess. What else can you think about?"

The original Ramones—the drummer has since withdrawn and been replaced —were four guys from Forest Hills who reinvented rock-'n'-roll while living in the back of a paint store. They did not, of course, set out to reinvent rock-'n'-roll. They set out to play it, but they encountered two problems right away. One was that they'd all reached their late teens without learning an instrument. The other was that they all had extremely bad attitudes. (Once Dee Dee and Joey, the singer, went to audition for some kids on Long Island who wanted to get together a group; asked if they knew "Gimme Shelter," they said sure, pulled out a conga and a guitar, and started making random noise.) These handicaps prevented Dee Dee, Joey, Johnny, and Tommy—that's what they called themselves—from developing in the normal way. Because they only knew a couple of chords, they were only able to produce the most rudimentary sounds. Because they were hostile and adolescent and too smart for their own good, they let it come out like a barrage of white hate. The result eventually became known as punk rock, but at the time it was just a last-ditch maneuver on the part of four fuck-ups who had dropped out of high school and didn't want to spend the rest of their lives sorting mail.

Dee Dee, Joey, and Johnny were the nucleus of the Ramones. They'd been hanging out together since Dee Dee was fifteen. Johnny had already quit school when Dee Dee met him, and Joey—well, Dee Dee doesn't think it was even possible for Joey to go to school. All three of them had the capacity to cause trouble simply by walking down the street, and all three of them talked about being in a rock band every day. But talk was all they could do; everybody they knew who was actually in a band had been playing since sixth or seventh grade.

Tommy appears to have been the catalyst of the group. The other three started hanging out with him when Dee Dee was eighteen. He was a couple of years older and ran with a crowd that was serious about music. He told them they ought to be a band because they looked good together. He took them to Manhattan, to places like Nobody's on Bleecker Street and Max's Kansas City, where David Bowie and Mick Jagger and Lou Reed hung out in the back room. That was in the early seventies, when the glitter look was in. People tromped about on three-inch platform shoes and wore skin-tight satin pants and frilly, open-chested shirts with sequins all over them. Everybody had either a shag hairdo or a multicolored afro, sometimes with Christmas-tree lights inside. Dee Dee and Joey and Johnny were embarrassed because all they had to wear were dirty blue jeans and old T-shirts; they looked like punk kids. Then they bought snakeskin boots and had their hair done.

Like everybody else who was into glitter, they spent a lot of time listening to the New York Dolls. Unfortunate marketing strategies and other factors conspired to keep the Dolls from ever becoming a national phenomenon, but locally they were the most exciting thing since at least 1966, when Andy Warhol had introduced the Velvet Underground. Musically, the Dolls were hard and loud and crudely reminiscent of the early Rolling Stones; stance-wise,

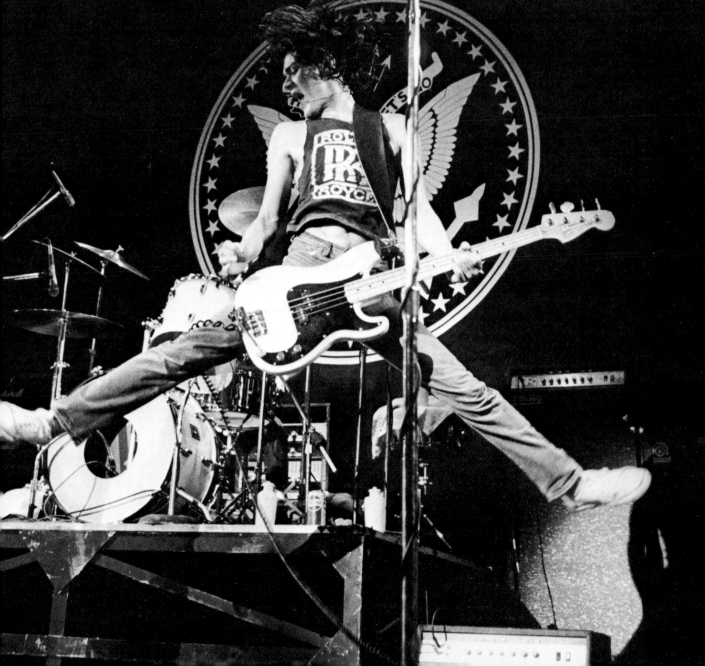

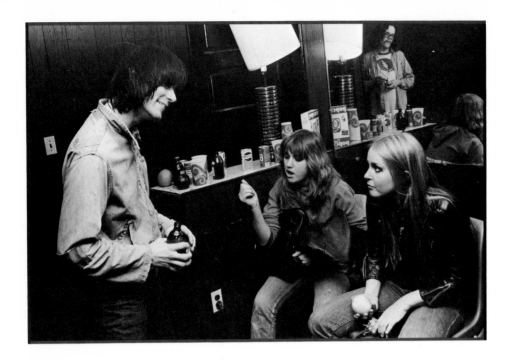

they were street-tough but femme. What really impressed Dee Dee and Joey and Johnny, however, was their ability to get onstage and express themselves without $20,000 worth of equipment.

Dee Dee had gotten a guitar when he was twelve, but he'd never learned how to play it. He'd tried, but it was harder than he'd figured and he got discouraged. But after seeing what the Dolls could do, he and Johnny bought $50 guitars and tiny little amps and started practicing. Joey put on gold lamé pants and gold lamé gloves and grew his hair two feet out from his head and formed a group called Sniper. Johnny and Tommy formed a group of their own, and Dee Dee was in another one. Then Dee Dee, Joey, and Johnny invited all their best friends to form a new group. At first there were a lot of people in it, but after the first day they all started leaving. One guy left because his mother made him; he was twenty-four. Another guy simply put his hands over his ears and had to be carried away. Since then he has done little but smoke pot and watch television and has refused to leave his room.

The line-up quickly dwindled down to the original three: Dee Dee and Johnny trying to play guitar and Joey banging away on drums, with Dee Dee singing. It didn't work, however. Dee Dee played so hard he kept breaking his guitars. He switched to bass because basses are more resistant to punishment (also because he always liked the way those Fenders looked), but he still couldn't sing and play at the same time. Meanwhile, Joey was a washout on drums because every time he played he got so violent he shredded his kit. And then Tommy, who was supposed to be managing them, went to work as a roadie for Buzzy Linhart.

At this point the Ramones were spending about two hours a week rehearsing. The rest of the time Johnny was working construction and Joey wasn't doing much of anything; Dee Dee was studying cosmetology at night school while shampooing the heads of middle-aged matrons by day at Bergdorf-Goodman, where he'd gotten a job as apprentice hairdresser. (It was another of his attempts to locate a career; he hated it.) After Joey's parents

kicked him out of the house, he and Dee Dee started sleeping in the back of a paint store. When it got cold, they found girl friends with apartments and moved in. Every spare cent they had went to buy records—rockabilly, fifties rock-'n'-roll, anything from England. They didn't like what was on the radio. They wanted songs, not guitar solos.

Around the end of 1974, Tommy came back, this time as drummer. That freed Joey to sing, and that, in turn, freed Dee Dee to concentrate on his bass. After that, everything started to click. They picked their name after Dee Dee read that Paul McCartney used to call himself Paul Ramone during the Silver Beatles tour. Dee Dee and Joey and Johnny started writing songs. They started rehearsing in earnest. Then they discovered a little dive on the Bowery called CBGB.

CBGB stands at the foot of Bleecker Street, its bright lights and dirty white awning illuminating a real-life stageset of urban depravity. Derelicts carrying oily rags stagger into nearby intersections, hoping to wipe someone's windshield for a quarter. Others lie sprawled unconscious on the sidewalk under greasy scraps of blanket. Crumbling tenements and weed-choked, rubble-filled lots create a sinister streetscape suggestive of Marlene Dietrich's postwar Berlin in *A Foreign Affair*. But when the Ramones found CBGB, nestled in among the gas stations and the fleabag hotels and the auto junkyards and the Off-Off-Broadway theaters and the soup kitchens, it was just what any fledgeling rock band would die for: a place to play, not Beatles and Led Zeppelin covers, but stuff that was original.

CBGB is a dank, narrow, tunnel-like room with a bar on the right, tiny tables on the left, and neon beer signs overhead. The stage is at the end, a tiny platform blocking the way to the grungy toilets in back. There aren't any

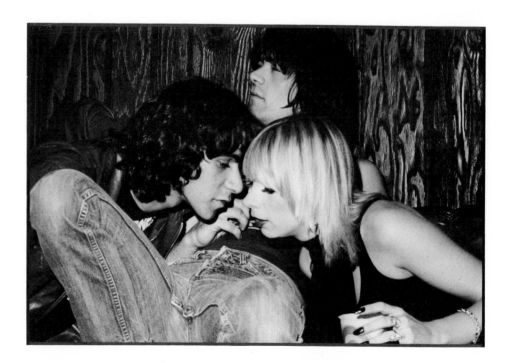

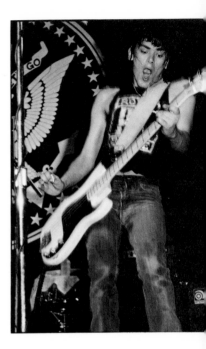

dressing rooms at all. In its previous incarnation, when it was called Hilly's, the place had been the favored hangout of the Hell's Angels, whose New York headquarters are a couple of blocks away on East Third Street. Then Hilly— Hilly Krystal, veteran barkeep, middle-aged with a weather-beaten face sunk behind a long, scraggly beard—persuaded them to drink elsewhere and started booking bands. Country, bluegrass, and blues was what he wanted; hence the initials CBGB. Instead he got Television, a grungy but arresting foursome led by a gawky, bug-eyed kid from Delaware who called himself Tom Verlaine. Television's manager persuaded him to forget about the country stuff and book nothing but neophyte rock groups. Word got around fast.

The Ramones liked CBGB, even though all they got was a percentage of the door and, at six or eight people a night, that wasn't much. They liked being able to turn their amps all the way up. The amps were small, but you could still get a lot of noise out of them. At other clubs, the owners were always jumping onstage to turn them down. At CBGB, nobody cared. They could do anything they wanted.

The Bowery could be pretty weird to four kids from Forest Hills: they'd go to a party and everybody would be doing angel dust and there'd be a man dressed as a wolf and he'd be howling in the middle of the floor. But the Ramones gave back as good as they got. By this time the snakeskin boots and mod hairdos were gone. They'd reverted to what they were used to—ripped blue jeans, dirty T-shirts, worn-out sneakers. And when they got onstage, they didn't feel like laying back. They put on shows that were, in Hobbes's phrase, nasty, brutish, and short: twenty minutes, on the average, with song titles like "Beat on the Brat," "Blitzkrieg Bop," "Now I Wanna Sniff Some Glue," and "I Don't Wanna Walk Around with You." It was simple assault: they mounted the stage, mowed you down, and were gone before you even had a chance to think about it. Nobody had ever done it like that before. They were a hit.

In January 1976, after circulating a crudely recorded demo tape containing four songs and performing at several private auditions, the Ramones became the first of many CBGB bands to land a record contract. They immediately went into a recording studio and cut an album of fourteen songs, all less than three minutes in length, at a widely reported cost of $6,000, which is about what most groups require to do the guitar tracks. The record was called *Ramones;* its front cover pictured the group in ripped jeans and black leather jackets, standing in front of a graffiti-scarred wall. It got a lot of press, but with lines like "I'm a Nazi schatze/Y'know I fight for the fatherland," it was not designed for maximum airplay.

Records that don't get airplay don't sell big; but at $6,000, that wasn't so terrible. On the Bowery, the Ramones had become superstars. Of the dozens of bands that regularly played CBGB, only they and a couple of others were widely acclaimed as original and important. ("Originality," Tommy told me at the time, "is hard to find.") Their detractors claimed they knew only three chords, but that didn't matter because they were indisputably the *right* three chords. ("I dunno who said it," he added, "but less is more.") In fact, although the CBGB bands were a highly mixed lot, it was the Ramones whose style defined the scene. That style failed to connect outside New York until July 4 and 5, 1976, when the Ramones played their historic first gigs in Lon-

don. The result of those two dates, according to their managers, Danny Fields
and Linda Stein, and to Seymour Stein, who runs their record company, was
the birth of punk rock—a Bicentennial gift from the Ramones to Great Brit-
ain, arriving just in time to inspire British youth to articulate a suitable re-
sponse to the Silver Jubilee: Johnny Rotten's snarling version of "God Save
the Queen."

There were two things about the Ramones that inspired Britain's nascent
punks. One was their ability to make coherent noise without expensive equip-
ment or even any real command of their instruments. The other was the
overwhelming amount of constricted hostility they managed to force through
their amps in the process. In particular, the Dee Dee Ramone style of bass
playing—raw throb, steady strokes—became a hallmark of the punk band.
(Much of the credit for popularizing it should go to the Sex Pistols' late
bassist, Sid Vicious, for whom Dee Dee was an early idol.) As punk became a
fad, many bands unfortunately failed to heed one of the Ramones' basic
points, which was that an inability to play should produce not poor musician-
ship but an extreme economy of style. But the hostility—the teen meanness
born of boredom and frustration that had led them to drop TV sets from roof-
tops onto passers-by in Forest Hills—was a message nobody could miss. They
packed a wallop into their two-minute nuggets of sound that was awesome to
experience.

But those early songs were not merely violent. The Ramones had a pas-
sion for punishment. Their music became a vehicle for inflicting it—on them-
selves, and on others. They were errant, and they knew it, and since nobody
else seemed to care, they had no choice but to take up the cudgel themselves.

"I was very delinquent," Dee Dee admitted. "I think I was tormented
somehow. I robbed people and stuff, I used to take drugs all day long, and I'd
hate myself for that, and then I'd just get in more trouble. I was just shiftless.
I never had a father to control me. There was nobody there to control me, so I
just ran loose."

"Dee Dee's so lovable! Dee Dee can get away with *murder*. Dee Dee can be
the culprit and you say, 'Awwww, it's Dee Dee.' He's kinda like a teddy bear.
He's the sweetheart of the Ramones. What can I say? He's Dee Dee!"

We were at the midtown offices of Coconut Entertainment, the manage-
ment company set up by Danny Fields and Linda Stein, listening to Linda on
one of her favorite subjects. A trade magazine on the table carried articles
hailing the advent of "creative sterility" in the music business. Linda turned to
ask Danny what he thought made Dee Dee so distinctive. "His IQ," Danny
said, in his laconic way. "His abiding sense of decency, justice, honor, integ-
rity, morality. . . . He'll also sleep with anything, which makes him very
hot."

Linda giggled. "He's definitely the sexiest Ramone, isn't he? The most
available. We could be in London, for example, and if I say I'm going to see
Elton, Dee Dee will be the first one to jump up and say 'I wanna go!' The
others just are not interested. John is very satisfied to stay home and watch a
great film, and Joey's idea of going out on the town is—well. Dee Dee just
likes to party more than the others do. And Dee Dee has the most girl friends.
People just fall in love with Dee Dee."

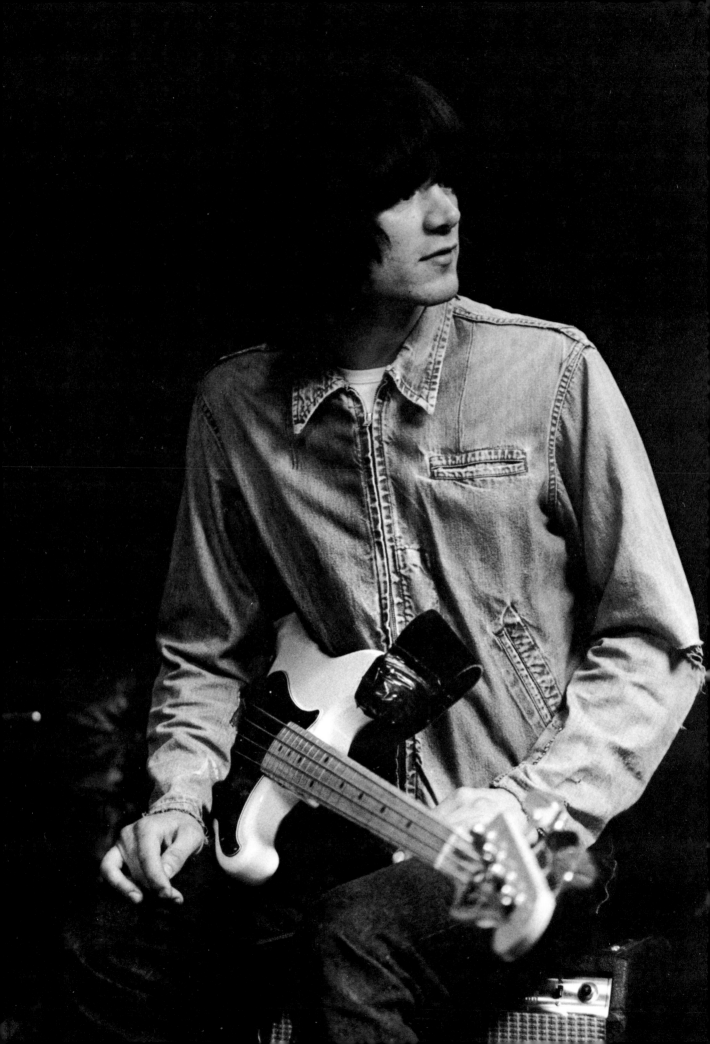

People do fall in love with Dee Dee—with his mischievous grin, his big brown eyes, his bashful, awkward voice, even his volatile temper. Naturally, Dee Dee is not unaware of his appeal. "I've always been very loved," he'd told me earlier, "and I always rejected it. I always felt too worthless to accept that kind of intimacy from anybody—relatives, girls, teachers, anybody. When you're leading a life of crime, and you're just doing that because you want to be destructive, you're not going to be happy with yourself. What I should have done was build some kind of foundation, but I didn't. I turned the opposite way. Something was tormenting me. Emotionally I went through hell, until I found myself."

Dee Dee took heroin for ten years—from 1967, when he was fifteen, to 1977, when the Ramones recorded their third album, *Rocket to Russia*. At first he copped in Central Park, buying, say, fifteen $2.00 bags for $24, keeping three for himself, and selling the rest to other kids in Queens for $4.00 apiece. But when the French heroin disappeared and the brown Mexican cut with procaine took its place, he started going downtown. The Mexican yielded a weird high, changing laid-back addicts to violent, hopped-up ones; there was no way to get satisfied. He'd cop at places like Avenue D and Ninth Street on the Lower East Side, and since that wasn't easy to do—especially if you were white—he found a lot of people who would give him $200 or so and let him keep half of what he bought. When that wasn't enough, or when his girl friend of the moment wouldn't give him money, there were other options. He didn't go in for burglary; he didn't like the idea of going into dark, empty apartments all by himself, or of running down fire escapes with TV sets on his head. Stickups, on the other hand, were not so bad.

Dee Dee's victims were mostly other junkies. For credibility, he carried a nine-millimeter Walter P-38 automatic he'd purchased from his connection. "I don't think I ever would've had the balls to use it," he said, "but if someone had pulled another one out—you know, what could you do?" For self-defense, he also carried a strong lock-back knife—as easy to open as a switchblade, and a lot less dangerous to get caught with. He was busted for a lot of things, including possession of heroin, but never convicted. Once, however, he was almost taken by two phony cops on the street. He'd noticed two guys following him and had turned to face them when they shouted, "Narcotics Control—hand over your dope!" That sounded a little suspicious, so he asked to see a badge. They said, "What are you, a wise guy?" and pulled knives. Dee Dee cut one, pushed the other aside, and ran. He got cut across the chest, but he kept his dope.

Dee Dee tried methadone detoxification several times, but always with unhappy results. Each time he was put on a twelve-day program, given no counseling, and started on a forty-milligram dose, which was stronger than the heroin he was used to at first. After twelve days he usually wound up more strung out than before. His first couple of attempts were sincere, but after that he began to use the detox program as a safe way of staying high if he couldn't hassle getting the money up to cop. In all, he went on it about sixteen times. Still, he scorned methadone maintenance. "The maintenance program is for vegetables," he said. "And I *never* wanted to be a vegetable."

Once he became a Ramone, Dee Dee could no longer afford to be a vegetable. At one time, when he was having trouble taking care of himself on tour,

he was afraid the other three wanted him to leave the group. They never said anything, though; they left him alone to deal with it himself. He still isn't sure how he stopped. He likens it to a miracle, or an exorcism.

Linda thinks part of it was the Ramones themselves, who have come to take the idea of rock stardom very seriously. "They want to succeed," she said. "They want to sell records and tickets and make money. So they're very demanding. You can't *ever* be five minutes late, you can't *ever* not come to rehearsal, you can't *ever* make a mistake onstage. I don't care if the audience is *howling* for encores, if you made a mistake, when you get off that stage you're being screamed at by the other Ramones. So there's no room for any fooling around or any getting stoned or any of that if you're on the road—and if you're off the road, you have to come to rehearsal four or five times a week. As long as you're a Ramone, there's no room to misbehave or get yourself screwed up. I think that's the secret of Dee Dee's being straightened out. I mean, it's like a Nazi army!"

Equally important, however, has been the influence of Vera Ramone. Dee Dee met Vera after he broke up with Connie. She was standing at the bar in Max's and he went up and told her who he was. She thought he was egotistical but kind of cute; to him, it was like love at first sight. The following May they were engaged, and in June, after several months of camping out in Danny's loft, they moved into a two-bedroom basement apartment in College Point, Queens, three blocks from where her parents live. They were married in August, one day before the Ramones were scheduled to embark on a month-long tour of Britain and the Continent.

Vera works part-time as a hairdresser in Brooklyn. She has the peroxide-blond look of a lot of girls one might meet at Max's, except that she smiles a lot and her eyes aren't dull. Everyone seems to like her and to agree that she's good for Dee Dee. ("Vera's like great," said Joey. "She's not a nut.") Still, the idea of marriage caught many by surprise, as did the idea of moving to Queens—especially since Dee Dee has always been viewed as the fun-loving Ramone most likely to lead the life of rock royalty.

"I couldn't believe it," Linda said. "Danny and I always thought Dee Dee should have an affair with Farrah Fawcett or somebody very famous. He could be like Cher Bono and just keep having continual affairs with famous people. But he chose to be completely domesticated and settle down in College Point—with all his cutlery and all his porcelain and his dinette set and his living-room sofa and his color TV. We wanted to buy him a very practical gift, but he already has everything. They're having this real wedding, they have this real dinette set, they're having everything except the honeymoon—because he's leaving the next morning for Helsinki."

The last Ramones' performance before the European tour took place at Hurrah, a sort of uptown punk disco—the concept is appalling to any purist—around the corner from Lincoln Center. The Ramones and their road manager had just driven the van in from Chicago the night before (they almost always travel by van in the States) and had spun out of control in a rainstorm in New Jersey. No one had been hurt. It was August, almost a year after the incident with Connie, a couple of weeks before the wedding. Hurrah's air conditioning was broken; the tiny dressing room was hot, damp, airless, and un-

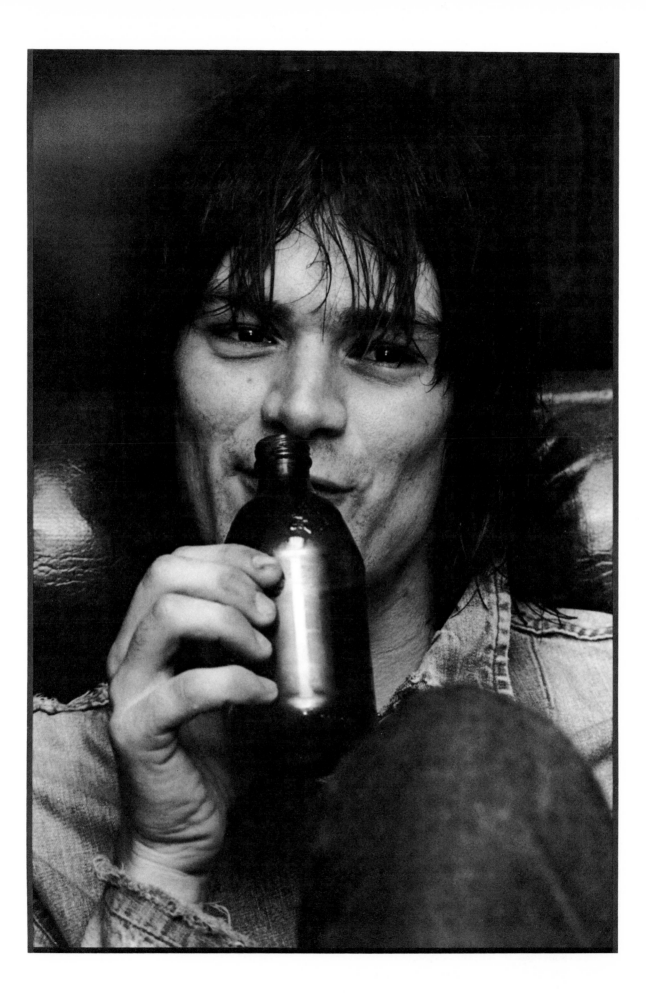

bearable. All four Ramones were wearing torn jeans, T-shirts, and Keds—that last a group rule, they being an American brand of sneaker. Eventually Dee Dee and Johnny pulled out their instruments and started to warm up. Joey, the tall, languid one with the hunched shoulders, pulled off his T-shirt to reveal flabby pink skin and began craning his neck, arching his back, letting his arms hang limp, and letting his fingers wiggle. Visitors were banished.

The crowd outside was getting impatient. Nick Lowe was on the turntable, singing "I love the sound of the breaking glass." A thin woman in a flowing black dress was dancing with two men, one spindly and spastic in white shirt, narrow tie, and iridescent pegged pants, the other self-consciously beefy in white shirt, tight jeans, and black leather chaps. A kid up front was pogo-dancing up and down in a white T-shirt that bore the legend "Today Skokie, Tomorrow the World." A chant of "Hey, ho, let's go!" went up— that's the opener to "Blitzkrieg Bop," the Ramones' first single—but the band refused to come out until half-past midnight. They never leave until they're ready. They have to psych themselves for every performance. They have to focus their thoughts. They have to be able to intimidate people.

Finally, as beer spray arced over the crowd and fists shook in the air, the Ramones stormed the stage, took their positions, and delivered a back beat that began with a roar and could have filled a horizon. "We're the Ramones," yelled Joey, "and this one's called 'Rockaway Beach'!" The intensity of their attack was broken only once, when Dee Dee destroyed two instruments in quick succession. Otherwise they mowed without interruption through an hour-long set that included "Teenage Lobotomy," "Gimme Gimme Shock Treatment," "Pinhead," "I Don't Care," and a new one from their soon-to-be-released *Road to Ruin* album, "I Don't Want You." After the second encore, Joey started stumbling and had to be helped down the hall to their dressing room. Snot was dribbling from his nose.

The show was somewhat unusual in that it was a benefit for their managers. Danny, a sort of underground tastemaker who's been involved with everyone from Jim Morrison to the Velvet Underground to the MC5 to Iggy and the Stooges, had been managing the Ramones in partnership with Linda, who'd worked with them at her husband's record company, since summer 1977. The economics of the music business are such that a band never gets out of hock and begins to make money until it makes a lot; in the meantime it lives, tours, and records on record-company advances. The Ramones signed with Sire Records, a small label then distributed by ABC, for a minuscule advance, and while they've never owed a tremendous sum, they've never made much either. They paid themselves four-figure salaries (excluding royalties, which are split three ways), and Danny and Linda waived their share when a new amp or a new leather jacket was needed. Now, however, the situation was changing.

The establishment of Coconut Entertainment as a full-time enterprise was one of several steps in the transformation of the Ramones from rock dream to legitimate business venture. Other steps, all taken in 1977 and 1978, included the signing of a distribution pact between Sire and Warner Brother Records, one of the two biggest distributors in the country; the signing of the Ramones with Premier Talent, America's number-one booking agency; and the hiring of an accountant to tell everyone in the band how much money they have. Perhaps the major step, however, was the recording of their fourth album,

Road to Ruin. Road to Ruin presented a different Ramones—more melodic, not above an occasional ballad, ready to build on the stripped-down musical structures Danny calls "primitive-evolved" and likens to ancient Egyptian pottery. In fact, they were finally learning how to play. They had also decided to make an album that would get AOR airplay. AOR—that's album-oriented rock, the basic late-seventies FM rock format—is what the Ramones need to break nationally, and like all formats, it has certain standards. One thing it requires is songs that are not characterized by overwhelming hostility or repeated references to glue sniffing. Thus, *Road to Ruin* contained two fairly innocuous singles and a ballad by Dee Dee that was expected to establish them as AOR artists once and for all. As far as the Ramones were concerned, it could have been the first ballad ever recorded.

The Ramones had conflicting feelings about the new record. Joey and Dee Dee liked it; Johnny was having trouble believing it was them. When Linda told Eddie Rosenblatt, Warner's vice president in charge of marketing and promotion, that the Ramones felt a little like they'd sold out, he said she should tell them to think of it as *reaching* out. Of course, only the Ramones could record one song about a kid who'd killed his entire family and turned into a vegetable, and another song called "I Wanna Be Sedated," and still worry about selling out.

Still, it was 1978 and time to carve out some sort of post-punk identity. The movement the Ramones had helped spawn had mushroomed into the kind of media myth hip college students write theses about. "I think punk's like seen its time, you know," Joey said. "It's kind of a lot of crap, you know." Said Dee Dee, "It's over. It's finished. And whatever it wanted to prove, it proved. I think it showed that self-destruction and chaos are fine to shake something up, but not fine to use as a pattern to live your life by. Otherwise you just end up with nothing, and so does everybody else."

The punk label was never much good for airplay anyway. According to Linda, a major reason their third single, "Sheena Is a Punk Rocker," met so much resistance was the presence of the offending word in its title. Even if that word had never been heard, however, many people would find the Ramones a threatening aggregation. They sing about boys beating up their girl friends and fling Nazi imagery around suggestively and make like thugs and do other things the liberal mind finds difficult to accept. But of course, that's the whole idea.

One of my favorite Ramones songs is a cut on *Ramones Leave Home*, their second album, called "Commando." Its refrain goes like this:

> First rule is: The laws of Germany
> Second rule is: Be nice to mommy
> Third rule is: Don't talk to commies
> Fourth rule is: Eat kosher salamis.

When I asked Joey about the Nazi charge, he said, "I'm into America. I'm not into Nazism and all that shit, I'm into the U.S., you know? Everybody's a commie these days. I mean like everything sucks anyway, you know.

"Most groups are like put-ons," he continued. "We're not trying to put anything over on anybody, you know. We're just us."

College Point, Queens, is a modest, quiet neighborhood of one-, two-, and three-family homes, located on a broad peninsula that extends into the East River in the direction of LaGuardia Airport and Riker's Island. It is a remote corner of the city, with well-kept yards, pleasant trees, and children who don't have to play in the streets. Two days before the wedding, we visited Dee Dee and Vera in their new home. It's a nice-sized apartment with a living room, kitchen, dining alcove, and two bedrooms, one furnished with a Mediterranean-style bedroom suite with matching green and white bedspread and drapes, the other filled with Dee Dee's collections of records and *Weird War* comics. The living-room furniture hadn't been delivered yet, so we sat at the glass-topped dinette table, which Vera said they'd gotten only by a miracle because somebody had found it in the warehouse. Dee Dee was suffering from a recurrence of hepatitis; for a while there'd been talk of canceling the tour, but he wasn't all that sick and anyway, Johnny would have killed him. Everybody was all excited about the upcoming weekend. Vera's gown, floor-length and white with a full veil, had arrived from California only the day before, and Dee Dee had spent the whole afternoon looking for a new black leather jacket to replace the last one, which had been stolen from the van. They don't make leather jackets like they used to, so he'd spent the whole evening putting the studs on himself. "I can't wait till our furniture comes," he said.

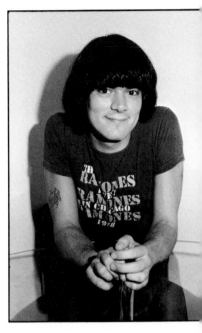

Dee Dee was happy about moving back to Queens. "It's more *normal*," he said. "I lived too bad for too long. I wanna start trying to live *nice*." He was also happy about getting married. "I think it's better if you want to have children," he said.

"It really seemed like the right thing to do," Vera put in.

"It's not something we were pressured into doing," Dee Dee added. "In fact, the priest almost tries to talk you out of it. And I'm not getting any younger, either."

"None of us are," Vera said.

I asked Dee Dee about stardom and the band's plans for the future.

"The way things are going now," he said, "I plan to stick with it for a long time. I plan to keep going. The whole group plans to keep going. What else are we gonna do? I have no skills. I couldn't get a job doing anything else now. And I *like* it. Plus, the work is less severe the bigger you get. You don't have to tour two hundred fifty days a year.

"But I'm not a greedy person or anything. If I ever have like millions of dollars—which I think I'm going to, probably I'll look fifty but at least I'll have it—I don't know what I'll do with it, probably just buy a house and try and relax. There's plenty of things I like to do. I like to go hunting and stuff and be able to do normal things like everybody else. But of course, there'll always be a mean streak in me. I can't help that, you know."

I mentioned that he seemed quite concerned with the idea of being normal.

"*Yeah,*" he said, suddenly tensing. "I wanna be normal really bad. I don't wanna be crazy." His knuckles were growing white.

Vera looked over from the sink. "What are you doing to the *table*, Dee Dee?"

"I'm *sick* of being crazy." He didn't seem to hear her. "It's been crazy all my *life*. I guess I have my crazy moments. But I have so many good friends, I have a very good life. . . ."

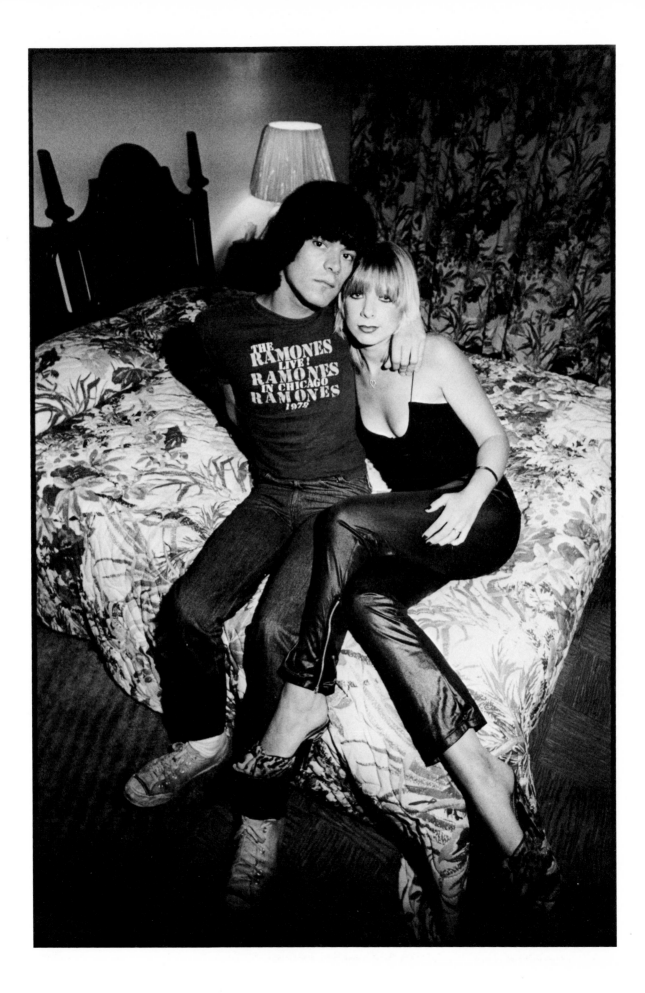

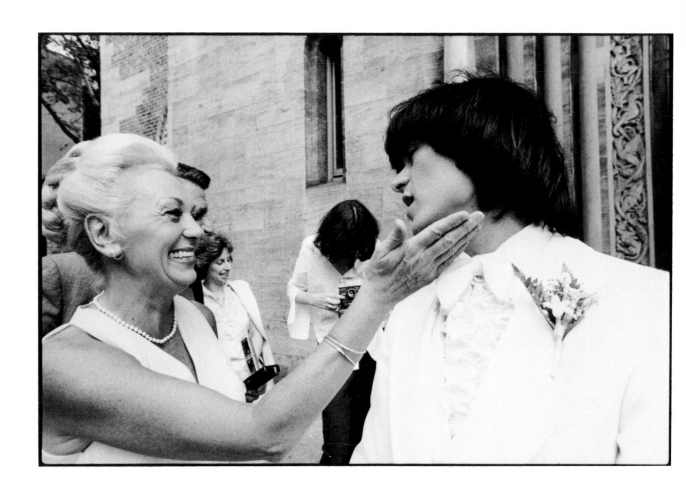

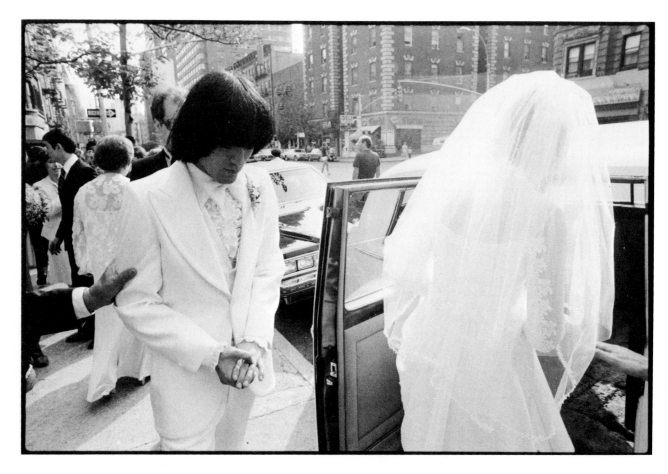

"He's loved, you know," Vera interjected. "Everybody loves him."

"Like I'm just a really happy guy, that's all."

Dee Dee laughed. Children were playing outside. Their shrieks came down through the open window and filled the room.

The wedding was held at St. John Nepocene's Roman Catholic Church on the Upper East Side of Manhattan; that was where Vera's parents had married and where Vera herself had been baptized. Only about fifty people were invited, most of them relatives. Johnny and Mark didn't make it, but Joey and Tommy did, and Danny, Linda, and Seymour. Afterward there was a reception at a restaurant in Queens with music by a rock band whose repertoire includes the Beatles, some disco, and a lot of wedding songs. Dee Dee had suggested they hire the Dead Boys, but he only meant it as a joke.

Dee Dee arrived at the church in a black Cadillac limousine. He was wearing a custom-tailored white tuxedo with frothy white shirt and white shoes. He said he'd gotten so panicky getting dressed like that he'd had to take out his old Ramones scrapbooks and look at them. Vera arrived with her parents in a white Rolls Royce. It was a beautiful wedding, with bridesmaids in acres of chiffon and a soloist high in the balcony who sang "Ave Maria" and "The Lord's Prayer"; just like thousands of others all across America that day, except that the priest interrupted the ceremony to speak extemporaneously and at length on the sanctity of the marriage vows and the importance of marital fidelity. It was a curious thing to do, but he married them all the same, and Linda sobbed as they got into the Rolls for the trip back to Queens.

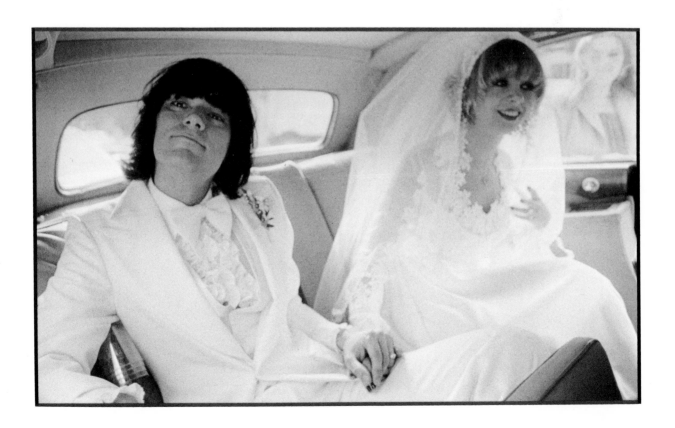

Norm Rathweg

Rathweg Design
New York, New York

Not far from CBGB, on a street dominated by turn-of-the-century loft buildings where light industry has recently been retreating before an onslaught of artists in search of living space, stand four grandly porticoed mansions that form a single crumbling marble edifice: relics from an earlier age. In the 1830s, when these houses were new, this was one of New York's most fashionable districts; but fashion moved steadily uptown for the next half century, and "Colonnade Row," as it's come to be called, found itself surrounded by warehouses and factories. Now, however, with Joseph Papp's Public Theater in the old Astor Library across the street, a landmark designation preventing exterior alteration, and theater-goers flocking to its ground-floor restaurants, Colonnade Row is experiencing something of a renaissance. It's hardly in the condition it was when Washington Irving and John Jacob Astor lived inside; but the apartments it's been divided into command respectably steep rents, and paint cans and lumber in the hallways attest to the owners' willingness to fix up, even though the cost of repointing the marble façade has now become prohibitive.

Norm Rathweg lives in a top-floor flat—although hidden behind the cornice, it still has ten-foot ceilings—with his lover, Louis Nelson, and a roommate who works in an art gallery. Norm and Louis both work for their landlord, who has real estate and entertainment interests scattered throughout Manhattan; Louis is his comptroller, Norm manages his residential properties. Norm's primary occupation, however, is as a free-lance designer of interior spaces. Soon he intends to return to graduate school for his architecture degree. At the moment he is finishing a loft conversion on lower Fifth Avenue and getting ready to remodel an upper Fifth Avenue penthouse that overlooks Central Park. He has lived in New York since 1975, having graduated from Florida State (B.S. in communications and technical theater) and received one job offer—in the audio-visual department of the Atlanta public school system. He hated Atlanta because all people do there is shop. "So I did the existential thing and moved to New York," he said. "I'd always wanted to live in New York because there's lots of buildings here. I'm real queer for buildings."

Norm's favorite New York buildings include Warren & Wetmore's Grand Central Terminal, Mies van der Rohe's Seagram Building, the Cathedral of St. John the Divine ("because it's an unfinished grand gesture"), and James Renwick's Gothic revival Grace Church ("a perfect gem"). Like most aspiring architects, he would like to design monuments. Also, "palaces, government buildings, schools—I mean, sure. Skyscrapers . . . shopping centers . . ."

Although he majored in set design—that's what technical theater means—Norm quickly discovered that he didn't like the theater. "It's not the

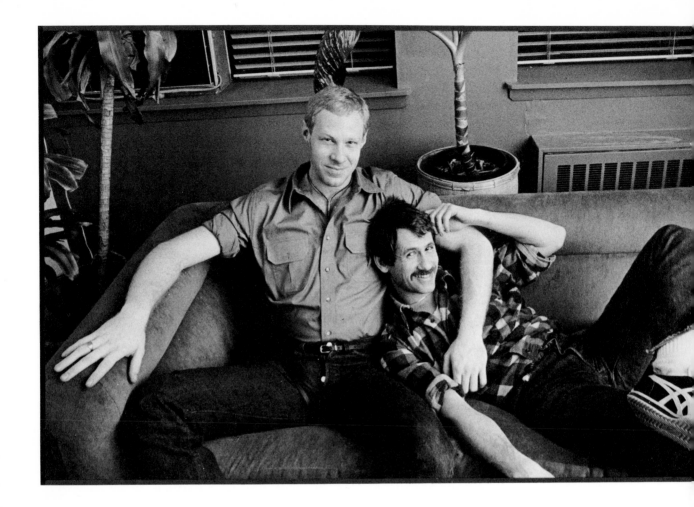

ephemeralness of the field," he said, "it has more to do with the dishonesty of
doing things for effect. The things I like in design are things that are just
there. Like my favorite furniture is Mission furniture, because Mission furni-
ture is all about just being furniture made out of wood. Other furniture has
other things to say. It says, 'I am overwhelmingly comfortable,' or 'I am
overwhelmingly expensive,' or 'I am well-designed,' or 'I am owned by some-
one who appreciates French antiques,' or—you know, furniture has three hun-
dred things to say. Mission furniture has only two things to say: it's made out
of oak, and it's made to sit on, lie down on, keep books in. . . . It's well-made
furniture that serves those purposes. At any rate, that's how I feel about archi-
tecture and design, and design in the theater has nothing to do with that. It
has all to do with pretense and effect."

Norm spent more than two years in New York before he designed any-
thing. He worked briefly as a waiter, then took a series of paper-shuffling jobs
in the nonprofit arts bureaucracy. In 1977, when he was twenty-six, he got a
grant to study architecture and urban planning at Columbia. His grant didn't
even cover his tuition, however, and at the end of his first semester, when he
was offered a job remodeling the St. Marks Baths—a decrepit old Jewish
bathhouse that was about to go gay—he quit grad school and took it. He spent
five months on that and has been doing smaller jobs since. His favorite is the
loft on Fifth Avenue—a 5,000-square-foot space in a turn-of-the-century office
building whose floors are being sold as residential co-ops. The St. Marks job
was a collaboration; this is his first opportunity to be "really creative."

Norm's client for the loft job is a young dancer who's just moved from San Francisco to found a new dance company. He paid $120,000 for the unfinished loft and will lay out another $60,000 to make it habitable. What began as an empty rectangular space with a hundred-foot wall of windows facing south and a shorter wall of windows facing west is being divided into dance studios and living and sleeping areas. Norm decided to emphasize the special attributes of the space by putting all new construction on the diagonal instead of at right angles to the original walls. The result is dramatic: the entire space is oriented toward the southwest corner, where the light comes in and the view opens out. Rounded corners and an open floor plan increase the sense of flow. Norm noted that although diagonal grids and walls that aren't at right angles have gotten a little trendy now, there's a real reason for them in this case; but even if the only reason was to be different, that would still be okay, because it would force you to see the space in a new way.

He also said placing the walls on an opposing grid was somewhat perverse—a word he meant to use nonjudgmentally, meaning simply to turn away from the intended path. He added that he thinks perverseness has gotten a bad name. "I'm the first one to admire perversity," he said, "even in design. It's perverse to use industrial materials in an interior, for example. I think I'm developing a philosophy of perversity, in almost an aesthetic sense." We talked

about it for a while and concluded that perversity is something loft apartments, high tech, and anal sex all have in common.

The age of the old-style homosexual—lisping, limp-wristed, effeminate, alcoholic, self-loathing, pathetic—has passed. Such people still exist, of course, but they are embarrassing anachronisms, unpleasant reminders of a preliberation past. The new-style gay man who has emerged on Castro Street in San Francisco, on the waterfront in Manhattan, and in other cities around the country is as rugged-looking and self-consciously macho as the old model was swishy and sad. The new gay man is known by his close-cropped hair, bushy mustache, flannel shirt, tight Levi's, construction-worker's boots, and brown leather bombardier's jacket. He lifts weights to produce bulging biceps and eye-popping pecs. He is a disco person, professional and affluent. He maintains an attitude that says power, money, sex.

In New York there are many display racks for this new masculinity. Most can be found along West Street in the Village and Eleventh Avenue in Chelsea, tucked in among the warehouses and meat markets in a stark and grimly romantic night zone along the Hudson. There are bars like the Ramrod and the Eagle's Nest and the Spike; back-room establishments like the Anvil and the Mineshaft, where sometimes a man will climb into a sling so he can anally receive a stranger's fist; abandoned piers that jut into the murk, offering the promise of brief liaisons where burly stevedores once toiled. An air of ruination pervades this district—ruination and decay. The men who cruise these bleak streets in torn denim and leather tend to live in well-decorated apartments and work in sleek midtown skyscrapers; but for the moment they are lonely adventurers, questing with their phalluses in a dirty, broken-down world.

The ultimate shrine, however, is not the Eagle or the Mineshaft or any of these waterfront haunts; the ultimate shrine is a Soho disco called Flamingo. Of course, Flamingo is more than a discotheque. It is a style, an attitude, a ritual, a celebration, a way of life. You have to belong. It's only open on Saturday night, and no one arrives before midnight. People sleep all evening to rest up. They rise at eleven or so, spend a couple of hours getting dressed, maybe drop some MDA or acid. They arrive in fours and sixes and eights—large groups, for Flamingo is not a cruise joint—and by three they have packed the place. What follows is sensational. The music never stops; the dancing goes on and on; the temperature rises higher and higher; amyl nitrate floods the air; and finally, around 5:30 or six, the deejay, who's been carefully modulating the floor action from his glassed-in booth above it all, will build to a crescendo that sends thousands of men into an absolute frenzy of pulsating legs, gyrating hips, and waving fists. After that things begin to cool out, and before long the bicep jungle starts to thin. The sun is rising outside.

There is nothing casual or low-key about any of this. Flamingo is not simply a hangout; it is where these men recharge their psyches, reaffirm their shared identity. "It's almost a tribal thing," Norm explained one evening. "It's celebratory in nature. It has a lot to do with passion—not just sexual passion, but passion for being alive. The closest thing I can think of is that it's a fertility rite. It has to do with being male and being sexual and powerful."

Once every month or so, Flamingo will stage a "party night." Every party night has a theme: there's black night, white night, Western tattoo

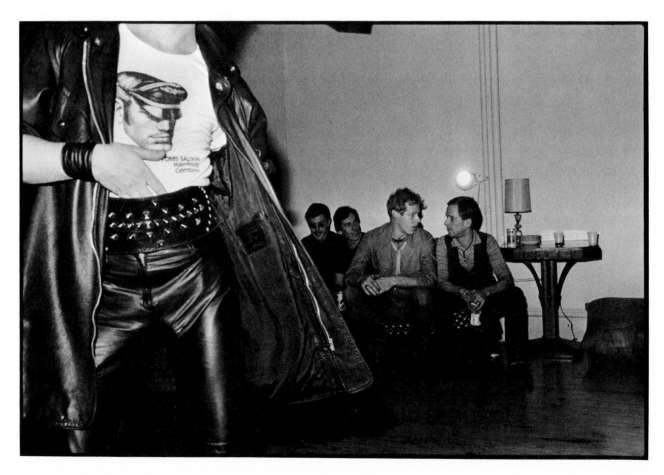

night, and so forth. On black night there will be men in chains near the bar, writhing in chains or groveling under the whip. On Western tattoo night there will be a booth by the door with tattoo artists ready to go to work on anyone game enough to volunteer. Cowboy attire will be *de rigueur* for the evening: this means shirtless revelers waving six-shooters and ten-gallon hats with flashing lights on top while bartenders run about in loincloths and war paint. When Norm went to Kauffman's, New York's leading riding store, to buy spurs for his cowboy boots on the afternoon before Western tattoo night, the saleswoman looked at him funny and said, "What the hell is going on? I must have had a *hundred* men in here today!"

No one engages in sex at Flamingo, although many do so afterward. "That's the best," said Norm. "You have all that energy, you're up, you've spent the whole night with all those men—it's a perfect release. The perfect moment is having danced all night, leaving at six-thirty or seven, fucking for a couple of hours, and then falling into a taxicab and riding home. You're completely drained, there's nothing on your mind, all your needs have been gratified—it's a clear, pure moment of existence only. The moment is best lying back in a Checker cab with your head on the deck, looking up at the buildings. The air is very clear, it's Sunday morning, there's not much traffic, it's very quiet, and all you have to do is go home and go to bed. And you've had an adventure—a night-long adventure."

Flamingo closes every summer because most of its members spend their weekends then on Fire Island. There are two gay resorts on Fire Island—the Pines and Cherry Grove—but the Flamingo crowd can only be found at the Pines. The Grove is full of tacky little houses with too many banners out front and middle-aged queens who slosh around a lot. The Pines is younger, flashier, druggier. Sailing into its harbor—there are no cars on Fire Island, no roads, and no way to get to the place but by boat—one is struck first by the yachts moored at dockside, their pristine whiteness set off perfectly by the pale blue of the water and the crisp green of the woods. Beyond the row of yachts is a miniature commercial district, very neat and done almost entirely in red, white, and blue. Beyond that, scattered among the pines and along the dunes by the Atlantic, is the most extensive collection of stunningly designed beach houses between Malibu and the Hamptons. Gay lawyers live in them, and gay stockbrokers, and gay artists and playwrights and actors and novelists and doctors and dentists and designers and businessmen and models, each one more chic and affluent than the next. Muscled bodies lounge in pools overlooking the ocean while American flags flap overhead. All this has given rise to what Norm called "the most considered social environment imaginable—I mean, it's *elaborate*. You spend hours deciding what you're going to wear, and it's all blue jeans and T-shirts—this faded T-shirt with that color webbed belt and this particular pair of blue jeans and that particular pair of shoes. It's the most amazing thing in the world. It's like the court of Louis XIV with no king.

"There's a great deal of competition," he went on. "The Flamingo/Fire Island Pines axis is all about competition. Everyone is always judging everyone else. It's not an easy life. They all work hard and they work out and they compete with each other on those terms—you know, who can keep it together the

best and the longest. It's odd—nice houses, nice clothes, nice body . . . travel, drugs. . . . But there's also a definite communal feeling at Flamingo or at a party in the Pines, because everyone there is sort of on the same level. They're all pretty much in the same class and pretty much the same age and look pretty much alike. And there's a sense of brotherhood that some of these people talk about. It's a real network of people."

Norm never actually decided to join this network; he just started meeting people he liked. He liked them because they were good-looking and hard-working—driven, in fact. (An obsession with work is one thing that distinguishes these men in New York from their counterparts in San Francisco: gay men with ambition tend to migrate to New York, while those whose ambition is to be gay are more likely to be drawn to the Golden Gate.) Even more, however, he liked them because he admired their sensibility. It's a sensibility he described as "forthright" and "aggressive" and defined (after noting that a sensibility is one of the hardest things in the world to define) as "an appreciation for being male."

The overtly erotic nature of that appreciation is not all that distinguishes this from more conventional masculine sensibilities. It is exceedingly self-conscious, for one thing; and it does not seek to eliminate sensitivity, for another. At the same time, however, it includes a very traditional masculine preoccupation with power and a tendency to link—some would say confuse—power with sex. Norm said, "I don't think you can separate the two. Straight men who have a great deal of power are frequently the most sexually active and the most attractive to women. The whole heterosexual monogamous relationship is all about power—the man is supposed to provide for a wife and X children. And what is more powerful than making a new life—you know, fucking? I think sex is all about power—particularly with straight men. It's only women that try to make it hearts and flowers."

Gay men who connect power with sex invariably have to deal with the problem of dominance—the top-dog question. When it was fairly common for homosexuals to ape heterosexual stereotypes—when there were butches who played the male role and femmes who played the female—this was a simple matter. But now that the butches are interested only in other butches, some new thinking is required. The solution that's been arrived at is to treat dominance as a game, ritualizing it and divesting it of meaning. If manhood becomes a matter of appearance—tight Levis, short hair, jangling keys, macho stance—then it no longer makes any difference (in theory, at least) who penetrates whom. That means the butches can screw each other—and as Norm pointed out, "What could be more powerful? Or sexy?"

A friend of Norm's once jokingly announced that homosexuality was the ultimate form of chauvinism. When Norm asked how that was, the friend said, "Well, it means they're not even good enough to fuck." Norm retells this story with a mixture of mortification and glee—glee at what was said, mortification that it was said out loud. To a certain extent, however, he will admit that it's true. Norm has a couple of women friends, but he's discovered women in business to be "flighty" and "disorganized" and lately he's found himself thinking they should all go back to the kitchen. In general, he prefers the company of other men. But since men have traditionally spent their time

with each other and women with their families, he doesn't see how he lives in an all-male world any more than other men. It's just that he doesn't need women for sex.

Butch gay men have achieved a society in which men can get all their gratification by playing with each other—by drinking with each other, socializing with each other, going to business meetings with each other, dancing with each other, and going to bed with each other. It's also a society in which men can channel their aggressive impulses toward each other into sex instead of violence. "Straight men do tend to be violent," Norm observed with a smile. "I think it's because they don't get fucked enough."

On a worktable in Norm's room is a mounted photograph of a bearded drag queen known as Ruth Truth. The photograph, which was taken in the vicinity of Christopher Street on July 4, 1976, shows Miss Truth dressed in flowing robes and bearing a torch as she rides the fender of a Checker cab like a mobile Statue of Liberty. " 'Give me your poor, your tired, your huddled masses,' " Norm intoned, " 'aching to be free.' Is that it? No, 'yearning to be free.' " Next to that is a series of mounted snapshots of Norm and his family. The most striking shows Norm and his younger brother Fred standing on either side of their father. The two teen-age boys are tall and blond and strikingly handsome in that clean-cut Florida surfer way. The father looked gray and indistinct and was obscured by a shadow whose source could not be seen.

Norm reached into a file cabinet under the worktable and pulled out a postwar wedding photo. Standing in front of the church were his mother, a delightfully frivolous-looking brunette of nineteen, and his father, broad-shouldered and blond but with a sternness that's disconcerting in an eighteen-year-old about to be showered with rice. "Oh, that's just the Rathweg look," said Norm. "They're real good people, just a little too rigid." Norm's father grew up in Dayton, Ohio. He played football, baseball, and basketball in high school and was a star at all three. After high school he played baseball semipro and raced cars, motorbikes, and planes while working as an auto mechanic. Norm's mother worked part-time as a hairdresser.

Norm's father was an enterprising young man who owned two bars and his own wrecking service and body-and-fender repair shop by the time he was the age Norm is now. Then he had an accident he never quite recovered from. He'd parked his wrecker on an incline just above a semitrailer, and as he was walking between the two the wrecker's brakes suddenly gave way, pinning him helplessly between the bumpers. His legs were no match for the steel; when his rescuers finally freed him they found one leg broken, the other leg crushed. He was laid up in bed for months, and by the time he was able to walk again he'd lost his business and begun to drink.

Norm's mother had to return to work full-time to support the family. His father went back to work when he was able to, but he hated working for other people and it seemed like all the initiative had been pinched out of him. After a while they moved from Ohio to Florida because he liked it better there, but that didn't help and neither did his periodic attempts to quit drinking; his problem only got worse. Increasingly he slipped into a life of chronic depression and insensible rages. The last five years of his existence he chased Bourbon

with beer from the moment he gained consciousness to the moment he passed out again. Norm thinks he wanted to drink himself to death. Eventually, he succeeded.

Norm was tall for his age and never very athletic. By the age of twelve he was drawing floor plans of houses and elevations of castles. He was also reading a lot and playing with Erector sets. His brother Fred was the athletic one, but even he was never as athletic as their father would have liked. Fred and Norm fought constantly as children; Norm thinks it was because Fred was always trying to catch up. Their mother says Fred even started walking six months earlier than most babies. She used to read aloud to Norm when he was growing up and was always pleased that he was bright; they were close, in a stand-offish way. Fred was closer to their father.

Norm and Fred went to parochial school in Ohio (the Rathwegs are a good German family and devoutly Catholic), but there weren't any where they lived in Florida and they had to go to public school. Norm had trouble adjusting—partly because they moved several times the first couple of years, partly because he was so much more well-behaved than the other kids that his teachers adored him. (He was used to Catholic discipline.) He didn't have many friends and he wasn't any good at sports, but he did spend hours in the library reading everything he could find. He picked up *The New Yorker* because he liked its design. He started reading the *Paris Review* because it had an interview with Jack Kerouac and Allen Ginsberg and he was interested in the Beats. He read books about religion. Then he started reading about sex.

Norm was twelve when the priests told the boys in catechism class about the mortal sin of masturbation. They said you'd burn in hell if you did it. Norm did not wish to burn in hell. He was terrified. He'd been doing it constantly for a year without even knowing what it was. He tried to stop, but he couldn't for more than a couple of days. He lived in fear of dying in a car crash before he could get to confession—although when he did go to confession, the priest just sounded bored and told him to say twenty Hail Marys. Then he began to realize he was attracted to other males. He was thirteen when that happened.

It wasn't that Norm didn't like girls; in fact, he'd reached his first orgasm fantasizing about the girl he'd just taken to a Valentine's Day dance. It was just that he liked men better. Within a couple of years he was sure he was "queer." There were times he wished he wasn't; times he thought he was the only one; times he was going to remain celibate for the rest of his life; times he was going to make it with an awful lot of girls. He did date a lot, but it seemed like a tiresome affair and he always wondered what people saw in it. So when he was fifteen, he began having sex with men. His folks had settled in Cocoa Beach by then, just south of Cape Canaveral, and he spent his summers lying around the beach getting people to buy him beer. He was hitchhiking along Route A1A one day when he discovered you could get more than a ride. Over the next few years he was picked up by several young men who made passes at him. He'd take them to the woods behind his house and close his eyes while they went down on him. Then one day he reciprocated. He suffered terrible guilt afterward. He also enjoyed it.

The first high school kid he met who was the same way was a boy who transferred from Seattle his senior year. Norm fell in love. They never did any-

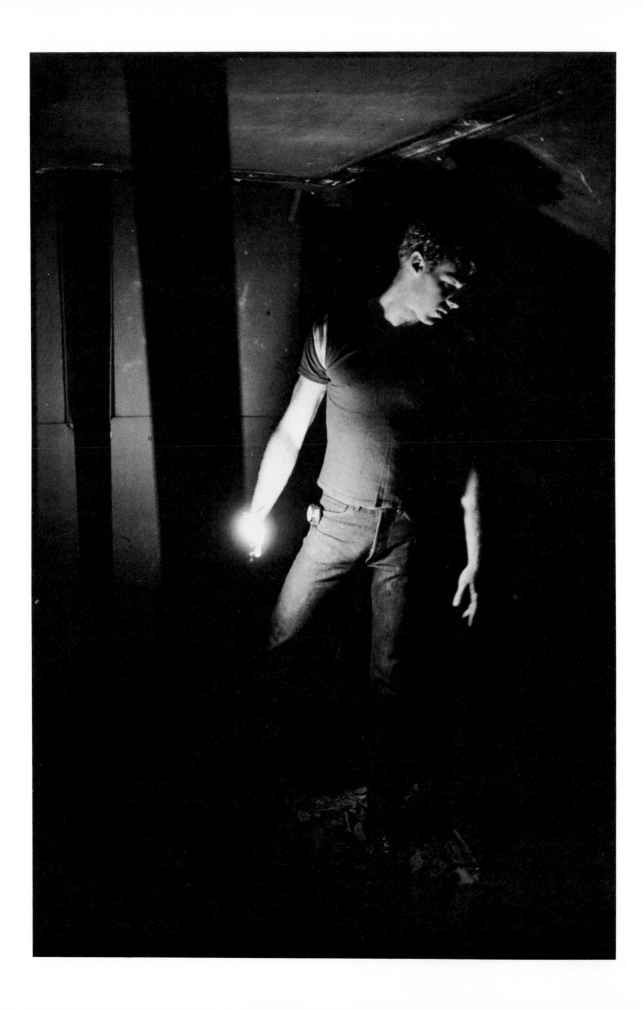

thing sexually, but they did become best friends, and after graduation Norm even returned to Seattle with him. It was during his year in Seattle that he began to deal with his situation—to accept it, to exorcise the guilt, to figure out how to live his life. There were no role models then, no patterns to follow. ("It's an amazing thing," he said when he told me all this. "You really have to make a life. If you're straight, everyone expects you to get married and have children and you have all these things to fall into. But when you're gay, and when you're gay in 1968 and '69, you sort of have to pull it together yourself—and that's taken years.") Norm eventually parted company with the boy he'd gone to Seattle with and moved in with a lesbian. They were good friends and they almost went to bed together—but they didn't, because she thought penises were hideous and ugly and couldn't imagine why any woman would want them poking her. Meanwhile, Norm was going to gay bars and having an affair with a black dancer—his first serious sexual relationship with another male. He returned to Cocoa Beach when his draft board ordered him to report for his physical. He didn't want to go into the Army because he was against the Vietnam War, so he decided to tell them he was gay. Nobody believed him until in desperation he screamed, "Go ahead, draft me! Put me in the Army! I'll fuck men!" He was standing in his underwear at the time. It was the most frightening thing he'd ever done in his life.

After that, Norm moved into a nine-room house with eight other kids and started putting himself through community college part-time. The only gay men he knew around Cocoa Beach were effeminate, alcoholic, and not particularly attractive, so he subsumed his homosexuality in the communal ethic. He had a steady girl and a wide circle of friends; they were free spirits, with long hair and a sense of infinite possibilities. A new world was dawning, and they were going to make it happen. The sixties were not yet over.

Fred was in the commune too, until he moved to Atlanta and started going to night law school. Then he joined the Army because of its educational benefits. He became an MP. Norm, meanwhile, had transferred first to the University of Florida in Gainesville and then to Florida State in Tallahassee, dropping his girl friend (she wanted to get married) and taking a male lover along the way. He worked construction during the summer and supported himself during the school year by waiting tables at the Tallahassee Hilton— waiting tables and watching porkchop legislators get pickled on double Jack Daniels for lunch. He cut his wavy blond hair because he got a summer roofing job and the Florida sun was too hot to keep it long. (Now he keeps it short because it gets too pretty otherwise.) He started lifting weights after reading *Sun and Steel*, Yukio Mishima's philosophical treatise on body building. Mishima, the homosexual novelist who transformed himself from a bookish weakling to a model of manly strength before committing hara-kiri, wrote of learning "the language of the flesh" through acquaintance with sunlight, fresh air, and that metal whose properties of hardness and strength can be transferred to human muscle. Norm needed an intellectual justification to perfect his body; Mishima gave it to him.

After graduation, Norm considered his job option and decided to move to New York. He had a friend from New York whose parents had retired to Cocoa Beach, and this friend had invited him to spend a month on Fire Is-

land; it was the best offer he had. He went home to put a new roof on his par-
ents' house before leaving. Then he went to Tampa for the weekend to visit a
friend from college. While he was gone, his father died. The immediate cause
was a stroke, but it was complicated by high blood pressure, malnutrition, cir-
rhosis of the liver, and other like factors. He was forty-six. Only Fred was truly
surprised; he'd been in Korea for two years and returned "pissing red, white,
and blue," as Norm put it. Fred and Norm fought for a week while Norm
took care of the funeral arrangements. Then Norm left for New York.

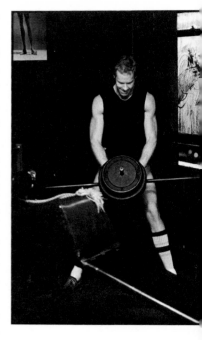

I asked if he felt anger toward his father. He said, "No, I don't think so,
not anymore. Not since he died. I had a great deal of anger earlier, but when
he really started to fall apart I don't think I had any anger left in me. I sort of
realized it really wasn't his fault, that alcoholism really is a disease and after a
certain point you really don't have any control over it. I'm sure there's a lot of
subconscious resentment, you know, unreasoning resentment somewhere in my
make-up, childish resentment. We talk about it in therapy sometimes. But I
feel sorry for my dad. I *really* feel sorry for my dad. I felt sorry for him when
he died.

"I cried at my father's funeral. At the viewing. The most barbaric—can
you imagine? The *viewing!* Do you know what a viewing is? In the funeral
home, with an open casket, when they have open house for people to come in
and look at the corpse? I cried then, in the little mourning room that was shut
off from the viewing room but had one-way glass. It was perfectly designed for
the bereaved to weep unseen. I cried then, and I cried because he'd lost the
last ten years of his life. I cried because it was an awful way to have lived—
that overtaken by a drug. My major feeling was one of loss. Not my loss, be-
cause I hadn't had a father for years, but his loss. Here, let me show you a
photograph. He was very handsome, you know."

On his first day in New York, Norm was taken by his friend to an abandoned
pier on West Street. The pier has burned down since, but then—in 1975—it
was a favored summer gathering place of homosexual men who wished to sun-
bathe nude and indulge in casual sex. It was an immense and dramatic space,
the size of a football field with a roof forty feet above and shafts of sunlight
streaking in through clerestory windows near the top. Norm found it quiet and
hot and quite beautiful in its ruined way. His friend wanted him to see the
view from a particular vantage point. It was Norm's first glimpse of the Statue
of Liberty.

The next day, Norm returned alone and had sex with a man who seemed
familiar. He couldn't place him, but as they were walking away together he re-
alized they'd had sex two years before in Tallahassee. After his visit to Fire Is-
land, he looked the man up again. They had a brief affair, and then he intro-
duced Norm to his ex-lover, who was Louis Nelson. It wasn't long before
Louis and Norm started going to the movies together and spending the night
together and walking through the Village holding hands. Then Norm moved
into Louis' apartment, and finally Louis gave him a brown leather bom-
bardier's jacket—Norm calls them "gay minks"—for his birthday. That's the
date they celebrate as their anniversary.

Louis is a quiet, introverted man who is nine years older than Norm. The
son of a lawyer, he grew up in Beaumont, Texas, where he went to school

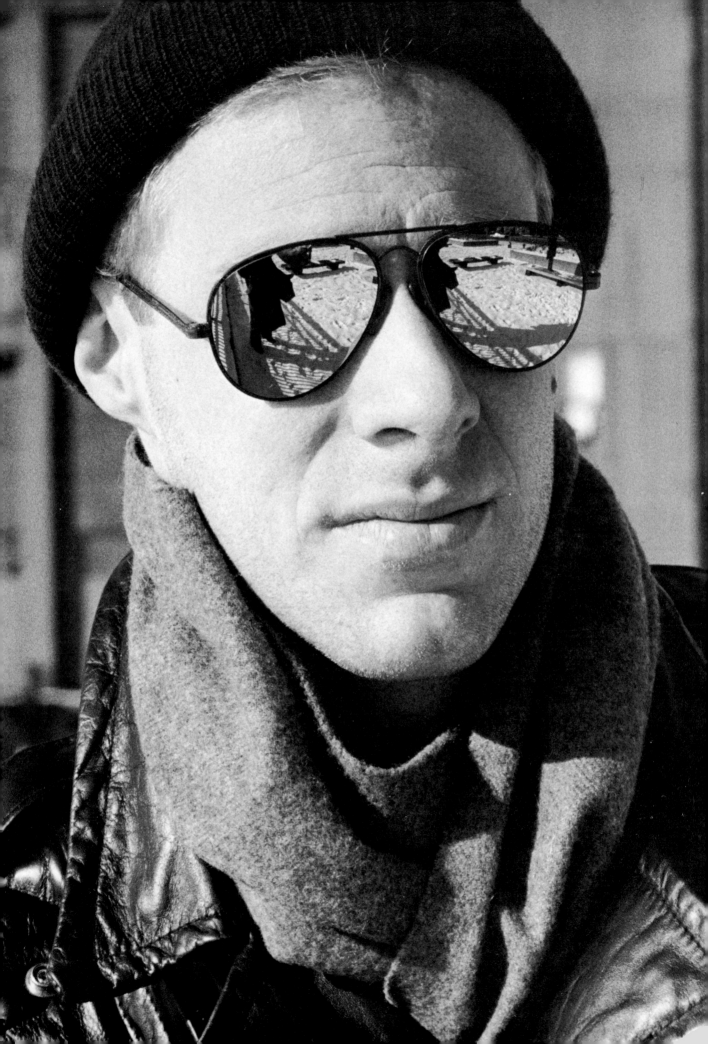

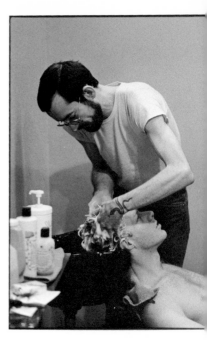

with Johnny Winter, and was educated in Austin, where he studied chemistry, Russian, and French and was about to start piano when he ran out of money. He first came to New York in 1964, when he was twenty-four years old, and he moved back and forth several times before finally settling in the city in 1971. During one of his stints in Austin he joined a *Hair*-like theatrical production called *Now the Revolution* which Joseph Papp (who'd sold *Hair* to Michael Butler and watched it gross a fortune on Broadway) brought to New York and produced at the Public Theater as *Stomp*. The next time he moved to New York he rented an apartment in Colonnade Row, having met the owner while performing across the street, and began working for Robert Wilson, the playwright. He went on to become a fiscal analyst for the New York State Council on the Arts and then his landlord's comptroller.

When he met Norm, Louis had been an alcoholic for seven years. His drinking had begun in the midst of a bad love affair and had progressed from three or four beers a day to a dozen beers a day to boilermakers chased with cognac to Valium and beer for lunch. By then he was having blackouts and waking up with the shakes. Norm recognized his problem instantly and didn't hesitate to point it out. Louis started going to Alcoholics Anonymous, and a couple of months afterward—about the time of Norm's birthday, in fact—he stopped drinking entirely.

These days, Louis likens his relationship with Norm to the marriage of the squirrel and the grasshopper. Louis works hard and stores his nuts while Norm —this is Louis' view, anyway—sings and plays. Louis and Norm really are opposites in most respects—short and tall, small and large, dark and blond, withdrawn and social, romantic and unsentimental; aside from a shared passion for intellectual pursuits (Louis' current hobby is microbiology; Norm's reading list of the past few months includes biographies of Napoleon and Marie Antoinette, *The Rise and Fall of the Third Reich,* three newly published gay novels, and Gibbon's *Decline and Fall of the Roman Empire*), virtually the only thing they have in common is their sex. Yet they get along well—so well that their only dependable source of disagreement is how to furnish the apartment—and are quite sweet with each other. Of course, this doesn't mean they're monogamous, especially as far as Norm is concerned. "Being young and gay in New York is a fuckfest," he said, "and if I weren't able to take advantage of that, I could see that I would start resenting it."

Norm doesn't care to hang out in bars—too much standing around drinking—and he never went to a gay bathhouse until the St. Marks opened and gave him a free pass, but he does enjoy a fling at the Mineshaft occasionally. He likes playing around with other men. "It's like you're twelve or thirteen again," he said, "only now you're doing it for real—with real men." Unfortunately, it got a little too real when he contracted a case of amoebic dysentery that hung around for three months. Now he's gotten more careful: no more foursomes or fivesomes. Anyway, so much of the novelty has worn off that he seldom goes at all, unless somebody comes in from out of town and wants a guided tour. He prefers having steady tricks he can call up and see for the night. Generally, these tricks end up becoming friends; in fact, that's how most of his friendships began. He's certainly not looking for a lover. He doesn't think about permanence in connection with his relationship with Louis, but in

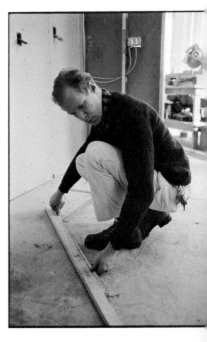

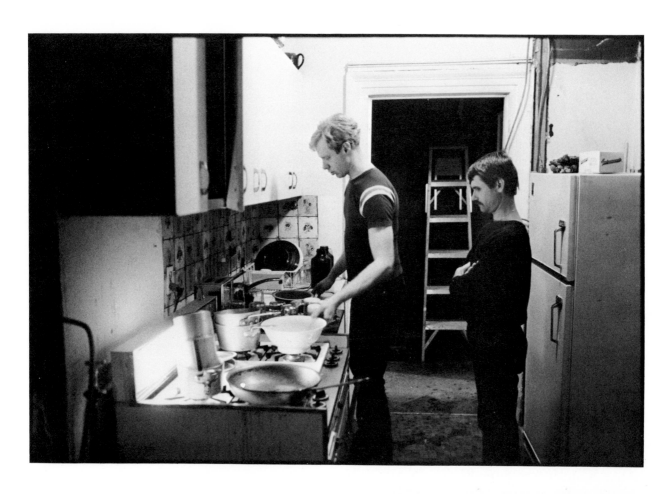

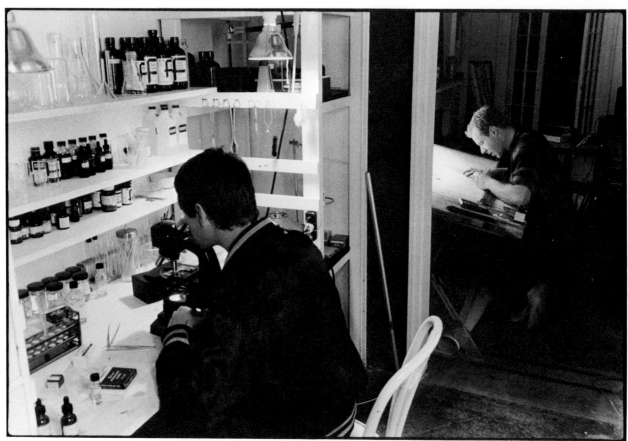

many ways—mutual investments, for example—he behaves as if they'd taken a vow. "I do have a commitment to Louis," he said. "It's not a formal one that I've ever thought about or even thought out to myself—but I can't think of anyone else I'd rather live with."

After Louis, the most important man in Norm's life is probably the one they work for, Bruce Mailman. Norm said there's only one way to describe Bruce, and that's as "an operator—a real estate operator, an operator in general." It was Bruce who showed Norm how to deal with contractors and supply houses, who made him see how exciting business could be, who helped lead him to the realization that work is more important than the easy hedonism of gay life in New York—not just more important, but more interesting, and more lasting. As a result, Norm is not the grasshopper he once was. He still goes dancing, but these days it bothers him that a night at Flamingo or Studio 54 means two days lost from work (one day to rest up for the experience and another to recover from it), and that means he doesn't do it as often as he used to. He gets more out of lifting weights. "If I'm in good shape, I feel more powerful," he said, "and that carries over into everything I do."

Norm admires discipline. He's never as disciplined as he'd like to be: he never gets enough work done, or gets to the gym enough, or works himself as hard as he thinks he should. Ideally, he begins his day about nine with a cup of coffee and a half-hour jog around Washington Square, works until six or seven (doing business on the phone, going to the bank, visiting showrooms, checking on his construction projects), lifts weights at the gym for two hours, eats dinner, and then spends the rest of the evening reading or having sex or drawing straight lines at his drafting table. Sometimes, working at home, he finds it difficult to get started; but he doesn't like it when that happens. He's a driven man—"driven to accomplish things," as he put it.

His brother, Fred, is driven too, but in a different way. Fred lives in Tampa now, working as a computer programer and going to school part-time while supporting the wife he brought back from Korea and their newborn baby. In a couple of months he'll be commissioned a lieutenant in the Army Reserve. Fred is driven to raise a family, to meet his responsibilities as a provider, to do it right. He's still uneasy about Norm's homosexuality, but they get along much better than they did before. "I admire my brother a lot," Norm said. "Because he's set in what he wants to do and he's trying to do it the best way he can. And certainly what he's trying to do is admirable. I mean, raising a family is—well, it has to be done." He smiled wryly.

I asked if he missed the idea of marriage and family for himself.

"God, no!" he said. "I couldn't *imagine* having a family. I couldn't imagine having children. I couldn't imagine having to put up with babies and buying them clothes every year and doctor bills and training them and raising them—I mean I couldn't *imagine*. No, I get down on my knees every morning and thank God I was born gay. It's true! I really like being gay. I really like being a homosexual man in New York at the age of twenty-eight in 1979. I like men, I like playing with men, I like being with men, I like being a man, I like being in New York right now. I like the challenge, I like the style, I like the discipline, I like the possibilities, I like the other men. They're all doing something interesting and they're all challenged and they're all driven, and I really like that. Yeah . . . I like the style of the life."

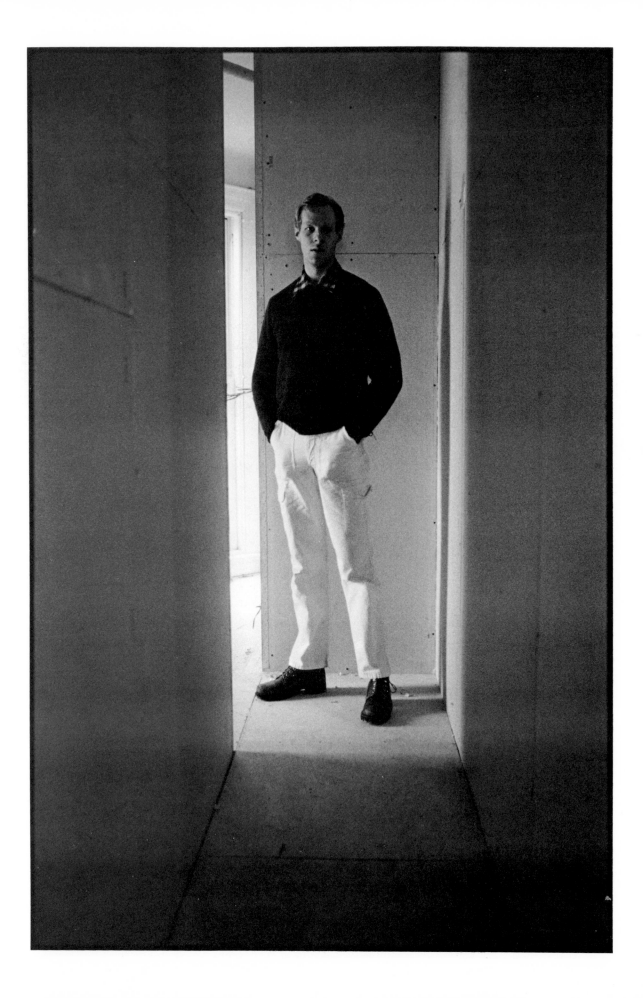

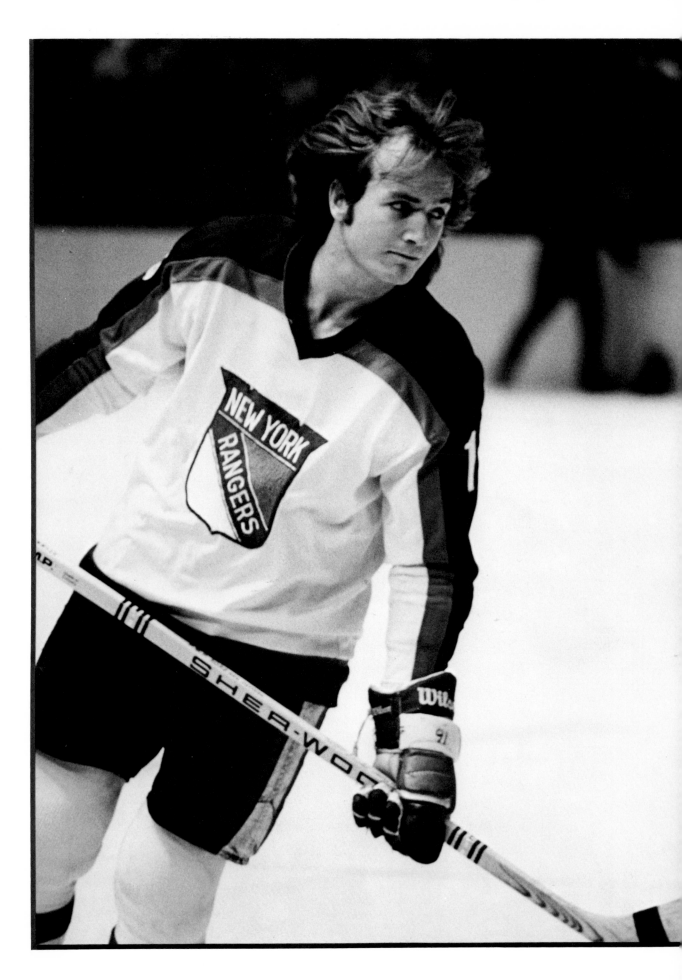

Pat Hickey

The N. Y. Rangers
New York, New York

Thursday, October 12, was the day of the first game of the season. At 8:45 A.M., his customary time, Pat Hickey walked out of his apartment—2 br hi-rise w/ tiny balc. on Manhattan's swinging East Side—rode downstairs in an elevator crowded with well-groomed young executives on their way to work, and got a pat on the back from the uniformed doorman on his way out the door. The morning was suitably autumnal, with crisp blue skies and a bright, warming sun. Hickey strode down the street—a narrow street lined with Victorian brownstones and tall trees, their leaves just now yellowing—and headed for the Soup-Burg around the corner for a coffee-to-go. Then he walked up Lexington to the garage, getting more encouragement along the way. "Atta boy, Hickey, you gonna do it to 'em tonight!" Doormen, neighbors, fans: all were eager to help spur him into action. "You live here three years," he explained, "you get to know everybody. Like Andy of Mayberry, I guess." He gave a brusque laugh, half-flattered, half-impatient. "Mostly they want tickets."

The garage attendant delivered the jeep and told him to be sure and have a good game. The jeep was a Renegade, dark green with a canvas top and zip-up plastic windows, purchased in Toronto when Hickey had first turned pro. Hickey jumped inside and headed toward Central Park. The suspension system turned every pothole into a spasm; he rode them like a cowboy on horseback, sipping scalding coffee all the while. At the Hudson Parkway he turned upriver and headed for Westchester County, exiting onto a wooded country road that leads to the Westchester Ice Skating Center. He arrived at 9:35, in plenty of time to suit up for the ten o'clock practice.

It would be brief; practice always was, the day of a game. Just enough to loosen everyone up. Training camp had begun less than a month before: four hours a day on the ice, two in the morning and two after lunch, plus eleven exhibition games, coming after a five-month layoff. "It's the games that knock the shit out of you," Hickey said on the way up. "Two weeks before you were lying on the beach, and all of a sudden there's some guy trying to cut you down with his stick or rub you into the boards. And you go, 'Oh no, what do you want to do that to me for?' But deep down, you know it's got to be done."

The season promised to be a good one for Hickey and the Rangers alike. It would be Hickey's sixth as a pro, his fourth in New York and the NHL. His first two seasons with the Rangers had been spent mostly on the bench, but during the second he'd somehow managed to score twenty-three goals, a fact that did not go unnoticed by either fans or reporters. (The coach was a little slower.) The following season he played every game, scoring forty goals and becoming, at twenty-four, one of the few bright spots on a team that finished

at the bottom of the division for the third straight year. This season he would be playing left wing on an offensive line whose other two members were "the Swedes"—Ulf Nilsson and Anders Hedberg, two Swedish nationals the Rangers had lured from Winnipeg for $1,200,000 each, payable over a two-year period. There was a new coach as well: Fred Shero, who'd led the Philadelphia Flyers to two Stanley Cups in seven years. The Flyers had beaten the Rangers four times the previous season; they'd be facing each other again tonight. The last time the two teams had met, in a preseason game, they'd gotten into a brawl that had emptied both benches and moved from one end of the ice to the other and back again before it could be broken up.

Shero was waiting at center ice when his players skated out of the dressing room. He let them fool around for a couple of minutes, taking random shots at the net, then blew the whistle and started drilling. There was a puck-handling drill, a passing drill, a shooting drill, another shooting drill, and a skating drill. No one was idle for more than a minute or two at a stretch; Shero kept them hustling across the ice, governing every move with sharp bursts on the whistle around his neck. It was 10:45 when the first players began to head back to the dressing room.

Hickey gave a ride back to town to Mike McEwen, the young defenseman who is his best friend on the team and something of his protégé. They were silent most of the trip. "I got a feeling tonight's game is gonna be pretty intense," Hickey remarked at one point.

"Yeah, we couldn't play Vancouver or somebody," Mike replied. "We're gettin' right down to the nitty-gritty, right off the bat."

Hickey exhaled. "It's the only way to go, really. I'm higher than a kite already."

Hockey moves fast. It's a game in which friction between player and surface has been all but eliminated by a sheet of ice not much more than half an inch thick. The players, whizzing around the rink on sharpened steel blades, approach speeds of thirty miles per hour in their pursuit of a frozen rubber disk one inch high and three inches across. Fighting for control with their long, supple sticks (no two of which are exactly alike), they nurse the puck along, sling it into the air, hack away at it through a forest of other men's sticks, hack at other men who have it. Seldom do any of them maintain possession much longer than ten seconds, or any team much longer than twenty. And it's not unusual, when one of them does get off a shot, for the puck to hurtle goalward at speeds exceeding a hundred miles an hour.

The ice makes hockey graceful as well as fast. It encourages fluid motion, produces a game played on smoothly intersecting curves. But because it is *so* fast, the curves shift second by second, sometimes flashing so quickly they suggest a panicked scramble, other times arcing out into long strides across the ice. And while the motion itself is fluid, the figures that produce it look like stubby-limbed tubs. Unswathed, many hockey players resemble ballet dancers in their remarkable muscle definition and graceful silhouette, but they play a game in which their natural contours must be hidden beneath quilted shoulder pads, plastic elbow guards, padded leather gloves, plastic shin guards, fiber thigh guards, thermal underwear, padded pants, and specially reinforced stockings and jerseys. Moreover, they play it while squatting down, their heels jacked up

on sharply raked skates, their hindquarters protruding behind them to power every stride and turn. On the ice, therefore, they look like people who have been redesigned for hockey.

Hockey players also look like men who are trying extra hard to keep warm. The cold gives the game a brittle feel, an extra edge of tension that's magnified by its characteristic sounds: the sharp crack of wood striking puck, the dull thwack of puck striking goalie's pads, the swoosh of steel cutting across ice, the thud of bodies slamming into boards. Moreover, the cold adds a subtle coloration to the violence that is one of the sport's special treats. There is an undeniable *frisson* to the sight of blood on ice—the spilling of the very warm onto the very cold, perhaps—that not even football can match.

There are many, players and fans alike, who regard hockey as an organized excuse for violence. It is difficult to justify an opposing view. The game seems modeled on a wolf-pack philosophy of life: five free-skating men teamed against a frozen universe that measures eighty-five by two hundred feet, has rounded corners, is circumscribed by a wall approximately three and a half feet high, and must be shared with five other free-skating men who have the same idea in mind. That idea is always the same: to gain possession of the puck and send it into the other fellows' goal—a target six feet wide and four feet high, behind which is stretched a white nylon net and before which is stationed a sixth man, masked and carrying the biggest stick of all—while simultaneously defending one's own goal from penetration. (The appropriate word: in *Power on Ice,* his 1977 autobiography, New York Islanders defenseman Denis Potvin wrote frankly of "the orgasmic delight of seeing the black hunk of vulcanized rubber penetrate the deepest recesses of the net.") And while only the forward positions are set up to score, an assist in hockey is counted the same as a goal when each player's points-per-game tally is figured. It pays to help your buddy get off his shot.

It pays, too, to stop the other fellow. Each player has to decide for himself just how far to go. Hockey has rules, but they are made to be broken. The casual fan often fails to understand that slashing an opponent across his padded thighs or tripping him with a stick between the shins, while guaranteed to draw time in the penalty box if detected by the ref, are harmless maneuvers accepted by other players as ways of getting out of a tight spot or sending a warning to a pushy opponent. The idea is not to get caught—although it's not so terrible if you do: the image of the sulking offender being banished to the icy penalty box, there to sit out his time while his teammates struggle shorthanded, is one of the heroic clichés of the game. But there's a place in hockey for genuinely rough play, too.

Some of the sport's greatest practitioners, in fact, have been notoriously violent men. Eddie Shore, the Boston bruiser who virtually invented modern defensive play in the 1920s, ended the career of a Toronto player named Ace Bailey in 1933 by ramming him from the rear and sending him twisted across the ice; two skull operations were required to save Bailey's life. Stan Mikita of the Chicago Black Hawks, one of the roughest men in hockey in the early sixties, once fired the puck at an opponent who'd speared him earlier in the game. Shore once shot it at a referee who'd given him a penalty he didn't like. Rocket Richard, the Montreal forward who in 1945 became the first NHL player to score fifty goals in a single season, attacked an official in a hotel lobby

for the same reason. In 1955, Richard was suspended for the balance of the season for breaking his stick across the back of a Bruin who'd high-sticked him and for then punching a referee in the face. Canadiens fans retaliated for the suspension at the next home game by hurling garbage onto the ice, assaulting the president of the NHL, and rioting in the streets for seven hours. Finally Richard himself had to get on the airwaves to calm things down.

Despite all this, only one man has actually died from injuries suffered during an NHL game. That was Bill Masterton, center for the Minnesota North Stars, who succumbed to brain damage after colliding with two Oakland players and landing on the back of his head in January 1968. Masterton might be skating today if he'd been wearing a helmet, but until recent years headgear was scorned as somehow unmanly by players and fans alike. It's still not standard. Face masks didn't even become standard for goalies until after 1959, when Montreal's Jacques Plante put one on after his upper lip was split to the nose by a flying puck. Plante had had his mask designed after getting his nose and both cheekbones smashed a couple of years before, but his coach had dissuaded him from wearing it for fear it might limit his vision. Even other hockey players consider goalies a little weird in their gluttony for punishment, however. The others at least get the satisfying crunch of human contact, not to mention the excitement of high speed and shooting; the goaltender plays a waiting game in which the only reward is getting hit by the black rubber missile. But all hockey veterans have traditionally worn their stitched and battered faces—Eddie Shore's featured a five-times broken jaw, a twelve-times broken nose, and one badly stitched-on ear—as hard-won prizes, the sort of living trophies only a life of professional ferocity can earn. And as for blows to the head—well, they haven't stopped every player. In 1952, during the seventh game of the Stanley Cup semifinals, Rocket Richard was carried off the ice with a gaping hole in his forehead and a crazily twisted neck. Emerging still dazed late in the third period and learning the score was tied one–one, he leaped to the ice, picked up the puck behind the Canadiens' blue line, carried it all the way to the enemy goal, and fired the winning shot. Afterward, when Canadiens' president Donat Raymon pounded him appreciatively on the back, the hero responded by going into convulsions. As Gordie Howe, the Detroit wingman who was one of the Rocket's great rivals, once remarked, "It's a man's game."

It's also a never-ending struggle between the good guys and the goons, between clean, classy playing and the brutal kind that leads to fisticuffs and worse. The tension between these two games, and the different philosophies they embody, is the source of much of hockey's excitement. Can intelligence and skill repel brute force? Or will brute force smear them all over the ice? The lesson of hockey history is inconclusive, but it does show that clean playing has a chance of paying off—providing it's backed up by a willingness to kill when necessary. In a game in which every man's mettle is constantly probed, the ability to fight is as basic as the ability to skate. That's why so many hockey players train with punching bags.

Pat Hickey is one of the good guys. He does not play a particularly physical game, but he doesn't get pushed around either. That's because he has a reputation for delivering knockout punches as needed. His first fight in the NHL—a crucial moment in any player's career—ended with his opponent

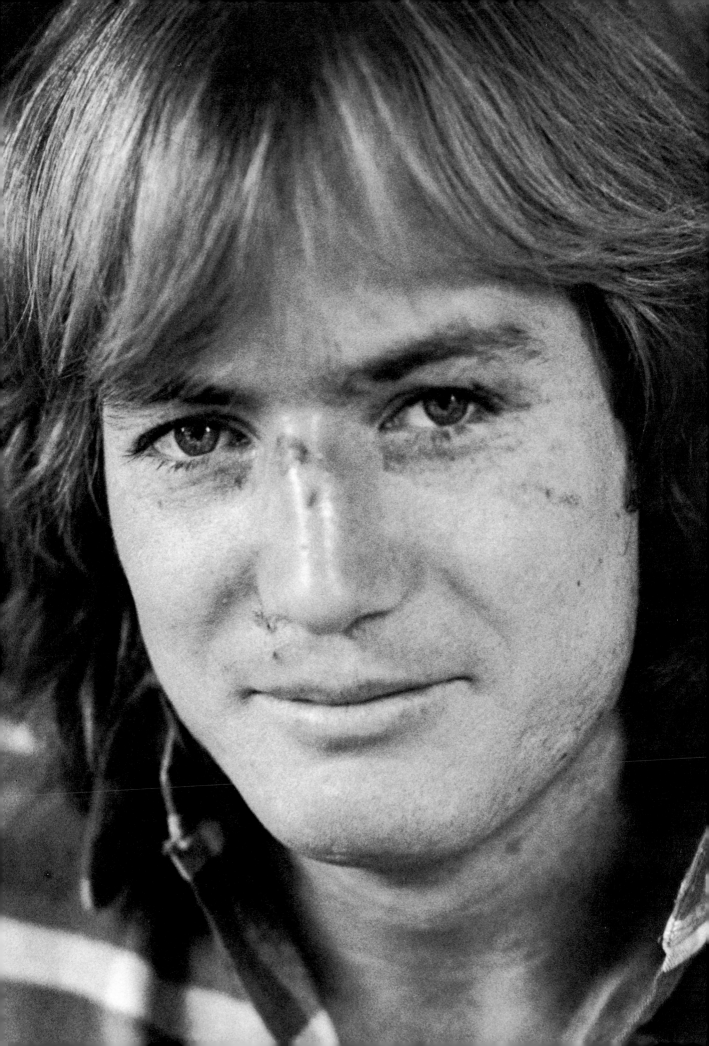

lying flat on the ice. So did his second. Since then he's had little opportunity to demonstrate his ability. "I never fight without a reason," he told me.

"I think I play the game fairly; I play it by the book. It's just kind of a philosophy I have. A lot of guys will use their sticks to intimidate you; I never will, because I figure I can intimidate a guy by being one-on-one. I'll never hit a guy with his back turned; I'll skate around him and take him out of the play. I wouldn't run him into the boards like you see a lot of guys do, because you're only asking for the same thing back. This is getting down to God's law: 'Do unto others as you would have them do unto you.' I think it works. It's worked for me.

"I don't think about injuries, but I know I'm gonna get mine sooner or later. When you start thinking about injuries, that's when you get hurt. When it happens it happens, and you take it from there. That's my philosophy. It's got to be, it's the only philosophy you can take. Because you never know—you just turn the wrong way and the puck hits you in the eye and you've lost your eye. A guy is checking the puck and he misses and snaps your jugular vein or something—who knows? What if some guy hacks your ankles and breaks your ankles? But you don't think about that. And if he does it, you just get up on your broken ankles and do what you've got to do, and then you feel it later.

"There's the old saying—like a team player, a dedicated guy, it's the seventh game of the Stanley Cup, the score is tied, it's the last minute of play, and they get a breakaway. Your goalie's out of the net and you're back there. Would you put your head in front of the puck? If it was going into the net? Sitting here, it sounds stupid—but if I was there, I would."

We were sitting at a table in Cronies, a fashionably designed little bar on Second Avenue that's run by two pals of Pat's. Hickey was downing his fifth or sixth beer of the afternoon. Some people think hockey players shouldn't drink beer, but they do it anyway. Fred Shero, the Rangers' new coach, takes the permissive approach. He'd even announced plans for a locker-room lounge in which players could gather in private to drink beer and smoke cigarettes. The Rangers' two previous coaches, John Ferguson and his stand-in, Jean-Guy Talbot, had both been sticklers for the little rules; but they were gone now, fired for failing to win. Their philosophy had resulted in the spectacle of men pushing forty, grizzled veterans on the verge of retirement, sitting in the back of the team bus sneaking cigarettes like schoolboys.

Hickey sighed. "Sports to me is like—I dunno. I consider myself kind of mature, have for a long time. But now I'm twenty-five, and to be sitting with intelligent people, I figure, who feel compelled if I light up to say, 'Hey, you're not supposed to smoke!'—that's so stupid. I consider myself a good person, I'm religious, I follow all the legal laws and spiritual laws and the whole bit to the best of my ability"—he chuckled slightly here—"but I'm not pure, I'm not all good and wholesome. That is that athlete-type thing—athletes don't drink, athletes don't smoke, athletes don't stay up after eleven o'clock. . . . They praise us for our barbarianism, and then they give us shit because we don't have a three-piece suit on."

Still, Hickey likes the athlete's life. He likes the clean sheets in the hotel rooms and the big meals in restaurants and the opportunity to travel and live

in New York and get paid a phenomenal amount for playing a game he loves. He likes having five months off in the spring and summer; he likes the daily routine during the season—up at eight, at practice by ten, sweating like a hog for two hours and then ready to face the day with a shower, a shit, and a shave ("the three s's," he calls them). He likes being in top shape physically. "I'm proud of it," he said. "Like with my father and my brother, they admire me for it."

"You amaze yourself, too. Like, 'Oh wow, I did that? I went that fast? I ran into the boards and any normal guy would be dead, but I brushed myself off and I'm fine?'

"You know how a guy put it to me once? He said, 'The thing about sports is, I watch you do something and I see your muscles flex, and when I was growing up, I always thought maybe I could do that.' So when he sees Ron Guidry pitch a no-hitter, he thinks, *If I was in the same position today, I coulda done the same thing.* Through us, everybody gets gratified."

Said Mike McEwen, "It's kinda like we're the epitome of—"

"What they could be."

"Yeah, and what the human body can accomplish." McEwen had two glasses of milk in front of him.

Hickey started skating at four; McEwen was that age when he joined his first hockey team. But McEwen grew up in a little town 350 miles north of Sault Ste. Marie, the product of a family he calls "hockey *nuts.*" Hickey's father had played in his youth for the Washington Senators, a farm team in the Bruins organization; but when he was twenty-two, he suffered a knee injury and was never able to play again. He raised his family in Brantford, Ontario, a small city between Buffalo and Detroit, working as a purchasing agent for a company that manufactures schoolbuses and coaching a number of peewee and bantam teams over the years. "We were born hockey players," said Pat.

Pat joined his first organized hockey team in fourth grade; it was the school team at Our Lady of Fatima. His father had never pressured him to play, but he did seem relieved the day Pat came home and announced he wanted to join. Before long he was playing for the Terrace Hill Bruins, a neighborhood peewee team, and then he was selected for the Brantford All-Stars. He played peewee, bantam, and midget with the All-Stars, and at fifteen he went Junior B with the Brantford Majors. His hero during this period was Bob Pulford of the Toronto Maple Leafs. Pulford, a center, was a good penalty killer and a consistent player who always got twenty goals a season. Pat played center then too, and he tried to be consistent, just like Pulford. His father drove him to and from games whenever he could, and when he couldn't he'd always be waiting for him at home. They'd sit up for a while, drinking tea, eating peanut butter on toast, talking about the game. Then, as he was tucking Pat into bed, his dad would say something like, "By the way, when you go down on the goaltender, why don't you shift your head a little? Make him go that way, and then shoot the other way."

Pat's mother never cared much for hockey. She's an artist—she'd studied for a year in New York before getting married—and an interior decorator. She painted portraits of Pat when he was growing up, carefully highlighting his muscles; she let him know his body was beautiful and had come from inside of

her. She liked what hockey made of him; she simply couldn't understand why anyone would want to take so much punishment. She pointed out that there were millions of kids playing hockey in Canada and no reason to think he'd be one of the handful to make it. She did not, however, try to talk him or his younger brother Greg out of playing. Instead, twice a week she would drive their two older sisters to drum-corps practice while their dad took the boys to a hockey game.

Pat went Junior A at sixteen, an eighth-round draft choice for the Hamilton Red Wings. He moved to Hamilton, a steel town twenty miles away on the shores of Lake Ontario, and played there three years. It was there that he acquired the nickname "Hitch," after hitchhiking across Canada one summer. Despite a schedule that included eleven-hour bus rides on school nights, he managed to finish high school and take a year at McMaster University. Everybody else on the team dropped out; Pat, however, was thinking about becoming a dentist.

He didn't begin to think seriously about a professional hockey career until his last year junior. What decided him was the money. Playing with the Red Wings, he'd been getting room and board and $15 a week. He'd figured on getting drafted, signing a three-year contract for $25,000 a year, and playing for a farm team in Dallas or Providence or some place while finishing college. But it was 1973 when he became eligible; the NHL was at war with the upstart World Hockey League, and big bucks were being hurled in the direction of promising young players. Hickey looked good, even though his team came in at the bottom of the league. The Rangers drafted him in the second round as a right winger (he'd started playing right wing in Hamilton) with an offer of $150,000 for three years. The WHA's Toronto Toros offered him $200,000, $75,000 of it up front. If he joined the Rangers, he'd probably have to start on their farm team in New Haven. He went with the Toros.

The money was ridiculous; there was nothing to do but goof on it. The Saturday after he got it, he woke the whole family at eight o'clock. His dad made bacon and eggs, and then Pat started passing out money. He gave his parents $5,000. He gave Theo and Karen, his two sisters, a $1,000 bill each, and he gave Greg the keys to his Mustang. Then he gave another $250 each to Greg and his sisters and $500 each to his mother and dad, with the stipulation that everyone get dressed, get in the car, drive to the new mall in Hamilton, and spend it by five o'clock. Later he got his lawyer and his accountant to show him how to handle what was left.

Hickey did well during his two years in Toronto. He scored sixty-one goals for the Toros. He set his mother up with her own interior-decorating business. He bought a town house and started importing antiques from England for her clients. He learned public speaking after vomiting from nervousness at his first engagement, addressing some Cub Scouts at a church breakfast. He broke up with his girl friend. "I'd thought about marriage," he said, "but she decided that with all the glory and fame and riches of the WHA, it should be then. Little did she know that I didn't know what the hell I was doing. I'd just stepped into something that looks secure to every Canadian, but I went through the stage of asking myself questions. Do I want to do this for the next ten or fifteen years? Do I want to bring her into something I don't have a clue about? I mean all of a sudden, instead of $10 in my pocket I've

got $1,000 in my pocket. Like, what do I do? You know what I did? I went to Nassau with four guys from the team. I mean, I wasn't going to take $1,000 and go with her. We didn't even have that much of a sexual relationship. We were in love and all that shit, but we never understood what anything was."

At the end of two years, the Rangers came back with another offer, this time for $150,000 per year. Hickey packed his bags and settled in Long Beach, Long Island, a decaying resort town where both the Rangers and the suburban Islanders held their practice sessions. Then he started trying to figure out what was going on. He had made the big time, he could see that. All the guys around him seemed very impressed with themselves. They told him he was in line for big cars, big blondes, and big cigars. One guy used to come up to him and say, "You're only *that* far away." Hickey would ask, "From what?" but the guy would just grin and say, "Keep working—you're only *that* far away."

The first year was a washout. He broke a rib twenty games into the season, missed the next ten, and then had to try to get back in shape. Emile Francis, the popular general manager and coach who'd bid for him, had been replaced by a new general manager/coach, John Ferguson. Ferguson had his own ideas about what to do with the team, and they didn't involve young Francis boys. Hickey didn't play much, even after his rib healed. One night in December he sat up with Greg, who's two years younger and had just started playing for the New Haven Nighthawks, and talked about quitting. "I was *that* far away," he told me. "I coulda done it.

"And Greg—he was like, 'Am I headed for what you went through in your last two years? And what if I don't even do as good as you do and still have to put up with his bullshit?' You know, the things coming down on you, the pressure put on you, the violence of it, the politics of it—the guy doesn't like the length of my hair so I don't play. Come on! I'm a man! If I play good, let me play! If I play good and I got long hair and I don't play, I can't understand that. I can't cope with it, I can't deal with it, and I don't want to spend any time with it—so I'll quit. You reach that point.

"If I had've quit—I would never have quit. I had to justify what I was going through by actually quitting in my mind, saying 'What if I did quit?' And I could handle it. The same way as if I broke my leg today and it didn't heal and I could never play again. I wouldn't be shattered. I'd miss it, but I'd, you know—I'd work just as hard as I work at hockey on something else."

Hickey's second year looked more promising at first. He'd been befriended by star forward Rod Gilbert, the Rangers' all-time scoring leader, and was beginning to settle in. Acting on Rod's advice, he moved to Manhattan, the borough he'd been scared to drive his jeep into at first. ("There's so many people, I'm afraid I might get lost in the shuffle," he'd told *Newsday*.) Instead of switching linemates and positions, he was made left wing on the starting line—with Phil Esposito and Ken Hodge, who'd been two thirds of the hottest line in hockey when they were playing for the Bruins a couple of years before. He got ten points in his first ten games, the same as Esposito and only three less than Hodge. But for the next four games the line went stale. Finally, with the Rangers in last place after a five-to-seven loss to Washington, Ferguson made a trade to Minnesota for thirty-two-year-old Bill Goldsworthy. Hickey spent most of the next thirty games on the bench. "He's been a big disap-

pointment," Ferguson told the New York *Post*. "I expected a lot more of him, but he just hasn't worked out."

Still, Ferguson didn't bench Hickey completely. He sent him out for three or four shifts a game—about five minutes of play. He used him as right wing, center, left wing, in dozens of combinations, never giving him a chance to develop in any one spot. Still, in a seven-to-two loss to Buffalo, he played four shifts and scored both goals. Two nights later, at Chicago, with the Rangers losing three to nothing in the second period, he got a breakaway and shot the puck. It bounced off the goalie's pads, but a linemate poked it in. Another goal was scored after he returned to the bench, and then he was sent out again. This time his shot was good. Clearly his line was hot—but for the rest of the game, which ended in a three–three tie, it sat on the bench.

Meanwhile, the Chicago Black Hawks (now coached by Bob Pulford) were trying to trade for Hickey, but Ferguson wouldn't deal. Clearly Pat was getting the raw end. It was Rod who kept him from mouthing off to the press. He said there were enough people in hockey doing that; do something else. What Pat ended up doing, because he played so well and never got any breaks and didn't complain, was gaining the sympathy of reporters and fans. He got to be known as the poor kid who tries hard but never gets enough ice time.

It all paid off in a home game against Atlanta. With the Rangers losing one to nothing in the second period, Ferguson sent him out to kill a penalty. When he scored a short-handed goal, the fans went crazy. A few minutes later they started chanting for his return to the ice. No one had chanted "We want Hickey!" in Madison Square Garden before. Fergy sent him out for a face-off, and everybody cheered. But then Fergy changed his mind—so he pulled Hickey back and sent out Hodge. The fans booed. Ferguson took notice. After that, Hickey played a lot.

The Rangers only won twenty-nine of their eighty games that season, but Hickey ended up with twenty-three goals—enough to make him the fourth highest scorer on the team and earn him a spot in the record book as the second player in NHL history to break the twenty-goal mark while scoring from all three forward positions. He'd also gotten a standing ovation for laying out a Cleveland player with one punch and a reputation as the team culture nut— the guy who collects antiques and takes in some opera and maybe an occasional ballet on the side. ("Bullshit," he said. "I'm in New York, I've got some money, I wanna go to the ballet. Thousands of people go; I just want to see what it's all about.") The next season, Ferguson's new coach, Jean-Guy Talbot, shuttled him constantly from one line to another but gave him plenty of time on the ice, so that by early November he was leading the team in goals. McEwen said he'd told Pat in training camp he was the hottest guy in the club. "And he kept it up the whole year," McEwen added. "Consistency, that's the whole thing. Once you prove you can do it, it's how many times."

By April, chants of "We want Hitch!" had become standard at the Garden. The last game of the season was played at home against the Black Hawks. Hickey went into it with thirty-nine goals. Before it started, he skated out to accept the Boucher Trophy, which is awarded by the Rangers Fan Club to "the most popular Ranger on and off the ice," while his teammates stood at the blue line and tapped their sticks. Then, with seven minutes to go in the third period, he scored his fortieth goal. As a roar filled the arena, he retrieved

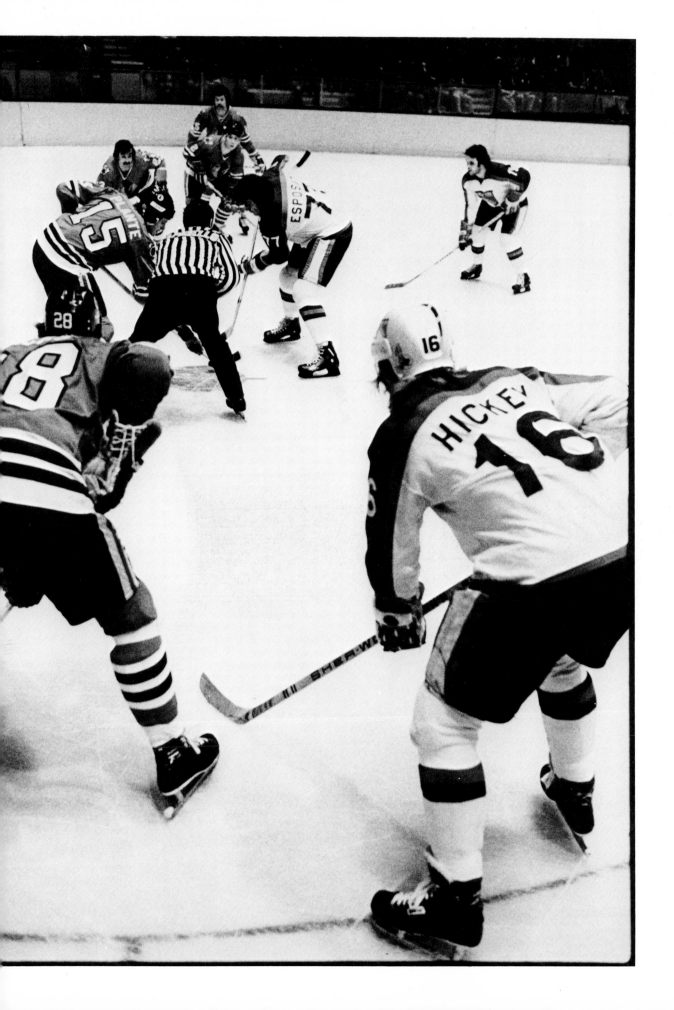

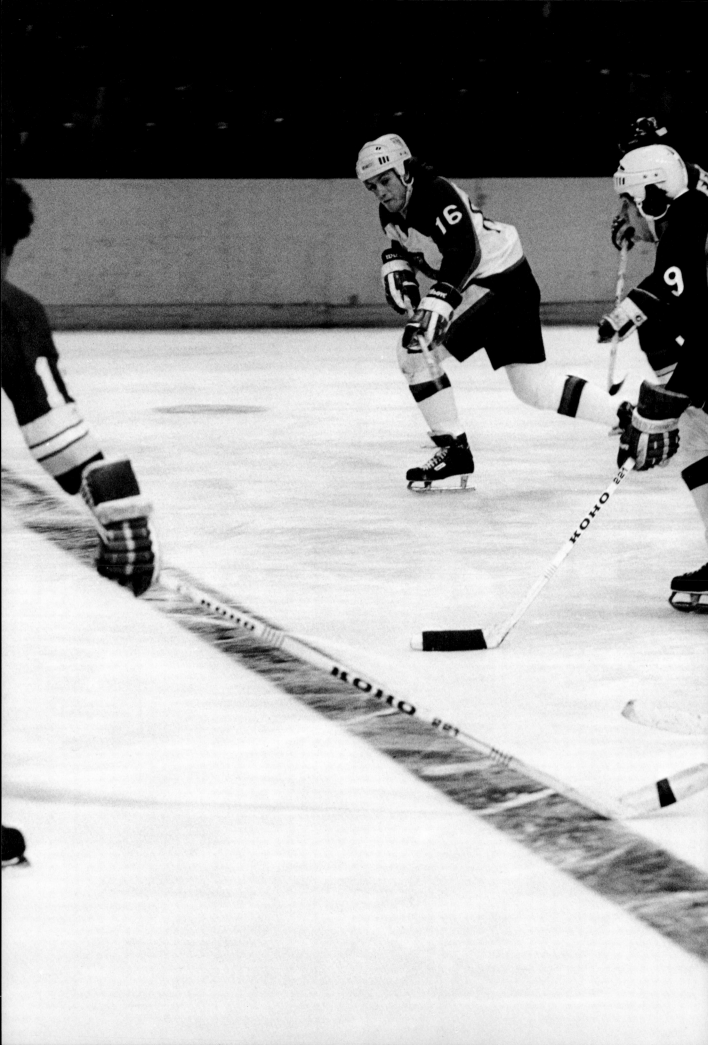

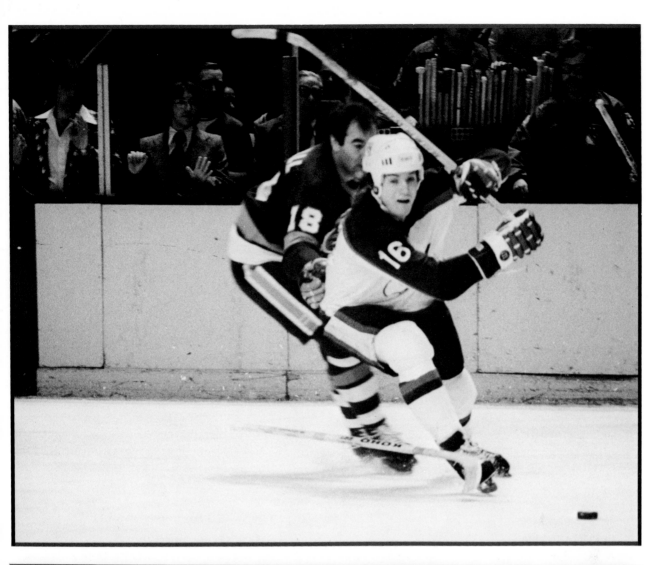

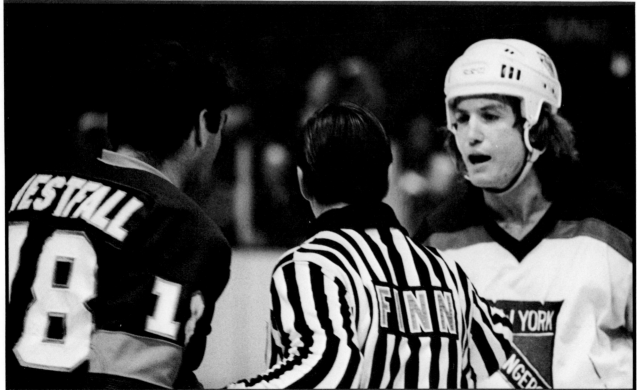

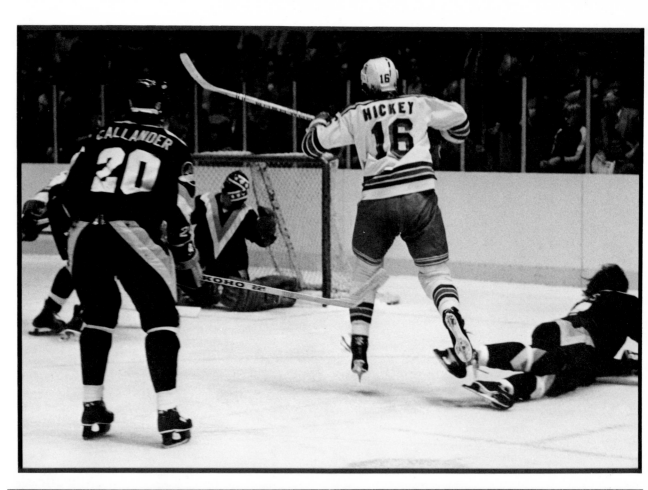
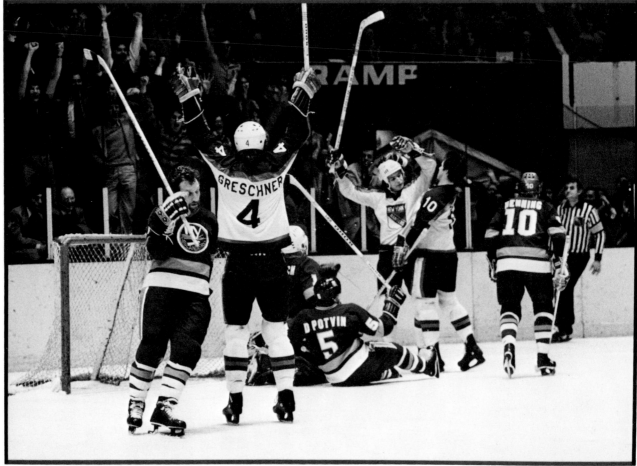

the puck from the net and tossed it to his father in the stands. The Rangers won, three to two. Hickey's was the winning goal.

Despite their dismal record (thirty-seven losses, thirteen ties, thirty wins), the Rangers managed to qualify for a wild-card berth in the Stanley Cup play-offs. Buffalo bounced them out in three games. Hickey took off for Prague, where he won a bronze medal for Team Canada in the World Cup competition with a spectacular goal in the last minute and a half of play. After a triumphant return to Toronto, he arrived in New York to negotiate a new contract. He was in a good position to do so. Because his original deal with the Rangers did not call for the standard option year after his contract had expired, he was a free agent. Moreover, the signing of the Swedes at $600,000 per year—about six times the NHL average, more than triple the salary of top scorer Guy Lafleur of Montreal—had been followed by an announcement by Fred Shero, who himself had just signed a five-year, million-dollar contract, that any Ranger who wished to revise his salary upward was welcome to come in for a chat. The Rangers are owned by Madison Square Garden, and that by Gulf + Western; and Gulf + Western, it seemed, had determined to spend its way out of the bottom, lest sluggishness on the ice lead to sluggishness at the box office.

Hickey signed a four-year contract for an undisclosed sum. Then, instead of making what would have been his third consecutive transcontinental summer camping trip, he went to Canada to sell his town house and buy a summer place in Ontario's Cottage Country. He found one near Huntsville on the Lake of Bays, two hours north of Toronto by jeep or by car. "I wanted to have a foundation, I guess," he said. "I kinda forced myself to do it, because I gotta settle down."

As the 1978–79 season approached, speculation among Rangers fans centered upon the performance of the Swedes and their ability to spend the sensational salary they were receiving. Fred Shero, however, was the man who really bore watching. For years the Rangers had been known as a fat-cat team—a collection of overpaid slugabeds personified by their captain, Phil Esposito, an aging superstar who was drawing the highest salary in the league and still missed few opportunities to complain. Under Ferguson and Talbot, the Rangers frequently looked confused and demoralized on the ice. Newspaper reports told of tension between player and coach, between player and player. What was lacking was the will to win.

Shero's job was to transform this collection of habituated losers into a winning combination. One of the first things he did was move the practice sessions from Long Beach to Westchester County. Then he suggested that players move into town and get to know some of their fans. (The Rangers had a reputation as the only team in the league that played all its games on the road.) During training camp he introduced the idea that a hockey team is like a family. One day he pulled four of the leading players aside and told them the best teams were actually self-coached, told them they could really help him out by giving tips to the less experienced guys. Then, when Esposito resigned as team captain two days before the opening game, he appointed a twenty-two-year-old defenseman to replace him.

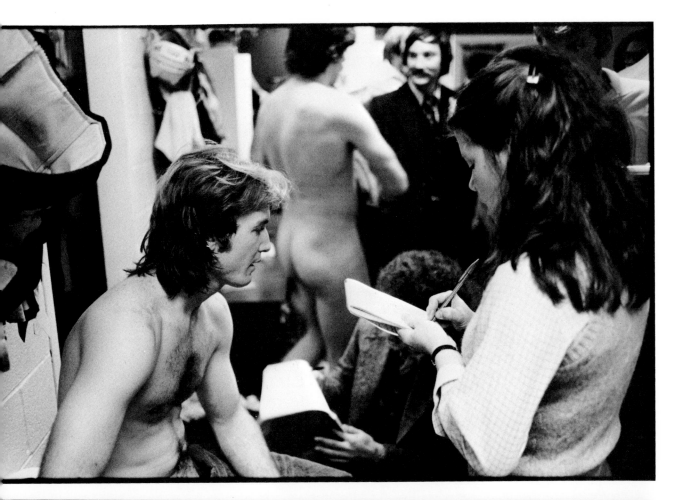

The change within the team was dramatic. "Last year it was a dicta-torship," said Hickey. " 'I know all. I will take care of everything.' And in the meantime, everybody was playing his own game."

"A good coach creates an atmosphere," explained McEwen. "He's the central figure among twenty guys, so they're all kinda looking toward him."

What if they don't respect him?

"Somebody asked me that the other day," Hickey replied. "It's not a lack of respect, it's a lack of faith. After a guy tells you, 'This is how we're gonna win,' and you keep losing, finally you say to yourself, 'Hey, boss, it's not that I don't respect you, but I'm not gonna do that. You keep losing.' "

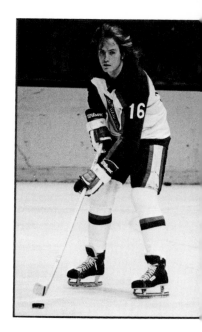

It's the coach's responsibility to fit every player into the team. Each player has his strong points. Some are great passers; they can lay the puck on a teammate's stick every time. Others are masters of the smooth play. They can skate in with the puck and maneuver everyone into position for the perfect shot. Hickey's game is hustling. He knows how to grab the puck and go with it. "Everything he does is almost impromptu," said McEwen. "Like he'll come up on a defenseman and make five different moves on him really fast and then go right through him. He's not a smoothie. You can't give him the puck at our blue line and expect him to be smooth all the way to the other team's blue line. He just skates up the middle and looks to see who he can give it to—like 'What'll I do now?' But he's a winger; that's not his game. His game is forechecking, basically. And when he gets the puck, he always goes."

Hickey's a loner, an attack man, always looking to score. He believes in forcing the play, works on the principle that the forceful player controls the game. When he sees an enemy defenseman coming for him he hits first, knock-ing the guy off balance and spinning off his body. His shot's no better than av-erage for speed, accuracy, and hardness, but he can get it away fast. His best shot is an extraordinary backhand he puts his whole body behind; the sudden shift in position invariably throws goaltenders off. Whenever he shoots, he aims to miss the goalie. That generally gives him a target area about three inches wide. He professes to uncertainty about how he hits it. "Nine times outta ten," he said, "it's just deke left, deke right, close your eyes, and shoot."

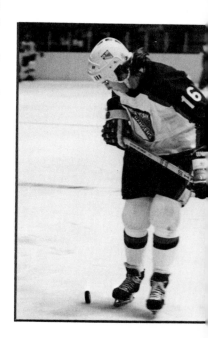

The secret of his game is no secret at all, just endless repetition. "You do it every day, you do it for years," he said, "and when it arises in a game you know it's going to happen before it happens, so you know what to do. It's moving fast, you're moving all the time, but you've gone through it already, you've been there, so you're always one step ahead. As that puck's coming to me, I'm already thinking about how I'm gonna be one-on-one with the goal-tender, or how I'm gonna have to pass it to this guy who's gonna be, or should be, over there. You see that he's checked, you can't give it to him, so you're al-ready thinking about another play. It's no big deal, you don't get frustrated. When you get frustrated is when all your options are covered. Then it's up to you; you gotta go all the way."

On the ice, Hickey's demonstrated willingness to go all the way has in the long run enabled him to fit in quite nicely, coach or no coach. Off the ice, he doesn't try all that hard. He values the closeness that comes from being on a team, but at the same time he gets a little bugged at some of the things his teammates do—at the way they annoy businessmen on airplanes with their

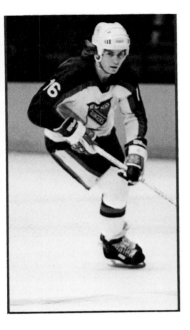

peanut fights, for instance, or fill the air with stale jokes on bus trips. ("How's your coffee this morning?" "Tastes like mud—fresh ground."). He is tired of having jeeps pointed out to him on the highway because he happens to drive one. He doesn't even speak with a sense of loss when he tells how he managed to escape "the shave"—that ritual of hockey manhood which calls for a gang of teammates to jump an unsuspecting rookie, pull down his pants, shave his genitals, and then pour alcohol onto the cuts.

Hickey is sensitive about the image of the professional hockey player. "I gotta admit," he said, "there's a lot of dummies in hockey. There's a lot of dummies in sports. Someone who spends ten years trying to be an NHL hockey player, when he does it it's a three-piece suit, a cigar, and a *Reader's Digest* and he's got the world by the balls. I can't knock anybody for attaining that and then being happy with it. It's great. I'd love to be able to justify saying to myself, 'I'm completely satisfied, I don't have to go any further'—but I can't. I don't *want* to be that hockey player, because I think that's holding yourself back. I want to get out and meet people."

One of Hickey's biggest regrets is his lack of formal education. Still, it's not as if he hasn't learned from his game. "It's *War and Peace*," he said. "I mean, bashing brains with a guy, hating him for the simple reason that his team beat our team tonight. But afterwards, if you run into him on the street, it's 'Man, did you ever pull a nice play there!' And that just goes on everywhere. In business it goes on. Politics is the same way. I wanna write a song called 'Analogy.'

"When I got to pro, I didn't have a *clue* what it was all about. Hell, I'd never eaten in a fancy restaurant before, except on Sundays with my grandmother and my mother and father if it was their anniversary or something. But in hockey it becomes a job. If you're on the road, you have to eat in fancy restaurants. If you eat in a diner or something, you never know what kind of food you're going to get, so you always have to go to a good restaurant because you have to eat good. So that means eight, ten dollars on a good meal, which also means a bottle of wine and a lotta gab with the guys and good times. It's never-ending.

"It's a crazy life. I love it. I'm at the stage now where I'm analyzing it—'What am I doing? What, actually, am I doing?'—and I'm finding it fun. I like hockey. I like its challenges, I like what it's done to me, I like the opportunities it's given me. I like the excitement of it. The one-on-one competition—that's where the excitement comes in. And the skating's gotta be—the movement of it—it's thrilling. Just to do a twirl at thirty miles an hour and land on your feet—and to be able to do it without even thinking about it. The one-on-one thing comes in your head. You know what you want to do, and you can do it or you can't—that's the one-on-one. The names or numbers or anything don't matter. If you're in the way, I've got to knock you over or get by you for the play to progress.

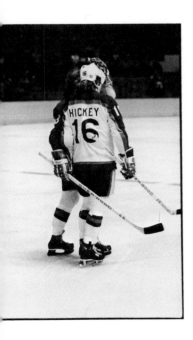

"Hockey's put a great pressure on me to succeed. Like the year before last, I scored twenty-three goals. Okay, twenty-three goals, I'm happy, I'm making a good salary. I could play for fifteen years at that salary and score twenty-five a year and be a good hockey player. But all of a sudden last year I scored forty, my contract's up, to get more money you have to do better. Every

year you have to do better. It's not them—they don't care if you screw up or if you do better. But for me, I have to do better.

"But at the same time, you know, I'd like to be a hermit. I know for a fact that there's going to be one day when as far as hockey goes I'm just going to call it quits, because there are other things in life I want. I want a home. I want a community. I want to build my own little world. But I still want knowledge of what else is out there, and this is the perfect way. I'm experiencing a *lot* right now, meeting so-called stars, so-called intellectuals, so-called people-that-are-an-influence-on-society. In New York, you're influencing the whole world. Yeah, I'm into it now, but I'm not gonna be for the rest of my life. Somewhere along, I'm just gonna be sittin' at home watching the Saturday night hockey game, watching the Wednesday night news on happenings around the world, and I'll just be very happy to think that for a period of time, I was there. I experienced that, I challenged it—and whether I was successful or unsuccessful, that's not going to mean a hill of beans to me."

Hickey's real ambition is to live in a house in the country with a wife, a family, a station wagon, and a dog. "That's what I want," he declared. "All-Canadian."

During his third year with the Rangers—the one in which he scored forty goals—Hickey was something of a playboy. He met Margaux Hemingway. He dated Miss U.S.A. He dated some of the top models in New York. He was seen at Regine's and at Studio 54. But after a while, he stopped doing that sort of thing. "Who needs it?" he said. "It's bullshit.

"I could get a date with a lot of people—but I don't want a *date*. A date to me is usually just a lot of money and a lot of time out. You go out with a chick and you want to take her to bed, but in the meantime some other chick is slipping you her phone number. You take her out and you find out she's looking at some other guy and she's gonna screw him after she screws you. Which is *fine,* I guess, but . . ."

Also, he hates disco music.

"Love is the big thing," he continued. "I believe in all that equality stuff, but I also treat a woman like a woman. I respect a woman. I'm a chauvinist, opening the door, lighting their cigarettes; I always think of the woman first. And when I'm with a woman I always play a love trip. I'm a romanticist, and I love her—for the time being. My time limit is usually about a month and a half, two months, for some reason. I don't know, maybe because of my job.

"But I don't treat it as any big deal as far as like women and stuff. I mean, I'm single, and if I'm talking to a stewardess on a plane, or if I'm at a bookshop in an airport and there's a girl there—it's almost like being single is a job. You try and meet the love of your life. Why not? So I continually do it. In sports you get a bad rap sometimes—'You're trying to hustle every pair of legs that comes your way'-type thing. But you're not, really. You're just trying to get by."

(When I asked McEwen what sort of women Hickey likes, he said, "Not some broad who really wants money. A girl who'd rather go on a camping trip and sleep in the snow for a week.")

Hickey believes in procreation as well as love. "That's what we're here for," he said. In fact, however, he's been too busy perfecting his game to find a

woman for either purpose. Even in high school he was too involved with sports to have many girl friends—ironic, since the popularity it gave him with girls was one reason he liked being an athlete. But athletes spend most of their time with other males, and he doesn't mind that either.* When he was a kid, he could never figure out why men belonged to legions and lodges and the like. Then, in Junior A, he realized that if he never made pro he'd join a men's club immediately. He gets "a little bit of security" from his association with other men: the knowledge that they experience the same thoughts and feelings he does, that he's not the only one.

"I associate with men probably better than with women," he admitted. "But I don't think it's because they're men. I think it's because of the female-male relationship—it's either love everlasting or 'Ta-ta, see you later.' "

With men, there is no such pressure. Hickey has considered homosexuality, checked out other men's bodies, but felt no attraction. ("Each to his own," he said.) With men, therefore, a different sort of love is possible, one that calls for comradeship and loyalty rather than sex and romance. A simpler love, perhaps, but no less intense. The model, he said, is in Damon and Pythias.

By no means all of Hickey's buddies are athletes. There's an old school friend in Toronto, for instance, and the guys who run Cronies in New York. But two that he's closest to are Rod Gilbert and Mike McEwen. It was Gilbert who helped him get through those first two years with the Rangers. The second year—when Pat ended up scoring twenty-three goals while sitting on the bench—Rod was honored with a "Rod Gilbert Night" at Madison Square Garden. The year after that, when Hickey was scoring his forty goals, Rod was brutally "retired" on Thanksgiving Day by John Ferguson, who noted publicly that there were younger players who could do his job, and given a front-office job as "assistant to the president." Following his own advice to Hickey, Gilbert —who had worn the Ranger jersey for seventeen seasons, longer than anyone else in the club—turned down offers to play elsewhere and set about his assigned task of boosting team spirit so vigorously that his efforts won praise on the editorial page of the New York *Times*. It was one of those analogies Hickey talked about: a devastating body-check to the soul, followed by that ounce of extra effort it takes to get right back into the play.

Hickey and McEwen met in training camp that second year. It was McEwen's first, and he wasn't even sure if he'd be playing for the Rangers or the New Haven Nighthawks. Hickey noticed him on the ice, though, and he was sure. The fourth day of camp, he and Mike and Greg—it was Greg's first year pro, too, and he did get sent to New Haven—spent a couple of hours drinking beer and playing pinball. McEwen went on to have a great season, setting a record for most goals scored by a defenseman his rookie year. But he and Hickey didn't see much of each other after that until the end of it, when they got drunk together and Hitch said he ought to come check out the city next year. (Pat has a spare bedroom that had been intended for Greg when

* Although he isn't threatened by the presence of female reporters in the locker room: "I think it's great. Women turn me on, and women looking at me turns me on too. But I really don't give a shit if they're looking at me or not. I thought about it at first—*Screw you, you're not going to get a free glance at my cock*—but that's like the male tradition thing, you know, you just don't give it away. When they come into the dressing room I'm sure they're there to do a job anyway."

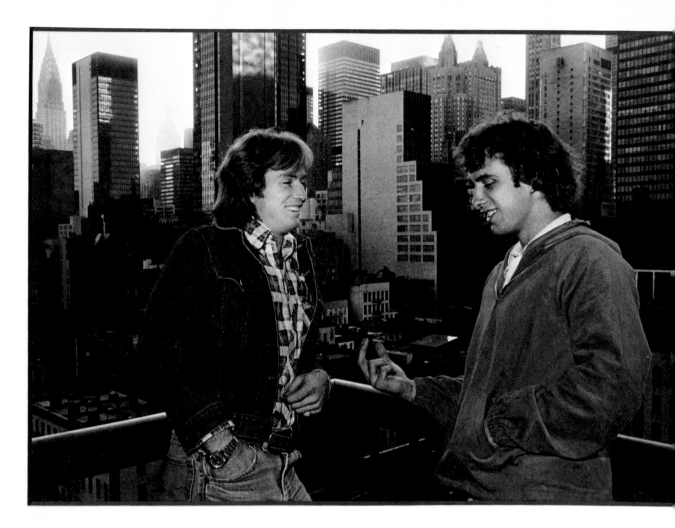

they both thought Greg would be playing for the Rangers.) So the following season, when he found himself inexplicably benched game after game, McEwen remembered the offer of friendship and the implication that he and Hickey were somehow alike. "So I asked him what was going on," Mike said, "because nobody else was talking to me, and he said, 'Don't say anything—be cool—you're just a happy guy, so go out there and work hard.'" And in the months since, Hitch and "Q"—that's the nickname Pat gave him—became best buddies.

"It's a good relationship," Hickey said. "It's kind of a manly challenge-type thing. The little bastard. I'd never played pinball—what are you guys laughing at? 'Cause you think he's a bastard? But he is, he's a cunt!

"So anyway, he challenged me at pinball and I accepted the challenge. And at practice, if we were lined up doing rushes up and down the ice, I'd say, 'C'mon, Q, I'm gonna beat your ass!' And I'd beat him by a stride, and I'd say, 'That little fuck, he's really challenging me, you know?' And then the next thing he'd be beating me. That's why I loved him."

I spoke with Rod Gilbert on the afternoon of the Philadelphia game. Hickey was in bed asleep; it was part of his routine. He eats by one o'clock, then sleeps for two hours before every game. At four or four-thirty he gets up, drinks some tea (Red Rose or Tetley), puts on some rock-'n'-roll with the volume turned up high, and smokes a couple of cigarettes. He tells himself it will calm his nerves, and it calms his nerves. Then he walks to the corner, hails a cab (always a Checker), rides through the park, and walks in the front en-

trance to the Garden. Once inside he grabs a stall in the men's room, sits down, and reads the paper. Then he takes a seat in front of his gear and looks around. He drinks some coffee, smokes some cigarettes, takes his time. Eventually he gets undressed and puts on his long underwear. Then he sits down again and tapes his sticks and gets two glasses of water, one to drink and one for his mouth guard, and maybe talks with the other guys a little. Then he's ready to get dressed. About three minutes after he finishes, the coach will come in to make his little speech. Then they'll all skate out onto the ice.

Rod spoke about the game. "The game is very difficult," he said. "It's like any other expression. If you're a novelist, if you're a professional dancer or a professional singer, you have certain abilities that will carry you to a certain plateau. Then it becomes difficult to separate yourself from the average. To bring yourself up on top, a lot of things have to happen.

"There's a lot of shortcuts to the game that, once you understand them, put you in a different class. You can actually slow down the game. In other words, although you may be doing twenty-five miles an hour, because of the way you've thought about doing certain things you're playing it in slow motion. You know that when the opposition commits themselves or puts themselves out of position, then they can't come back at you. You're thinking about three plays ahead of time, and it becomes easy. It becomes a very slow game once you have this feeling.

"The beauty of the sport, I think, is that in order to be successful, to make the levels, you have to have a certain toughness about you as a kid. You're challenged an awful lot. Whenever you have contact at that speed you're liable to get hit in the mouth a couple of times by accident. But if somebody hits you in the mouth by accident and you take it, then the next time he doesn't do it accidentally. So even if it's an accident, you've got to retaliate.

"Pat doesn't look for violence, he doesn't look for fights, but the game is important enough to him that he will go out of his way to retaliate if attacked. Which is an absolute necessity to be successful, because if you're a good player you're going to get challenged. You can't just be good; you have to be tough, too, to show the other players that you're not just there on a fluke. Sometimes it's unfortunate, I feel, but I didn't make the game.

"Pat was always good with his game, but he needed a little push, I think. He was getting down on himself. He had a feeling that the game wasn't defeating him, it was the judgment of other hockey people. I pointed out that that was easy to handle. When you're not good enough for the game, then you have two fights on your hands. You have to prove yourself to the game and prove yourself to the management. That's difficult. But the game wasn't defeating him, because every time he went out there to play, he was good at it. And the judgment of other people—we knew that would change if he kept a good attitude.

"But the game can easily defeat you at any one time. If you're not confident enough, or if you don't have the help of other people around you, you get lost—especially in the early stages of your career. I went through that my first three years. I had a hard time breaking in and getting all the results I expected. That's what happened to Pat. But he sort of erased all those doubts last year, when he had such a good season. So he's an accomplished hockey player. Now the pressures start."

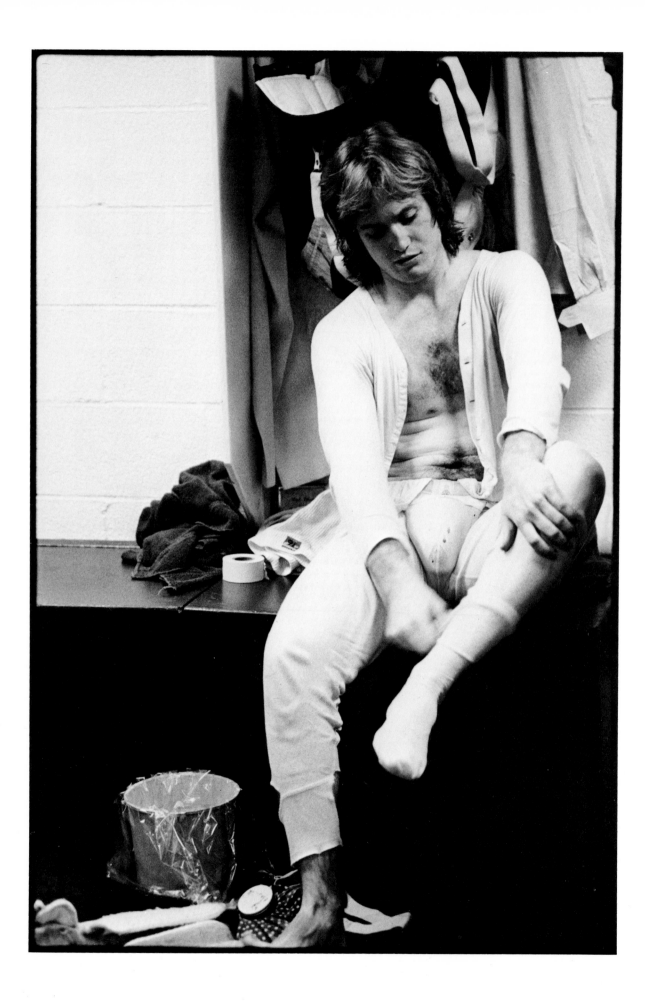

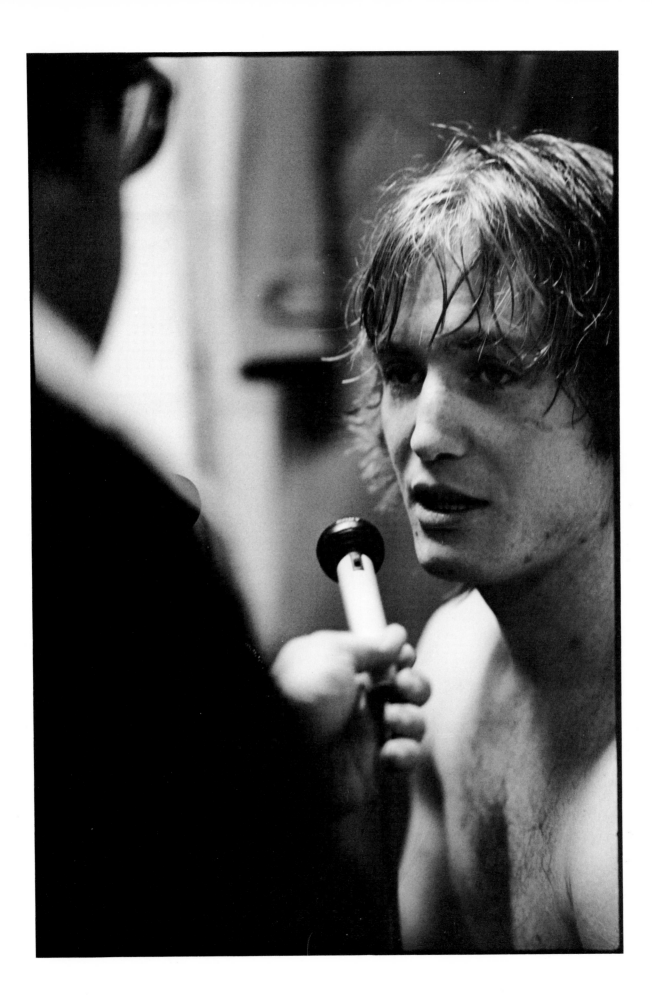

Hickey scored once that evening, midway through the first period, tipping the puck past Philadelphia goaltender Bernie Parent after McEwen had fired a shot his way. The Rangers had a two-man advantage, two Philadelphia defensemen having been sent to the penalty box for tripping and slashing, and twenty-three seconds earlier they'd scored the first goal of the game. Hickey's made it two–zero. Six minutes later, on another power play, McEwen scored a goal of his own. Less than two minutes after that a brawl broke out and three men—Anders Hedberg and two Flyers—had to be escorted to the penalty box. The score was still three–zero when the buzzer sounded.

The second period was a different hockey game. The Rangers, who'd been playing so well that sportswriters compared their first period to the Canadiens the next day, fell apart completely, and the Flyers came back looking for blood. They got it in a pile-up in the Ranger zone eleven minutes into the period, when team captain Bobby Clarke and Ranger counterpart Dave Maloney were banished from the ice for fighting. A cheer rose to the rafters as Maloney skated toward the penalty box. At one point Hickey went hurtling head over heels against the boards, but he landed on his feet and went right on playing.

The score was three–three when the third period began, and for the remaining twenty minutes the two teams fought to a stand-off—literally fought, with their hands on each other's collars almost every time the whistle blew. The Rangers took twelve shots-on-goal to the Flyers' three, but Parent or a post was in the way every time.

Still, there were no glum faces in the New York locker room after it was over. If the Rangers hadn't won the game, they'd at least proved they could win a period—not bad against a team they hadn't beaten in the previous twelve tries. And they hadn't let the Flyers win, either.

"Pat," said a reporter, pointing a microphone at Hickey's still-damp face, "what was your reaction to what happened tonight?"

"Whew!" Hickey exhaled sharply. A huddle of reporters formed around him.

"Three different games, huh?"

"You got a point. We jumped on them in the first, they jumped on us in the second, and the third was—well, the third was played well."

"Did you feel the excitement of the new coach and these two new guys?"

"I felt the excitement of the opening game. It happens every year. The excitement of the new coach and all that, that's over with."

"Pat," another reporter broke in, "did you sense any differences between this opening-day Rangers team as opposed to a year ago?"

"Well, it's too far gone to look into the past, but opening day is always exciting and I'm sure everybody was excited today—them, us, everybody around the league."

"In what ways do you think the Rangers are a different team?"

"*Completely.* It's so different I don't even think about it. Before it was all just up in the air—questions about simple things you shouldn't even have to worry about. Now we're not worrying about anything. We're just going out, doing what we're told, and trying to play better than the guys we're playing against. It's a pleasure. It's a hockey challenge-type thing, you know?"

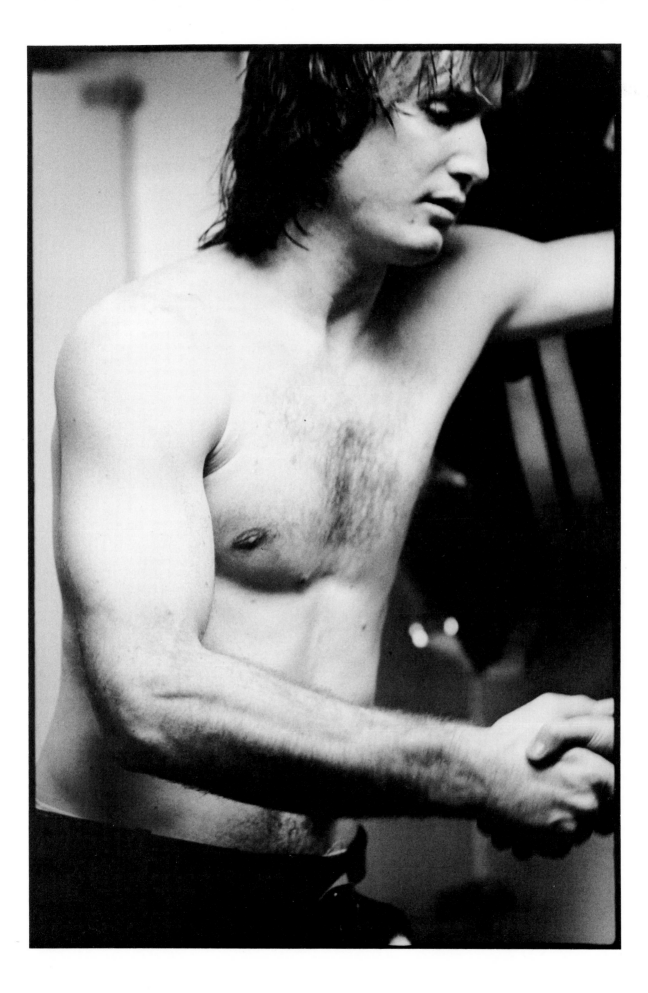

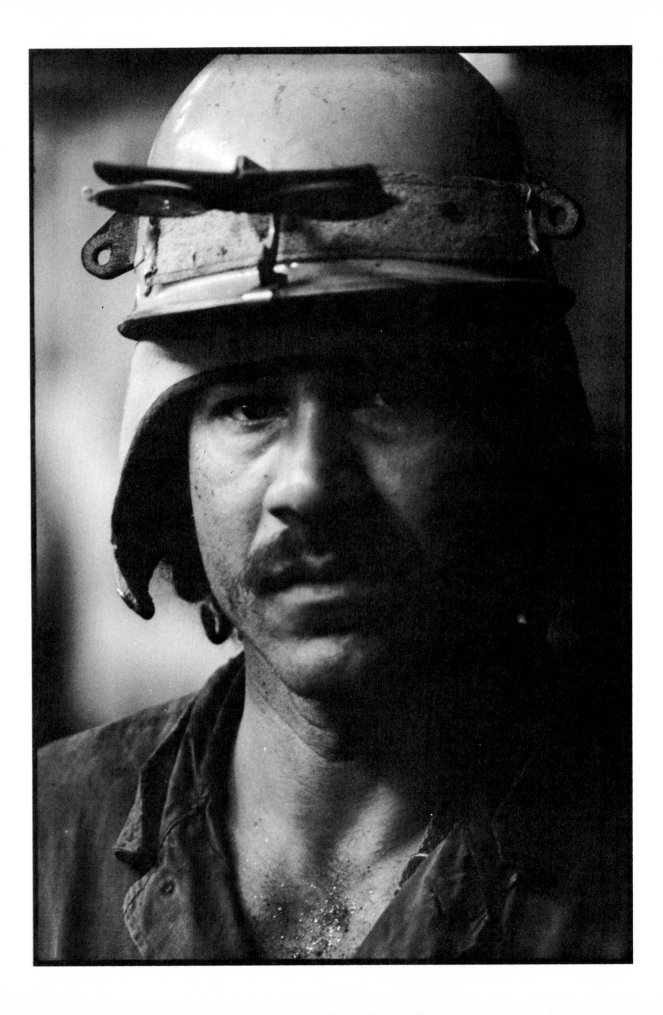

Carroll Megginson

Youngstown Sheet & Tube Company
Youngstown, Ohio
"Mr. Lucky"

Carroll Megginson is thirty-six years old. The past ten of those years he has spent at the Brier Hill works of the Youngstown Sheet & Tube Company, making steel. Five days a week, eight hours a day, he helps tend an open-hearth furnace. As a second helper—number two on a three-man team—he has two main tasks. One is to monitor the temperature and chemical composition of the boiling steel inside the furnace. The other is to unplug the two-foot hole at the bottom rear of the furnace whenever the readings indicate the steel is ready. This happens once or twice a shift and is usually accomplished with an explosive charge. When the charge goes off—sometimes when he's expecting it, sometimes not—his responsibility is to scramble out of the way of the molten steel as quickly as possible, taking care not to get splashed by the metal itself or blown by its accompanying blast of hot air into the ladle that's waiting below. It is his skill at doing this that has earned Megginson the nickname "Mr. Lucky."

Steel is a hellish substance to make. It requires the melting and slow cooking at temperatures upward of 2,800 degrees Fahrenheit of iron, lime, scrap metal, and various combinations of minerals: aluminum, manganese, molybdenum, and so forth. The iron itself has to be made from ore shipped in from the Great Lakes and melted in a blast furnace with lime and coal that has been baked to form coke. After it's been cooked, the fiery steel is cast in ingots which are allowed to solidify before they're heated to a bright orange and (in the case of Brier Hill steel) rolled and rerolled into tubular rounds that are cooled, reheated, and then pierced from the end to make seamless pipe that will sink deep into the earth. This is rough, dirty, dangerous work, and there is no way to make it otherwise. The antiquated mills of Youngstown, however, make it rougher, dirtier, and perhaps more dangerous than need be. They also make it more expensive, which is why they've been on the wane in recent years.

Megginson, in fact, is lucky to have a job. Sheet & Tube's other open-hearth steel mill, five miles downriver at the Campbell works, was phased out completely in the last four months of 1977. Other departments in the Campbell plant were eliminated or cut back too—the blooming mill, the hot and cold strip mills, the continuous-weld tube mill, and the bar mill. Five thousand workers were let go between September 1977 and January 1978. The company reported a loss for the year of $180 million. But as long as the Brier Hill open hearths remain open, Megginson pulls in about $350 a week. That's good money in Youngstown, especially if, like Megginson, you have no children and a wife who works. Good money in Youngstown never quite

translates into the good life; the town is too gray for that, too coarse and too rough. But it's still possible to have a good time on Friday night, assuming you're a steelman and you haven't been laid off yet.

Megginson is not your typical steelman. That would be someone about fifty years old with pasty skin, bulbous features, an enormous gut which he would pat affectionately and hoist around with pride, a Polish or Slavic last name, and two generations of forebears who'd worked in the same mill. Megginson is trim and fit and bears the name his great-grandmother took from the Virginia tobacco planter who'd owned her and sired her children. His father was a sharecropper who moved to Baltimore during World War II and took jobs in shipyards, in steel mills, and finally on the railroad. He was a hard worker, but he didn't have much education and it took most of his effort just to survive. Carroll's mother stayed in Virginia, in the tiny Appomattox County hamlet of Stonewall, and didn't survive at all; she died of tuberculosis when he was still young. Tobacco got her coming and going: she had to wash diapers in the creek no matter what the weather because they didn't make enough money as sharecroppers to afford a well, and even after she lost her health she couldn't give up cigarettes. Carroll and the other kids—two brothers and a sister—spent most of their childhood with relatives.

Carroll eventually dropped out of high school, despite his father's admonitions not to, and joined the Marines. He served two hitches and spent most of his time at Guantanamo, at Quang Tri, and on Med cruise aboard the USS *Rockbridge*. Between hitches he returned to Appomattox. He wanted to trace his mixed blood, get in touch with his people. He worked as a butcher's assistant and found out about his great-grandmother: that she was fair-skinned and wore a wire hoop skirt, that the planter had left her his plantation when he died, that she'd been killed in a thunderstorm while surveying her domain on horseback. In 1966 he returned again to Virginia and got a job in Lynchburg, the city closest to Appomattox. The job was in a steel fabrication plant.

Megginson's first exposure to steel came thus by accident, because he needed a job and one was there. A year later, when he left Virginia to look for work in Ohio, he landed a job at Sheet & Tube, making steel instead of cutting it. He went after that job because the work looked challenging and because pay on the open hearth was top dollar. "And I guess it's something I always kind of wanted to learn about anyway," he said. "As a kid, I used to ask what steel was. Somebody told me that steel was an alloy of iron. I never figured that out, but as I got older I pursued the idea. I wanted to separate that from the word t-h-e-f-t. I'd been exposed to that kind of stealing long before I'd heard anything about steel, the alloy of iron."

Does he still connect the two?

"No, no, no," he laughed. "I'm strictly legitimate."

The Youngstown Sheet & Tube Company entered 1978 as the nation's eighth-largest steel manufacturer, with annual sales of more than $1.5 billion and plants employing 15,000 people in Youngstown and East Chicago, Indiana. The Indiana Harbor plant in East Chicago had been completely modernized in the late 1950s, but it produces flat-roll steel and unfortunately the world was experiencing a glut of flat-roll steel. Losses were reported at $4 to $5 million a

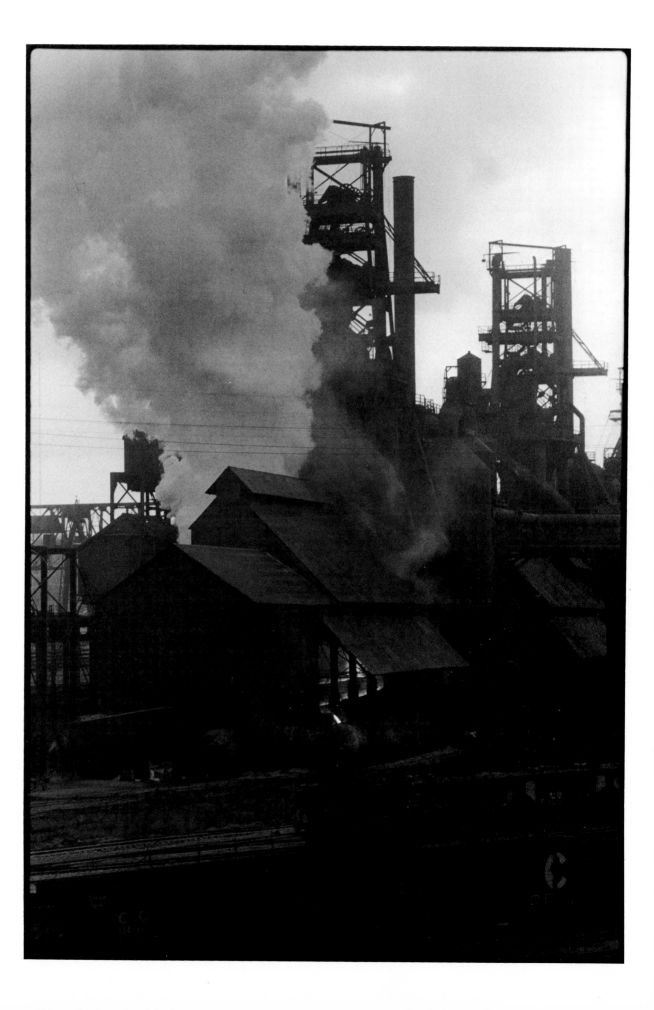

month. The Campbell and Brier Hill plants in Youngstown, both dating from the turn of the century, had been making top-grade seamless pipe by the open-hearth method, which was at least twenty years out of date; but after the layoffs only Brier Hill was producing, and there was open speculation about how long that would last. Meanwhile, the Lykes Corporation, Sheet & Tube's parent company, was preparing a financial statement which noted that severe cash shortages could be expected soon unless "significant external relief" were forthcoming. On January 13 it was announced that relief was being sought, in the form of Justice Department approval of a proposed merger with the Dallas-based LTV Corporation, and that without it, Sheet & Tube's prospects for continued operation were "dim." Six months later, U. S. Attorney General Griffin Bell approved the merger, observing as he did so that it was Sheet & Tube that was "primarily responsible for Lykes losing money."

This was ironic, considering the large cash reserves Sheet & Tube had enjoyed when it was taken over by the Lykes Corporation less than ten years before. Sheet & Tube, which had been founded in 1900 in a wheat field three miles southeast of downtown Youngstown, had by the late sixties become a prosperous but conservatively run organization whose major capital improvements in the profitable postwar years had been the Indiana Harbor modernization and the construction of a new corporate headquarters on a landscaped site in suburban Boardman. (The headquarters has a moatlike reflecting pool and is known locally as the Taj Mahal.) In 1969, the company was forcibly absorbed by Lykes, a New Orleans-based steamship concern one third its size, after Lykes offered its stockholders the chance to exchange common stock yielding $1.80 per share for preferred stock with a guaranteed dividend of $2.60. Lykes borrowed heavily to finance the takeover, and afterward it used Sheet & Tube cash to finance new acquisitions in banking, insurance, and other fields. It spent little to upgrade Sheet & Tube's outmoded facilities in Youngstown.

As it happened, the Lykes takeover coincided with the beginning of a long slump in the steel industry. There was inflation, recession, steel price controls. There were new environmental requirements. There was no longer an American monopoly on the world steel market. The Japanese and the Germans, their steel capacity destroyed by Allied bombers in World War II, had built modern mills while American steelmakers—Sheet & Tube was not alone —continued to use facilities that were inefficient and expensive to operate. (The six operating open-hearth furnaces at Brier Hill, for example, require thirty people per shift to produce 2,500 tons of steel a day; the Japanese, using two basic oxygen furnaces, can produce 10,000 tons a day with half the number of workers.) Third-world nations, recognizing the importance of steel production to economic nationhood, were developing their own capacity, eliminating profitable markets for American manufacturers. Rising imports, particularly from Japan, were accompanied by charges that foreign producers were "dumping" steel in American markets—selling it below cost. Even in a fair-market situation, however, American steel, with its deteriorating plants and its expensive and troublesome labor, was beginning to look dangerously uncompetitive.

The same year Lykes took over Sheet & Tube, LTV—the Texas aerospace/electronics/defense outfit that set the pace for go-go conglomerate build-

ing in the sixties, when it was known as Ling-Temco-Vought—acquired the Jones & Laughlin Steel Corporation, seventh-ranked among American producers. Jones & Laughlin has proved more successful than Sheet & Tube, in the sense that it's lost less money—only $3 million in 1977—but it too has shown how easily a steel operation can dwarf other concerns. The merger of LTV (39 on the *Fortune* 500 list, with debts of $1.1 billion) and Lykes (140, $670 million) creates a new, refinanced LTV that is now the twenty-third largest industrial concern in the United States—"a steel company with some things hanging onto it," one executive was quoted as saying. The restructured steel operation is expected to save an estimated $60 to $80 million per year, all but about 1,200 jobs, and Sheet & Tube's entire $260 million pension fund. There has been some doubt, however, as to whether this will actually work. On the day the merger was approved, the New York *Times* noted that informed observers consider massive layoffs of the sort Youngstown experienced in 1977 to be necessary for the steel industry's long-term "rationalization." "There is also a widely shared feeling," the report continued, "that extending the life of marginal facilities—and Lykes and LTV have some of the most marginal—simply postpones the day of reckoning."

The open-hearth steel mill at Brier Hill is a vision of turn-of-the-century industrialism cut loose in time. Like all mills in the Youngstown area, this one lies alongside the Mahoning River, a small but long-suffering stream which flows southeast toward the Ohio. From the expressway that crosses the river just downstream, the mill is visible as an enormous, lofty barn sheathed in corrugated metal, large portions of which are either curling at the edges or missing entirely. The narrow valley surrounding it is crammed for miles in either

direction with furnaces, ovens, sheds, and finishing mills, some standing silent and empty, others wreathed in steam, soot, and fire. The river glints silver in the sunlight as it slips between them.

At about six o'clock on a Monday morning in spring, Megginson turned left off the Federal Street Expressway, drove past the abandoned office building that used to house the Sheet & Tube execs in charge of Brier Hill, and pulled up as usual to a spot in the wire-fenced employee parking lot. He was early—daylight shift doesn't begin until seven—but everyone reports early to the steel mill for reasons no one can explain. He entered the mill through a small door near one corner and headed for the open-hearth washroom. The washroom is a long, narrow room painted an institutional green. It has green benches along the length of it, showers and toilets at one end, and fifteen-foot ceilings from which everyone's clothes are suspended. (Lockers won't do because people sweat too much here; this way, clothes can dry.) Megginson went to his pulley on the wall, opened the padlock, and lowered his work clothes down beside him. He put on a set of long underwear, a baggy pair of olive-drab fatigues, workman's boots with steel-reinforced shank and toe, an aviator's cap and goggles, and an orange hard hat. Then he hoisted his street clothes to the ceiling and climbed up the steps to the floor.

The floor of the Brier Hill open hearth extends for a quarter of a mile into a haze of lime dust and glittering graphite. On one side are the open hearths, a long line of furnaces, twelve in all, each with five four-foot-square doors a couple of feet above the ground. Some of the furnaces have been torn down and lie gray and vacant; others at any given time are being rebuilt, as every furnace must be at least once a year; the rest are charged around the clock with roaring heats of steel that lick at the doors and spill onto the ground. On the right, across from the open hearths, are mazes of pipe, a succession of tiny, grubby rooms, and six-foot-high furnace-control panels covered with knobs and gauges. Above is a cathedral-like space roofed with curling metal and split by slanting beams of sunlight. Underfoot is the floor itself, dirt laid with railroad tracks interspersed with heaps of gravelly lime and dolomite. Railroad cars and heavy trucks and great charging machines rumble periodically across the floor; enormous cranes swing sixty-ton ladles of molten pig iron overhead. Every surface—moving or stationary, alive or inert—is covered with a thick, choking layer of mineral dust.

The furnaces themselves are brick-lined steel cauldrons designed to accommodate 180 tons or more of boiling metal. First they are charged with lime, then with various forms of iron and steel: ore, molten pig iron, scrap. As the metals melt together, the lime rises, bringing with it certain impurities—principally carbon and sulphur—which either escape as gas or float to the surface as slag. The underlying principle of steelmaking is chemical change through heat; steelmen liken it to cooking a stew. The basic chemical change is the oxidation of carbon.

Steel—the English word is derived from a Teutonic root meaning "strong" or "rigid"—was first manufactured in India and the Middle East hundreds of years before Christ, but it is only since the middle of the last century that anyone has known it for what it is: iron with a narrow range of carbon content, generally less than one per cent. Before then, people knew it only by the extraordinary hardness it assumes when quenched in cold water, a

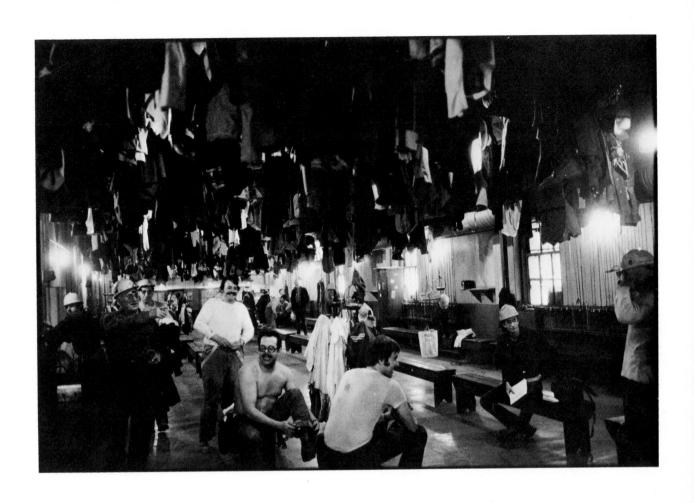

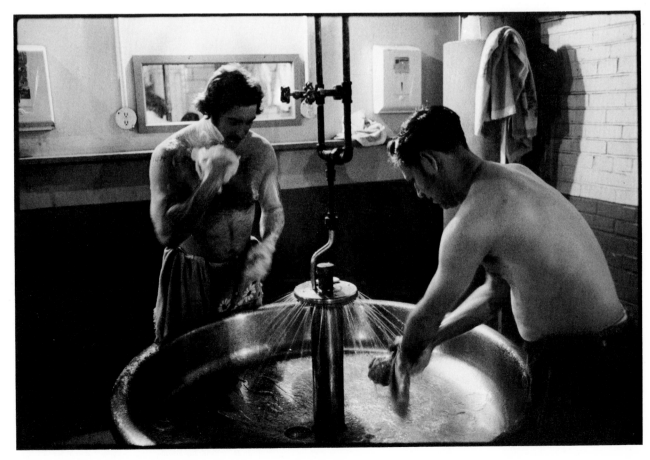

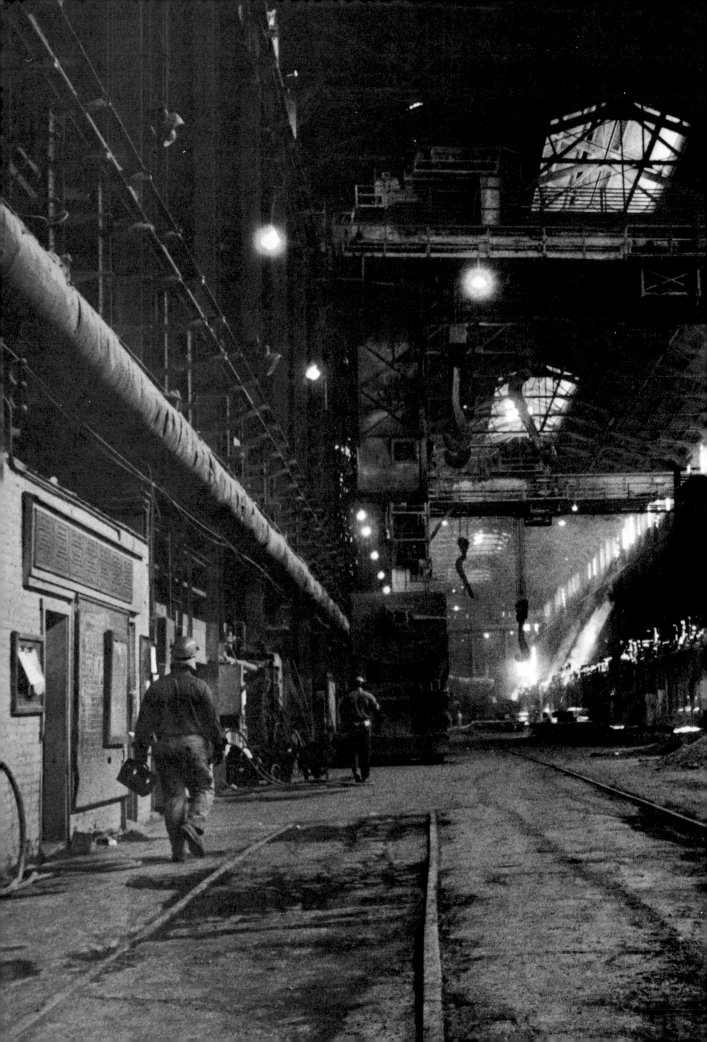

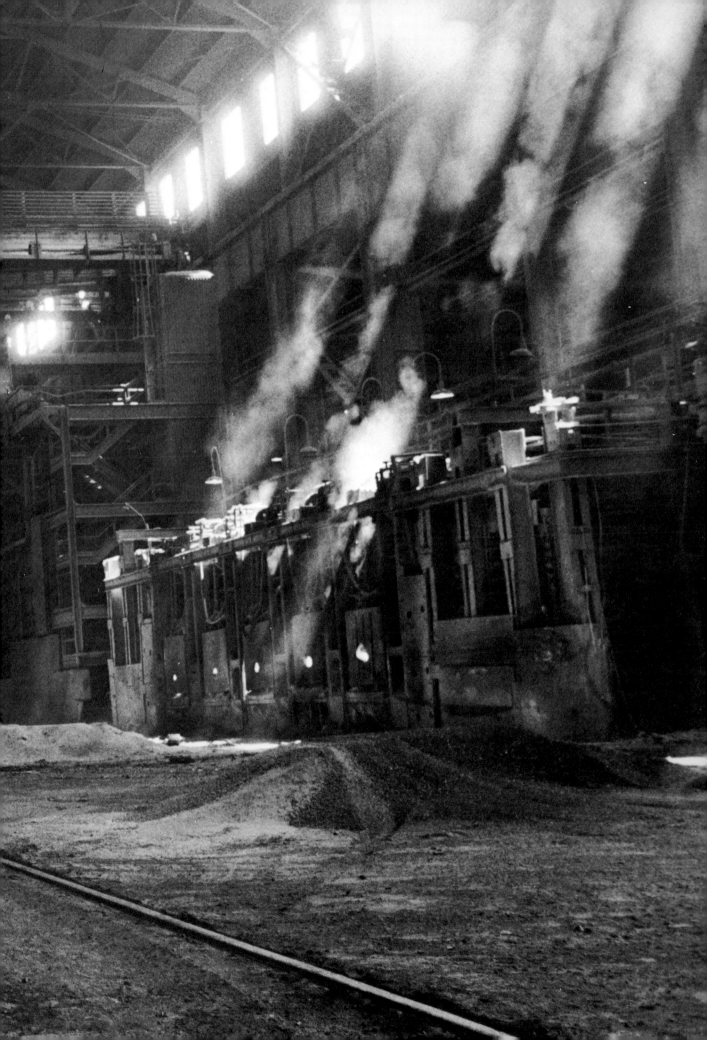

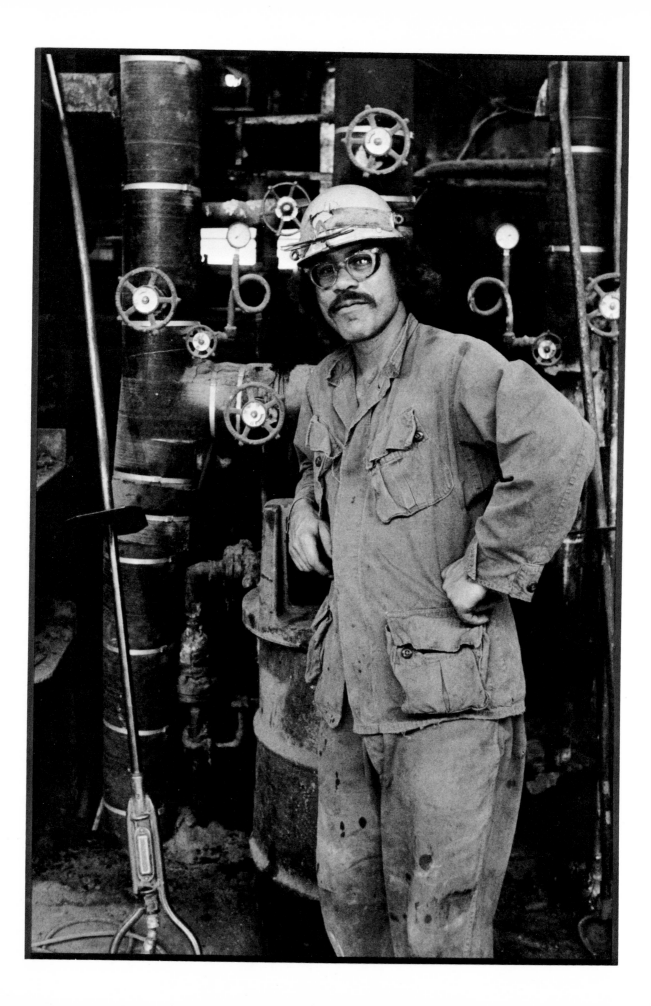

hardness quite distinct from that of ordinary iron. Because this hardness enables it to penetrate any number of other materials, steel has been particularly valuable in war. The modern age of steel began, in fact, with the Crimean War, which spurred research that led to methods of production that would yield tons instead of pounds. In the years since, the mass production of steel has made possible not only modern warfare but also the modern American kitchen, the automobile, and the extraction of that other most crucial substance, oil.

It was 6:30 when Megginson walked past the ruins of a gargantuan hot-metal mixer to the number seven furnace. The number seven is a fast-burning furnace because it's equipped with oxygen lances to feed the fire; the number eleven, which he'd worked last week on the three-to-eleven shift, requires eight hours to cook a heat of steel instead of four or five because it doesn't have oxygen lances. This morning the number seven was carrying a G216—Sheet & Tube designation for a low-quality steel high in manganese and silicon. It was almost ready to be tapped.

Tapping a heat—unplugging the taphole at the back of the furnace—is the most dangerous job in the mill. Megginson does it once a day, sometimes twice on a fast furnace like the number seven. First he takes a scraper the size of a hoe and digs out the loose dolomite from the outer two and a half feet of the taphole. Then he inserts a long pole with an explosive charge at the end— it looks like a giant suppository on a stick—into the hole. The dynamite blows out the six-inch-thick seal of oil-treated dolomite that plugs the hole, releasing the steel inside. The flaming, viscous liquid cascades down a mud-covered steel runner into a brick-lined ladle waiting empty in the pit below. Sparks and drops of steel shower thirty feet into the air and rain down on the unflinching steelmen, who regard the holes in their clothing and the scars on their skin with pride. In five minutes or so, when the furnace has drained, Megginson goes down to reseal the taphole and repair it if it's gotten jagged and sloppy, as tapholes do. Meanwhile, massive hooks reach down from the overhead crane and swing the ladle to the other side of the pit, where the steel is poured into ingot molds. Later, when a crust has formed on slag that runs out the flush hole and into the pit, a bulldozer will move in to scrape it up. The empty ladle will be back in place, waiting for the next heat.

Megginson put on a flame-retardant wool jacket and a wire-mesh face mask, then walked through the narrow passage between furnaces to the catwalk that overhangs the pit. The steel inside the furnace was glowing orange through chinks in the brickwork. He climbed over the rail and down beside the runner. Short, high blasts were sounded on the whistle to warn people that he was going to work. He couldn't blow this taphole out with dynamite because ingots were being cast directly across the pit and the workers supervising the process might be splashed in the explosion. Instead, after digging out the loose dolomite, he went to work with a portable oxygen lance, burning the tap out. This takes longer than the explosive method and is more dangerous because you can never be entirely sure when one is about to break through, but until a few years ago it was the customary means of doing the job at Brier Hill. Of course, half a century ago it was done without eye protection, too.

Megginson spent several minutes crouching by the entrance to the hole, probing the tap with his lance; then, without warning, he leaped back onto the rail. The steel followed him out with a convulsive roar. He climbed back

onto the catwalk as it filled the ladle in a shower of light. Then he jumped
back down with his lance and burned whiskers of hardening steel off the
runner. Steve, the first helper—a great-bellied man with thirty-two years in the
mill and a gimpy leg acquired in a long-ago encounter with a front-end loader
—stood on the catwalk and shoveled silicon into the flaming crust of red slag
that was forming on top of the ladle. It was not yet eight in the morning.

Back on the floor, the furnace's inside walls were being dressed with
dolomite to keep the next heat of steel from burning through. Then the charg-
ing machine moved into position before the open doors. Long and powerful,
with a rod at its center to move in and out, it charges the furnace with the
metals that will become steel. Working clumsily, the machine picked up coffin-
sized steel boxes filled first with lime, then with Brazilian iron ore, and thrust
them deep inside. Then it did the same with large hunks of scrap. Megginson
walked across to the board to see what they'd be making this time.

It was a U251—a high-quality chrome/molybdenum alloy characterized
by unusual hardness and an ability to withstand intense vibration. Megginson
began to get the ingredients ready. A heap of charging boxes filled with
twenty-pound cans of molybdenum powder sat across the floor from the fur-
nace; he got the craneman to set them in place for the charging machine.

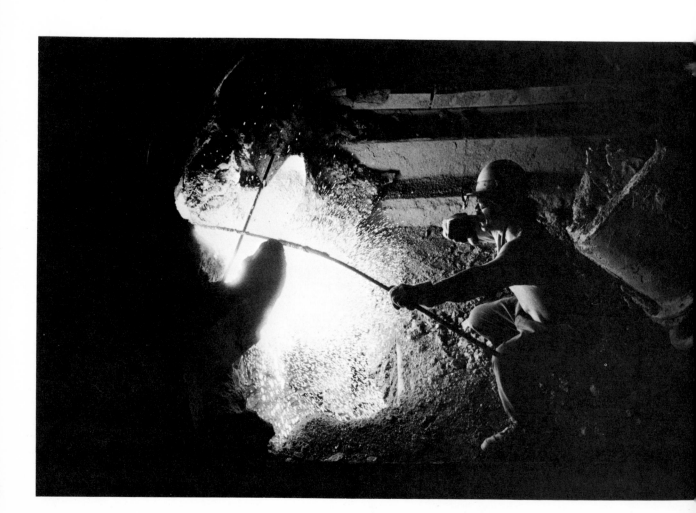

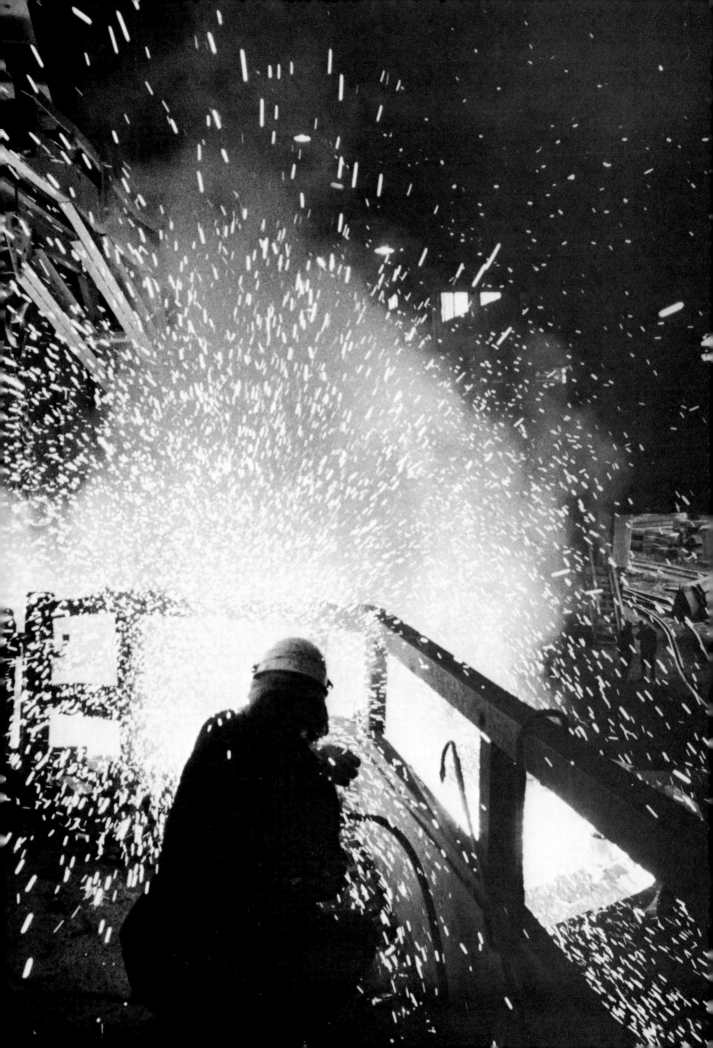

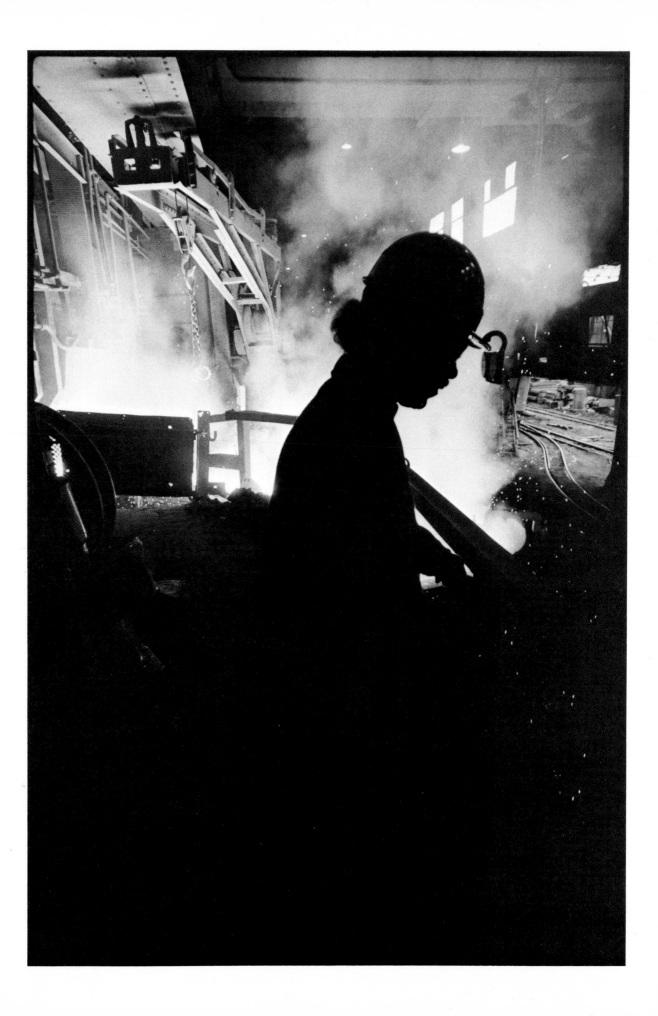

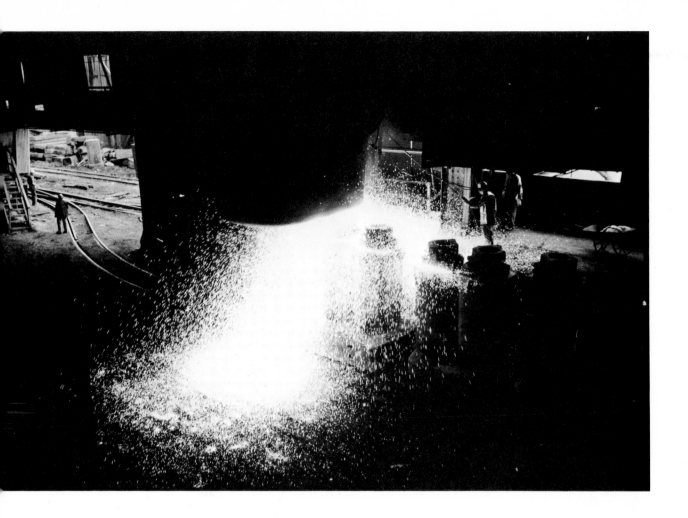

Then he climbed down into the pit behind the furnace to supervise as another craneman lifted a four-by-four-foot pan of manganese boulders and dumped them into a chute. The manganese would go into the ladle after the heat had been tapped. When he returned to the floor, molten pig iron was being poured from a ladle into a spout aimed into the furnace. He walked to the other end of the floor to get some ferrous silicon—"that twenty per cent shit," he called it —that would be put in to block the heat, stopping all chemical reaction, when the temperature inside reached 2,880 degrees and the carbon level reached .050 per cent. Those were the specs for this heat of steel; that would be the last addition to the bath, just before the heat was tapped.

By 11:30 the charging was finished and the furnace doors were being banked with dolomite by a front-end loader. Oil jets sprayed fuel first on one side of the furnace and then the other, sending flames bursting out of the wicket holes in the center of the doors. (The doors are water-cooled; one door's cooling system got clogged the year before, but someone noticed the door glowing bright red seconds before it blew, sending jagged hunks of steel hurtling aross the floor. His warning enabled everyone to jump in time.) When the jets went off, oxygen lances were lowered from above. Megginson had a little more than an hour to relax. Then he got ready for the preliminary test.

Pulling down the cobalt-blue spectacles attached to his hard hat—they cut the glare inside the furnace, enabling you to distinguish actual waves of boiling steel—Megginson approached the furnace with a baseball-sized spoon on the end of a pole as long as he is tall. He inserted the spoon through a

wicket hole, then withdrew it and laid it on the ground. The spitting, hissing steel cast an angry red glare. Kneeling over it, he dipped it with a thin aluminum wire to quiet it, then took a sample in a small copper tin. He walked that outside to the lab and returned to await the computer analysis. The print-out coming in over the teletype would tell them, for the first time, exactly what was in this steel.

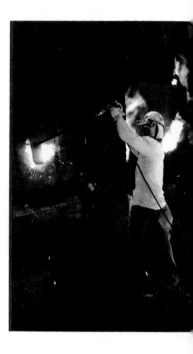

The reports came in: sulphur, .018 per cent; chromium, .030 per cent; tin, .002 per cent, and so forth. None of the residuals went over maximum, so they were all right. Pulling his gloves back on, Megginson walked out to the control panel, picked up an eight-foot-long thermocouple, dragged it and its cable across the floor to the furnace, and stuck it inside. The temperature registered on a graph on the control panel: 2,760 degrees. Then Steve approached with the spoon. This time he took the sample with a small glass pin, plunged it into a bucket of water to harden, cut off a piece about half an inch long, and gave it to Carroll. Megginson took it across to the room with the teletype machine, put it into a crucible, and put the crucible into a small computer-analyser that would give him a reading on the carbon and sulphur content. They were going down.

Carroll began to look worried. There was a good chance he would have to tap this heat before he left. Twice in one day was too much.

At 1:50 Megginson repeated the testing process. The temperature had gone up sixty degrees in fifteen minutes. The carbon was falling rapidly. The two oxygen lances were shut off and raised out of the furnace: oxygen takes the carbon out of steel, and the furnace was losing carbon faster than it was gaining temperature. If the carbon got too low, they'd have to give the steel a drink of hot iron to bring it back up to specs. At 2:05 he took another test; the temperature was 2,745 degrees, the carbon was still dropping. Smoldering flakes of paper ash suddenly filled the air: desk workers from the offices above the lab had just dumped some of their old paper work into another furnace. At 2:15 the tests were taken again. This time the temperature was 2,730 degrees—150 too low—and the carbon reading was .042. When you have a 42 carbon and you need a 50 carbon to put the molly in, there's only one thing you can do: give the steel a drink. Megginson looked relieved.

Megginson's replacement came on promptly at 2:30. A warning siren sounded as the charging machine rumbled over to the last door on the left and set a spout into place. A ladle of hot iron swung into position above the spout, the heat from its contents causing the crane parts above it to glow cherry red. "We're working on a U251," Megginson told his replacement as the dogleg hook reached down to tip up the ladle, "and it's about to take a drink."

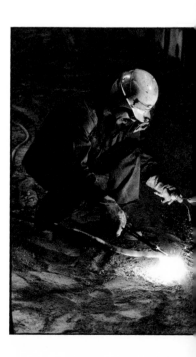

September 19, 1977—the day Sheet & Tube announced its 5,000 layoffs—is remembered in Youngstown as Black Monday. The community reaction ranged from shock to panic to anger—anger at Lykes for "raping" Sheet & Tube, anger at the future for being so out of control. There had been indications that something would happen; a month earlier, 700 white-collar workers had been dismissed from the Boardman headquarters. Union leaders like Bill Sferra, president of United Steelworkers Local 1418 at the Campbell works, had requested a meeting with top management and been told that that would be about it as far as firings went. Sferra lost 1,000 of his 3,200 members. The

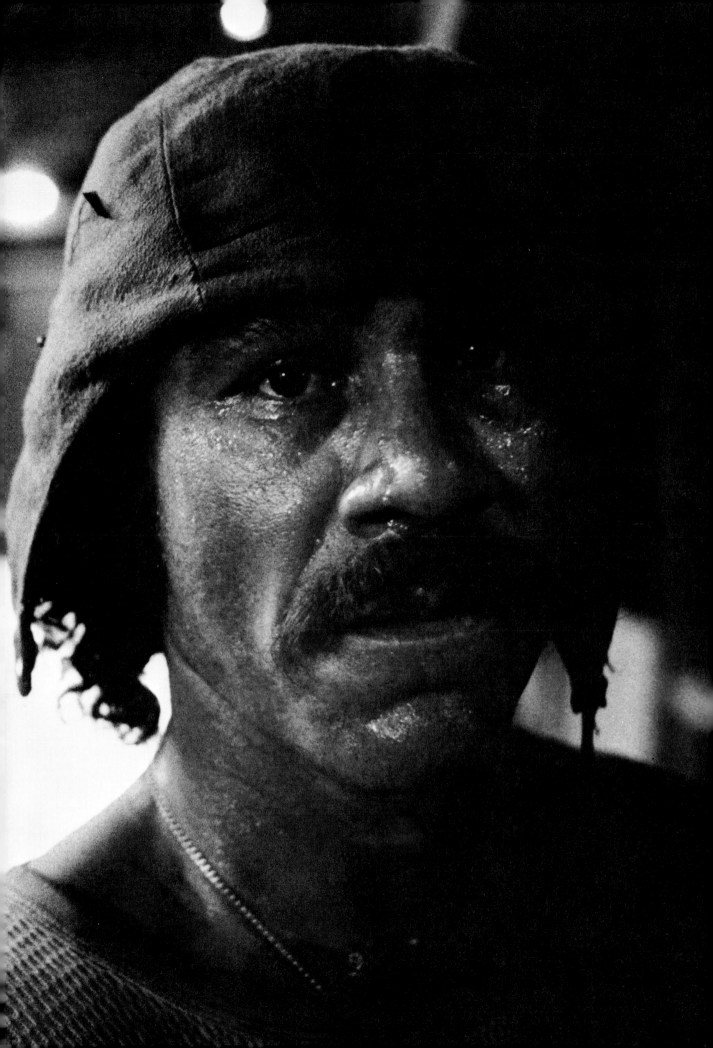

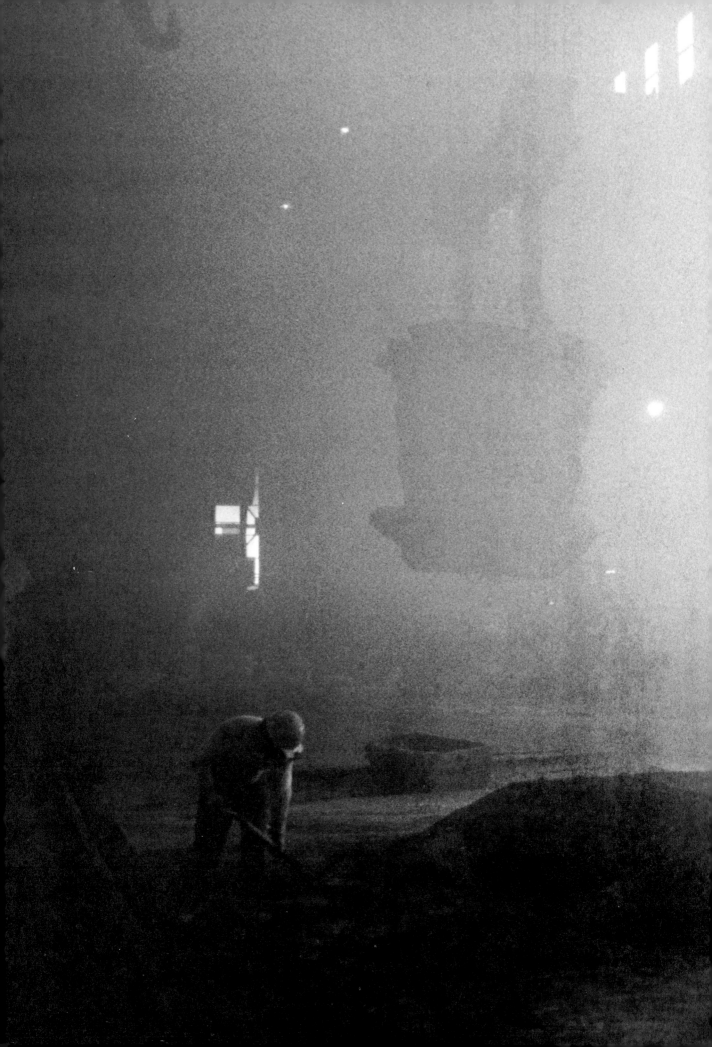

other local at the Campbell works lost 2,000 out of 3,000. "I was surprised," Sferra admitted later. "I thought there would be some layoffs. And a long layoff with benefits isn't bad news as long as you go back, okay? Sometimes it's good news. We never dreamed it would be like this."

Until the layoffs, Sheet & Tube had been the largest single steel employer in the two-county area of eastern Ohio known as the Steel Valley. It's actually the Mahoning River Valley, and the heart of it—a twenty-mile stretch from Warren in the northwest through Niles and Youngstown and the twin mill towns of Campbell and Struthers to Lowellville, hard by the Pennsylvania line—is home to half a million people. At one time, it was called the Little Ruhr. Since then, however, steel employment has declined steadily, and the population with it. "Where we'll be ten to fifteen years from now," Chamber of Commerce president Wesley Johnstone admitted to me, "I honestly don't know."

Johnstone was speaking in his office high in the Wick Building, one block from the center of downtown Youngstown. The Wick Building, named after one of Sheet & Tube's founders—the other was an ironmaster named Campbell—is one of a half dozen or so Art Deco towers, most of them occupied by banks, that recall the years when business was booming in America's Little Ruhr. Today these structures are surrounded by boarded-up storefronts and blocks of vacant land. Like the mills that supported it, Youngstown's center has rotted from neglect.

Youngstown was founded by an enterprising frontiersman who bought the land from Connecticut in 1797 (before Ohio was formed) and named the settlement after himself. Picturesque black furnaces using low-grade native ore to make minuscule amounts of iron were established as early as 1803 but had mostly been abandoned by 1839, when a canal linking Lake Erie and the Ohio River was built along the Mahoning River. The canal and the discovery of local coal combined over the next decade to make Youngstown a center of ironmaking. By the mid-1850s, native ore had been replaced by high-grade ore that had to be barged down from Lake Superior. Coal production peaked in 1870, and by the nineties, Youngstown was dependent on the railroads for ore and coal too. Unfavorable freight rates put it at a disadvantage to Pittsburgh, so local ironmakers began to switch to highly finished steel, figuring that the higher price of a more refined metal could be used to cover their higher freight costs. It worked.

The Steel Valley reached its acme in the 1920s. The booming market in specialty steels—sheet for railroad cars and automobiles, pipe for oil wells— enabled Youngstown mills to expand far faster than their competitors in other cities. Most of their steel was made in old-fashioned Bessemer converters then, not on the open hearth, and the violence of the sudden oxidation of great quantities of iron would cause the sky above the river to light up orange in the night. Steelworkers lived in company houses on the slopes above the mills, bought their goods at the company stores. Steelmasters packed handguns whenever they ventured out of doors. Prostitution and gambling thrived at places like Big Ethel's in Campbell and the aptly-named Jungle Inn just across the county line, where Mafia stooges bearing tommy guns kept an eye on the action from balconies near the ceiling and big winners were escorted home to avoid messy holdups in the parking lot.

Time and neglect seem to have caught up with Youngstown now. The new concept in steel mills, typified by U. S. Steel's proposal for Conneaut, sixty miles north of Youngstown on Lake Erie, calls for plant construction on a greenfield site by the water's edge, so that iron ore can be unloaded at one end of the mill and finished steel can be taken on at the other. The Steel Valley has been landlocked since the close of the canal era and suffers in addition from depleted mineral reserves, an inadequate water supply, sadly outdated production facilities, and a labor force with a reputation for wildcat strikes and endless bickering. The flood of Japanese steel from Great Lakes ports is even eroding its advantage at being near the center of America's largest steel-consuming region. The one advantage Youngstown still does enjoy is its people. They may be disputatious, but they do know steel and they make it well. In particular, Sheet & Tube's seamless pipe, identifiable by its bright orange stripe, has a reputation for hardness and durability that has made that company America's number two producer of oil-country drilling goods. So despite everything, it has still remained possible for Chamber of Commerce president Johnstone to say, "If you want good steel, get Youngstown steel." And the reason for that, he will freely acknowledge, is the people who make it.

Steelmen, it is regularly asserted, are a breed apart. Certainly they look different from other people. Out on the open hearth they look like grub zombies expiating some dreadful birth-sin, their enormous bellies glowing orange against the flame like mutant wombs. They are not "men of steel" in the ordinary sense; they are men who *create* steel, midwife gnomes who officiate at the birth of a metal that helps separate humanity from the animals. They pride themselves on their ability to take its punishment, but still they are twisted by it into alien shapes, gnarled and toughened. It is their readiness to risk not only health but existence for its manufacture that marks them as different from other people. They possess a straight-on sense of authority.

"To me, it's a challenge," Megginson said one afternoon as we lounged in a bar drinking Stroh's, "America's only fire-brewed beer." "There's more to it than just walking out on the same old assembly line. I guess above all the commotion and pollution and whatever, that's the one basic reason I'm still there—aside from the fact that it pays a decent buck. But the danger, that's just something I put up with because of the money. I have no fetish for tapholes blowin' out—no fetish at all. Not even the least bit of pyromania." He paused, then smiled insinuatingly. "But sometimes I look at some of those guys, you know—when they dump the ore, when the flames jump out almost across to the panel board, and they're staring at that flame, open-mouthed. . . ."

Carroll and Margaret Megginson had only been married two months when Carroll left Virginia to look for work. They'd had something like $20 between them on their wedding day, which was New Year's Eve, and in February he and his cousin Nate had lost their jobs at the steel fabrication plant in Lynchburg because they didn't show up for two days. They had a lot of cousins in Ohio, so that's where they went. Two days after his arrival, Carroll got a job paying $120 a week at a steel fabrication plant in Columbus, but he never showed up for work. Instead he went to Youngstown and got himself hired as a third helper on the Brier Hill open hearth. All twelve furnaces were in production then.

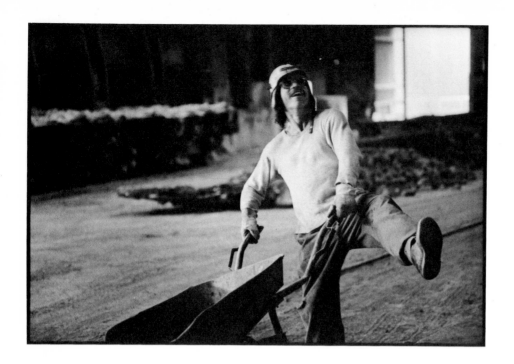

Carroll started work on the eleven-to-seven shift the night of April 5, 1968. There were race riots and curfews in Youngstown then, but he was too busy trying to get established to get into trouble. In July he was laid off for two weeks; at the end of August he was laid off again. The second time he and Margaret had to get by on $53 a week unemployment for three and a half months. Since then, however, it's been a steady five days on and two off, different shift every week—eleven to seven, three to eleven, then daylight.

Only in recent years could someone like Megginson—someone with African blood—have gotten an open-hearth helper's job. When the steel mills were built, the men who worked them were either Anglo-Saxon ("Johnny Bulls," Megginson calls them) or Irish. Poles, Slavs, and Italians moved in later, but blacks were restricted to the most menial positions until after World War II. They could work on the charging gangs—ten-man teams that shoveled minerals into the furnaces until the machines took their job—or the dinky railroad, but they couldn't work on the standard-gauge railroad and they certainly couldn't tend the furnaces. The federal government has hiring standards now, which among other things means that fathers can no longer be assured of preferential hiring for their sons, but there still aren't any black first helpers at Sheet & Tube. There used to be one woman crane operator, but she went in the firings.

It took him a while, but Megginson has finally gotten used to the weekly shift changes. The eleven-to-seven shift still messes up his digestion, but not as badly now that he no longer stays in the bars until almost noon, shooting the breeze and sucking up suds. Now he comes home, has a breakfast of steak and eggs, and naps off and on until nine, by which time Margaret is usually home from work. She's a salad girl at the Youngstown Club downtown, which is where the city's top lawyers and bankers all eat. Sometimes he naps on the job, too; a lot of men do on night shift when they're not needed on the furnace. Others gulp bennies or coffee or hang out at the canteen, which dispenses potato chips, soft drinks, hot soup, and candy from machines and has a sign that reads

This Is Our
Lunch Room
Yours and Mine
"Let's Keep It Clean"

Carroll doesn't put much faith in the canteen.

Megginson first second-helped on the number seven furnace, working the eleven-to-seven shift. It was only a few months after he'd been hired, and he almost got into a fight because no one had told him what he was supposed to be doing. There's no on-the-job training on the open hearth; co-workers like to laugh when new people make jackasses out of themselves. Naturally, this leads to accidents. A new kid was once fired for running over someone with a front-end loader; nobody had told him the machine had no brakes and could only be stopped by shifting into reverse. When it doesn't lead to accidents, this usually leads to fights. You can be fired for fighting on company property, but sometimes—like on hot summer nights, when it's broiling in the mill and things start going wrong and everybody just wants to be someplace else—that's no deterrent. "Guys just get on guys' nerves," Megginson said with a shrug.

As far as accidents are concerned, the entire open hearth is fraught with possibilities anyway. In his ten years at the mill, however, Carroll has had only one, and that was with a front-end loader. He was driving it down a ramp and couldn't get it into gear when he tried to downshift, so he ran it into a wall. He was back at work the next day; the headaches lasted about six months. Digging out tapholes has shaken him up sometimes but never harmed him physically. That's why he's known as "Mr. Lucky." "Red Lutes pinned that name on me three or four years ago," he said. "He was a ladle craneman, so he had a good observation point. He's seen me tap heats, seen them blow out, and didn't even know where I was at until the smoke cleared. He told me, 'You're the luckiest guy I've ever seen on the open hearth.' And I kinda go along with him. I just hope my luck holds out."

Megginson was eager to test himself at first. It was a challenge; he figured he'd been up against worse than a furnace full of steel. It took him a couple of months to develop a feel for the job—a literal requirement, since no one is going to actually look up a taphole—but once he did so he developed a reputation for digging the hole out all the way, right up to the crust that seals the steel inside. That's risky because it increases the likelihood that the heat will blow out while he's still working, but it's also the way to get a good, fast tap. And if your job is digging out tapholes, that's what you want to do.

"At times," Megginson confided, "I have lost my nerve digging out a taphole. I have. What I've seen happen to other guys—I've seen those heats come outta there and just blow their face masks off, blow their helmets off. You never know how a heat's gonna come out. It might come out like a lion and it might come out like a lamb. But you've gotta remember—you've got a hundred and eighty tons in there, sometimes more than that, and it's resting on an area about like that." He held his hands a couple of feet apart. "When it breaks loose, baby, it breaks *loose.*

"When I first started, I used to dig heats out for a lot of guys. I had no fear at all then. I volunteered to dig a heat out for a shaky second helper once and the damn thing blew out on me. All I could see was a ball of white heat,

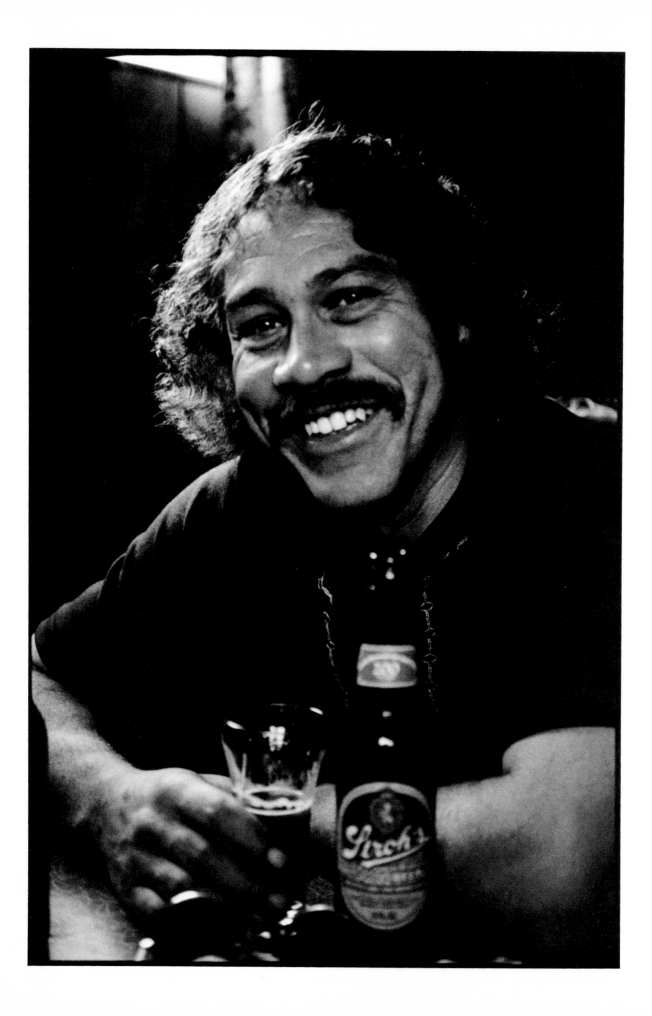

man—smoke, dust. . . . I didn't have time to do anything, I just ducked down. I didn't get burned, but I tell you, it was like standing at the end of a 105 howitzer. Naturally, I didn't show no fear or anything—'Oh no, it was nothin'.' But twenty minutes behind the open hearth, that's like three or four hours anywhere else. There's a little bit of nervousness involved.

"It's not so much getting burned. The thing that bothers me is getting blown into the ladle by the shock wave from the heat. That's enough to make you sit up and think twice. Can you picture yourself falling into a ladle of liquified steel? You'd die instantly. You'd probably even blow up, because the liquids in your body would react with the steel. You'd be popping like a deep-fried french fry. I talked to one guy in the blooming mill a few years ago—he said that in 1938 he saw a buddy get blown into the ladle. He said that's why he transferred from the open hearth. But I guess it's just like anything else, it's a phase you go through."

In the old days, Megginson said, if someone was blown into a ladle the entire heat of steel would be thrown out, on the theory that the presence of a human body rendered the steel unfit for use. Now, however, with the rising cost of raw materials, the steel is used anyway, except for two ingots that are set aside as a memorial to the dead man.

At one point, early on, Megginson had ambitions in the steel mill. It looked like you could make a lot of money as a union leader—at least thirty grand a year if you made district manager, and nothing to do that Carroll could figure out except make speeches and glorify yourself on local TV. Eventually, however, he decided he didn't have the patience to play union politics or the charisma to win. He had other ambitions too, though. Once he was at the top of a list of men who were showing a lot of enthusiasm on the job. He was told he'd be the first black man to make first helper. "I told 'em, 'I'm not even interested in that,' " he said. " 'I want your damn job.' " At about the time he decided to become the first black in supervision on the Brier Hill open hearth, however, he began to notice that the new supervision was being recruited not from within the mill, as it always had been, but on college campuses. The new people were younger than he and tended to have master's degrees in things like engineering and metallurgy. He noticed that even the Johnny Bulls weren't being promoted. "I'm not feeling inferior about it," he told me, "but I figure I got one strike against me already.

"So I said, 'The hell with this.' And I must say, too, I'd rather be the type of dude that comes home and—hey, eight hours there, here I can do what I want. I just figure, hey, I don't do too bad. Maybe that's saying I'm rolling over and playing dead, but I don't know how things are gonna pan out, and I don't want to put all my hopes and ambitions into something that might be a flop. And as a blue-collar worker, you're guaranteed that as long as they're working, you're gonna have a job. The only way I'm gonna leave there is if they shut the place down. But I've seen guys up *here* today and *gone* tomorrow in supervision. They can just literally manhandle you. But then, I've also looked at the other end—you might get offered another job just like *that*. You've got credentials.

"I've thought about relocating myself, and I've kinda come to the conclusion that I'd have to go through a retraining cycle. The government has acknowledged that all this is going on in the Mahoning Valley, so if I get kicked

off the job right now as a result of low productivity, I do have some insurance. I can take that and my own little resources and I can retrain, fit into some other program. I figure at my age I'll always be some sort of blue-collar worker. This is something I accept in life, you know. But I'm in a predicament right now where my best shot is just to wait and see how things are gonna pan out, even if it takes four or five years, because I'm honestly afraid to venture forth right now. And as far as supervision goes, I wouldn't stand a snowball's chance in hell. But you got to take the bitter with the sweet—that's something I learned years ago."

When the streets are dirty in Youngstown, people say, that means folks have money in their pockets; but when the streets are clean, that means the mills are dying. Of course, cleanliness is relative. Even in the worst of times, enough soot filters in through the closed windows of the downtown office of the Ohio Environmental Protection Agency to turn the sills black. The report from the coroner's office is that pink lungs are a rarity in any resident over the age of ten. Automobiles and stop signs acquire a dull finish from oxidizing paint. Homeowners in many parts of town experience a phenomenon known as "black rain"—sulphuric acid in the raindrops that reacts with lead-based paint to produce black streaks on the sides of houses. The athletic teams of Campbell High are somewhat perversely known as the Red Devils, after the reddish specks of iron oxide dust that settle on everything in town. "People here just don't care if they get lung disease," said a disgruntled young EPA employee, "as long as they get money."

The flight of capital actually has shaken Youngstown in a way that cancer or emphysema never has. The layoff of 5,000 steelworkers meant the loss of an estimated 10,000 other jobs in the area. It is a measure of the Steel Valley's desperation that local clergymen have attempted to organize a community/worker buy-out of the shut-down portions of the Campbell mill. The effort, which goes under the name "Save Our Valley," began with a federally financed feasibility study and a campaign to persuade local residents to open Save Our Valley bank accounts to demonstrate their support. Should the study show that the Campbell works might actually turn a profit if they were owned and operated by the local population, people with Save Our Valley accounts might decide to invest their money in the operation. Then again, they might not.

Dick Fernandez, an activist minister (civil rights, Vietnam, amnesty) who came from Philadelphia to run the Save Our Valley campaign, was admittedly depressed about his prospects for success at first. On the day he and his staff moved into their office in a downtown storefront, for example, the ceiling fell in. Before long, however, he grew more sanguine. Area congressmen declared their support; the mayor declared "Save Our Valley Day" and urged municipal workers to open accounts; and in the first ten weeks $1.7 million was deposited. Each depositor received a personal letter from the Bishop of Youngstown, expressing thanks and suggesting that two friends be urged to do likewise. But neither Fernandez nor the bishop ever really expected local residents to invest enough money to start the dead mill producing again. That would require, by preliminary estimates, about $80 million in cash and $400 million in loans during the first four years. There's only one place in America

to get that kind of money, and that's in Washington, D.C. "What we want to do," explained Fernandez, "is put our eggs in a row out here, to be able to stress to the government that we have been into self-reliance and have had wide community support in a district that won Ohio in the last presidential election. When those things are in place, we'll begin working Washington pretty hard."

Initial responses from the steel company were not encouraging. One executive I spoke with placed a theoretical value of $3 billion on the properties in question at the same time Fernandez was talking about purchasing them as scrap. The executive also said, "If we could have had what they're asking for —a long-term, low-interest, guaranteed loan of that magnitude, a guarantee of raw materials, a guarantee of the percentage of the goods to be marketed by somebody—we'd never have shut down." He had a point: Save Our Valley was asking for a lot, and the chances that its desperate scheme would work seemed even slimmer than LTV's chances of becoming a healthy, happy steel company. But management certainly wasn't offering anything else to Youngstown, not even hope. Coincidentally with the announcement of the Lykes/LTV merger approval, in fact, it was announced that the "streamlining" of the combined Jones & Laughlin/Sheet & Tube steel operation would include the cessation of steelmaking at the Brier Hill works and the termination of all 1,200 jobs on its open hearth. With Brier Hill, of course, goes Carroll Megginson's job. With Brier Hill, too, goes the seamless pipe that Sheet & Tube has been so celebrated for. Jones & Laughlin will continue to produce its own seamless in Aliquippa, Pennsylvania. It's not as good a product, the steelmen in Youngstown say, but it's cheaper to make.

The Megginsons live in a modest white-frame bungalow in an integrated section of Youngstown across the street from a park named after Abraham Lincoln. The house is well kept and comfortably, if a bit overbearingly, furnished. They bought it several years ago from a Lebanese family who had the living-room sofa perched on bricks. "You'd be surprised," said Carroll, "how some people can sit down and not even worry about something like that." So far Carroll has put in new plumbing and wiring, renovated the bathroom and installed ceramic tile, and refinished the golden-oak woodwork. Lately, however, he hasn't had much ambition.

Carroll and Margaret are extremely appealing people, but in different ways. Carroll is outgoing and generous, with a quick, broad smile and a hearty laugh. His face is open and expressive, his manner is relaxed, and when he speaks he's friendly and direct. Margaret is more reserved, but with too sweet a smile to appear stand-offish. She has a soft, warm voice and an intriguing presence. She also has black skin.

They met at a party in Appomattox County after Carroll's second hitch in the Marines. They didn't hit it off at first. "A woman is a peculiar thing, really," Carroll said by way of explanation. "I was trying to rap to her and right away she gets a negative attitude. But I was persistent. I wasn't gonna let this chick get the best of C.L.M., you know. So I said, 'Hey, I want to take you home.' She said, 'I didn't come with you and I hardly know you—and furthermore, my brother's gonna take me home.' I thought, *Hey, this is a challenge.* And of course it had a lot to do with the male's ego, too. The average

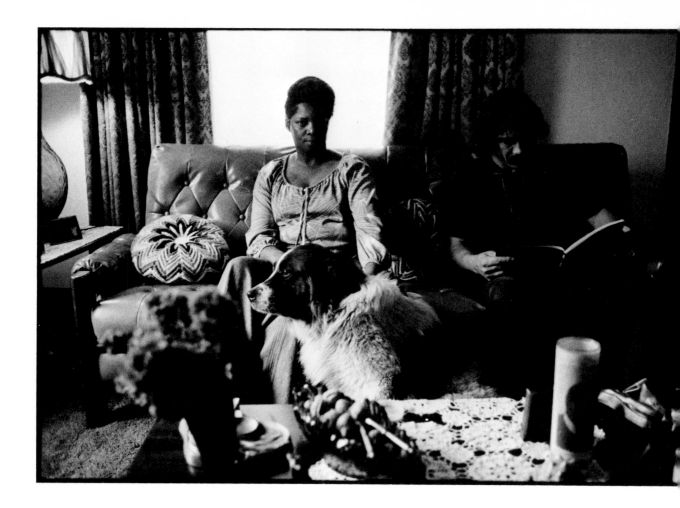

guy doesn't even want anything that isn't a challenge to him. So I said, 'I'm gonna follow you home.' She said, 'I don't care what you do, just get out of my life.' I followed her home, and all my manliness—'Come here, I want to talk to you. You don't put me off that easily.' So she got up on the porch and I just—well, you know the old feeling, she was getting ready to run off and I just grabbed her and kissed her. And sometimes you can feel a response from some women, you know.

"I found out right off the bat she wasn't no pushover. She wasn't like those chicks I had taken out before. If you really care about somebody you won't be thinking about getting in their pants the first time you meet 'em. Being a man, you do think of that, because usually that's the most challenging thing. But a man will respect anybody more just automatically if it's more of a challenge to him. Well, it was months, man. I started to give it up. I was used to those one-night affairs, and I guess I had an ego *that* big. She kinda punctured it a little bit, but it was a nice puncture.

"I really wanted a family, but things didn't turn out that way. Since they didn't, I'm kinda glad. I really think if I had a family I would have a whole different attitude about things, because I do love kids. But hell, I'm too old to even worry about it now. I have a low sperm count. One of the first things the doctor said to me was, 'You do a lot of athletic bullshit?' I said, 'Yeah, I like to work up a good sweat, cool down, and take a nice hot shower. Then I feel like I'm clean.' He said, 'For you, no more hot baths.' I said I wasn't going to give up my athletic abilities for anything. And my job—you can see the heat

involved. It was just like telling me, 'If you want to have kids, you're going to have to give up working on the open hearth.' "

Carroll was no more interested in giving up his job than he was in giving up his physical activity. He did offer his wife the chance to leave, but she declined. "We surmounted that one with ease," he said. A bigger problem has been his persistent womanizing.

"I guess I've always been something of a tomcat," he admitted. "I was married under the Christian faith—one wife and all that stuff—but I just can't conceive of that. A man's whole physical make-up is just different from a woman's. A man likes to meet a challenge, whereas a woman—even if she's a whore, excluding that she's doing it for money—she feels that she's got to have some reassurance because she's kind of giving up her body. A man, Christ, he'll try to hang his dick in anything.

"A man is an aggressive creature to start with. When it comes to a set of drawers, he's even more aggressive. A man—what the hell does he care about being rejected? But you let a guy reject a woman—God. I've been in predicaments where I just straight-up told chicks, 'Hey, no'—or been in bed with 'em and the old thing fell, you know. And they want to know why. They won't actually come out and say it, but deep down inside they know, *Hey, I just don't have what it takes to turn this guy on.* But it's even natural for a man to be rejected by a woman. You see a foxy broad, you almost introduce yourself with the feeling that you're going to be rejected. But the next day you wake up —*Aw hell, I was high anyway.*

"Women's lib and all that crap, that's something I feel strongly opposed to. It's petering out a little bit, but women tried to put themselves on the same level in every aspect of life as a man. Up to a point I agree with it—they are human beings. And naturally women are going to stick together, just like men stick together. But with this women's lib thing going on, that just intensifies things. My wife and my sister-in-law and my cousin and I, we used to sit up drinking beer. We used to have a pretty open conversation. And for every viewpoint that Gregg and I offered that we considered to be really philosophical, they'd come up with some off-the-wall shit just to prove their point —in other words, to equate themselves with men. And I say, *No way in hell.*"

There was a woman Carroll knew a few years ago who made quite a difference in his life, and might have made more had things happened otherwise. "I started to leave my old lady for her," he said. "She was outta sight, too. She was the one that really encouraged me to go to college and all that stuff. She came from an upper-middle-class family in Warren, but she was in Youngstown doing postgraduate work at Youngstown State University. Believe it or not, I met her at one of these little after-hours clubs down in Campbell— one of those places the fuzz never bother, you know. There's gambling and shit going on, and they search you when you walk in to make sure you haven't got a piece or anything. But it's cool in a way because, you know, gambling naturally breeds violence. I don't get into that, though. My old man broke me out of the habit of gambling when I was about sixteen. He threw me through a storm door.

"Anyway, I met her, and she wasn't a stuffed shirt, but she was a cut above the crowd that usually caters to that place. I got to rapping to her and she seemed interested. We had an affair for a good five years. She enlightened

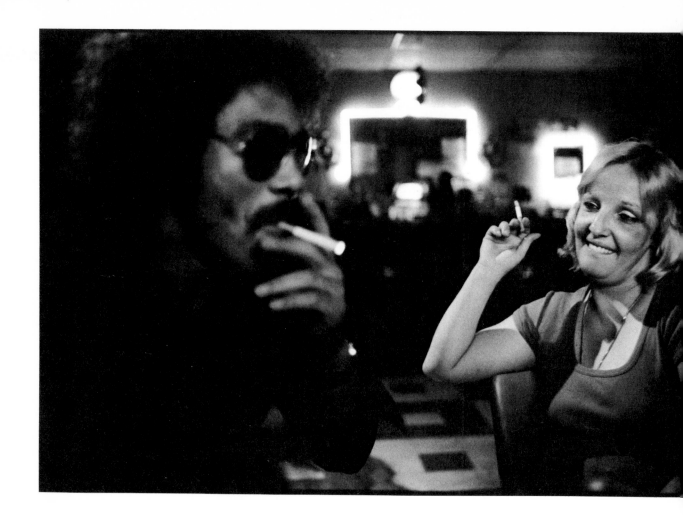

me to a lot of things. Plus we hit it off good in the rack and, like I say, every aspect of togetherness. She was the type of chick, she would even encourage me to go home. She did have my interests at heart. But I didn't really pursue it that much and, well, after she got her master's and graduated . . .

"But it was one of those things I never will forget as long as I live. You know how some women just inspire you automatically? It's really nice to have someone in your corner that you can really relate to. That's a problem me and my old lady have, communication. I don't mean to criticize her for that, really, because to be down on her is to be down on myself. It's just that I've gotten to a point in life where I'm not making any progress. It does bother me. Sometimes it gets to the point where it's almost unbearable. I guess that's why I live my life the way I do. I know I do have a greater potential. . . .

"I dunno. It's so hard to communicate with my wife. Then, too, maybe it's me. Maybe I'm still on an ego trip. We just don't get the same—*reading* outta the same things, you know? Like on my days off, I'll be gone somewhere. I'll be with a different chick maybe twice a day. Maybe I'm sick, I dunno. It's just the way I feel. . . . I got this one little seventeen-year-old chick, man, she is *laden*. She's got a fucking body on her, Jesus Christ. She's tall, too—long-legged. . . ."

Over the years there have been many women. A racketeer's daughter. An unemployed lady steelworker and mother of four. A laid-out chick named Sammi with a body on her that was outta this world. It hasn't always been smooth; incriminating evidence has sometimes been discovered. "Sometimes

you get your shit crossed up," Carroll admitted. "You can't play the game the way it should go." There's been a lot of time spent in the bars where steel-workers hang out, long, low places with small windows, dark, grungy interiors, and names like the Flat Iron Cafe and the Top Hat Lounge, names that do not derive from a sense of camp. Some of these places are pretty rough; sometimes Megginson feels obliged to keep his .38 in the glove compartment, at least. Usually, though, he doesn't go anyplace where he knows there's going to be trouble.

Trouble happens easily in Youngstown, but at least it's not too often of a racial nature. "That's why I belong in Youngstown," Carroll said. "The people are really together here." Certainly the ambiguity of his racial status is more comfortably borne than in Virginia, where, as he put it, "if you've got an ounce of black blood you're a nigger as far as they're concerned." Carroll has light skin and hair that's kinky the way a white person's might be. His father has tan skin and kinky hair, and his mother had fair skin with brown hair and blue eyes. Her father was white. A lot of the older people in the family considered themselves better than black people, but of course most white folks wouldn't associate with any of them. Megginson figures he got over his own racism in the Marines. Still, in Youngstown, he seems to get along better with whites than with blacks. When he walks into a black joint and starts rapping with some foxy chick, somebody's liable to ask her why she's fooling around with a honky. In white joints he's often taken for a Puerto Rican or a Greek. What he likes to tell people is that he's half black and half white, you can pick the half you like.

Either way, he's ready for a good time. "Who wants to get old?" he asked me one afternoon. "I always say, 'Nothing old but gold, nothing big but a bankroll.' A lot of people used to tell me, 'Carroll, why don't you act your age?' But I like to think young. And I think in order to feel young and be young, you've gotta kinda go down the ladder just a *little*—just a cunthair, you know?

"I love life, man. Providing it's something I get some enjoyment out of—and I do enjoy most aspects of life. It's just like that song, the Floaters thing—'My name is Charles and I'm a Cancer/And I love everybody and everything.' "

One place Carroll and I spent a great deal of time was the International Bar on Poland Avenue, just around the corner from Sheet & Tube's district headquarters. The district headquarters sports green lawns and a sign bearing the familiar Sheet & Tube logo—a slightly modified male symbol emerging from a ladle. The International is a flat brick building squeezed between the street and the hillside that drops down to the recently silenced open hearths of the Campbell works. It has pinball machines along one wall and a pool table in the middle and a long bar that stretches its entire length. Elaborately attired ladies lounge at intervals along the bar, waiting to be pawed. Lately, however, there have been fewer steelmen to oblige them.

One afternoon, in fact, a couple of hours after the end of daylight shift, there were only four people in the place: Paul, its stooped and grizzled owner; Mary, his wife, a broad-shouldered, big-busted woman who was running the place from behind the bar; a truck driver in his early thirties who lounged

nearby; and a lone man who seemed lost in his beer. They were discussing the empty open hearths down the hill behind them.

"They ain't gonna start that mill up again," the truck driver declared. "This whole Save Our Valley thing is a farce."

Paul gave a snort. "You know what they did to me down in Lowellville? They shut Sharon Steel down. They closed our place same as here. It's *obsolete!* This place is *obsolete!*"

He paused, then began to sputter. "And we used to make the best—the best—"

"Stainless steel," his wife prompted.

"Stainless steel and bars around here. I used to see it in the paper—Ford wouldn't use nothin' but Lowellville steel."

"They used to make good steel then," said the truck driver. "They don't make good steel now."

Paul walks with a limp because twenty years ago he almost fell into a soaking pit—one of the pits in the blooming mill where steel ingots are heat-soaked until they reach the proper temperature for rolling, which is around 2,100 degrees. His father grabbed him by the ankle as he was going down; it broke his ankle but saved his life. He was laid off in 1960, and after that he sold some stock and purchased the International. "He bought himself a job," Mary explained. "That's how we're in this business."

"I bought headaches! You know what a headache is?"

The truck driver broke in. "If Lykes woulda took all that money they took outta this mill and rejuvenated this place, it wouldn't *be* so obsolete."

"They didn't spend a dime down there." Paul motioned toward the wall behind the bar.

"You know what they did? All the big shots, when Lykes took it over, they sold their own stock. They knew what was coming. They all resigned and left. All the top dogs that knew what was going on. They got out."

"Save Our Valley." Paul's lip curled in disgust. "They'll never start up Sheet & Tube again. Never. *Never!* Never see it no more. It's done. This town is gonna be a ghost town. Christ, you can see our business. People ain't workin', they don't wanna spend money."

"His brother worked at Sheet & Tube twenty-eight years," Mary volunteered. "Twenty-eight years, and he gets phased out. Five children."

Paul surveyed the bar. "We used to have people lined up two feet deep when we bought this place. You couldn't get in here."

"We used to have a lotta young kids who were going to college," Mary said. "They used to work night shift so they could go to school. All those kids have left town. There were three of 'em in here about three weeks ago that went to Houston. They said it's just fantastic down there. They said all you have to do is walk past a construction site and they hire you. They never wanna come back here no more."

"Texas has got to be the boomingest state right now," the truck driver declared. "This place here, man, it's just—I was born and raised here. I left here and the biggest mistake I ever made was coming back. For all the manpower they have here, it's just amazing they let this place die."

The conversation continued. Eventually the door opened. Everybody turned to see who the new customer would be. It was a familiar face.

"Henry!" Mary shouted. "You want a shot or a beer this time?"

"Shot," Henry said, sourly.

"Shot."

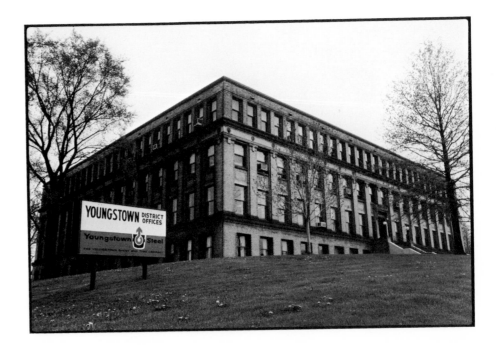

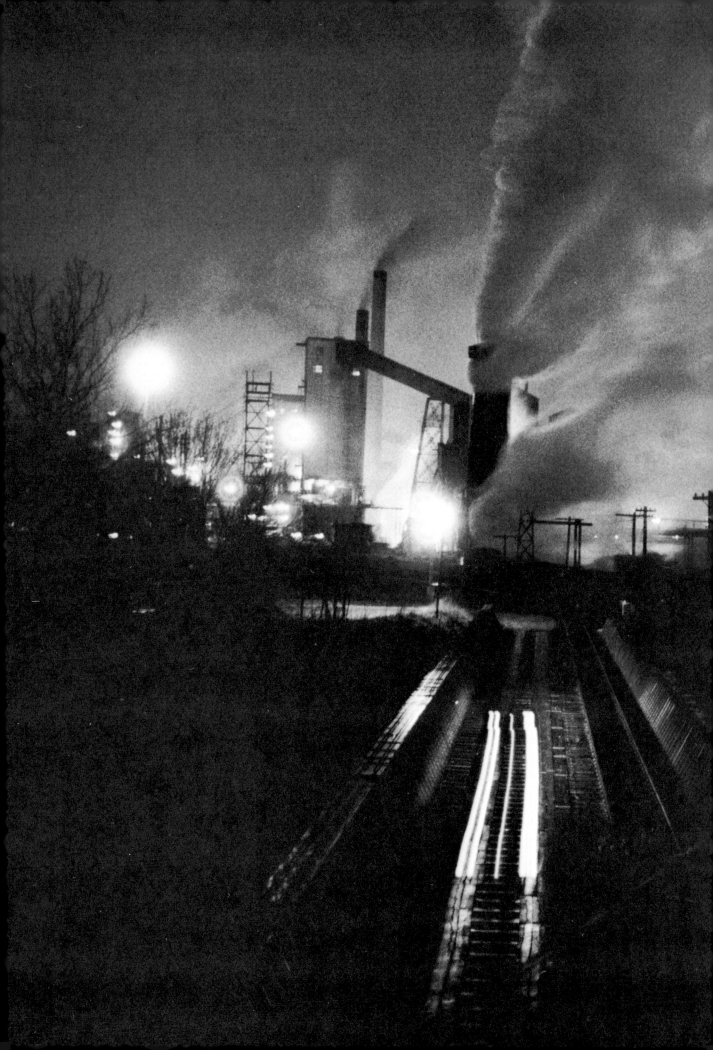

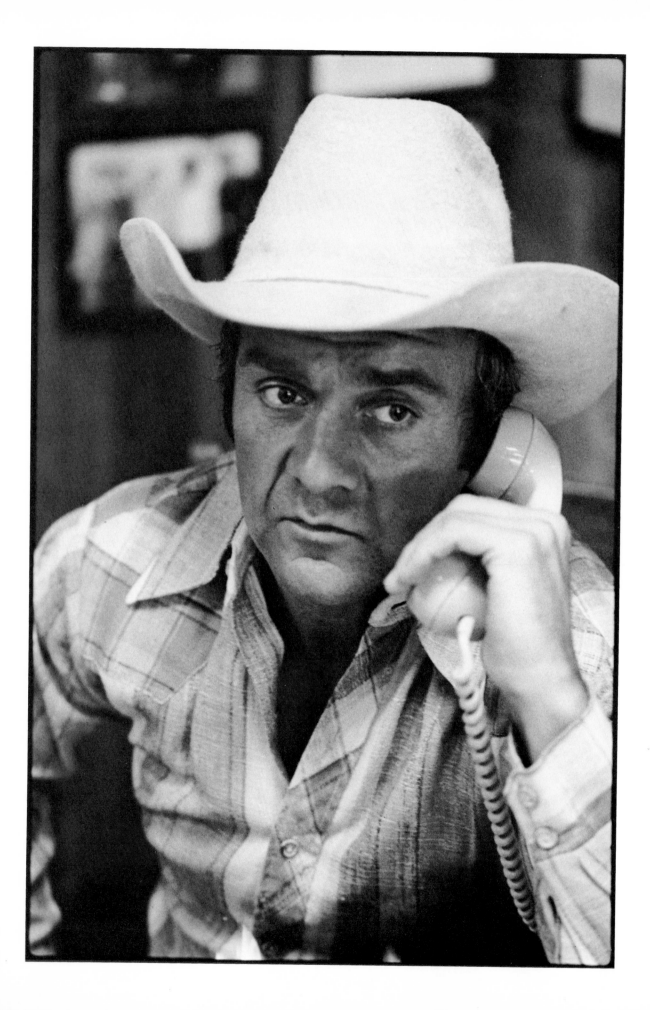

Billy Bob Harris

A. G. Edwards & Sons
Dallas, Texas
"Mr. Dallas"

We're just kinda *easin'* around Dallas," Billy Bob said, and indeed we were, riding in style in the back of a long black Cadillac limousine on loan from a friend who owns a bank. Billy Bob's own Cadillac was in the shop. Billy Bob leaned forward to point out landmarks on the skyline. "See that one with the star on it that has that phallic-looking symbol? That's the Republic National Bank. And the other one over there with the two big buildings is the First National Bank. That's the two biggest banks. The Hyatt Regency Hotel is those glass-looking space buildings beside—see that Hertz Rent-a-Car sign? That is the Texas School Book Depository, that's not the Hertz building. That's the building where the President was shot. We've got a lot of things we're more proud of in Dallas than we are of that, but still . . ."

It was nighttime on the Friday before the Fourth of July. We were on our way to the Mesquite Rodeo, which is held every Friday night in the little Dallas suburb of Mesquite, Texas. Behind the wheel was Larry Mahan, the only rodeo cowboy ever to have won six world championships. We were going to see Monty Henson, twice a world champion in the saddle bronc competition and a graduate of Larry's rodeo school. Monty would be riding tonight. Later we would all go over to Billy Bob's for a party. Billy Bob's parties are held every Friday night too.

Larry Mahan successfully negotiated a roadside checkpoint set up by the Mesquite Police Department, then drove up to the stands and into the parking lot reserved for rodeo contestants and staff. He and Billy Bob led the way to the narrow wooden platform behind the chutes where the bulls and broncos are held just before they're let bucking into the arena. The only other people behind the chutes were young cowboys about to ride, all of them tall and slim in blue jeans and brown leather chaps. Each one began to shift nervously from foot to foot and make twisting motions with his hips and shoulders as his turn to ride approached. The air was redolent with the mixed aroma of fear and horseshit.

Henson stayed on his bronco the required eight seconds and then dismounted uneventfully. One of his competitors, however, got thrown into the air and landed facedown in the mud. He lay there for several seconds, with his knees under his stomach and his rear end in the air, before anyone could react; then other cowboys came running from behind the chutes and helped him to his feet. A cheer went up as he hobbled out, stunned but with vertebrae miraculously intact. The sight reminded Larry and Billy Bob of a fellow in Larry's rodeo school who'd been thrown and then trampled. Larry had found an ear on the ground and carried it in a handkerchief to the hospital, where an attempt was made to graft it back on. The kid got religion upon regaining

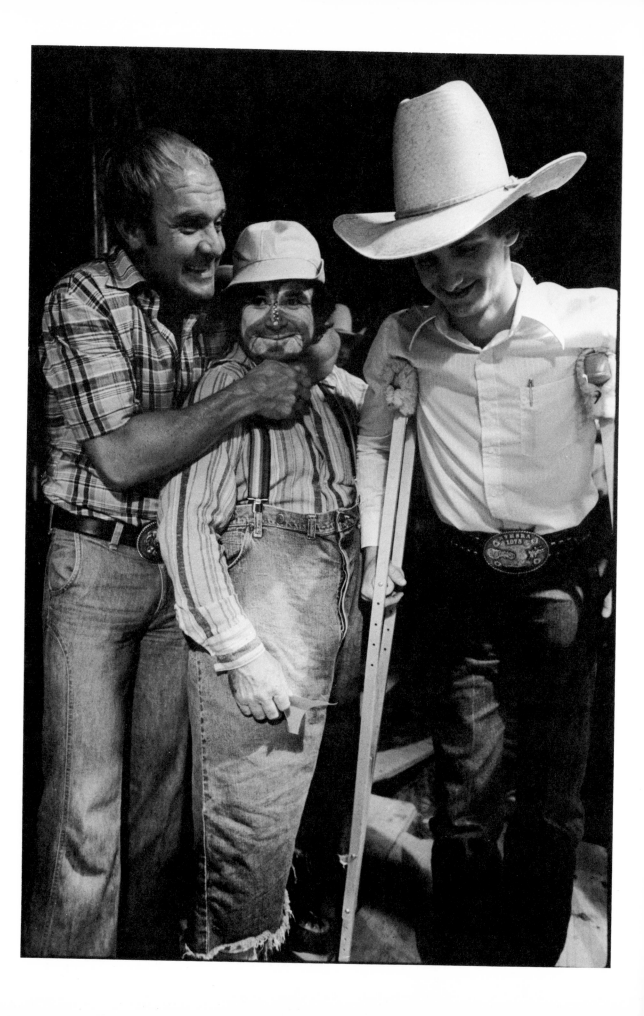

consciousness, but then he backslid and the ear refused to take. The doctors tried to build another ear back up, but he got himself in a barroom brawl and got smacked up side the head.

Billy Bob shook hands with everybody he knew and most of the people he didn't. Besides his wide smile he was wearing tight white jeans, hand-tooled ostrich-skin cowboy boots, and one of Larry Mahan's six world-championship belt buckles. No one mistook him for a cowboy, however. He's a stockbroker by profession, but no one took him for that either. He looked more like a radio evangelist on hand to offer salvation between events.

"Billy Bob is an amazing character," Larry Mahan had told me that afternoon. "My life has definitely changed since I met him. Shit, I used to be an introvert. Now I'm a pervert—I mean *extrovert,* that's it." Larry'd grinned.

"I wasn't really outgoing. I wasn't inhibited, but I didn't have the courage just to *go* for it. If you don't swing at 'em, you can't hit 'em. At first the idea is to make money; then it just becomes to do things successfully. Of course, the more irons you've got in the fire, the more problems you're gonna have. But then the benefits are greater in the long run—even if they are the mental benefits of achieving something a lot of people wouldn't go for because they're satisfied with what they're doing.

"I think Billy Bob probably has more friends than anybody I know. That's because he's done so much for so many people, from rodeo cowboys to old ranchers to movie stars to famous musicians. He really likes to make people happy. He should be an entertainer, he's that kind of guy. And beautiful women—he knows 'em all. If they live in Dallas or any one of the forty-nine surrounding states, he knows 'em. But he has a lot of respect for them. It's not like he's keeping score to see how many he can nail this week. He just meets 'em. Going down the road, he'll pick up the phone in his car and start—" Larry was waving his arms. "I think he's a true believer in, you know, if there's a will there's a way. Even if he has to have a wreck—then he'll roll out and have some sort of fit. Pretty soon they're caressing his forehead, thinking they've killed him.

"The guy is a movie—I mean, the son-of-a-bitch is a movie. You can tell right here from the walls." We were sitting in Billy Bob's apartment; Billy Bob himself was out by the pool. "No, I've never met another one like him. I've met a lot of people, but he's a one-of-a-kind."

Actually, if you were to judge by the walls in his apartment, you'd have to conclude that Billy Bob Harris is not a movie but a photo album—a photo album filled with hundreds of fuzzy color snapshots of Billy Bob and his friends, each snapshot blown up by a photo lab and framed by an old frat brother named Terry Thomas. They cover every wall in the downstairs half of the apartment. Each one is of special significance to Billy Bob. "That's Mac Davis and I," he told me one afternoon. "You can tell what kind of shape Terry Thomas thought we were in the way he tilted the frame. . . . That picture was of Alex Hawkins—you know, the announcer?—and Ray Wyley Hubbard and Larry Mahan. Larry had his arm broken and had a beard. . . . This picture is one of my favorites. It's of D. D. Lewis. What had happened, he had sprained something and they were tapin' him out at the Cotton Bowl and it looks like the guy's doin' something else to him, the way he's

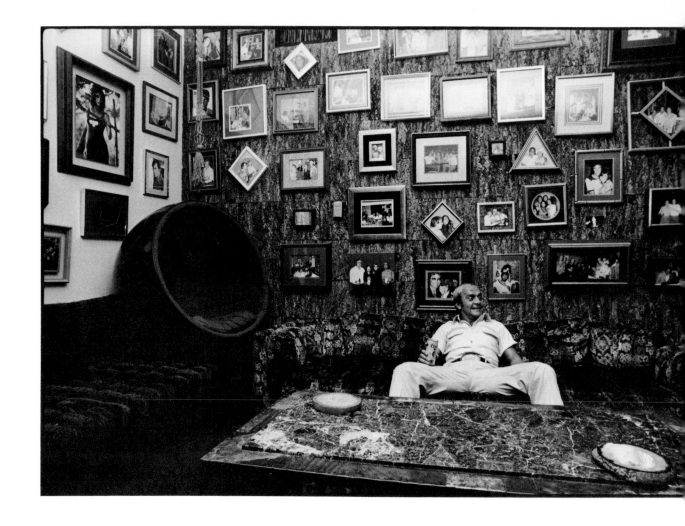

wrappin' his arms around him and got his pants pulled down right in front of probably seventy-five thousand people. . . . I was at this wedding where Kenny Rogers and Marianne got married—Marianne Gordon, she's on 'Hee Haw.' That's John Davidson and Glen Campbell and John Denver. . . . That picture up there was when Larry Mahan was hung to a bull, which is the worst thing you can do. He had his hand hung in the bull and he couldn't get loose. Hooked him there in the rear end and then you can see, he got a horn run right into his stomach. . . . That picture was made in Las Vegas, we went out there to see Elvis. There's Wade Moore, trying to let a little joyful noise fill the air. . . . That picture's of Dan Pastorini, quarterback for the Houston Oilers. . . . That's a picture of the Righteous Brothers with Wade Moore. . . . That's a picture of Larry Mahan and B. J. Thomas. . . . There's Don Meredith and myself, that was made down in Atlanta. . . . That picture up there is of Larry Mahan, my father, and Roy Rogers. That picture was taken when Larry took my dad out to see 'em makin' a movie. I got the same one in my office. . . . That girl with the rose in front of her face is one of the leading models here, her name is Carla Pate. . . . And I *love* this picture of Golden Richards and Craig Morton. You know how football players pat one another on the rear end? He was patting him just as he snapped that thing and it looks like he's right up there in front of sixty thousand people with his hand on his butt. I call it 'The Golden Touch.' . . . That's when I was in London, England. I was over there on a business deal and I walked up beside that guard and stood up real straight like he did. . . . That's a picture of

Roger Miller and Cathy Carlson and myself. . . . Connie Stevens and my-self. . . . There's Tootie, my secretary, and Jim Grant, used to be one of the Five Americans. . . ."

A plowboy from West Texas who came to Dallas to become a stockbroker, Billy Bob Harris is a classic American success story with a style that suggests he learned it all from a matchbook cover. He didn't. Friends say he was born with his winning personality—the down-home charm that captures people's attention, the ability to entertain that holds it so easily, the earnest desire to give that binds it so tight, the obvious sincerity that saves all this from feeling calculated. He was born with something, to be sure—like his tremendous energy, which enables him to approach everyday life with an intensity most people can summon only in moments of dire emergency. But a lot of it was instilled in him, too—the determination, the discipline, the endless succession of goals, the positive attitude. Most of all, the positive attitude. Billy Bob comes from Dust Bowl country, where without a positive attitude you simply don't survive.

Billy Bob grew up on a farm in Hansford County, Texas, just outside a little town called Gruver. Gruver is a settlement of eight hundred people about one hundred miles north of Amarillo and twenty miles south of the Oklahoma panhandle. It's a place where the temperature goes over one hundred degrees in the summer and below zero in the winter and the winds pile the snow into drifts as high as your house. It never rains. There isn't much to do except work, and not much work except farming or pumping gas. Billy Bob left at eighteen to go to college in Denton, forty miles north of Dallas. He liked it there so much he stayed five years and got two degrees. He wanted to keep on going forever, but instead he went back to farm his daddy's land. He hated it, however, and after a couple of months he got a job, with the help of his stockbroker friend Wade Moore, at A. G. Edwards & Sons, a large, conservative, St. Louis-based brokerage firm. He has been there ever since.

Billy Bob's is not the style of the average broker. His clothes are unconventional: the outfit he wore to the rodeo in Mesquite is the same kind of outfit he wears to work every day. His manner is aggressively folksy. His apartment is a riot of color—sunken living room with yellow walls, black drapes, red striped chairs, gold and black sofa, electric-blue spherical easy chair in the corner, marble coffee table, deep-blue carpet, bright-red telephone, and of course snapshots everywhere; "soul room" in the back with red upholstered banquettes, red and orange flowered wallpaper, built-in bar and refrigerator, and flashing antique jukebox stocked with Elvis Presley and Jimmy Reed singles; master bedroom upstairs with deep-blue patterned wallpaper, mirrored wall opposite the bed, and private bath with a speaker in the shower and mirrors on every surface, so that when one Billy Bob takes a razor to his stubble, a thousand Billy Bobs do likewise.

There are two other bedrooms upstairs: one is used as an office and has photographs of his parents on the walls, the other is the spare. It has long been customary for the spare bedroom to be assigned to one of Billy Bob's closest friends from out of town. Currently it's reserved for Larry Mahan, who makes his home in Sherman Oaks, California. Before that it was used by Donny Anderson when he was playing fullback for the Green Bay Packers. Billy Bob's friends love to tell you about the time Don Meredith was on ABC's "Monday

Night Football" and remarked that Anderson might be called "the Golden Palomino in Green Bay, Wisconsin, but in Dallas, he's known as Billy Bob Harris's roommate."

The Friday before the Fourth of July had dawned cloudless and hot. The Dallas *Morning News* carried a front-page article about a gun-toting night magistrate who defended his practice of accompanying sheriff's deputies on drug raids when he was "sitting around with nothing to do." "Men losing testicles needlessly, doctor says," warned a large headline inside. After the rodeo, Larry drove to a white ranch-style antebellum mansion deep within the leafy recesses of North Dallas to pick up Billy Bob's date, a young lady named Dana whose dad owns an advertising agency. Although Jewish, Dana has blond hair, blue eyes, and those bottomless pools of charm that are the mark of the true southern lady. Shortly after stepping into the limousine, she asked how I liked Dallas. When I replied that I liked it fine even though I hadn't yet seen the main part of town, she made a gesture toward the trees and the lawns, fixed me with a big-eyed smile, and said, "But Frank, this *is* the main part of Dallas."

Billy Bob's party began around one. Any number of pretty girls showed up, each one of them charming, some of them delightful, quite a few divorced. Flirtatious hands passed beneath the three Larry Mahan world-championship saddles on the banister and were met by syrupy responses like "Come over here, sugar-bugger, *good-ness!*" Several musicians came, including Alex Harvey, who wrote "Delta Dawn," and each one took his turn performing on Billy Bob's out-of-tune piano or his own acoustic guitar. Terry Thomas did a real low-down Delta blues number about this big-legged woman, and then a long-haired lounge musician did some Elvis tunes that had Billy Bob hollering preacher-fashion in the middle of the floor. "You ain't nuthin' but a hound dog," he would sing, while Billy Bob raised his arms and shouted, "Oh children! *Talk* to me now!" "They said you was high-class/Well that was just a lie," he would sing; "Aw! *Testify!* Deep down from the bottom of your soul, brothers and sisters!" And so on. It was well past four by this time.

Despite such merriment, Billy Bob's friends later gave this party only a fair-to-poor. Their Monday-morning quarterbacking laid the blame to a sudden overdose of cowboys who appeared uninvited at the door. Billy Bob strives earnestly to have the right mix of people at each gathering, but his Friday-night parties have grown so popular—no, legendary—that people who don't even know him tend to drop in anyway. He is hospitable enough to make no objection as long as they are polite and attentive to the music, even though this does make more difficult his task of finding the proper mix. Nevertheless, a young man who said he owned an oil company did look me firmly in the eye and say, "This is the best place to be in Dallas on a Friday night."

Saturday morning dawned very late, well after noon in fact. Billy Bob's first major activity of the day was to worship at the 7 P.M. Praise 'n' Prayer service at the Highland Park Presbyterian Church. His own car still wasn't back from the shop, so he took the limousine and drove to North Dallas to pick up a wealthy divorcée named Ann, who emerged from her doorway in a white silk gown embroidered with red silk roses. "Isn't this the richest church in the world?" he asked after she got in. "It's *not?* Well, it oughta be."

Praise 'n' Prayer is Billy Bob's regular weekly devotional. It was run that week by a middle-aged, beer-bellied preacher with steel-gray hair and a guitar slung across his back. He swung the guitar around for the praise part, which consisted of folk/gospel-type hymns with quasi-erotic titles like "Reach Out to Jesus" and "He's Everything to Me." The prayer part was shorter and mostly involved people picking prayer requests out of a collection basket and then praying aloud for their anonymous fellow worshipers. On the way out Billy Bob spent several minutes chatting up a little crippled boy he has befriended and introduced to numerous superstar athletes. Ann took me aside and said, "Pardon my language, but our Praise 'n' Prayer's been all shot to hell." It seems the preacher had only been there three weeks and didn't know the right hymns. The former preacher had left to sell real estate.

Dinner was at Campisi's Egyptian Room, generally touted as the finest Italian restaurant in Dallas. There was a long line outside, but Ann got the proprietor to let us in by the back door, which was conveniently located right next to where everyone was waiting by the front door. We were joined at dinner by a twenty-three-year-old bail bondsman named Rhett and his girl friend Tracy. She told racist jokes ("Do you all know math? Well, what's this equation: 270—P=ANOW? You don't know *that?* That's '270 days minus the pill equals *another nigger on welfare'!*") while he fanned himself with a money clip stuffed with hundreds and chatted with an enormous black athlete who was carefully pretending not to hear her. Billy Bob picked up the tab.

Sunday dawned pretty late too. The papers were full of news about the previous day's rock festival at the Cotton Bowl: 75,000 people, temperature on the floor reached 130 degrees, had to hose 'em down like animals. Dana joined us for dinner, after which the limousine's electrical system died. Billy Bob called the shop and hailed a taxi. We stopped backstage at the Cotton Bowl, where Willie Nelson was holding his annual Fourth of July picnic ("Have you ever been to a picnic where they were sloppin' hogs?" one girl asked; "Well, that's *exactly* what it smells like in there."), then drove on to an intimate little singles place best known for its unlikely combinations of alcohol. Billy Bob remarked that at Wellington's, a disco he turned into the most popular nightspot in Dallas, they'd mixed rum and Coke and Kahlua and cream all together and made it the hottest drink in town. "It's amazing how a drink can catch on like that," he said.

Billy Bob's own car, a dark-brown Cadillac with a telephone under the dashboard, was waiting in his garage the next morning, so he drove it to the office. By the time he got there it was boiling over again, so he called the shop and they left him a light-brown Cadillac in the parking lot. After the stock market closed he drove it to the airport to meet Jenny, his date for the Fourth.

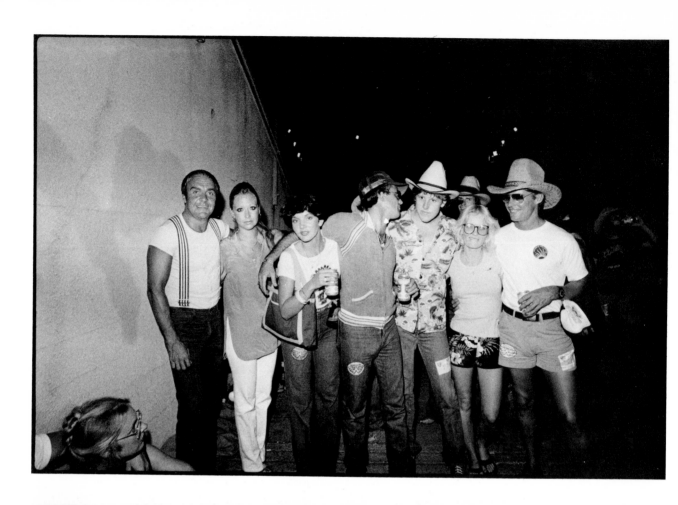

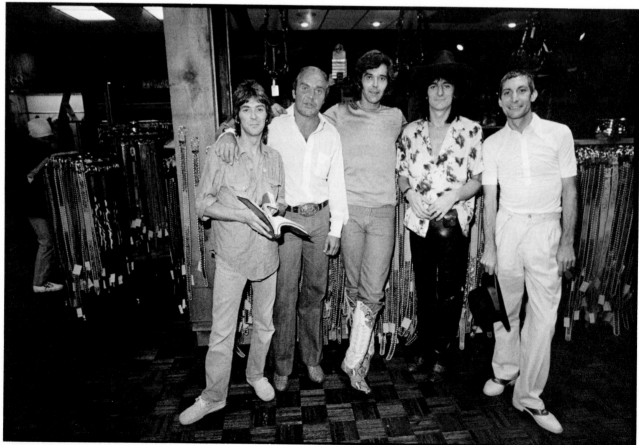

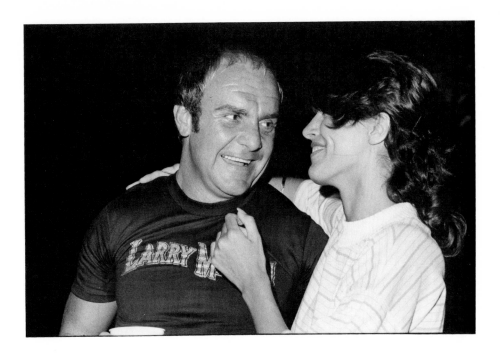

Jenny used to be a Braniff stewardess before she won the Miss World Airlines competition and went to Los Angeles to do television commercials. Billy Bob met her years ago in a supermarket. He saw her pushing a shopping cart and thought she was the prettiest girl he'd ever seen. He started to go up to her but she was so pretty his mouth wouldn't work. So he went home, called the supermarket, and asked them to page the pretty girl in the red dress. When she got on the phone he told her his name was Billy Bob Harris. She told him that was the funniest name she'd heard yet. He told her she was the prettiest girl he'd ever seen, and they made a date.

It was still only the third, but we drove that evening to a Fourth of July barbecue at the Flying W Ranch, which belongs to a dress manufacturer. The food was traditional and superb: smoked sausage and beef brisket with barbecue sauce, cole slaw, beans, and beer; but Billy Bob had to be careful, because spicy food gives him instant intestinal trouble. On the way back he told a funny story about Susie Sirmen, the one-time model, now homemaker and born-again Christian, who enjoys the distinction of being the only girl he's ever seriously fallen in love with. Susie is now married to Craig Morton, former quarterback for the Dallas Cowboys. Craig is one of Billy Bob's closest friends. "I'd been dating Susie for a year or two and everything was fine," Billy Bob said, "but the latter part wasn't as good. So I told Susie, 'We need to start dating other people and not ask each other any questions.' She said, 'Okay, that'll be fine.' So for about a month I kinda rocked around town and I thought, *Hey, this is perfect.* Then Susie started leaving on weekends, and I thought, *Where in hell is she going?* But our deal was that we wasn't gonna ask any questions.

"At the same time, Craig Morton was battling Roger Staubach for his job. On Friday it was announced that they were gonna start Staubach, so that Friday night it was all across the headlines—'Staubach Beats Out Morton.' Elvis was in town that night, and I knew how bad Craig was feelin', so I called him and said, 'I've got two tickets to see Elvis, just come with me and it'll make you feel better.' He said, 'Fine.' So we went in and we sat down and everybody was walking in and saying, 'There's Craig Morton, there's Craig

Morton!' Well, this comedian opened the show and he'd read the papers that day and he said, 'You know, a guy walked up to me and said, "Hey, I must be your manager." I said, "What's the matter, don't you have a job?" And he said, "No, I lost mine." So I said, "What's your name?" and he said, "Craig Morton."'

"With this, Craig just *died*. I reached around and said, 'Craig, Craig, don't worry about it, it's just some comedian. Come on, let's have a good time now.' So Craig kinda raised back up in his seat, and then Elvis came on with all the *splendor,* the spotlight, the little cameras goin' off, and everything else. He sang three songs, took his microphone off the podium, walked to the front of the stage, and said, 'My next song is going to be "The First Time Ever I Saw Your Face"—and this is goin' out to you, Susie.' Craig and I raised up and there was my girl in the front row. All of a sudden it hit me—that's where my girl's been going. And Craig said the smoothest thing in the world. He reached over and said, 'Billy Bob, Billy Bob, don't worry about it. It's *just* Elvis Presley.'"

It was later that evening, back in his apartment after the barbecue, that Billy Bob demonstrated his fabled Elvis impersonation. We'd stopped by a hotel on the way back to see Floyd Dakil—Floyd's a Lebanese boy, has a lounge act, father's the Lebanese consul in town—and had gone home to Billy Bob's to party with some of his musicians. When "Blue Moon" came around on the stereo, Billy Bob jumped up on the coffee table. He'd turned up his collar and was swiveling his pelvis wickedly as he lip-synched the words into an imaginary microphone. The bulge in his pants grew noticeably larger. It was a splendid performance, worthy of the King himself. Afterward we helped him off the stage while he panted. "It hurts me when I do those sexy things," he moaned. "*Great* God almighty!"

Coming as it did after all this, the actual Fourth of July seemed somehow anticlimactic.

Dallas is flat but not devoid of character. Its cultural tone is set by an overabundance of money, a widespread reverence for Jesus, a lingering antipathy for "niggers," and an almost unseemly preoccupation with the phenomenon of the pretty girl. Football and divorce are unfailing topics of conversation. There is violence in the air, but nobody locks their doors at night, for it is not the big-city pattern of random violence from without but an altogether different pattern of random violence from above—from lofty perches, from summits of power. Cadillacs, testicles, and bulging money clips are the sure routes to the higher places, although a high-powered rifle and an empty stairway will do.

One of the places we went with Billy Bob was the new Hyatt Regency Hotel, a complicated-looking assemblage of silver mirrored glass between Dealey Plaza and the interstate. There is a large concrete needle next to the hotel and on top of that a revolving restaurant, the highest spot in town. There's nothing much else in the neighborhood except the book depository, the grassy knoll, a courthouse, and several parking lots. The Hyatt Regency has valet parking. As Billy Bob's Cadillac was being retrieved, one of the black valets—the valets are adolescent boys, some black, some white, who wear little blue shorts and often lounge around with their testicles spilling out—told me

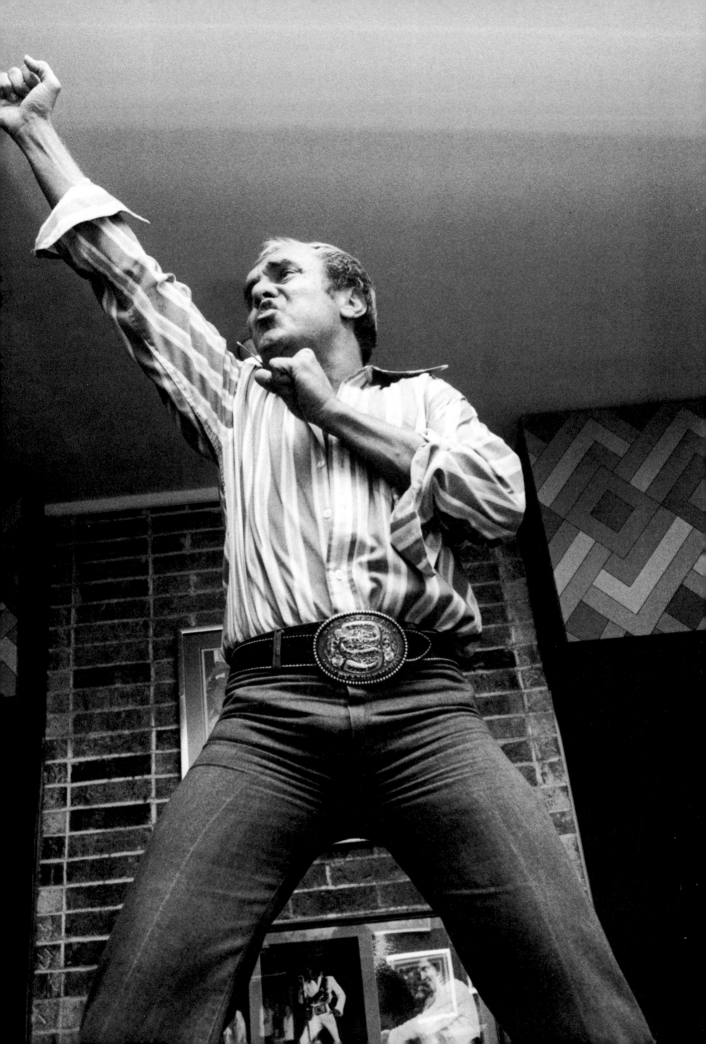

that as sure as the sun comes up in the morning, you're going to find white Christians in Texas. He did suggest, however, that if you were to drop an atomic bomb on Waco, one hundred miles south of Dallas, you could eliminate a whole lot of them.

People in Dallas seem to have an ambivalence toward Jesus and "the niggers" that they don't show at all toward money and pretty girls. "The niggers" don't offer salvation, but then Jesus never got down and sang the blues on Friday night. You can see the dilemma. It's not surprising that most of Dallas' social contradictions should touch the Jesus/"nigger" nexus. But for most people, that's a matter of minor concern. Dallas is primarily a money town, and there are no contradictions there at all.

Downtown Dallas is where the money goes to work; Highland Park and North Dallas are where the money sleeps at night—the "really old" Dallas families in Highland Park, the "*real* money" in North Dallas. Akard Street is the conduit into town for traffic from the Dallas North Tollway, which runs in a straight line connecting the three. Billy Bob's office is right on Akard, just past the Fairmont Hotel (fanciest in town, must have been designed by an architect with an uncle in the marble business), on the first floor of a big new building, with two walls of windows overlooking the street. Friends like to tell about walking up Akard and looking in Billy Bob's windows and seeing him with a telephone at each ear and a pretty girl outside getting the ogle. Billy Bob often does appear to be having a good time, with his ostrich-skin cowboy boots propped up next to the nameplate that was whittled by his friend Walt Garrison. But the phone calls and the pretty girls don't really happen at the same time; that's myth. When you're on the wire with Billy Bob, you have his undivided attention.

Billy Bob estimates that 99 per cent of his work is done on the telephone. Most of the physical labor in his job involves pushing buttons. He has a push-button phone on his desk, and on the table behind it a Quotron, a push-button device that provides an electronic readout on any stock—its price per share when last traded, its high and low for the day, its volume for the day, its closing price the day before, and so forth. Every broker has one. There are also two phones next to the Quotron that have no buttons; they just ring when you pick them up. Each is a direct line to a major investor. In addition, Billy Bob has ten phones in his apartment (one each in the living room, hall, soul room, kitchen, two bedrooms, three bathrooms, and office), two conduit lines to the pool, and of course the short-wave phone in his car. He calls them his security blanket.

Most of the people he talks to are investors. He's also in frequent communication with Edwards' head analyst and over-the-counter traders in St. Louis and floor brokers on Wall Street. When someone wants to buy, he calls the floor broker and stays on the line until the transaction is completed. "I can buy however many million dollars of stock you want to," he offered, "in thirty seconds."

He earns a quarter of A. G. Edwards' one per cent commission on all transactions. He does not get a salary. Sometimes he makes mistakes that cost him money. The other day he lost $1,700 in two minutes because of a slip of the tongue. Sometimes the people he buys stock for change their minds after he's bought it. That usually happens if it goes down instead of up before they get around to writing him a check. He got burned that way for $30,000 once early in his career, when he was making about $500 a month. Edwards picked up half of it; he paid for the other half out of his paychecks.

Since almost all his work is done on the phone, and since Edwards is easygoing about these things, Billy Bob has dispensed with the usual pin-stripe suits and club ties. He does not wear boots and jeans and form-fitting cowboy shirts out of rebellion, however. "If I felt it would offend a client not to wear a tie," he said, "I'd wear one. I'd wear *three* of 'em!" Of course, it helps to be successful, and Billy Bob is. Not long ago he passed the $1 million mark in commissions earned for the company and received a gold clock. He's had offers from other firms, but he likes the freedom Edwards gives him and the dependable record of its analysts. Recently he was made a vice president.

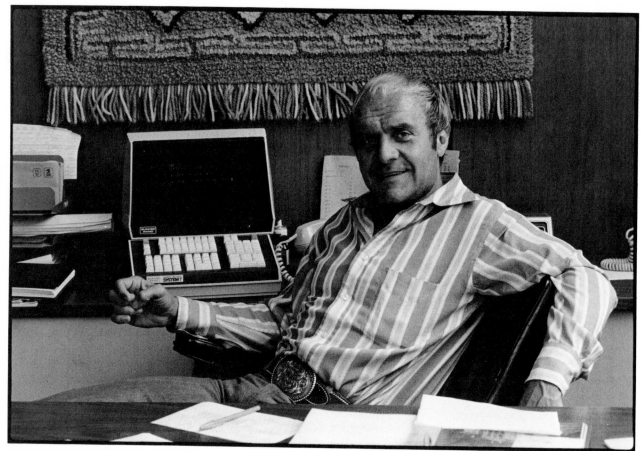

Billy Bob had never held a job before A. G. Edwards, which has 1,100 brokers in 135 offices in thirty-four states, hired him as a trainee. For six months he learned the business; then he was registered as a broker and put immediately on commission. He only earned $130 his first month, but he didn't get discouraged. He read you should approach the people you do business with, and since he only did business with his answering service, he called the man who owned it and has been handling his business ever since. His most influential client, now deceased, was Jack Vaughn, who owned the building his office was in. They met in the elevator. Billy Bob knew Vaughn was a board member of the Dr. Pepper Company and the First National Bank and had large stock holdings in both. He'd get on the elevator and say, "Jack, Dr. Pepper is thirteen and a quarter, First National Bank, forty-one dollars and fifty cents." Jack would say, "Thank you, Slim." That's the way it started. After a while Vaughn started opening accounts for his children with Billy Bob, and finally he gave Billy Bob all the stock he had with Edwards. He also introduced Billy Bob to other successful men in the business community, including Ethan Stroud, one of the leading tax attorneys in Dallas. One of the hot lines in Billy Bob's office is to Ethan Stroud; the other was to Jack Vaughn.

Billy Bob first attained success about five years after he started—about 1968. That was the year he bought his first car with a telephone, a Lincoln Mark III. The year after that he moved into his current apartment, which is in a modern town-house development only six minutes from work on the Dallas North Tollway. (It takes longer on the way in, however, because he stops every morning for silent prayer at the Oak Lawn Methodist Church.) Now he has fifty active accounts, some of which buy $300,000 in stock a week. Some days he might handle $2 million by noon. But he defines his job in terms of servicing the account, not selling stock.

"I don't have a real high opinion of most stockbrokers," he said. "I see what they do to make the commission dollar. I want to do good for people. I *really* want to do good for people. I'm very sincere about that. We've done real good for some people, other people we've lost some money. You know, you're gonna be wrong in the stock market, especially trading, but it *still* bothers me. Some people say, 'Well, you get used to it after you've been in the business ten or fifteen years.' I don't get used to it. I *worry*. But there's nothing that's any greater feeling than to do it successfully and make people a lot of money. Especially like some older lady that has some money, maybe the only means of support she's got is the money she's saved—to see her totally happy, that's a great feeling, man.

"I've got my priorities right, I think. Some people think I'm a real rock-around playboy, but when I'm down here it's totally serious. I've got a few interests in other things, but the stock market, and giving service to my people, is my top priority."

On the day after the Fourth of July we had dinner at the Ranchman's Cafe in Ponder, Texas, population 208. The Ranchman's Cafe is run by a woman named Pete who serves the best steaks most folks have ever tasted, accompanied by enormous glasses of iced tea and followed by grandiose slices of home-made pie. Our dinner companion was Rex Cauble. Rex owns three ranches, two Western-wear stores, a world-champion quarter horse, a horse-trailer com-

pany, some oil wells, a steel company, and a small bank. A cousin in Houston
handles half his investments; the other half goes to Billy Bob, whom he calls
"one of the most outstanding young men I've ever met." All his orders are
split down the middle.

Cauble was born and raised on a Texas cotton farm. He finished high
school at sixteen and went roughnecking in the oil fields. On his office wall,
across from the signed portrait of his good friend John Connally, is his high
school diploma and the $80 bank note he had to take out so he could get it.
He has a reputation for handling the money he's since amassed with what's
known as "Western flair." Certainly flair is the term for his Western-wear
shops, which cater to the multi-multi-millionaires of Dallas and Houston the
same way Nudie's caters to the entertainment celebrities of Los Angeles. The
stores are known as Cutter Bill's, after the quarter horse, which Rex keeps in
an air-conditioned barn the size of an airplane hangar on his ranch at Denton.
They offer an expanse of costly denims, leathers, jewels, and silk and are
staffed by sexy young sales personnel in skin-tight jeans who offer you beer
while you browse. The real Cutter Bill, now aged and wart-ridden but still val-
ued for his stud service, is a golden palomino who was a world-champion cut-
ting horse five times. (A cutting horse cuts calves out from the herd.) His first
foal was a world-champion cutting horse, and he has since sired a world-
champion reining horse, two world-champion halter horses, and a world-
champion Western pleasure stallion. Rex bought him when he was a yearling:
it was simply luck.

During dinner the talk turned to cat fries. Cat fries—Rocky Mountain
oysters, calf's testicles—are something of a delicacy in Texas. Cauble keeps
them in his freezer, but most people eat them only in the summertime, which
is when the new calves are branded and castrated. (That's one of the things
calves are cut out of the herd for.) Ranch hands put them on a stick and roast
them over an open fire. Other people slice them and then fry them batter-
dipped. Rex observed that the secret is to cook them well-done. "There's one
other delicacy that's really good," he added, holding thumb and forefinger
close together in anticipation of a truly succulent morsel, "and that's turkey
nuts."

"My father believed in labor," Billy Bob told me one afternoon. "Child
labor." We were talking about Billy Bob's early years in Gruver. Billy Bob
learned at an early age that he didn't want to be a farmer. When I asked how
early, he said, "About three."

There are a lot of reasons why one would not want to spend one's life
farming wheat and cattle in Gruver, Texas, but none of them deterred Billy
Bob's father. J.C.—that's his father's name—was an only child like Billy Bob,
and he grew up on a farm near Gruver too. His own father had come to West
Texas from Tennessee in a covered wagon. When he met Willie, Billy Bob's
mother, J.C. was running a filling station by day and farming by night. Later
he sold the filling station and borrowed enough money to buy his first section
of land. That was during the Depression and the worst days of the Dust Bowl,
when there wasn't enough to eat and the dust was so thick in the air you could
sit at the table without being able to see the overhead light. J.C. went seven
years without turning a profit, but he managed to keep borrowing, and finally

he brought in a crop so bountiful he was able to pay off all his debts. Later he became involved in other ventures—grain elevators, a truck concern, digging irrigation wells—and when some of the leading citizens of the community decided it was time to charter a bank, he was one of them. At the time I spoke to Billy Bob, J.C. and Willie—then sixty-eight and seventy respectively—had just returned from a church-sponsored trip to Red China and the Philippines. They're very religious.

Billy Bob's biggest problem with farming was the tractor: he hated it. It was hot and dusty and the wind would be blowing and he'd be up there on top of it all day long, all by himself. Billy Bob says he never felt lonely in those days because he never knew any better. Nevertheless, he did sense that somehow he didn't fit in in Gruver. He didn't know how or why, he just felt different. He kept wondering what he was doing there, what he was supposed to do with his life. Yet he managed to have a normal adolescence, Texas-style. He ran track, roped calves, drove the tractor, and got into a heap of trouble. He stole watermelons, he put a milk cow in the schoolhouse, he hid a school bus in a haystack. What time he had left he spent drinking beer and chasing girls.

His partner in most of these escapades was a boy named Mike Miller. Mike is still a good friend of Billy Bob's; he lives in Dallas now and was appealing a conviction for conspiracy to violate the federal gambling laws when I spoke with him. He grew up in a place called the Plant—a flat, barren spot of prairie that's home to a Phillips 66 plant and several other plants and the people who work in them. The Plant is nearly twenty miles north of Gruver on a road I'm told has one curve in it. It always seemed to Billy Bob like a lot of pretty girls came from the Plant, so he used to go up there on Friday nights. He drove it in fifteen minutes.

Billy Bob's first car was a '49 Ford he bought in 1956. The next year he got a '54 Ford, red, six cylinders, with overdrive. Mike had the same car only blue. They spent most of their evenings burning up the pavement between Gruver and the Plant and Guymon, Oklahoma, which is twenty miles on the other side of the Plant. There wasn't any place to drink in Gruver at all, but there used to be a little lounge in Guymon that would serve anyone tall enough to look over the bar. A friend took Billy Bob there once and bought him his first girl—a middle-aged hooker. Later Billy Bob took Mike. Mike remembers being petrified with fear. Billy Bob discounts the importance of both incidents.

He does not, however, discount the importance of the years he spent chasing girls. "We'd go up there to dance with the Plant kids, go into Guymon, Oklahoma, even go up into the edge of Kansas chasing girls," he said. "One summer we went off to Red River, New Mexico, about three or four of us guys, just chasing girls. That's all we wanted to do. That was the most important thing to me. When I was running track and roping calves, that was still in the back of my mind.

"Oh, Lord, I just run the *wheels* off those cars, you know—but then, I'd generally go ahead and go to work in the morning. And it wasn't like the stock market, the farm didn't open at nine; the farm opened when my daddy decided it was supposed to open. That could be five in the morning, could be six in the morning. I'd get up and I'd think, *Oh my gosh, I'm gonna stay home*

tonight, but then the sun would start boiling down where I was sitting on one of them tractors all day and I'm tellin' you, my mind would start to clickin' and I'd get in the car and go pick Mike up and run to Guymon. I never did— I continued doing it. I started to say I never did learn, but maybe I *did* learn. Maybe I was learning what I was supposed to *do!*"

Billy Bob went to North Texas State on the advice of his friend Rod Barkley. Rod was a second cousin, but he was more like an older brother to Billy Bob. He'd gone to North Texas himself and sung in a little quartet there with Pat Boone, Roy Orbison, and Wade Moore (who wrote "Ooby Dooby," Orbison's first hit). Rod had gotten his own TV show in New York after he'd graduated, but three years later he chucked it and came back home to Gruver to farm. Billy Bob was about fourteen then; he and Rod's younger brother Leslie used to sit up nights reading the fan mail.

Rod told Billy Bob the girls were seven-to-one down at North Texas. Billy Bob liked those odds. When he actually got to Denton he drove up to Texas Women's University, which is on the other side of town, looked around at all the girls, and thought he'd died and gone to heaven. Even when he discovered his mistake and went to the North Texas campus, he still found more pretty girls than he'd ever seen in his life. ("In Gruver," Mike Miller said, "they sent the pigs to school and took the girls to market.") What's more, he discovered that a little skinny kid like himself could ask them out and they'd go. Before long he was asking only the prettiest ones.

He ran track his freshman year, pledged Sigma Nu after Terry Thomas rushed him half to death, and shared a room above a doughnut shop with Leslie Barkley. The doughnut shop was known as the Chat 'n' Chew, but they called it the Barf 'n' Gag. Leslie quit school after a while, went back to Gruver, and married his high school honey. He has two kids now and farms the land that belongs to Billy Bob's parents. ("I guess he took my place," Billy Bob said.) Billy Bob stayed on—although he did quit track after his freshman year, so he'd have more time to run after girls. He used his time to hang around the student union and go on afternoon Coke dates, picking up a pretty girl at her dorm and taking her to a drive-in burger stand where they'd sip Cokes together. His record was twelve Coke dates in one afternoon.

Sigma Nu was something of a "good ole boy" fraternity at North Texas; they didn't go after the jocks or the cool daddies, which was good because Billy Bob wasn't a real sharp dresser when he first arrived and wasn't even that much of a party guy. But that changed before long. Terry Thomas was drafted into the Army at the beginning of Billy Bob's sophomore year, and when he returned two years after that, Billy Bob had become a living legend. Everywhere they went together, people would wave at him and ask him what was happening, what they were going to do. He was so popular his frat brothers didn't even complain about his being too jumpy to sit through their long, boring meetings. He wasn't a particularly good student, but he did earn a degree in business and another in psychology. He never worried about what he was going to do; he thought you could go to college all your life.

The day college was over, he thought his life had ended. The situation was somewhat exacerbated by his impending marriage to a professional beauty

queen he'd begun dating that winter. She was from one of the leading families of Memphis; he was head over heels for a while, but when the school year ended and she went home while he finished up at summer school, he began to have second thoughts. He went to Memphis and told her father he needed a little time to think. Her father said the hell he did, he'd been throwing receptions all summer and had their pictures in the paper and was planning the biggest wedding in Memphis. Billy Bob returned to Denton somewhat embittered.

The night after Billy Bob graduated, all his friends got together and threw him an enormous party. The next day he drove back to Gruver with Rod. "I remember goin' up there on campus about three in the afternoon," he told me. "I just went there to check my mail one last time. Rod went with me. I stood there on the steps, school was gettin' ready to go on and all the kids was changing classes. Oh, I hated to leave. I mean, I *really* hated to leave. I remember I met some girl on the steps that I hadn't met, some freshman, and I stopped and shot the breeze with her. She went back and helped me pack. And then Rod and I drove home and I was talking to him about everything and he kinda told me that when he came back from New York, he *wanted* to come back to Gruver. I told him I didn't *wanna* leave North Texas. 'Yeah,' he said, 'but life'll just really be beginning'—and I think it was."

But not in Gruver. Billy Bob lasted there about two months. Then he climbed off the tractor and told his father he wanted to come to Dallas and be a stockbroker. His father asked if you didn't have to know people to sell stock to them, and Billy Bob said yes, you did. His father asked if he knew anybody in Dallas, and Billy Bob said no, he didn't. His father said that if that was what he wanted to do, then, he ought to go ahead and do it.

The move to Dallas revived Billy Bob's interest in life, but not in his marriage. He began to spend more and more time with his friends, less and less at home with his beauty queen. Six months after he started at A. G. Edwards, he went on a business trip to New York. When he came back, she was gone. He's never seen her since. Terry Thomas said she got married to the guy Billy Bob stole her away from, but then he started running around on her and they got divorced too. There was a little talk going around for a while that she might have some kind of jinx on her when it came to men. The term for that in Texas is "snake-bit." But Billy Bob assumes a hundred per cent of the blame for their break-up himself.

Mike Klepak is one of Billy Bob's friends from college. These days he's a rancher who owns, among other things, the shopping center where Dallas' hottest disco is located. He's fat and jovial and full of spirit. He and Billy Bob got to know each other because they admired each other's style so much.

"I was real spoiled and had a red Cadillac," Mike said one evening as we all dined (cautiously, in Billy Bob's case) at a Mexican restaurant. "But the only trouble was, I didn't know Billy Bob. That's all I wanted to do was meet him, because he always had all the good-lookin' girls hanging off both arms. I said, 'Well, what we've got to do is combine forces,' and it wasn't long before we did. We have been friends for, well, I guess a little over twenty years now, and nobody has any more fun than Billy Bob—never has had.

"Billy Bob will always walk up and say, 'Is there anything I can do for

you?' If he says that, he is your friend, and it doesn't make any difference what you say back, it is done. So one time Billy Bob said, "Mike, you *never* ask me to do anything for you, now *please* tell me, can I do anything?' So I said, 'Tell you what—there's this girl . . .' and I've forgotten her last name, it's been twenty-some years now, but her first name was Maude and she was the head cheerleader at North Texas. I'd had a little crush on her for a long time so I said, 'Well, I dunno, if you could kinda introduce me to her or something . . . I know she's not gonna like me, but I'd go ahead and say hi to her anyway.' Fifteen minutes later I was sittin' over there looking at the wall and drinkin' beer and thinking about it when he walked up and said, 'Mike, I want you to meet somebody.' I looked up and here's this girl, head cheerleader at North Texas, and she was just *beautiful*. She was batting those blue eyes and had long, long brown hair and a perky figure and just a little-bitty waist. And Billy Bob said, 'Mike, I was wondering if you could do me a favor tonight. Maude lives in Dallas and she needs a ride in, and I was wondering if there was any way she could get a ride with you.' Boy, I mean the top went down on that Cadillac convertible and the dual pipes went *br-r-r-r-r-r-rtt!* and I said, 'What'd you say—ride into where?—Dallas?—hold it! My darling, do you need a ride *in?* How about a little stop at the lake and . . .' "

Over dessert I asked Mike to tell me the most outrageous thing Billy Bob had ever done. This caused much sputtering and confusion.

"I was in downtown Dallas on a Saturday morning with a wretched hangover," he said at last. "A guy was coming in from New York and I met him outside my office and we got to talking with his cab driver and he said, 'By the way, I wanna tell you something. I saw the most phenomenal sight I ever saw in my life about two hours ago. I saw this big white Eldorado come drivin' down the street real slow and there was some guy and this *fabulous-lookin'* gal and they were right on top of it and—well they *sure* weren't holding hands. And the girl kept screaming, "Billy Bob! *Billy Bob!*" ' "

"Six people in the car," Billy Bob interjected.

"And on top of that, there was something about whomping himself on the butt with a cowboy hat—'Giddy-up!' "

"You ever seen a paper boy fall off his bike?" Billy Bob inquired. "This one landed right on his head."

"Now I'm not gonna say that's the most outrageous thing he's ever done, but I'd have to say it's in the top ten."

"I don't know what it is," Billy Bob said one afternoon. "I don't know why I like 'em. I don't think I like challenging things especially, so it's not because it's such a big challenge. I don't know—it's exciting, like the Olympics and Elvis. There just can't be anything much more exciting than a real nice pretty girl that's thoughtful and has an air about her.

"I remember I had a psychology test one time at North Texas and they asked me some far-out question, they said this guy was seen standing under a drain, and I'm sure it meant he had some type of guilt or something, but I put that he'd been in West Texas and never had seen it rain before. Maybe that's the way it is with me. If I'd grown up over on Boogie Boulevard, maybe they wouldn't be so unusual to me, but I grew up out on a farm and I wasn't used to 'em. It seemed like what money I had or what effort it took was of no con-

sequence to me. I mean I just had that burning desire—and I'm not talking about sexual desire, I'm talking about just a *burning* desire to be with and to enjoy. . . .

"I'm not pushy with girls at all. Now somebody like Larry is very pushy with girls. I get around him and I get to thinking, *Well, maybe something is wrong with me.* He'll say, 'Well, did you try her on?' and I'll say, 'No.' I have spent a lot of nights with a lot of girls that I didn't even have sex with. But everybody has their own way of doing things, and I'm beginning to get comfortable with mine instead of thinking mine is inadequate or whatever.

"I have had a lot of success, and it sure wasn't because I had any looks or money or anything to offer. I never did have any false illusions about my physical looks, and I figured they'd want to go out with some real good-looking movie star. Then I got to realize that the thing that makes the most difference is your attitude. I've had people tell me I've gone with the most beautiful women they've ever seen. Everybody likes to be considered to have the best-looking, and I've always thought I liked to be considered to be with a pretty one all the time. I think when I was growing up, *any* pretty girl I'd like. But as you become older, you get more demanding. They have to be charming and attractive and attentive and enjoyable and thoughtful and congenial and pretty and beautiful and built good . . . dark tan. . . . Yeah, I think it makes me feel good about myself when I'm with 'em."

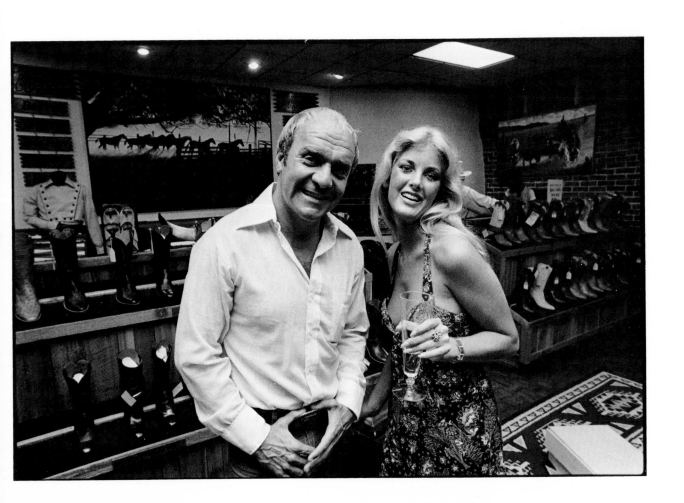

One of Billy Bob's friends is a fellow named Walt Garrison, who spent ten years as a running back for the Dallas Cowboys. Garrison now lives in Lewisville, Texas, his home town, where he runs the western marketing office for Skoal. We drove up there a couple of days after the Fourth in the Cadillac Billy Bob had been given while his own car and the borrowed limousine were being repaired. Billy Bob had called the shop just before we left and learned that the limousine, which had been parked right in front of the place, had been mislaid. "You can't *start* the thing," he commented tartly on the way up. "I don't see how it could've gone very far."

Skoal's western marketing office is a little storefront in downtown Lewisville where Walt and his pals hang out and play beer-joint shuffleboard and make nachos in a little tabletop oven. They also plan various promotional activities—scholarships, a world-championship quarter-horse show, a college rodeo program, and so forth. Once they even made a "snuff film" to illustrate the varied life-styles of Skoal users. Garrison's involvement began when he was still playing for the Cowboys. One of the fellows at Ward, Welch, and Miller, Skoal's New York advertising agency, saw a television show that showed Garrison wrestling a steer and dipping snuff in quick succession. Walt met Billy Bob through Craig Morton and some of the other guys who played for the Cowboys.

"Billy Bob's been around forever," he told me. "He's been with a lotta good-lookin' hides, I tell you—lotta good-looking girls. So many of the athletes like him 'cause he's so down to earth. Hell, he comes from a town smaller than Lewisville. And he's a genuine person, you know, he's not a goddamn flake or a phony son-of-a-bitch. He's somebody athletes can relate to. You run into guys when you're playing football that want to be your friend just so other people can say, 'There's Walt Garrison, he's a friend of so-and-so.' Billy Bob's not that way, 'cause he doesn't associate with all football players—he just associates with the ones that like him."

Billy Bob was lounging by his pool when he received word that Elvis had died. Tootie called with the news after it came in on the ticker. Mike Miller was lounging by his own pool when Billy Bob called to tell him. He said Billy Bob was "in shock" for several days thereafter.

Billy Bob first saw Elvis on "The Ed Sullivan Show." He and his parents always went to the Gruver Methodist Church on Sunday night, and he was in the bathroom getting ready when Elvis came on. J.C. and Willie didn't even know who Elvis was, but Billy Bob did, and the sound of Elvis's voice sent him running to the TV set. The first time he saw Elvis live was in Amarillo in 1956; the last time was in Dallas a couple of months before Tootie's phone call. Billy Bob likes a lot of singers, but the feeling he has for Elvis is special. And that shouldn't be surprising: aside from the fanfare and the charisma and the natural glory that comes with being the King, Elvis connected the dual impulses that power Billy Bob and so many other white southern men—the ones that have Billy Bob shouting like a tent revivalist while his friends make like the great black bluesmen. Elvis had his finger on the sexual component of the Jesus/"nigger" nexus, and the result was convulsive. Also, given his digestive difficulties, Billy Bob cannot have overlooked the fact that Elvis died on the toilet, a king on his throne indeed.

What Billy Bob didn't know when Elvis died was that his friends were on the verge of getting Elvis to sit down in the corner next to Billy Bob's fireplace and sing a little song. They'd spoken to three or four of his people and they thought they had a chance because it was just the kind of gesture Elvis loved to make. It is typical of Billy Bob's friends that they would be working on a scheme like this. When someone keeps asking what he can do for you, it's only natural to ask yourself what you can do in return.

Billy Bob has no one person who is his closest friend; he has about twelve. There's Wade, Larry, Craig, Mike . . . the list goes on. At least three are women, Susie Sirmen among them. All have become close to one another through Billy Bob. In addition, Billy Bob has hundreds of other friends— friends from Gruver, friends from college, friends from Dallas, friends in sports, friends in business, friends with ranches, friends without portfolio. He's introduced eighteen or twenty couples who later got married—although several of those have also gotten divorced, so he's not sure how much good he's done. But most of all, he has created an ever-widening circle. "I don't know if I have an ability," he said, "—maybe it's God-given—I don't know, some type of ability to go out and find somebody and bring 'em in."

"I think Billy Bob's been looking for years," Terry Thomas told me. "Going through a lot of friends and meeting people, trying to end up with a solid group of—I wouldn't say *disciples,* but it could be compared, and I would say that most of us would say that we are disciples. I'd say he's probably for a good many years been hoping to finally get it down to a core of people he feels like he can stay with. He's probably real close now, but I've seen him trying out people, through the years and some of 'em don't work out.

"This picture up here"—he pointed to one of Billy Bob's walls—"that was at Floyd Dakil's wedding. It's ironic, neither one of those girls is Floyd's wife. . . . This is Wade and there's Billy Bob and Craig and Donny Anderson and then there's this fella here—he at one time was president of a bank. He was a fair-haired boy, he was born with a silver spoon in his mouth. A good-looking man, and everything he touched was doin' good. He was a good, good friend at one time of Billy Bob's, but he got greedy. He got into real estate and really got to pullin' a bunch of stunts and I think it all caved in on him. He went off the deep end and they had to go and put him in an institution for a while. His wife—that's his wife, sitting on the right there—she divorced him. He screwed a lot of people, he just really stuck it to 'em—including Billy Bob. But he's doing very honorable work now. He's a carpenter."

Billy Bob has had to learn about people the hard way. When you're known as "Mr. Dallas"—a sobriquet Billy Bob dislikes, by the way, partly because it might offend someone else—you get a lot of folks on your doorstep. When you draw for your wallet as smoothly and ceaselessly as he does, you draw a lot of people who never do likewise. When you're as generous with your resources as he's been, you put a lot of people in touch with their instinct to plunder. But what taught him was the time he lost all his money. That was in 1970, not long after he'd gotten the white Lincoln and the new town house. Business investments turned bad—a fast food company, a lamp company, some real estate transactions. Friends he'd loaned money to went bust. Friends he'd co-signed notes for did likewise. When it was all over, he owed $375,000 to thirteen banks on a collateral of $10,000. Eight years later he'd gotten it

down to three banks. He said he never even considered going into bankruptcy. Friends who knew the situation he was in—and only a few friends did—told him he was crazy not to just start all over again. But Billy Bob knew from the way he was brought up that that wasn't the thing to do. He still has a lot of hostility toward the people who let him down, but he doesn't let himself think about it much because he knows that's wasting energy he could use in some productive manner.

One of the qualities Billy Bob looks for now is success. "I admire successful people," he said. "I've got some people that are not successful that I love dearly and find very charming to be around—but not as much as people that are successful. And I don't mean just people with money. A lot of rich, successful people are *pricks*—you don't want to be around them. But I like to be surrounded by successful, likeable people.

"I've got some people that generally every *time* what they say is right. I mean, little things, which way to go around the block—they've just got a certain amount of common sense, of judgment. There's a book called *Psycho-Cybernetics* and it said something about your motor, something up here just drives you. It's kinda like a torpedo that's shot from a boat and it's got a magnet on it and it's gonna weave its way through and find its target—that *thrust,* or whatever it is. If I go buy a car, if I go buy something at the ten-cent store —my father is a *genius* at doin' something like that, his judgment is so good. Larry Mahan's is good. I respect so much what they say 'cause I've seen their past results.

"But if somebody comes over here and we're gettin' ready to go and they can't find their keys—that's such a small thing, but it'll give you an indication right there. Next thing you get in their car and you go two blocks and it runs out of gas. And then we get to the station and they can't find their credit card. You learn how to deal with people like that, but it's not the most pleasant thing. And why should you get in bed—when I say get in bed I mean, you know, why should you partner with or depend upon somebody—when in the past their results have not been that good? So maybe that's why I like to be around successful people. I like to do business with successful people. I like to be associated with 'em."

Most of Billy Bob's personal ventures are in the stock market. Over the years, however, he has been involved in various business ventures, some successful, others disastrous. His newest interest is in a seven-hundred-seat nightclub designed to become a music-business showcase, like the Bottom Line in New York or the Roxy in Los Angeles. He has a music-publishing company called Billy Bob Publishing, and an arrangement with two lawyers in Beverly Hills who have begun representing several of his friends who are athletes. And then there was Wellington's, the disco he owned with Craig Morton and a local attorney named Parks Bell. Their arrangement was relatively simple: Bell provided most of the money, Morton lent his name, and Billy Bob acted as host. That meant being there every night from 6:30 until 2:00 for two years, and of course he went crazy partying and chasing pretty girls all night, and then in the morning he'd get up and go to the office. "I like to wore myself to a frazzle," he said. "Then I slowed down."

He didn't slow down, however, until Wellington's closed. The real story

on Wellington's demise is hard to come by, but it seems to have been triggered by something bad that happened in the parking lot, something that involved black people, some pretty girls, an abduction, and maybe a murder. Whatever it was, Billy Bob needed the rest. He was exhausted, he was a nervous wreck from the fights and the nit-picking and the endless cadging for free drinks, and he was suffering in addition from hemorrhoids, a deviated septum, and wisdom teeth in need of surgery.

The first thing he did was have all his ailments taken care of. Then he started working out at a Nautilus health spa. He also stopped partying every night of the week and running after every pretty girl who crossed his path. He was thirty-five, and his attitude was changing. He was beginning to realize there were more important things in life than running around all the time. He was beginning to enjoy being alone. He was beginning to focus his energies.

"I'm a bachelor," he explained. "I live in Dallas, Texas. You can't party all the time; I don't want to party all the time. I have to work out some; that kinda keeps me in line with something. My religion keeps me in line with something. My job keeps me in line with something. You just can't blow it all with a party all the time."

Two years of working out have given Billy Bob an extra twenty pounds, enough to transform him from scrawny to muscular. He hasn't enjoyed the process—two hours on the weight-lifting machines, three days a week—but he has enjoyed the results, and the discipline it took to achieve them. Self-discipline plays a big part in Billy Bob's new outlook.

Religion has always been part of his life. "I don't push my religion on anybody," he said, "but I know what I've got with the Man upstairs and it's very, very important to me. Other people I want to do what they want to do. I want everybody to march to his own drummer." In fact, however, Billy Bob doesn't push his religion too hard on himself either. Mike Klepak called him "the only guy in the world who goes to Praise 'n' Prayer and cries for two hours with tears streamin' down his cheeks, about as sincere as anything I've ever seen, and then walks right out the door, wrings his hands, and goes out there and has a big time." Wade Moore, noting the same phenomenon, called religion "the great balancing factor" in Billy Bob's life and said, "He's just a balanced person, because he has a little bit of everything going for him."

Work has grown increasingly central, though it has always been important too. In fifteen years, Billy Bob has taken three vacations. Once he spent a week in Hawaii with Donny Anderson and Dallas' leading surgeon, a man named Doyle Sharp. Once he took a week to produce a rodeo with Larry Mahan at the world's fair in Spokane, Washington. Once he spent a week in London helping a client sell some oil properties. Occasionally he will take off for a three-day weekend in Los Angeles or Houston or some place like that, but he has found it difficult to relax on such occasions. Recently he decided that was because he has so many obligations.

As his obligations have grown, Billy Bob has gotten himself increasingly organized. One of his tools is a thick notebook with the names and phone numbers of about two thousand pretty girls inside, listed not alphabetically but in order of their appearance in his life. This makes sense because if he wants to remember one he met, say, two years ago in Atlanta, he has only to flip through the pages until he gets to the names that were written in about that

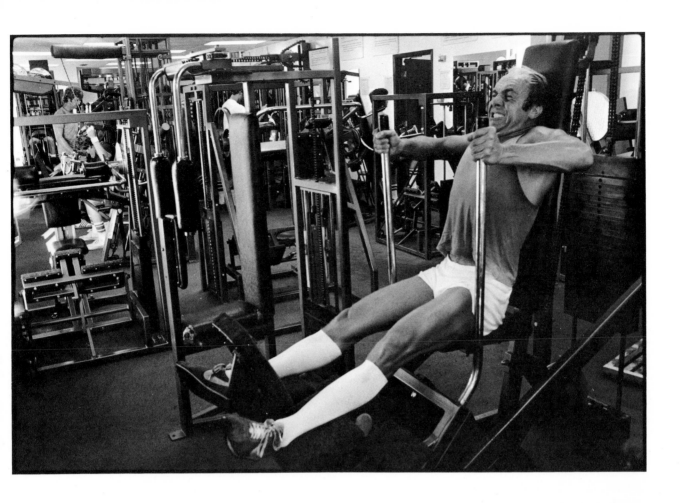

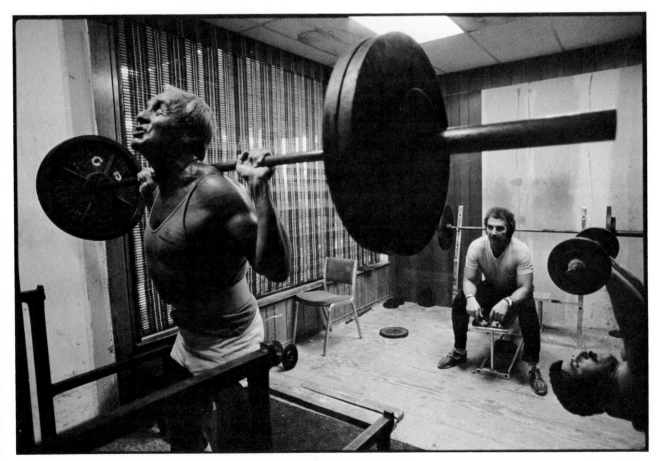

time. It looks like a card trick. He lost the phone book once and now keeps photocopies of it in several different places. He also has an appointment book in which he writes every task he has to accomplish. He received his first such book as a gift in 1970 and thought it was wonderful. The next year he received another one, and this time he had an idea: if he liked the way they were helping him get organized and successful so much, why not have them printed up and give them to his friends so they could get organized and successful too? "The first time I ordered six of 'em, and the next year I ordered ten of 'em, and one year I left a guy's name off and he called up and said, 'Where's my book? I can't go on!' Then Larry Mahan and I started writin' little captions on the back—great words of wisdom like this: 'The lion and the calf may lie down together, but the calf won't get much sleep.' I don't know anybody who don't use 'em."

It is true, as Wade suggested, that Billy Bob has a little bit of everything going for him. But he has two things in particular, and he knows it. "You know," he said one afternoon by the pool, "like if somebody were to ask you what your good points are? I think mine are attitude and enthusiasm. I think I was born with a good attitude, and I am very, very thankful for that. I don't

go around moping, I don't think the world owes me a living, I don't feel bad when I have to work or I have to work out or things don't work out good. If life was fair, there wouldn't be any wheelchairs, you know? But I don't think I pout much, I don't think I feel sorry for myself much, and I'm thankful that I don't. I've been blessed with a good attitude.

"I think a lot of my positive attitude comes from my father, because my father was always so positive. No matter if the dirt was blowing and it was a hundred and ten degrees and the cattle were out and the fence had broke down, he always went ahead and did his job. And when I started to pout and everything, he told me that wasn't the thing to do, and when I saw his results I guess I just inherited it from him.

"I think one of my shortcomings is probably patience. I'm impatient. The only time I *ever* relax is laying in the sun. That's one thing about long, drawn-out dinner parties. I wanna get things moving, I wanna get things working, I wanna get things done. I think I'm impatient."

Billy Bob attributes his success to many things, not excluding his attitude. He likes success and is ready for more of it. "I don't think we've all had as much success as we want," he said one afternoon as we lounged by the pool. "I certainly haven't. I always look up the ladder at somebody who's more successful than I am.

"Everybody in business wants to hit a home run. I think everybody wants to buy some stock at two and have a couple of hundred thousand shares of it and sell it for five hundred. But realistically, I've learned through the years that instead of trying to hit those home runs, you maybe just pick up a few hits now and then. Would I like to hit one? Definitely. But I'm not out there frantically swinging at every ball."

Billy Bob figures that if he ever does hit a home run, it will probably be in some sort of partnership with Gayle Schroder. When Schroder owned the Dallas Bank and Trust Company, Billy Bob was on the board of it. Schroder now lives in Baytown, an industrial suburb of Houston—it has the largest oil refinery in the world—and owns a bank, a discount-store franchise, some oil property, and a small insurance company. He drove up to Dallas one day shopping for something to buy—"a little bank or something"—and stopped by Billy Bob's.

Schroder said knowing Billy Bob was kind of like memorizing the encyclopedia, because Billy Bob knows everyone and everything. He also said, "You know, you've got to do something that you enjoy doing. I've always loved banking, but I can only enjoy it a couple of days a week. I'm forty-one years old, and I've decided that there are things in my life I enjoy doing and there are certain people I enjoy being around. In the next twenty or thirty years of my life, I'm going to do some of the things I could enjoy, and I think I could enjoy doing some business with Billy Bob. I think we could have some fun together."

One evening near the end of the week of the Fourth we drove over in the limousine—Billy Bob's Cadillac had been fixed two or three times but was back in the shop again—to see Paul Thayer, who is chairman of the board of the LTV Corporation, and his wife, Margery. Billy Bob knows the Thayers

through their daughter, a television actress who is one of his twelve closest friends. She lives in New York, but they live in a rambling ranch-style mansion a little past the Lover's Lane exit on the Dallas North Tollway. The walls of their home are lined with souvenirs—somewhat like Billy Bob's walls, except that these souvenirs are not snapshots but the mounted heads of some of the more challenging and exotic antelopes Paul Thayer has bagged on safari in Africa.

Thayer did not seem to mind discussing the Youngstown Sheet & Tube situation at all. He told me he had been to Youngstown once in his life, for three hours, to discuss the situation with the mayor and the leaders of the Ecumenical Council there. He did not seem particularly sanguine. LTV, he said, had stated its willingness to work with any group in Youngstown but had no desire to hold out any false hopes—especially the false hope that it might agree to purchase steel from a worker-owned Campbell plant. Nor did it wish to hold out the false hope that it might itself rehabilitate the Campbell works, since even with a federal loan guarantee the extra debt would upset the corporation's already shaky debt-to-equity ratio, and that would destroy its ability to complete the short-term financing necessary for day-to-day operations. "But all in all," he concluded, "it appears to us that by putting the two steel companies together, there's a distinct possibility—*probability*—that the quantitative savings we are looking for are there."

Margery Thayer, meanwhile, was giving Billy Bob a tour of the heads. "Paul," she said, pausing before one particularly overgrown specimen with spiral antlers, "isn't this the animal that was the hardest for you, the most challenging?"

"Yeah, sure was." Her husband rose to reinspect the trophy.

"And what is it?" she inquired.

"This is a mountain nyala." His voice assumed the expansiveness one associates with the wilds of Africa.

"This thing grows out in West Texas," Billy Bob joshed.

"This is about the twenty-eighth one that's ever been shot." Thayer was intent. "I shot him at five hundred and fifty yards. I aimed about that far above his shoulder and hit him in the heart. I was looking through the scope into a setting sun, so there was a lot of glare."

"Were you excited?" Billy Bob asked.

"Oh, yeah. The grand slam of Africa is not the lion or the leopard, you know. The grand slam is four animals that most people have never heard of: the mountain nyala; the situtunga, which is the first animal right there; the bongo . . ."

On our way back to Billy Bob's, I asked him what qualities he admires in women, as opposed to his friends and pretty girls. "The properties of Mrs. Thayer," he said, after a slight pause. "My mother and Mrs. Paul Thayer. I'm not comparing them to one another by any means, my mother is probably twenty years older or maybe more than that, but they've got the same charming, lovable, warming, comforting—I tell you what, Frank. You sit down and you write a profile on Mrs. Thayer, and that's the quality I appreciate in women. She's very attentive to her husband, but she doesn't smother him, she doesn't question him, she is charming, she is *beautiful*—she's one of the most beautiful women I've ever seen, physically—she's smart, and she's so nice to everybody, and she can fit into any given situation. She can fit in with a bunch of shitkickers over here at the Mesquite rodeo, or with the prime minister of anything. And she's got that little bit of naïveté about her that makes her so refreshing, besides being gorgeous and beautiful and . . ." Billy Bob paused. "She and my mother, both of them have the same loving traits."

Susie Sirmen and Craig Morton met us at Billy Bob's later that evening. Craig discussed football with Billy Bob in the soul room while Susie, looking every bit as ravishing as promised, sat in the living room and talked about a Christian rally in South Carolina at which she and Craig had just witnessed. Later I asked her about Billy Bob. She said she had met him in 1969.

"He was well known as being a bachelor around town," she said. "And a guy that I was dating at the time, we were at a club one night and he saw Billy Bob and he said, 'Man, Billy Bob Harris is the neatest guy in Dallas, Texas.' That's how I knew his name. Then somebody approached me at a swimming pool one day and said, 'Do you know Billy Bob Harris?' And I said, 'No, but I've heard his name,' and he said, 'He wants a date with you.' I thought, *Billy Bob Harris wants a date with me?*—because I'd just gotten out of college and I thought that was the neatest. It was just a blind-date-type situation, except that after the date was arranged he came over to the swimming pool where I lived to check me out.

"But we dated for three years and . . . it was fun. We never went on too many dates alone. It was always, 'Poor Rosie, her boyfriend's out of town,' or 'Poor so-and-so, she has to stay at home.' He's such a gregarious person. But that's what happened to our relationship—it's not that the feelings really died, it was that he wanted one type of life-style and I wanted another. You know how relationships sometimes start off, when you first fall in love and then you

talk about marriage? We did, but as time went on we talked about it less and less. Then I think Billy Bob realized he could never be exactly what I wanted and I realized the same thing. But it was tough, it was one of those things that hurt for a long time."

I asked if she thought Billy Bob would ever get married.

"I don't know. It's something I've talked about with him. There's a thing about men and their freedom. Myself, having waited so late in life to get married, I understand getting set in your ways, but I never had a fear of losing my freedom. Knowing him and his personality, it would be difficult for a girl to accept. It was for me. It was like every Friday night when we went out, I always knew that we were going to bring the club home with us for an all-night party. I don't know that he would ever want to give that up. He's such a giving, loving person—he used to cook dinner for me, he waited on me hand and foot, and he could really be giving in that kind of way. But whoever it would be would just have to be really understanding. It's so hard for me to picture the girl—the girl who would have a good time doing it and yet in other ways command the respect he would want to have for the person he would devote his life to. It'll be real interesting for me to see."

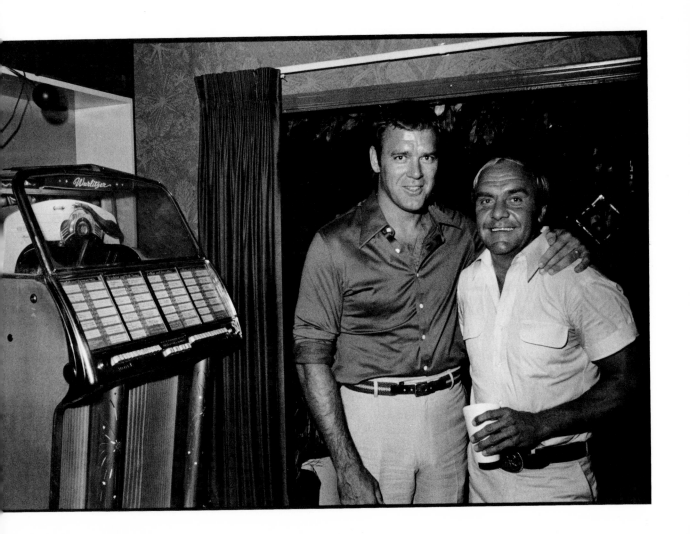

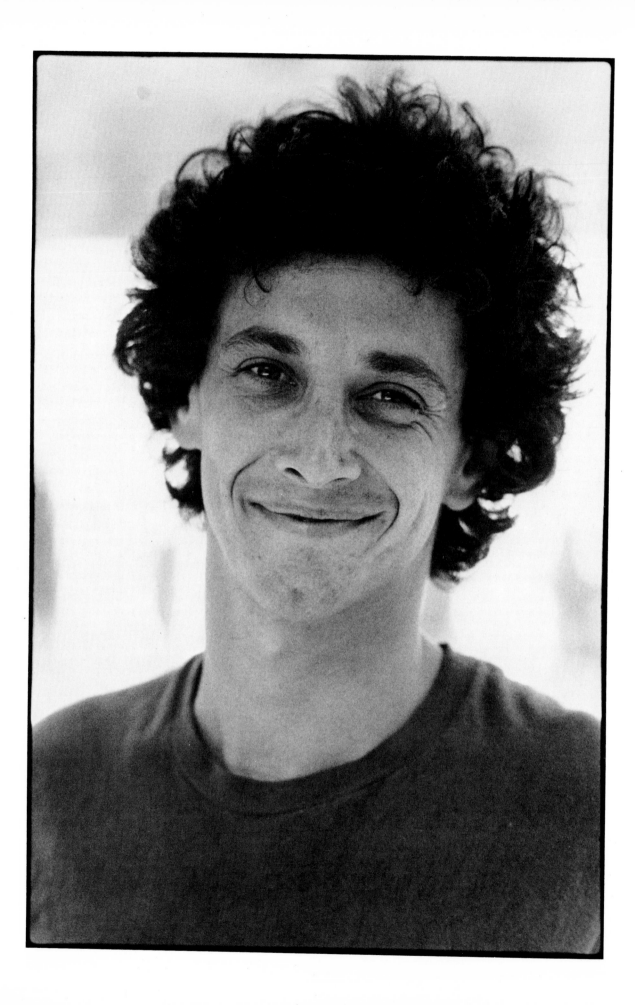

Andrew Rubin

Malibu, California

Like so many others for so many years, Andrew Rubin came to Hollywood to act. He came from New Bedford, Massachusetts, by way of New York City, where he had studied at the American Academy of Dramatic Art, worked in the publicity department of NBC-TV, done a little Shakespeare, and knocked on a lot of doors. He made his first trip West to do his first acting job (not counting the time he'd gotten $350 to wear a cop uniform at a trade fair), playing Cosmos opposite a girl called Francine in a series of Sprite commercials that never ran. Francine had a funny accent and Cosmos was always a little dizzy, and whenever they took a drive or a walk on the beach, Cosmos would collapse and Francine would have to "renew" him with a cold bottle of Sprite between the lips. The campaign had to be scrapped because local bottlers, who pay for air time, began complaining that it was Cosmos who ought by nature to be "renewing" Francine. But if Sprite never put Andrew on TV, it still provided him with a taste of Hollywood. He fell in love with his producer, a seductive older woman (thirty-two to his twenty-three), and when incessant rains held up the shooting for days, the two of them had no choice but to hole up in the Beverly Hills Hotel, ordering champagne from room service. Andrew became quite taken with the actor's life. When he returned to New York, he realized he'd have to quit NBC or be stuck for life. He had some money from the commercials, and Michael Brandon, his actor friend from the academy, said he could use his car while he was shooting in Europe. So he left his job and went out, to reconnoiter.

That was in 1970. Eight years later, Rubin had become one of the best-known out-of-work actors in Hollywood. His first film, *Casey's Shadow* (directed by Martin Ritt and starring Walter Matthau), had just premiered, and though the box office was disappointing, Andrew got remarkable reviews for his portrayal of Matthau's son, a lanky Louisiana cowboy. Liz Smith called him "superb" in *Cosmopolitan*. Judith Crist called him "striking" in the New York *Post*. And in the *Daily News*, Rex Reed said he was a "sinewy and athletic young actor" who "never makes a wrong move." But because the movie wasn't a hit, a lot of people in Hollywood never saw it—unless they were on one of those cross-country flights that offered it over Kansas.

So fourteen months after completing it, Rubin still had not been offered a part he liked well enough to take. Nevertheless, he professed not to be dispirited. One reason for his confidence was that on the last day of shooting, Ritt—the man who'd made *Hud* and *Sounder*, a formidable figure, paternal and taciturn and gruff—had said, "I wanna talk to you, kid." "He was really complimentary," Andrew recalled. "He felt I'd be one of the next ones coming up, and he told me, 'The next thing you do, you make sure of two things—the script and the director.' And he said, 'This won't put you over the top, *Casey's*

Shadow, but the next one could.' So I'm sorta like on the brink. A lot of people around town feel I have a good shot. It's just that they want somebody else to give it to me."

At 9:30 on a midsummer morning, Andrew showed up at a concrete condo on Hollywood Boulevard. The sign outside read "Versailles Tower—The Right Address for the Right People." Andrew was taking a meeting—that's Hollywood jargon for the activity that occupies most of an actor's time between jobs—with a young director named Mike McFarland. McFarland, who was wearing neatly pressed pale-blue brushed-denim jeans, a blue sport shirt with epaulets on the shoulders, and a meticulously trimmed beard, turned out to have two projects in mind. One was a "fast-paced science-fiction horror film" called *Without Warning,* about a teen-age couple who are hunted by an alien nobody in the audience ever actually gets to see. ("Audiences are very sophisticated," McFarland explained. "They know it's some guy in a suit, no matter what you do.") The other property, *Dead-Eye,* was about a big-city lawyer who flips out and decides to become a cowboy. For *Without Warning,* McFarland wanted somebody with "name value" to impress the TV networks. (He described the picture as "one of those marriages of business and art" and remarked apologetically that "you have to be constantly aware of the business side, especially if you want to make more films.") But he could see Rubin as Dead-Eye's sidekick, a scuzzy, alienated Dustin Hoffman type. The problem was that he hadn't found a director—this film would require too much nuance to direct himself—or cast the other lead. He asked Andrew about his rapport with Martin Ritt.

When Rubin said it was excellent, McFarland thought of a way they could help each other out. He'd been trying to reach Ritt, without success; but now Andrew could read the script and pass it along if he liked it. Andy asked who he was thinking of for the other lead.

He was thinking of Gary Busey. In fact, he had guaranteed backing if he could get Busey and a good director. It was a month after the release of *The Buddy Holly Story,* which Busey had carried brilliantly.

"So Gary Busey's now bankable?" Rubin inquired.

"In certain types of pictures."

"What a trip." Andrew left with both scripts.

His next appointment was with his agent, Tom Chasin of Chasin-Park-Citron. One of the more prestigious agencies, Chasin-Park-Citron is located in a steel and glass high-rise on Sunset Boulevard, about one block before the steel and glass suddenly gives way to the verdant luxury of Beverly Hills: business zoned before pleasure. Chasin, who could have passed for a young Wall Street lawyer but for his tan, stood behind his chair and reviewed recent business developments. First, Steven Spielberg was casting for a movie to be called *1941.* There were going to be five male leads, and one of them might be right for Andy. John Milius was still writing the script, so there was nothing yet to look at, but he had already made an appointment with Spielberg's casting director for tomorrow morning. He would advise going this route, since there was no time to wait for the script.

Then there had been a phone call from Norman Lear's office. They were casting for a feature film called *Summer Camp* and wanted to see Andrew for

the lead—a Connecticut youth who's trying to decide whether or not to go to Juilliard. He'd made an appointment for 3:45 this afternoon, and he thought there was a script somewhere in the office. Also, Steve Railsbach had been picked for the part Gary Busey had turned down a $500,000 offer to do, and nothing more had been heard from the people who were doing *Stormy City Bowl*, except that now it was called *Dreamer*.

When Andrew started to talk about his meeting with McFarland, Chasin sat down. Neither of them was enthusiastic. Then Andrew mentioned the

manager he had just fired and the interest he was getting from John Travolta's manager, Bob LeMond. Chasin pointed out that there was a good side and a bad side to working with someone like Bob LeMond. The bad side was that LeMond was becoming a producer and might sign you up, go out and produce a movie, and forget all about you. The good side was that he might get you involved in some of his projects.

A secretary came in to report he couldn't find the script for *Summer Camp* because someone had thrown it away. He did, however, have an ICM story-department synopsis on *Without Warning* and more details about the plot of *Summer Camp*. After he'd recited them, Andrew asked what the appeal of the movie was. "There wasn't any appeal to the movie," he replied.

Andy retrieved his light-brown Wagoneer station wagon from the garage, then drove into Beverly Hills and parked off Wilshire. He was on his way to the Ron Fletcher Contrology Studio, next door to the Brown Derby and one flight up. Fletcher has become fitness freak to the stars with a "holistic" exercise program built around devices with names such as the Trap Table and the Reformer. Andrew was admitted a little more than a year ago. Before that, he'd worked out at the Y. Now he joins people like Ali McGraw, Candice Bergen, Don Henley of the Eagles, Michael Brandon, Raquel Welch, Lois Chiles, and Debra Winger, his twenty-three-year-old actress/girl friend, for an hour-and-a-half workout every two or three days. It's important, he pointed out, to

stay in shape; you never know when you're going to get a job, and you might have to be ready immediately.

The *Summer Camp* meeting was extremely brief and marred by verbal shrapnel. It was run by two slightly overweight young men, one scruffy-looking in a big plaid shirt, the other spiffy-looking in a sweater vest and slacks. Both had that self-consciously aggressive air that marks the apprentice mogul. The spiffy one held up Andrew's press clips and said, "What's this—a book you wrote?" The scruffy one said they were looking at Andy for the twenty-two-year-old camp counselor and asked, "How old are you?" "I ain't twenty-two," Andy replied with a grin. "You sure ain't," he shot back. The spiffy one said "Thank you" a few seconds later. It signaled the end of the meeting.

Andrew drove down Sunset to Brandon's house in Brentwood. Andy and Debra live on a ranch in the Santa Monica Mountains beyond Malibu, an hour's drive from town; but their real home, as Debra pointed out later, is the back of the wagon. Michael's place is their in-town rendezvous and sometimes overnight layover. It's an early ranch-style on the edge of a steep ravine, blocked off from the street by a row of newly built apartment houses. The interior is dark and low-ceilinged but richly paneled and lit in one spot by a sliding-glass door that overlooks the abyss. Michael wasn't back yet; neither was Debra. We went inside and took a seat at the table, next to the glass door.

Andrew took a look at the *Without Warning* synopsis. The story opened with a man being pursued by a strange blue force, shot by strange blue darts, and dying in agony. Cut to two attractive young girls, college age, waiting for their attractive young dates. The couples drive through the Oklahoma countryside to a lake, ignoring the advice of a spooky old hunter to avoid the place. One couple goes skinny-dipping and immediately gets zapped by the strange blue darts. The other two find their corpses in a deserted oil derrick, barely escape the strange blue force in their van, take refuge in a diner where a local crazy shoots the sheriff and raves that they're aliens themselves, escape from the diner only to be assaulted by the strange blue force again, float downstream and hide in a deserted cabin where they make love (it is her first time), flee in different directions when the strange blue force strikes again, and are miraculously reunited after the spooky old hunter sacrifices himself to kill the strange blue force several adventures later. Andy flung the synopsis down and laughed out loud.

Michael appeared at the door, his face haggard. "Hey!" Andrew shouted. "You look like you just came from a meeting with the lawyers." This was a safe guess, since Michael was divorcing Lindsay Wagner (his wife of two years, television's Bionic Woman for three) and was involved in an insurance suit over the accident two years ago in which Lindsay had wrapped her MG, with both of them in it, around a tree on Coldwater Canyon Drive. The accident had resulted in the sudden midseason appearance of an unexplained scar on the Bionic Woman's lip and had necessitated surgical reconstruction to restore the right half of Brandon's skull. "They all lie," Michael said tiredly.

"That's the standard expression after meeting with anybody in the business," Andy explained. "Lawyers, producers—how'd it go?"

"They all lie."

"Agents . . ."

"They all lie. It's like the joke—" Michael's face brightened at the joke.

"A guy had an audition, see? It was for a monster movie, so they dressed him all up with hair and plaster and a big outfit with all kinds of glop on it and he read. Then he called up later and said, 'Did I get the part?' And they said, 'No, you didn't look right.'

"They lie. They all lie. I got to write down new meetings."

"You got new meetings?" asked Andy.

"Yeah. This was a preliminary meeting for the meeting I'm having on Monday for the *real* meeting on Tuesday. No kidding."

"So what was today?"

"Today was—bullshit."

Andrew Rubin is not one of those actors who's had a consuming passion for the big screen from the age of three. When he was growing up in New Bedford, he rarely even went to the movies and certainly never thought he could be in one. "And if you don't think it," he said, "certainly nobody else will."

New Bedford is just not a fantasy town. It was built as a snug harbor for whalers, a place where they could stand on solid ground after a year or more of being tossed about at sea. Andrew felt loved there, but he also felt restrained and confined. The youngest of three children in a Conservative (but not devout) Jewish family, he experienced growing up as an enormous struggle. "There were a lot of rules and regulations," he said, "and a lot of people telling you who you should be, and that whoever you were was fine but don't let anybody see it."

Andrew's father, now deceased, was a prosperous furniture manufacturer who worked hard and tended to rely on Andrew's mother for information on how the children were developing. His mother is a travel writer and author of several books, including one called *How to Defend Yourself at Auctions*. Andrew was much closer to her when he was growing up. They had terrible fights, but she was good to him. "My parents were good parents," he said. "It's just that—I dunno. Your parents get stuck sometimes, and whenever you deal with them you're in their rut."

Andrew worked summers in the furniture factory when he was in high school, but just enough to get a good dose. He'd decided he didn't want to "be a junior," as he put it, when he was six or seven. He had no idea what he did want to be, however. He wasn't very interested in school, and his career in sports was checkered at best (sixth man on the junior high basketball team, called "the clown" by a coach he couldn't take seriously enough; second-stringer on the junior high football team, got the wind knocked out of him in the first and only play of his first and only game; failed to make Little League, known as "the statue" on the baseball diamond because he couldn't decide when to swing the bat). He was awkward physically, and never much for being one of the gang. Acting was the only thing he did well, but that was just in high school productions and it was a joke to think about making a living at it. So he grew rebellious—not violent, he was never much for fights, but headstrong and troublesome. He cut school, he shot pool, he always had a buddy: they were rebels-with-a-heart. Andrew would go his own way.

After high school, that way led by mistake to Wagner College on Staten Island. Wagner was a strict institution, and Andy was more interested in "liv-

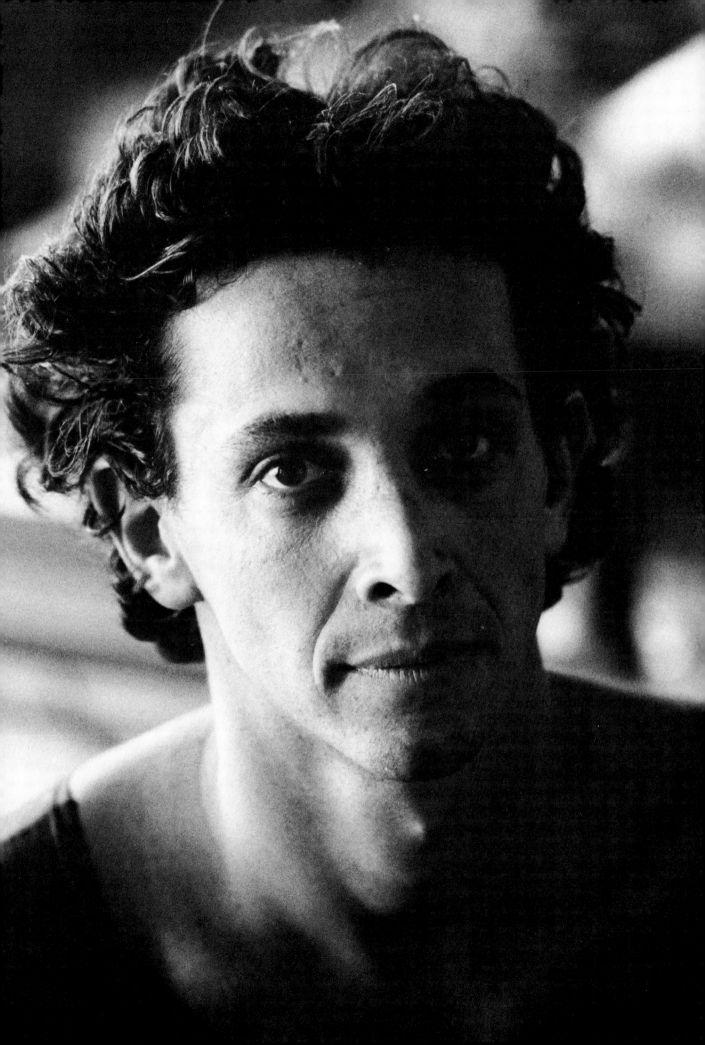

ing experiences," which could be had by riding the ferry to Manhattan and hanging out in Washington Square, than in four more years of high school. Anyway, he didn't fit in at Wagner. The football team tried to cut his hair; the dean of men staged a midnight raid on his poker game. He was tossed out at the end of his freshman year. That summer he went home and worked construction and tried to figure out what to do next. He wasn't going to get drafted because when he'd reported for his physical he'd told them he shot heroin, sucked his thumb, wet his bed, was a latent homosexual, and had several other problems. He didn't want to go back to college, but he didn't want to be what they said you would be if you didn't go to college either.

Then his mother spotted an article in the paper about an ABC competition for scholarships to the American Academy. She clipped it out and nagged Andrew to apply, since he'd done so well in the high school drama productions he was in. He did apply, and he made it to New York as a national finalist. But the night before his audition he stayed out partying with friends, and when morning came he flubbed his chance for the scholarship completely—although he did win admission to the academy. In 1967, after two years of "gestation," he graduated, got a job as an NBC page, and started looking for an agent.

He progressed much faster at NBC than at acting. From page he made the jump (without the requisite degree) to junior writer in the publicity department, where his knack for making up funny Phyllis Diller quotes and the like kept him moving upward until he was made assistant trade editor. His time was his own, and he spent a lot of it going on auditions and looking for an agent. The first agent he got was Bob LeMond, who picked up John Travolta around the same time. Work was harder to find.

The Sprite job changed everything. Andrew was shocked when he got it. He thought it was untrue. He thought they were kidding. He drove home to New Bedford for the weekend, convinced he'd die in a car crash on the way. Three months later he moved to California with letters of introduction from his superiors at NBC. His girl friend, an actress named G.D. who lived a Ginger Rogers fantasy but was actually Grace Kelly's niece, followed shortly.

In two months he got a job playing a dope dealer who supplies pot to a policeman's daughter on "Ironside." He'd never been on a sound stage before, and when he showed up for his scene—he had one scene, in which he smoked a joint and talked with the daughter for a couple of minutes—he was nervous and unsure about how to behave. Also, he hadn't yet broken the habit of stumbling just as a performance was getting its rhythm. So he fumbled a line on the second take, and instead of turning to the director and mumbling "Sorry" or something like that, he yelled "Cut!" He didn't know that only the director could yell "Cut!" He didn't know that he had broken one of Hollywood's most treasured rules. A deadly silence fell over the sound stage; the air grew thick; a break had to be called. Andy never worked for that director again.

On the other hand, he did fall in love with the policeman's daughter, a young actress named Kathy, and later, after his five-year relationship with G.D. had ended, he and Kathy moved in together. He also got more work. His next job was playing a movie star on "Bracken's World"; he earned $750 in three days for five scenes with no dialogue. He played a hippie on "Getting Straight" and an Armenian PCP manufacturer on another "Ironside" episode (different director). Then he was hired as Monroe Hernandez, the son of Tony Ran-

dall's Puerto Rican building superintendent in "The Odd Couple" series. It was his first three-camera show, and originally it was supposed to be a semi-recurring role, except that after two episodes the character was eliminated.

His first guest-star appearance was as a cop-killer on "Streets of San Francisco." Because he'd gotten only co-star billing before, the people at Quinn Martin Productions were reluctant to up him to guest-star status (which on this show meant having his name announced and his picture flashed onscreen); but they gave in when he threatened to refuse the job. When he got to San Francisco he developed severe tendonitis because he had to do so much running in heavy boots. It got so bad by the end of the week—a week he was getting $2,000 for—that the remaining running scenes had to be done in one take and set up so he could run around a corner and fall down. Meanwhile, he was staying in a waterfront Travelodge that had no room service and was several blocks from the nearest restaurant. Michael Constantine, who was the top-billed guest star, had demanded better accommodations right off, and Ina Balin, who was also a guest star, had done the same a couple of days later. When Andy told her about his tendonitis, she urged him to do likewise. So two days before the end of the shoot, he called the production manager and asked to be moved. Instead he got chewed out, first by the production manager and then, on his return to Los Angeles, by the casting director, who lectured him on the perils of acting like a big star when he wasn't. One of those perils soon became clear. Andrew had worked for Quinn Martin before, on "Cannon," and he knew they hired the same actors again and again for their series; but he never got in for another meeting there, even though his agent was assured they didn't keep a blacklist.

Still, he continued to find work, usually playing the villainous ethnic types that feed the snow-white paranoia of the cop shows. He guest-starred on "Serpico," "Petrocelli," and "S.W.A.T." He played the obnoxious Puerto Rican newscaster on "Mary Hartman, Mary Hartman." But his appearance made it tough to get better roles. Andrew is not only dark and curly-haired, he is also somewhat oddly built—and at that point, he hadn't yet managed to make his body work for him. "He was like olive oil," Michael Brandon said. "I mean he was really an awkward-looking person. His legs were too long, his arms were too long, and he just was not centered." But he kept working out, kept meditating, kept doing workshop (first with Joan Darling, then with Milton Katselas, then with Joan Darling again), with a discipline and a persistence Brandon found amazing. "I always felt lazy next to him," Michael confessed, "even though I was the one who was working a lot."

For his first three years in Los Angeles, Andrew lived in an A-frame at the top of Laurel Canyon, overlooking the layers of smog that cover the asphalt-gridded basin below. That was when the canyon was still funky, when Joni Mitchell wrote her idyllic little song about it, before the new ranch-styles were built on stilts up and down the mountainsides and the traffic on Laurel Canyon Boulevard began to resemble rush hour at midnight. After a while he moved out because he had hit a slow streak and couldn't afford to pay the rent. He lived for a while in friends' houses and in the back seat of his Volkswagen; then he and Kathy found the cottage on the ranch. Michael was living on the next ranch then, and a mutual friend named Jay had just bought the

property on top of the hill. The three of them were very close for a while. By the time Andy got the part in *Casey's Shadow,* however, everything had changed. Michael had met Lindsay Wagner and moved back into the city; Kathy had left him; and Jay was no longer his friend.

Andy didn't see people much after Kathy left. He spent long periods of time alone at the ranch—isolated, with no television, no radio, no diversion of any kind, nothing but the occasional drone of a light plane overhead or a car winding up the road. It was during this period, he told me, that he began to see the perfection in everything. He began to understand how everything that happens is as it should be, regardless of how it may diverge from our expectations. He started to learn patience and acceptance. Eventually he hit a hot streak in his career and made five TV guest appearances in a row. After that he got the *Casey's Shadow* job.

Casey's Shadow offered Andrew something television never had: the chance to grow into his part, to escape the swarthy-ethnic type-casting, to become a real actor. He met the challenge well—so well, in fact, that when the movie came out, a lot of people in Hollywood thought Ritt had found him in the bayous. The problem he's faced since then is getting those people to believe he can play anybody else. He was turned down for the role of the New York union agitator in Ritt's next film, *Norma Rae* (starring Sally Field), because he didn't look Jewish enough. He was offered the role of Linda Blair's boy friend in a TV movie called *Summer of Fear,* but he turned it down because it seemed more a plot device than a character—and besides, as he pointed out, "How many Linda Blair witch stories have you seen?" He's gone out for several jobs he ended up coming in second for but he hasn't been offered a part he felt he could take.

Of course, money is a consideration. *Casey's Shadow* brought in $22,000, but that was more than a year ago. Since then he has gotten by on unemployment, loans from friends like Michael, and "the smile on my face"; but he's not prepared to hold out indefinitely. "I'm not waiting for the perfect role," he said. "I'm just looking for something that turns me on until I have to go to work."

Work is what agents are supposed to find. For this, they get 10 per cent. When an actor begins to think his agent isn't giving him enough attention or getting him enough work, he's likely to look for a new one. Andrew has had four agents since coming to Hollywood, one of them three times. He's only been through one manager. Managers are forbidden by law to look for work for their clients; they guide and advise, at 15 per cent. Andrew had been with his current manager for four years when he decided to sever the relationship. He was still happy with his agent, but that didn't prevent other agents from being interested in him.

One who was especially interested is an up-and-coming Sue Mengers type with a small but impressive young client roster. Once she mailed a bio of herself to his manager, but he never passed it on to Andrew, possibly because she's the kind of agent whose clients tend not to have managers. Later she left a note on the windshield of Andy's car. She was happy to talk to me but did not wish to be named, lest her efforts to woo him go unrewarded and professional embarrassment ensue.

I picked her up at her house, a nondescript white bungalow hidden behind an enormous but fastidiously manicured hedge whose branches had muscled over the curb and into the street, where they loomed over passing cars. We drove to a nearby West Hollywood restaurant, took a table not far from one occupied by Bill Murray and friends, and had a couple of drinks. She proved friendly/aggressive, driven by what Debra Winger had aptly called "a New York kind of energy," with a manner of speaking that was forceful, seductive, and very, very fast. "I think Andy is not in a good place in his career," she announced, "in that he's made a lot of decisions which have kept him out of acting too long. I think anyone who's chosen the path he's chosen, meaning a selective acting career, has to be very, very adept at waiting creatively. Now, I happen to know that Andy is very highly respected by everyone who's in a position to hire him in this town. I mean everyone. I check into these things, I go to the tastemakers I trust and I ask them. I think his work in *Casey's Shadow* is universally applauded, as it should be. But I think Andy physically is not any type, so to speak. He's not simply a rural type, he's not simply a Western type, he sure ain't simply a city slicker. Because he falls between the cracks physically, I think what may have been happening is that when his agents, who handle mainly very big money-earners, receive a phone call saying 'We love your young guy and he's terrific but he's not the right type,' no one's been on the other end of the phone doing some cagey thing to position the situation so people have to take a second look. I think agents are highly overrated, believe me, but when a person is just starting out it can make a huge difference. There's thirty-five thousand actors in this town. Why should Andy Rubin get the job? There's no reason, believe me. That's why I love it when my youngsters are doing so well and cleaning up and working for the best directors. It has a little something to do with me, every time."

I asked how she would deal with someone who falls between the cracks, as it were.

"There are two ways to combat falling-between-the-cracks," she replied. "One is, when you get the phone calls saying 'He ain't physically right,' you have to do something to unconvince them. You explain that beauty is not the way features are arranged on a face; it has to do with what can come out of the performance. I am very hip to doing that. Secondly, you make sure that every time the actor or actress goes out to his or her reading, he gives the kind of reading that just induces that producer to hire him—because if the producer has any brains at all, he knows he has just seen the finest actor he can possibly get. I have a client like that right now who's going to be a major motion-picture star. She's only twenty-two, and already every single film that's casting wants to see her—and she looks like nothing this town thinks is pretty."

I asked if she thinks Andrew has the potential to become a major motion-picture star.

"Yes," she said, without hesitation. "Because he has sex appeal. He has very definite, strong, and *unique* sex appeal. There's no doubt about it. Many, many people say the same thing. If he were just a fine actor, that would be super—but he has star quality.

"His strength is the kind of strength that draws you in. Other people have magnetic strength or dynamic strength, but Andy's strength is something else. He has a quiet dignity which is apparent in his entire being. He's a very

unique individual, and he wouldn't do anything to change. So that's it, it's laid out, that's who he is—and he's totally relaxed about it. It's very unusual to find somebody who's in a very fragile position, say, egotistically or psychologically, but who nevertheless has beautifully formed his energy. I don't think he would fall apart under pressure—and I'm not talking about a director yelling at him, I'm talking about a life crisis. He's a man. He's a fully fleshed-out, feeling, developed, loving, grown-up man. It's very nice, they're few and far between."

The casting meetings for the Spielberg film were being held at A-Team Productions in Burbank. Andy and Debra went together, since by coincidence her agent had scheduled a meeting fifteen minutes after his. Upon entering A-Team's office—a one-story, red-brick structure across the street from a gas station and a car wash—they were directed to a wide space in a corridor to wait. The wide space was furnished with a couch, a wicker chair too flimsy to support anyone, two bicycles, a copying machine, a water fountain, an up-ended coffee table, two very large boxes of copying-machine paper, and a dying plant. "Feels sorta like an abortionist's office," Andy remarked.

Sally Denison, Spielberg's casting director, proved to be a sympathetic young woman given to such nonintimidation gestures as hugging her knees to her chest while sitting behind her desk. She and Andrew made a point of looking into each other's eyes as they talked. She explained *1941* as a kind of wild and crazy fantasy about what might have happened if the Japanese had bombed California in World War II. Then she asked Andy about himself. She hadn't seen *Casey's Shadow* (not on the right plane); he assured her it was far better than its Disney-style promotion would imply. "The guys in the studio can't help lying," he said. "It's in their blood." She smiled and replied, "That's what they're paid big bucks for." Later she said she wanted him to see Steven when Steven started seeing people.

Andy waited for Debra, then drove to Michael's. A message was waiting from his agent. Sun Classics, the outfit that had made the movie version of *Chariot of the Gods,* wanted to see him for a Bible mini-series. Andy was not so interested. He'd met with Sun the week before, when they were looking for a Tom Edison for their mini-series on great figures in American history. He told Chasin to tell them he'd read the script if they wanted to offer him the part. Chasin said he had a copy in his office and he'd send it over by messenger.

There was a time, Andrew said, when he would take a meeting on a project he wasn't interested in, just to meet people. Then he found he wasn't putting his heart into those meetings, so he stopped taking them. His attitude toward meetings has grown increasingly relaxed as his career has progressed. No longer does he stay on edge all weekend after taking a meeting on Friday. After all, the farther along you get, the more you prove yourself, the better your prospects. It's just like life. "That's why I love acting," he said, "because it's the same as my life."

One way acting is like life is that it teaches you to deal with rejection. Acting is a very physical business, until you become so big it doesn't matter what you look like, and it's run by people who like to be on sure ground: the untested actor might be perennially late, or likely to freeze in front of the cam-

era, or egotistical beyond his worth. But acting is also like life in that everyone must proceed at his own pace. "Your own growth is your own growth," said Andy, "and when something happens, that's the time it's supposed to happen. That's the lesson of the business—patience and acceptance, which are two things I still have to learn."

Andy's approach to acting—and hence, life—is a kind of carefully cultivated passivity, Zen-like in the nature of its response to reality but quite Western in its goal of adjusting personality to suit ambition—in this case, the ambition of making a living in Hollywood without becoming a pill case. His speech is strewn with phrases like "being in the moment" and "what is, is"—California buzzwords that initially smack of post-hippie avocadoland nonsense but gradually reveal themselves to serve actual purpose. Just as "go with the flow" is a sensible imperative in a freeway culture, so "be in the moment" is a good idea for people who make daily contact with uncertainty, rejection, and the possibility of instant stardom. The buzzwords are merely the jargon of an elaborate defense mechanism that seeks to protect the actor's psyche from the ravages of an impersonal and unpredictable industry.

This is especially important to actors, to whom normal defense mechanisms are denied. Unlike other people, actors cannot numb themselves to life —because all they have to call upon in performance is the sum of life experience. If an actor hasn't left himself open to his own life experience, he isn't going to be able to convey fictional life experience in front of a camera; and if he hasn't thoroughly explored his response to that experience, he isn't going to know what he has to work with. Every tradesman must know his tools, and an actor's only tool is himself. That's why the Sue Mengers-type described acting as "a more sensitive existence for business purposes."

"Your relationship to yourself is a great deal of what acting is all about," Andy said. "To explore other characters, you have to start at home, because that's where every character originates. Every character you play is *you* in that particular situation. If you were born in England, you have an English accent. If you have some physical defect, or what is called a defect, it's you in that situation. You can't play *being* somebody else; it's just you, *as* that person. You hear the term about actors, 'He's in character'—and that's really the truth, you know. An actor is a person in character. And that doesn't mean they're separate things; it's when they're united that a beautiful performance comes out.

"You get in front of a camera and at first the tendency is to be very self-conscious, which takes you totally away from whatever is going on and into being uptight and thinking about yourself. And there's the tendency, so you're not left just hanging out there with nothing to do and nobody to be, to form this concept about the character and that concept about the character. Then you don't have to really assume responsibility for being out there."

Responsibility?

He thought for a while. "I guess what I'm talking about," he said finally, "is that certain actors are not willing to take responsibility for the fact that the character is you, in a certain situation. When you see bad acting, it's because whoever's playing the villain is being their idea of villainous instead of being in the moment while the scene is happening. They might not like the character personally and might not want to portray that. But the beauty of a great per-

formance is that you can play anything and if you do it well, that's what's responded to.

"And sometimes it's not just that they're not willing to take responsibility; more often than not, the difficulty is that they don't really have a process of working. They get a role and they don't know how to approach it. See, the character in anything you do is never supposed to be any way. The character is just supposed to be whatever comes out. But because people haven't had the experience of where the character really comes from, they think it's from outside them. They don't know how to get to the place where it's really going on. That's what workshop was for."

To develop a process of working?

"I discovered real early on that that's what acting is. Performance is process, acting is process—life is process. So if you have your process, which is just your basic understanding of what's happening within the scene, then you're in a place where things will just happen on their own. You're the vehicle.

"That's the whole thing about concepts. If you have a concept, you have a concept for the future, so the future's taken care of. So when you get to that place you throw in your concept, although something totally different may be going on. I mean, the person's pants may have just fallen off and he's saying, 'But you told me, darling, that when I saw the lawyer today . . .' You know what I mean? It's sticking to an idea rather than to what's happening. It's total obliteration.

"For me, there's one thing that's real important, and that's becoming really familiar with the material—reading it every day so you keep getting more and more inside it, and then when you get inside it you start thrashing around and it gets deeper. It's not just words on a page anymore; it starts to take on colors and textures, and it starts to come together. You've just got to take it as it comes and try to have an over-all picture of what's going on, because that's what's important as an actor—what's going on? What's really happening? What's this person going through, where's he coming from, who is he? And you have to be open to the moment available, because that's the only moment there is. It's not when you rehearsed yesterday and what went great then. It's not the way it was set up in the rehearsal you had just before you did it. A good actor will see his performance for the first time as he's doing it. He will never have seen it before and he'll probably never see it again.

"A lot of good performances are taken for granted because of the subtlety with which they're executed. You believe the character so much that you don't think it took anything to play that. You lose the idea that it's a film or a play, it's just life happening."

Isn't that the whole idea?

"Yeah, life happening. If you're not seeing life on the screen, you're seeing—not life."

The messenger arrived with the Sun Classics Bible script just as Debra wandered in from the pool. It was about David and Goliath and contained lines like "Where is your armor and your weapons, you maggot?" It also bore the notation that Andrew was being considered for one of David's brothers—Eliab, Abinadab, or Shammah. "Those are all Jewish producers," said Debra, "so they can pronounce those names. Then they get these guys in there, you know, blond hair from Kansas."

"You think that's funny?" said Andy. "You know who they want to play David? Shaun Cassidy."

Casey's Shadow is a horse-race movie in which a born-loser patriarch (Walter Matthau) wagers all on his one chance for salvation: fate has dealt him a lucky horse, and he's determined to use it to get his name in the record books. The film is set in Lafayette, Louisiana, where Cajun horse-trainer Lloyd Bour- delle and his three sons live grub lives in their bachelor shack (dirty dishes in the bathtub), and in Ruidoso, New Mexico, where the All-American Fu- turity lies beckoning with its million-dollar purse. Eight-year-old Michael Hershewe plays Casey, the adorable brat they name the horse after; Stephen Burns is Randy, the adolescent jockey who gets the love interest; and Andrew Rubin is Buddy, the oldest brother and *de facto* custodian of their motherless den. Aside from Alexis Smith, who plays the rich horse breeder who tries to lure the boys away from their dad, and Susan Myers, the girl jockey who catches Randy's eye, the only female in the picture is a horse. She dies giving birth to Casey's Shadow.

When Andrew was up for the job, Martin Ritt asked him one question: ever do any Shakespeare? (He had.) Afterward Andrew heard from his agent that he was in first position to get the part, although there was some question as to whether he looked "charactery" enough to play Matthau's son. Three days later he got a call instructing him to pick up some scenes on Friday and come in on Monday to read with Matthau. He spent all weekend rolling around in the dirt and working on his scenes. On Monday he entered a tiny room and read with Matthau for an audience of five. An hour later he got the phone call informing him he'd gotten the part.

He spent five weeks in Glendale riding horses with Stephen, Michael, and Susan. That was when Stephen had the first of several riding accidents: one of his stirrups broke, and as he slid under the horse it trampled one of his hands, all but severing a finger. When they got to Ruidoso a horse stumbled out from under him, plunged off a cliff, and was killed; someone in the production company tried to get him to pay for it until Ray Stark, the producer, found out and paid himself. Later, on a racetrack in Lafayette, Stephen split his lip when another horse reared. It was the split lip that altered his role in the pic- ture; there was no way to explain it in the story, so he had to be written out of several scenes. Andy's role grew consequently larger.

Andrew had an accident of his own during the first week of shooting. He was whizzing down a mountain road in New Mexico on a motorbike, with Stephen clinging to the seat behind him, when suddenly he realized they weren't going to make a turn. He rolled the bike over to avoid hitting a tree and slid a hundred feet or so. Stephen was unhurt, but Andy's right arm was split at the elbow and stuffed with dirt and gravel. Then he developed blood poisoning because he tried to heal it himself, without going to a doctor. The scar is two inches long, almost a quarter-inch wide, and jagged.

"The whole thing was very definitely a waker-upper," Andrew said. "I had a leading role in a major film, and I went down there and I didn't know how to act. I didn't know who I was supposed to be. That's how I got in the accident: I didn't know who I was supposed to be, and I had that accident to wake me up.

"About a week after the accident, a couple of days before my first dialogue scene—I hadn't any dialogue scenes, I'd been in long shots and shots where I didn't speak—I went into my dressing room and I just sat there looking in the mirror. I was thinking, *Here I am, it's happening,* and as I was looking at myself I started to see these tears come out of my eyes and I started to feel this emotion. It just started to come, you know. It was a release. So I had that experience for a couple of minutes, and after that it was real good. I had let go of whatever I expected of myself, so I could just go out and do my thing."

As the shooting progressed, Andrew noticed that something special was happening in front of the camera. Other people noticed it too, and became eager to get it on it. The feeling peaked at the Columbia Ranch in Burbank, after the five weeks in Ruidoso and the four and a half weeks in Lafayette, when they were filming the birth of the foal that was supposed to be Casey's Shadow. The colt they'd used in Ruidoso had four white socks, but the mother of the foal only had one, and they didn't know who the father was, so there was no way to tell if the foal would match. But the foal came out—on camera, in a tiny stall, with Andy and Ritt and the cameraman and a veterinarian dressed to look like Matthau—with white socks on all four legs. Everyone took it as an omen.

That was in November 1976. The following May, the cast and crew reassembled in Ruidoso to shoot a new ending. The original ending had Andrew leaving his dad's hopeless brood to work for the wealthy lady breeder, but then Stark and the studio decided they needed a happy ending—so he stayed with pop and the boys. The film was released ten months later with expectations of great commercial success. Much thought has been given since to the reasons for its failure.

Andrew thinks you can find most of the answer in the two print ads that were prepared for it. The ad they finally used featured a cutesy-poo cartoon of Matthau and the kid. The original one, however, was a photograph of Walter, his pickup truck, the horse, the kid, Stephen in his silks, and Andrew, with everyone looking straight into the camera and a legend that read:

"One beautiful long shot."

"To me," said Andy, "that's what the movie was about—a family with a horse. Not about a horse and a kid. Like I said, they lied about it. They could never tell the truth because they didn't think the truth was interesting enough.

"The fact that it didn't make money is a black mark against it in most people's minds, no matter how well they understand the system of Hollywood. But people still seem to like it. Bob LeMond said, 'I loved seeing it, but I'd never make it because I wouldn't know how to market it.' And that's the kind of film it is. You can't call it anything, you can only say 'Go see it!' That's why they had so much trouble. It's not like they purposely did a shitty job. They tried to find a level they could sell it on—and when I say they lied about the film, it's because they didn't think the level they could've sold it on would work, probably because they'd never seen it before."

He sighed in exasperation. "I mean, there's no *reason* for it not to do well, because it tested out really high with audiences. They put meters on 'em and registered their emotions or something, I don't know, but it tested out really high. But anyway, it's a dead horse now."

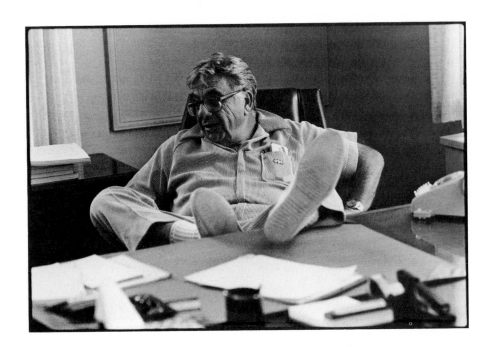

Martin Ritt's office while *Norma Rae* was in production was in the main
building of the Twentieth-Century Fox lot on Pico, hard by Century City, the
steel and glass office development distinguished by flags and flower patches and
broad expanses of asphalt with names like Constellation Boulevard, Galaxy
Way, and Avenue of the Stars. Ritt's window looked out at—indeed, had been
incorporated into—a lavish reconstruction of turn-of-the-century New York;
just out of sight behind that was a dusty Western town, and around the corner
was a sleepy Spanish-colonial village. Ritt himself sat behind a very large desk,
a short man, feisty and direct.

"I needed somebody to play that part, he walked into my office, and I
liked him," Ritt said of his decision to cast Andrew. "It was as simple as that.
Casting is always kind of an educated guess anyway, unless you've seen the
actor play that kind of part before or unless you've seen him play many parts.
It was not without some difficulty, but I got him. The opposition was from the
studio—and I can understand that, because he wasn't anybody. But I took
him because I thought he would be very good, and he was better than that.
Only I know how good he was, because I know what the part in the script was
like. He gave it an anchor which I always wanted and which I didn't feel any
of the other kids who'd been in to see me would give it."

An anchor?

"Well, it was about a family that was light-headed at both ends—the kids
and the old man—and right in the middle was this combination older
brother/mother/general factotum. I could sense that Andy was a pretty good
actor, but more than that I sensed about him humanly that he was the kind of
guy that could make that family work. Of course, if the film had been a
success—and I still don't know why it wasn't, I finally thought I had made a
film for Middle America and I was going to get rich as hell—but if the film
had been a success, I think Andy would have been well on his way. As a mat-

ter of fact, I gave him some advice at that time. I said, 'Don't get buried in television, you're going to get a lot of job offers.' That shows you how smart I am—he didn't get *any*. But he's a very good actor and he's going to have a genuine career, I'm sure of it. The first part I have he can play he's going to get.

"I know he felt he should've been in the film I just finished, but I just felt he wasn't *quite* right. At the center of the film was a Jewish labor organizer, and although Andy is a Jew, I wanted there to be no question in the mind of the world that the fellow playing this part was a Jew. If Andy's name were not Rubin there'd be plenty of question, because, you know, Andy could be— Andy could be Gary Cooper, he has some of those qualities. I know Andy was very disappointed, and a lot of people who knew how much I like Andy kind of took me to task about it, and in my own manner I told them to go fuck themselves. I don't have any obligation to anybody but myself and occasionally the writers when I cast a film. But I think he'll have a genuinely decent career. You never know about stars, because that really depends on what I call a high fuckability quotient. But I think he's got it. I think all the women who saw *Casey's Shadow* liked him, liked him very much."

I asked how much of an actor's career might depend on luck.

"Very little of it," he replied. "Luck is involved only in the first exposure. There was a time in this town when a guy in my position, if he had a couple of broads he was having a thing with, he might use them and protect them in some way in his films. But films are too difficult now. You can't do that anymore. When they put you in center field, you gotta be able to play. There are some stars who are not that good actors, but they are terribly, *terribly* charismatic. They have this fuckability quotient I was talking about. They have some mystery about them, some strangeness about them, that a lot of people find very attractive.

"But there are no longer thirty-five young guys in the image of Ty Power being carried under contract at a studio like this and being used in one film after another, hoping that one or two of them would quit. Most of the actors today come from the theater. They have decent backgrounds, they didn't come here to be discovered—although there are some of those around too. I mean, Sally Field is a girl who went to high school here in California and knew she wanted to be an actress when she was twelve and single-mindedly set out to do that and was picked up on the corner of Hollywood and Vine by a television producer because she looked like Gidget. That happens—once in a great, great while. But still, she has to deliver.

"I don't really believe there are stars who are real washouts anymore. Since I've been in Hollywood, which is twenty-odd years—Newman, McQueen, Redford, Reynolds, Hoffman, Pacino, De Niro . . . you know, none of them are stiffs. Burt Reynolds, Sally's boy friend—funny, tough, very bright, and down in the section of the country where I made *Norma Rae* —he's God. Shit, I wouldn't let him show up until two days before we finished shooting because I didn't know what was going to happen. And we almost had a clitoral attack in the community when he did show up. It was *brutal*."

I asked if he thought Andrew was in touch with himself.

"I think he is. The whole business of acting, after all, is relating to objects. If your kid walks into a room, you don't have to act. The object is a real

one, and so you light up in a certain way. That's what an actor has to do thirty times in every scene. That requires a high degree of skill and knowing yourself, so you know what really affects you—why you like some people, why you don't, what you like about yourself, why you do certain things you don't like about yourself. So most people do their best work when they're in their own gold vein. But nobody has to know that but you. You may live in a very strange and dark world, but that doesn't matter. All they have to know is the result—what they see on the screen.

"Andy's good, he's solid. In the old days there would have been no question about a kid like that, because he'd've been protected. He would've been under contract, and he would've gotten a lot of work. Today, if there are leading parts he has to take them away from De Niro and Pacino. It gets tough. But he's a nice kid. I really like him. He just needs to be a little lucky."

Michael Brandon has been lucky, so to speak. He and Andrew have been best friends since the mid-sixties, when they were at the American Academy together, but their careers have proceeded quite differently. Michael has had leading roles in films since 1969, when he was the bridegroom in *Lovers and Other Strangers*. The streetwise son of a Brooklyn auto mechanic, he claims to have tried bribing his way into the academy ("Whaddaya want? A thou-

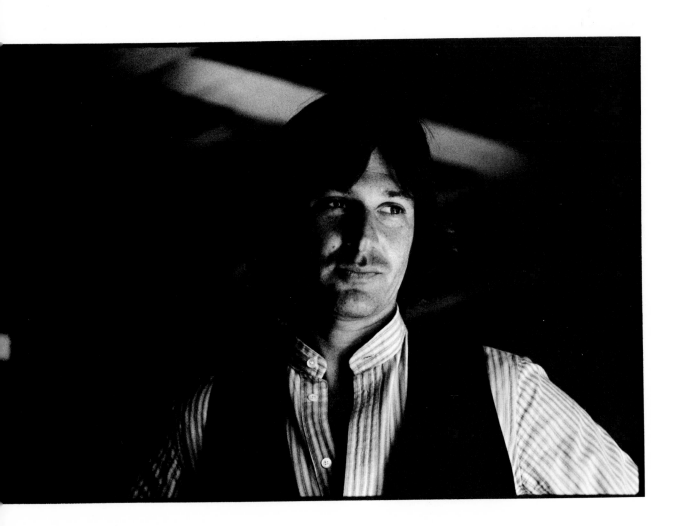

sand?") and tells a great story about his entrance audition, in which he delivered Hamlet's "To be or not to be" soliloquy in heavy Brooklynese and ripped his shirt open when he got to the part about the bare bodkin. (The judges allegedly figured him to be a great comedic Shakespearean actor.) He's not sure how Andrew held on all those years doing odd jobs in television. "I would never have lasted it like he did," he said. "I needed those successes all along the way to continue."

In other ways, too, Michael and Andrew are different. Michael is aggressive; Andrew is more relaxed. Michael goes to parties at the Playboy mansion; Andrew likes to hear about them. But they do have one thing in common: however transitory the women in their lives, they regard their relationship with each other as constant. "We've been friends for so long," said Michael. "We know each other so well, we never argue—we could be great roommates, but it's never been able to happen because we've always been in a relationship.

"I said something to Andy once—I said, 'Where's Debra?' 'Out at the ranch.' So I said, 'Oh, you wanna fuck?' I can embarrass him"—he snapped his fingers—"like *that*. Like the time I said, 'You don't realize—we wouldn't have to go through all this pain if you and I were lovers.' And he just looked at me, you know, like . . .

"He used to have this way, like I'd bring a lady out to the ranch and he'd come around and get her really loaded and then start that little shy, lusty act. It took me a long time to catch onto it myself he did it so well. See, I was right out there, and he was coming around the back door. So I said, 'I've brought women out here, and you have one way or another slipped off with more than a few. And the thing that bothers me is not that you do it, but that you don't bring anything in. I get the feeling that we're not *sharing* anything here—and unless you can, you know, make a deposit, I think your account is closed.' And then I met Lindsay.

"I guess women have been the great changers in my life. Different eras are marked by them. They'll do it to you, you know. I remember sitting out at the ranch and kind of realizing what was happening. I said, 'I am about to commence on this road of temporary insanity. I'm going to thrust myself into this thing here and have what life has to deal out to me at this particular moment.' And, *whew*—gone from the ranch, horses made into cat food, fortunes squandered, Lear jets, travels around the world, pain, laughter, pain, throwing up, the end—I just saw the whole thing.

"So we were sitting out there one night and I said to Andy, 'Look, I just want to clear something up with you. Lindsay's probably going to be around here a lot more and this little routine that you have will cease. I'm telling you, don't do it.' And he said, '*What?*' I said, 'I'll take your head off.' He said, '*What?* I can't believe you're saying this to me!' I said, 'Neither can I. I've never said words like that in my life. Especially to my closest friend. But I'm insane. I'm in love! I'm insane! I can't control what's going on with me. I'm just telling you, "Don't fuck around here, because this one is different!" I don't care what you do with the others; don't touch this one.'

"See, I always had a thing that I never would go for any friend's lady, because it isn't worth it. That was a code, and when you grow up in Brooklyn you learn your territorial codes by instinct. And there was a violation there that didn't seem that important to him. But it was interesting because what

happened after that was that the lady he was living with went over to some-
body else. That was such a big one for him, and what he got from it all was
the karma. He said to me, 'You know, you could leave Lindsay and me alone
on an island and I'd never do a thing. This was the lesson of lessons.' That's
why we can get along in the relationship as it is now. I mean, Debra could've
stayed in town tonight and Andrew would've been out there and it would've
been very cool—because he knows where I'm at in relation to that, and I
know where he's come to. I guess the only one we can't trust is Debra." He
laughed.

From Michael's house in Brentwood, the drive to Andy's ranch takes you
down Sunset's swooping curves to the Pacific Coast Highway, then west along
the Pacific Palisades, past Topanga Canyon and Malibu and Zuma Beach
nearly to Oxnard. Then, on a stretch where the four-lane highway is cut
directly into the base of the Santa Monica Mountains as they jut out of the
sea, you take a sharp right and head into a narrowing canyon. The one-and-a-
half-lane road rises gently for a few hundred yards, then makes a hairpin turn
and begins to zigzag up the sheer, treeless mountainside. Half a mile farther on
and you're peering over the edge at the highway and the breakers a thousand
feet below; half a mile beyond that and you're slipping between the moun-
tains and skirting their crests. Gradually the precipitous landscape of dry grass
and scrub brush widens sufficiently to accommodate pastures and an occa-

sional home. Andy's turnoff is marked by elaborate wrought-iron gates and a long row of mailboxes.

A flagstone drive lined with yucca, jade, eucalyptus, and pine leads straight down the mountainside, past a faded gazebo, past a crumbling arbor, past a rusting aviary stocked with pheasants, past the pull-offs for the cottages hidden behind bushes and vines, before finally opening out onto a dirt patch where three or four empty pickup trucks are parked. Directly opposite is Boney Mountain, its jagged, rock-encrusted brow looming almost unnaturally close. A flagstone walk lined with yucca and succulents and flowering geraniums and imitation Renaissance statuary leads to the house—flat-roofed, balustraded, pagoda-topped, and long ago painted aqua and pink—of the old-timer who owns the place: an ancient and eccentric Hollywood set designer who has littered his property with the detrita of a hundred forgotten screen productions, each piece snapped up cheap at auction. The half-buried American Airlines quonset huts set into the other side of the mountain were intended as dormitories for the art school he never started.

The house Andrew and Debra share is about halfway down the drive, opposite the aviary. It's not actually a house but an early house trailer, dating from the fifties perhaps, camouflaged by vegetation, with shaded patios at each end and a glass-walled living room built onto the far side. The trailer's rickety walls contain a Lilliputian kitchen, a diminutive dining area, an incredibly cramped bathroom, and a tiny "medi room" where Andy and Debra do their yoga. The living room overlooks two valleys and the Pacific beyond, with the craggy blue bulk of Santa Cruz Island rising out of the most distant mists. None of the Hollywood ruins are visible here; like all the cottages, this one is set into a notch on the mountainside and looks straight off into space, with no apparent thought for the breakneck drop to the valley below. Yucca trees frame the view, their flowers towering overhead, their blades thrusting up like

spikes from the ground, pushing hard against the glass. Debra said they'd break in soon if they weren't cut back.

Nature is more extreme out here than it is in town. It's colder in winter, hotter in summer, more lush in the springtime. Sometimes torrential rains pummel the mountainsides; other times the hot, dry Santa Ana winds sweep them at sixty, seventy miles an hour, leaving dementia in their wake. The house protects from wind and rain and cold but little else. There's no air conditioning, only a tiny swivel fan, and no screens on the windows; the dust that coats the tongue outside filters inside, leaving no escape. But just as it is impossible to escape the choking air, so it is impossible to ignore nature's daily spectacle. The house faces southwest, which means dawn sneaks up from behind and sunset plays out its colors on the wide-screen window in front. All day the blue of the ocean washes into the blue of the sky as the fog rolls out and then in, like a tide in flight from the sun. Sundown brings not just ever-shifting bands of iridescent colors to the sky but deepening shadows that restore three-dimensionality to a landscape flattened by the sun. The constellations pop out as the sky turns black, their light far steadier than the twinkling glimmers from the Ventura Freeway and the Navy missile base at Point Mugu. Sometimes the moon sets pink at five in the morning and wakes you up with its brilliance. Andy doesn't mind. Living with nature helps him keep his balance—"what I think of as my balance."

The house where Michael used to live (Bob Dylan owns it now) is just around the corner, and Jay's house is on the crest of the ridge overhead. Jay's

is different from all the other ranch houses: not tucked into the terrain and nestled behind foliage, but stark against the sky, naked atop a dominating knoll. It looks like a Western movie front. Jay has a reputation for being as strange as his house: an alien being almost, remarkable for his ability to remain calm and unruffled in the face of anything life can deliver. That's what Andy admired in him. They were like a high-consciousness Three Musketeers for a time; then they went spinning off in different directions.

Andy said everybody who visits the ranch says the same two things: (1) they love the place, and (2) they want to move out to the country immediately. Nobody ever does move, though. Andy moved away for four months after the two years he spent alone there; but the place he moved to was down near the beach at Malibu, and the noise of the traffic was too loud. ("The only traffic around here," he'd said earlier, "is airplane traffic." It was true.) When he was alone, after Kathy left, he'd often gone for days at a time without seeing or speaking to anyone, even on the phone. He read a lot, he smoked grass, and he meditated. "The only way I can really say it," he said, "is facing yourself. In the city you have the opportunity to have so much stimulus, you know, external stuff. When you're suddenly alone and there's nowhere to go and nothing to do and you don't want to read, you don't want to sit down,

and you don't want to eat—we didn't have a TV, but you get only one station here anyway—you just start to go through something. Something starts to happen, and it just keeps happening. But that was a long time ago and I just sort of forget, because it's not real important for me to remember.

"I was dying was what was happening. Or my idea of myself was dying. Or something was dying. But there was a death and a rebirth for sure. It was catalyzed by one thing in particular that really sort of put me over. Somebody lied to me. A friend of mine. About a woman. It's really not important, you know. But simultaneously with being told a lie, I saw my own. I had to take a look at it, I had no choice. And it was great, you know. It was really painful for a while, but . . ."

Debra moved out to the ranch ten months ago. She and Andy had met not long before, when he'd asked her to do a screen test with him. He'd actually called her agency for another actress, but she wasn't available, so the person at the agency ran down the actresses who were while Andy flipped through the *Academy Players Directory,* looking at photos. Debra's was the one he picked. "So I got this call," Debra told me, "and this guy was like really *vague.* But as he kept saying the same thing over and over, I realized he wanted to check me out first. So I just said that on the phone. I said, 'Oh, I know, you wanna come over here first and make sure I pass all specifications.' There was this long silence, you know, and then he said, 'Yeah, I guess that's what it is.' So he came to the door and it was one of those." Love-at-first-sight, she meant. "At first he wasn't sure about this Jewish chick living in Beverly Hills, but that was all coincidental. I was just stuck out there, and as far from Jewish as he is."

Debra's family came to America from the Balkans several generations back, having taken advantage of their next-door neighbor's death to escape a pogrom by burying his body in the back yard, assuming his family name, and using his identity papers to get out of the country. That's how she got the Winger name; the Debra came from Debra Paget, who was her father's favorite actress at the time. Her dad's had sort of a rough life, having worked in the meat business, the burglar-alarm business, and several other businesses before beginning his current enterprise, which is selling Ansafone recordings by the stars for KISS radio. Debra grew up in the San Fernando Valley, which is flat and suburban and on the other side of the mountains from Hollywood, and although her older siblings are "both normal" (the sister a secretary, the brother a schoolteacher), she herself has been acting since the womb and entered the world, as she put it, "doing an Esther Williams." Like Andy, however, she was scared at first to try it professionally. She waitressed in high school, including once on roller skates in a restaurant that had an overlong counter. (The boss didn't want her to at first, but soon there were lines outside on Sunday mornings, and then she quit before it could get old.) After graduating, she got a job as a troll at Magic Mountain, a Disney-type amusement park just off I-5 between L.A. and Bakersfield. She was on the verge of making the jump to acting as 1973 approached.

On New Year's Eve, she and three other young trolls were told to report to the other end of the park. They pulled off their costumes and hopped into the Cushman truck that would take them there—except there was only room for two in the cab, so Debra and another troll got onto the back. They were

going up a slight incline at twenty-five miles an hour when Debra noticed her costume—which was expensive, and which she was responsible for—sliding off the edge. Just as she reached for it, the truck swerved and she fell over backward. She hit the pavement headfirst and suffered a cerebral hemorrhage that left her comatose, paralyzed, and blind. She spent the next year in hospitals.

The coma lasted almost a week, and she was in a semicoma for two weeks after that. It took several more weeks for the paralysis to loosen its grip, and the blindness might have been permanent: of the five ophthalmologists who were consulted, only one said she might regain her sight. She took all this remarkably well. "It was much harder on the people around me than it was for me," she said, "because from the minute I fell off the truck I knew I was going to be okay. But you're lying in a hospital bed, paralyzed and blind, telling your mother, 'I'm going to be fine,' and she thinks you're just telling her that to make her feel better. But the minute I fell out, I had an experience, and I saw it was going to be all right. I saw myself leave my body and I thought, *Well, this is either it or not*. I was completely unconscious, but witnesses said my arm shot up—and I remember pulling myself back in. But the heaviest time came not at the time of the accident but in making the transition back to living my life as normally as I could. I'm still looking for some way to incorporate it into a script or something before it slips away."

Debra became an actress after her sight returned, her career financed on the $13,000 she had left from the $80,000 Magic Mountain settlement after paying her medical and legal bills and giving large sums to her parents, her brother, and her sister.

"I think the experience was really rich for this type thing," she said. "I'm not a masochist, it's just that the things people consider really traumatic events in your life give you stuff to work with. They're rich experiences, they make you feel a lot. It gets to the point where you don't put a judgment on whether it's a good feeling or a bad feeling, the fact is you're feeling it—and if you're feeling, that's hot. Everything is a chance to look at yourself. So it's all like one big mirror, if you can take it that way. Sometimes you get caught up and spun around and land on your ass—but there's a quote that was up in my room for years that said, 'Falling on your face is still moving forward.' That's kinda like what I like to live by."

Before she met Andrew, Debra spent some time on television as Wonder Girl. Then she found a loophole in her contract and quit. Her most recent job was in Casablanca FilmWorks' *Thank God It's Friday,* the Donna Summer disco smash, and at the moment she was up for several other roles, including that of a foreign exchange student in *French Postcard* and that of Neal Casady's sixteen-year-old girl friend in a movie about the Beat era. She and Andrew appear to have little conflict over their careers—probably, as Andrew suggested, because neither one is stagnating.

Andrew and Debra don't think much about marriage and children. Andrew said things like that don't concern them. "When people who have lived together get married," he said, "sometimes it seems like the relationship isn't really happening and they're trying to recapture the excitement by doing something new. It seems like the law has provided a way to get deeper into an unhappy relationship. And then, when it gets worse than that, they have a kid. It's really like you're digging your own hole."

I asked how permanent he considered his relationship with Debra.

"I don't really look at it in terms of permanence or impermanence or a commitment," he replied. "As long as it's happening, as long as something's really there between us—which we're pretty attuned to, because when it's not happening we sure know it—that's as long as it will be. It's not important for either of us to think that it will be for this amount of time or that amount of time. It's more important not to, because it just doesn't matter. As long as it's good, that's how long it will last."

I asked what value he puts on permanence as an idea.

"All permanence is is an idea," he responded. "That's all it can be, because it has no relation to reality. Everything's impermanent, you know. So it's just a head thing, it's just psychological security. *If I think I will be with this person for a certain amount of time, I'll feel more comfortable now.* I'd rather not know I was going to be with somebody tomorrow, because it will make me pay more attention to now—because it can go any time."

When I made a remark about Los Angeles being the world headquarters of impermanence as an idea, he smiled and said, "I guess it's true. I look at my home town and I see people are really rooted—but I don't look at it so much as 'rooted' as 'stuck.' 'Rooted' to me means you've stretched into the earth. There it's more like 'stuck.' But you see, all those security things—marriage and stability and roots—they don't mean anything to me. I don't look at my life in those terms. I just don't see it that way."

We sat for a while and gazed at the mountains. It was late afternoon, still

too hot to wear anything but gym shorts: Andy's response to the environment is to submit to it, not to armor himself against it the way a cowboy does. Flies buzzed outside. I asked Andrew how he felt about getting older. "I feel younger every day," he replied. "I enjoy getting older, because I'm happier all the time. When I was young I felt old, and as I get older, supposedly, I feel younger, because I feel more clued into what's going on. I associate youth with a freshness of spirit, but when I was a youth my spirit was not that fresh. It was sort of dampened."

The talk turned to ego. Andy said he was trying to do away with his. I wondered how an actor can do away with his ego. "It's a tough trick," he laughed.

"Everybody's fantasy is to be a movie star. Not everybody, but a good 90 per cent of the people I've run into. It's really an ego trip, I guess—and a film is perfect for fantasy, because a film *is* fantasy. But fame is the heaviest pull of all. Heavier than lust and greed and everything. When you get hung up on it—when you've tasted something and that meal's over but you want more—that's when you find out that more will never be enough. But fame is actually sort of distasteful in a way. I really dig being anonymous. It's nice for people to come up to you once in a while and tell you they appreciate your performance, but it's nicer to be able to move through life the way you always have. You get a lot of good work done, watching people. But to be besieged, to have your trailer almost turned over—that would be a drag. I'm mostly into the work. I'm into earning a living doing what I want."

When I brought up the subject of ambition, Andy turned strangely blank. "Oh . . . pay the rent," he said when queried about his goals. "Get

enough to eat . . . some gas in my car . . ." What about goals as an actor?
"Oh, I sorta know how everything's gonna turn out." He grinned. "I do
things to do them now, not because I may get some reward off them later, al-
though certainly I'm aware that I might. I don't know if I have any goals."
He gave a short laugh. "My guidance counselor would not like to hear that.
When I was in high school, they gave you three choices. Everybody put down
doctor, policeman, lawyer—and I had soldier of fortune, professional gambler,
and the last one was blank. That's sorta still the way it is. Whatever comes
along for me is what I'll be, I guess."

Debra served dinner: omelets of green chiles and jack cheese with sour
cream and orange slices on the side. The sun began its approach to the ragged
blue mountaintops as we ate. With each moment of descent the sky turned a
deeper and more luminous indigo; Debra said it looked bruised. After an eter-
nity of anticipation the sun slipped red between two distant peaks, leaving a
crimson halo that slowly dissipated to form an orange slash across the already
livid sky. The sound of crickets came up with the wind. A large insect flew in
and buzzed the ceiling. "That's Irwin Allen's promotion for *The Swarm,*"
Andy cracked.

Debra shook her fist at the intruder. "You've gone too far, goddamn it!"

After dinner I repeated a remark by Bob LeMond. LeMond, comment-

ing on the phenomenon of the newly sensitive man, open and vulnerable and with emotions unmasked, had told me in the Burbank screening room where we'd just seen *Casey's Shadow* that nobody wants to be Clint Eastwood anymore. "Well," retorted Andrew, "somebody wants to be Clint Eastwood— and is.

"I don't think it's so much a matter of not wanting to be Clint Eastwood," he continued. "It's just wanting to be whoever you are, not having the necessity to create an image of yourself. It's more important to be who you are than to put out something because you think people will buy it. I mean, why put out an image when you can be the real thing? It just doesn't seem to be a choice. Who you really are seems so much more authentic." He laughed.

"I don't pay much attention to society's idea of what you're supposed to be anyway. I've learned that one. Look what society has done so far—thwarting and trying to shape and mold you into the perfect happy human being, when society doesn't know shit about being a happy human being. Society is a big zero, an empty hole. People playing characters in life. They're playing themselves. Ostensibly they are themselves, but then they start playing who they think they should be—which in fact may not be who they are at all but society's idea of who they're supposed to be—just so they have comfort in the knowledge that they're like everybody else, that they're part of the group. The thing is, you're like everybody else in a much deeper, cosmic sense of the oneness of everything, but in another way you're totally different. And that's where the conflict comes in, trying to be something you're not.

"But I think it's a thing of the times. It seems like more men are more willing to express themselves, you know, not to be somebody else's idea of what a man should be. What a man should be is no longer valid, because it's an idea —it's a concept of what a man should be and not what a man really is. I think men are less concerned about being a man. I don't know. I know I am."

As we drove back to the city that night, I realized with a start that, of the men we'd encountered, only Andrew had a mate, a place in the country, a station wagon, and a dog. Life can be funny.

The next day Andy and Debra came to town for more meetings. Late in the afternoon we drove down Sunset to meet them—through the billboard jungle that is the Strip, past the homes of the stars where the land is green with photosynthesis, through the endless procession of highly polished status vehicles (including today a fifteen-year-old Jaguar painted lemon chiffon, a taxicab uprooted from the streets of London, and a wine-red Mercedes 450 SL with California license plate LTSDOIT) that zip past the equally ceaseless procession of broken-down out-of-state station wagons filled with wide-eyed urchins gawking at the dream. When we got to Michael's we found Andy inside, seated next to the abyss.

"I just want to go to work," he announced when we joined him. "My attitude—I'm trying to keep it as healthy as possible and as positive as it genuinely is, but, uh . . . I wanna go to work. I mean, that's what you do. You want to get involved in some kind of project. Patience, I guess." He sighed. "Whatever.

"It's just one of those days. You know those days?" He cleared his throat. "I wouldn't want to give you the impression that—yeah, let's set the record

straight. All this stuff I talk about is . . . talking about it. Living it is another thing. It works some of the time, but . . ." He gave a rueful grin. "Yes. It happens in Hollywood, folks. Glitter City.

"Things change so fast. In this business it's amazing how quickly they can turn around. Positions of power crumble to dust, and somebody rises from the depths of anonymity and rockets—I mean, it's almost as if we were out in space, zipping around. Sometimes it's difficult to deal with, because how much can you depend on what other people think of you? It does get to you. It used to get to me a lot more. Then you start to realize that you really don't know. You don't *know* what's going to happen. There's nothing to hold on to. But that's real good, because then you keep having to face it—and that's the way it really is anyway, you know."

A couple of months later I got a phone call from Andrew. He said Debra was leaving for Paris on Monday to do *French Postcard,* and he was about to begin work on an A.I.P. production called *Sunnyside,* in which he'd be playing an over-the-hill street-gang leader. The star of the film would be Travolta —Joey Travolta, John's older brother, who would be getting $100,000 plus for his first motion picture.

"Yeah," he laughed. "But that's showbiz."

Frank Rose was born and raised in Virginia and educated at Washington and Lee University. He has worked since then as a journalist in New York City, writing about sex, drugs, and celebrity for *The Village Voice, Rolling Stone,* and other publications.

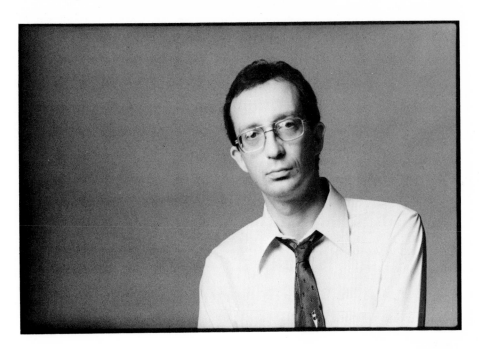

George Bennett's photographs have appeared in the editorial and advertising pages of *Business Week, Cosmopolitan, New York, Photography Annual, Town & Country,* and other magazines in the United States and Europe. In addition, he has designed and published two previous books of photographs: *Mannequins* (Knopf, 1977) and *Fighters* (Doubleday/Dolphin, 1978), the latter with a text by Pete Hamill. He spent three years as a naval officer after graduating from Cornell and has lived since then in New York City.

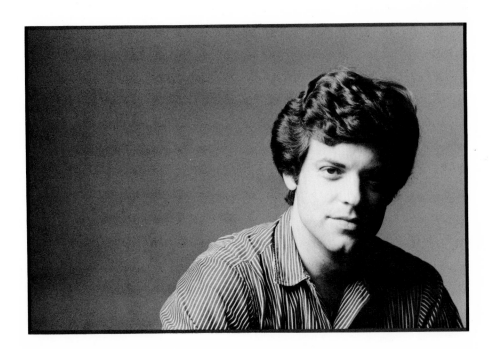